CATAMANIA

*The Dissonance Of Female Pleasure
And Dissent*

Adèle Olivia Gladwell

Credits
Catamania
Adèle Olivia Gladwell
A Creation Book
Copyright © A.O. Gladwell 1995
All world rights reserved
First published 1995 by:
Creation Books
83 Clerkenwell Road
London EC1R 5AR
Design:
Bradley Davis
A Butcherbest Production

Cover photograph:
Adèle Olivia Gladwell, by Michael Jones, © 1992
Inside cover photograph:
Jarboe, by Tamara Rafkin, © 1994

Acknowledgments
The author wishes to thank:
Dr. Jean Fisher, Jayne Parker, Tamara Rafkin, Kim Fuller, Julia Kristeva, Esther Windsor, Paul Kidd-Stanton, Andrea Fisher, Harriet Maunsell, Hélène Cixous, Brett Butler, Kaja Silverman, Kathy Acker, Jarboe, Diamanda Galás, James Williamson and all the writers, auteurs, performers and theorists mentioned in this book.

Very special thanks to:
Margaret Fagan

Contents

Prologue

I would like to elucidate in a pre-conclusionary effect, that my initial intention (when I first discussed this project with my publisher) was to write "about" women's voices; describing a heterogeneous selection of female performers.

I came to realise almost from day one of the execution of the book, that it was simply not possible for me to do so; moreover that it was not actually my truest intention. I realised that I could not (in honesty) write "about" any woman – therefore my positings became suppositions; my proposals and presumptions showed themselves to be descriptions of myself. My analysis became self-analysis and I became aware that I could and was only theoretizing my self; relating to (when able) other/Other voices, within contexts.

I claim to be unable to write on behalf of externalized others (only if in relation to a self-conscious dynamic that includes myself) – I can only write on behalf of these selves interiorized. I can only chart my own cognitive landscapes of expression, projection, silence and relativity to the Voices that reach out to me, and are within me. This, I should point out, effected no strident or restrictive boundaries upon me. Paradoxically, it allowed me a greater freedom; a greater insight.

This is all I can do. Therein (a soundscape/space) began my theoretic, phonetic, genotextual journey. I do claim to having a subjective allusion to empathy and affinity with some of the women mentioned in this study: performers and writers alike, but this is my illusion/allusion. Not theirs. I regularly cite others' works as paradigms or diagrammatical devices for my own translatory allusions or scenes of *dêjà entendu*. This allusion is illuminated by the respect I hold for their works and often for what I know to be their *public* characters. But, this "projection" should be taken as just that – a subjective projection. In writing about the Voice – I rejected putting words in others' mouths for the sake of dissemination or simple identification.

It is integral that, especially with the chapters concerning themselves with mental illness and imaginary or symbolically-mediated mythologies, it is heard to be myself speaking, and only for and as myself (albeit with external inspiration). Although that self may be multiple in its subjects, apparently discursive in a different progression and poetic at times, I have embarked on this project as a trial against pure self-indulgence, believing that there is a point or many points when one projection meets another or is met by it and some communication or intercourse occurs.

My own personal experience with the vast private and public arena of mental illness commenced around the same time as I first began my research. I have written not about the "madwoman", but *as* the madwoman; the dynamics range out from this juncture. I have described, not another woman's depression, pain, anxiety and "shamanistic" outsider-ness, but my own. And if I have pedestalled the "madwoman", shaman, hysteric, mother or witch – it has been

through self-belief in my own subjectivity and reclamation; which I have heard echo-ed back to me (so I believe) in others' voices. As I am aware of my own protest song and lullaby as an inspiration and terrible fear – so I have heard snatches of songs and works which remind me. *Déjà entendu.*

I have also taken within my discourse, the speaking Voice(s) and the Voice(s) of the text as a kind of metonymy, in a semiotic fashion – wherein signs and forms are seen and heard as equal but different; and metaphors and functions as associative, linked, yet uncodifiable and pleasurable – arising from a polysemous, intractable language.

This differs to an extent from Derrida's theories of the Logos and the Word of God (concerned with the metaphysics of presence and absolutism), as identifiable with the oratorical, and conversely, with writing as being closer to experience – exclusively. It also differs from philosophies of the Text as solely linear and the Spoken as a manoeuvre purporting to a (phallic) transcendence. I have attempted to address such issues within this work, and have found interesting ambiguities (and subversions), and stepping stones in both such philosophies.

Therefore, I hope, that my work is open to invention of meaning; through my absences from my own text (the stranger within me!), presences (the authorial in me), traces, drives, sojourns, graves and cribs; and the constituting and resulting (sexual) difference(s) and *différance*; and importantly the steps forward to a state of non-sexual difference in the contexts following symbolic castration.

So these Voices are mine Alone; but some of them are voices which instead of being spoken by me – speak me. And although Alone – not so lonely.

—A.O.G., London 1995

Introduction

Catamania is a study of the agency of the voice, and of women actively using oratorial expression and acoustics that subvert the accepted aesthetics of the phallocentric "rock" hegemony and patriarchal expressive discourse. Yet, it is delivered to you in my own voice[s]; a multi-contextual theory and analysis of the polemic of feminist rhetorical discourse, as it presents a fresh and vital approach to an anatomy and ideology of a subjectivity through precise and "blurred" listening and the audacity to speak aloud in a "new" voice.

Throughout time women have been silenced. Their voices were stolen and their roles reduced to mute muses, never active orators. Moreover, if they did wish to utter something, the linear discourse of patriarchy was presented as the sole available valid mode of expression. A language that has failed so many women with its false allusion to absolute meanings, as well as its straight and narrow semantic path.

Moreover "woman" was established as the LISTENER; her vocal input was too "weak", "passive" and "emotive" for the "common sense" and "logic" that men talked. Language was seen as communication first and foremost, and the concept of speech, and writing or expression beyond the context of logocentric discourse (i.e. that which wasn't/isn't emotive) was viewed as nonsensical, or at best useless. However, we now know that language is very much to do with (communal and individual) expression, and not merely the passing on of human knowledge.

The powerful reconciliation of the projection, or projected noise, with the body; the reconciliation (albeit problematic) of the ostensibly "castrated" female with a re-embodiment, and re-figuration. Upsetting the staid notions of the body/voice or body image synchronisation.

Catamania refers back to mythology in its examination of the voice of Female. Back to Echo, cursed to utter only the last phrase of others' speech. Through the ages, women in their imposed roles as listeners have become CULTURAL SECRETARIES. They listen to people's problems; they *lend an ear*. They write down what they hear and they translate and mediate the "truth". But where in this continuum of conducting information do they seize control of language? Where do they appropriate a voice that is their own? Where is their "new" phonetics and eloquence aside from this second-hand regurgitation? As seen in Echo's story, the nonsensical lingo amalgamated from cut-up and illogical syllables became her great vocal gift; her own cadence and cataphonics.

No-one can surely deny that women have naturally or nurturedly acquired powerful hearing (or, sensual receptivity), and as the great "receivers" of the world they have become visionaries, often sensing what men do not. But today we have women who are not merely singing their *lament* – song has always been the remedy to silence – but are *screaming*, gutturally, with a resonance. They are making cacophonous NOISE, resounding around the "old" patterns of speech structure and musical aesthetics like a hurricane, like a chaos from

elsewhere that many men cannot begin to comprehend; nor can they explain it other than in the context of their own sounds. But it is not within that context. Women have been singing for centuries, with much of this singing originating as cries of joy or pain. Mating songs or funeral dirges. But women will no longer be separated from their bodies and voices, and no longer can Female Noise be seen as "mere" emotional caterwauling.

Women today are not only subverting, not only undermining, the patriarchal music language; they are creating new languages of incredible space, of a history that points to the future. No longer ashamed of "bad" language or sexual language, they are appropriating and adding requisite female sexuality and semiotic space to usurp sexist innuendo and to demonstrate the strength and vastness of female desire. Anti-censorship: their aim is to expose their society's hypocrisy and shame, for only in the open can it be changed. This is not shock tactics; rather, it shows that these women have no qualms about the position they are in, be it moral, immoral or amoral. They want to tell it like it is.

As *Catamania* covers a history of Female Noise from Greek myth, through primitive singing and the aural roles imposed on women which are now being usurped, it points to the main body of work which is giving cathedral acoustic space to the voice of contemporary women. Some are resounding their dissent at patriarchal society, and what they see as its narrow-minded ignorance and fear of Female Power; for it is *they* (the women) who are writing the music, playing the instruments. Others simply use their voices to trace primordial, timeless and startling rhythms. Their multi-octave vocal works add a new meaning to the previous concept of a woman's "passive", "helpless", "hysterical" scream of terror: these new screams have the sensibility of true lament, but are out to pierce the eardrum and spear through to the heart, conscience and very confidence of the listener. Others utilise non-verbal noise; some use patriarchal language (the weapon of the oppressor) with deadly and deliberate irony. An agency constituting anger and most importantly, pleasure; delight, bliss. A pleasure that is vital to women and men. In this way abjection holds a promise of a little dark light, for one to journey on.

Catamania is a celebration of women who refuse to be seen and not heard.

1. The First Voice

"The voice is the muscle of the soul."
(Frankie Armstrong)

What can move, touch, stir, excite, incite like the voice? It can "move" one, literally. The feet commence their kinematics; to tap and shuffle of their own accord. The stomach jumps, churns and quivers with emotional response. The chill that runs down the spine causing the insuppressible shudder; the nape hairs tingle and the fine down on the cheek feels raw. The lump in the throat and the watering eyes. The spontaneous smile or rueful grimace.

The human voice touches the entrails. Journeys inside to snake around the body and psyche, like a pneumatic exchange. You let out a sigh. Take a deep breath.

The Breath. The First Breath. From now on every sound. Cadence. Word. Whisper. Whisper-sibyl with pneuma (will be) delivered like a ssh-baby wrapped ... in the blankets and cloths of phonetics. This is the first breath. Deeply inhale to shout. The most precious. The breath on the cheek of the beloved. The feel. Sensation of hurr; ssh; sss; tsk-tss. Then there will be the First Voice. A song ma-ma taught you. Mummy. Moth-er. Me-ma. Ma-me. A sound to bring warmth, food and love to you. Maybe. And then it withdraws. The cry of anguish. Suffering. Have you forgotten she came (to you) with the First Voice? And that First Voice was the Noise made. Top C sharp. Small death cry – shattered glass. Screaming caul. Cater-waul. Her high voice as the child. Baby-high-phonetics. Low notes. Yelling bellow. Blighty. Boom. Moo? Coming through her. Eee-you. Not only from Her. The First Voice. Primeval. Primordial. The primal scream, as the long suppressed cry at the pain of birth; the first castration. Reliving the uterine experience. Somewhere a woman screams. In a space. Landscape. Inside. Or silence.

Volume. With timbre. Then, there were stories which we all soon forgot. Or not. A reiteration. A sound *déjà-vu*. Like the church bells on Sunday. The confluence of pitches. Tintinnabulation. Your ears were ringing. Or whistling. Out of tune. And overtones. Overtures. The tuning fork humming in sympathy with you. A certain resonance. Leaping an octave in harmony. Even silence and stillness reverberates. Un-silence. An atom vibrates. We hear ours names. Calling. Calling you. Waves of white-noise. Matter noise. The voice within.

The possibility of sound, so delicate. Itself a funambulist. This distressing but narcotic function. Would that it always emerges. But, myriad noises fester internally; regressing into the bowel. Evacuate. The mediator, the mouth – shuts. A death trap. So many interior screams. Convulsing the spleen. But, by the temporality of sound, sooner or later it comes around. Monumental. Helical. Vertiginous. A continuum of expression cyloning. Inside. Inhume. Exhume.

Living-dead sound. Alive again.

During the 1970's:

"She's such a nice, quiet little girl." This was frequently said, about me, during my childhood. I recall that it was supposed to be a compliment.

Is sound a delusion of the senses? What we hear are sound waves; travelling through time and space. Energy is vibration. The ear picks up the frequency of the vibrations; some rapid, some slow. Some we will never be able to hear. There are many things we do not hear. Politicians pretend to tell us ultimate truths; which they demand we hear. They want to be perfectly clear in what they say and how we hear it.

The inner ear is fragile. The sounds waves mask each other; so that many frequencies are heard as only one undifferentiated sound to the ear. There's always background noise; a white noise in the backs of our heads. Or else our ears play tricks. Our ears tell us how far away from the walls we are; they define space. In her book *Woman And Nature: The Roaring Within Her* Susan Griffin imitates and presents to us many "voices" (a poetical plethora and mixture of patriarchal and feminist voices); one of the voices tells us that " ...there is no absolute relationship between what produces sound and what is heard, what is heard is a delusion of the senses and cannot be said to be real."

So do sounds exist without ears? Does sound exist in the mind? If it all exists in the mind then who believes anyone, or what they say? Is this why the judicial system demands corroboration? Because injustices against women are just in the mind? And because inanimate objects have no mind, how can sound exist in a musical instrument?

But the sensuality between the ear and a piece of wood (even) is a dialogue, and it is hence a reality.

He tells her he didn't mean "it" like that. That it's all in her mind. Over-active imagination. He says – "What I meant was ..." And – "You've got it all wrong, because what I really said was ..." And then – "Why are you being so defensive? I never said that." He raises his voice. Becomes almost violent.

She tells herself she's imagining this "violence". All the words she was once going to say have been robbed of any meaning. Absolutely meaningless. She becomes ashamed of what she thought of saying. Then hates herself for the ugliness of what she once thought she wanted to say. She tries to say something else. Tell him how she feels. He doesn't answer, deliberately blocking her words. They fall like dust. Fall back into her dry tired mouth. She is forced to ponder her ability to communicate. Like a child who doesn't know words. She is forced to shout if that's the only way to make her words work. She is forced to scream. She screams abuse. The minute she screams she hates herself for the sound she makes. She sounds just like the person he wants her to sound like. She is a stranger to her own discursive or expressive sounds. Her sounds either have no meaning or they are the sounds he says "hysterics" make. She hates her own voice. Can't bear to hear herself on an answering machine or a tape recorder. She can't speak up in public. She whispers apologies. She can't join the debating team because her heart beats frantically and her mouth becomes parched every time she attempts to speak. She thinks she's tone-deaf and can't sing. She wants to ask questions and to relay stories but she cannot reconcile

herself with the sound that comes from her own mouth.

Nag. Nag. Nag. All you do is nag. And all you do is rant on like some nazi-feminist fascist. And all you do is talk rubbish. I'm not listening.

She talks to the cat, the baby, the mirror. She has a mind's eye voice. Hers is not a silence like Ada's – hers is an imposed silence. And she has no alternative voice. She couldn't possibly get up on a stage and sing. If she did she might find – laughter, derision (it's unthinkable). She might also find – listening. Lots of listening.

Instead of the silence she is trapped in.

Polyglot

We can hear. We can hear what is outside of us and inside of us. After a while the voice sounds beautiful no matter what noise it makes. We learn to listen. Become our own instruments. The throat. The glottis. The larynx. The solar plexus. The stomach chamber music. The sound of rain applauding. The drum skin. The pipes and valves of the heart. We become our own instruments.

The Siren

Sits and screams on the rocks; on the breakers. On the borders between sure land and the turbulent oceanic depths. Between sanity and insanity. Between life and death. Her song echoes.

The unconscious, our sexuality, our desire (constituted from all we have loved and lost, and also what we fear) becomes the dread, the dead, the deep of salinity, fluidity, scatology, viscidity and (horrifically) repetition. No escape! Constitutes the black engulfing sea, which swallowed many a lover, many an innocent, many a sinner without distinction. A metaphorical pelagic abyss (and we are drowning) in the chaos of our inventions, constructions, and selves. It could be a darkly lit mirror. A macrocosm mirrored by microcosm (or vice versa) which we see by the light of that "little dark light".

2. His-story Or Hysterie?

Lend me your ears! We are going to tell a story. It is a tale about time and space. In fact it is set within a certain vatic space, and the temporality is of a monumental and cyclic and linear kind. You may have heard snatches of this story before. Segments of its narrative will have flowed over you, or through you; they may even have come from you. But, for sure, the entirety of this story is set down in no novel, history book, tome, poem, song or grimoire. And we make no claims that it is written here in its totality. But, myriad nuances of this story do exist within this book; although, of course, the narrative might not always be the linear path of sequences usually expected. This story exists in fragments, fractures of primeval sound and word, whispers of myths, and in the lungs, mouths, minds and innards of many women today. As a magnified helix too vast to comprehend in its entirety; a sempiternal matrix. Those that speak will now tell you a story. Of sorts.

3. Mirror Mirror

(A Male Speculates...)

A man sees a woman on a stage. A metaphysical mirror exists. Then, the woman opens her mouth. A stream of verbal abuse. A vulgar diatribe of angst and dissent. The Voice mimics the cry of the angry young man. The mirror cracks a little. The Voice ironically mimics the urban expression. Ripples waver the reflective surface. Then, the Voice pitches; screams – the Voice of the First Voice. The mirror shatters; explodes; implodes. A million shrapnel fragments vacuum into this man. The mirror explodes (slow motion) with the First Voice. He hears a sound; the sound of the limits of his own consciousness; bordering on chaos but still decipherable.

Let us take the speculum, the speculation, the specularization. It is a context. A patriarchal context.

The speculum (*specere* – "to look") sheds light on the female sex in gynaecology. Its concave shape is required; it actually imitates the object which it in the first place objectifies. The vagina. So "like" needs "like" to "see" itself. Freud's theory of sexual difference (although a reasonable startpoint it is not now terribly seminal) is based on visibility; of the eye seeing. The male has his phallus to see and when he looks at the female sees no phallus. Doesn't acknowledge the female sexuality in its own right, just simply sees no phallus. He sees nothing; an absence. Based on Luce Irigaray's theory about specularization, this is because the male needs to reflect his own being. He can only see in this context. The context of the visibility of the phallus. This is the basis and grounding for patriarchal discourse, which is formed by acknowledging linear, affirmative, property-orientated and symbolic qualities. Anything "outside" of this self-reflexivity is unthinkable, literally. Unfortunately, Western discourse seems incapable of representing woman other than as the negative of its OWN reflection. This is the phallocentric logic of the Same.

So, the woman is a projection of the male hypothetical fear of castration. For she with her no-penis reassures him that he must possess his blessed tool and is therefore superior; a smooth operator with his symbolic order and contract. But to castrate a woman is surely to attribute her with the desire to have her own penis in the first place. And as we shall find out in our journey through this book, that is most definitely not the case. But, man is incapable of thinking outside of this specular structure; reducing woman to not only his Other but his negative or mirror image. And his discourse situates her outside of representation: absence, like a lesser man. In fact the highest position a woman can "achieve" seems to be as man's Other.

Importantly, regarding this book's premise (with the female body as visual spectacle – a symbol of projected male hypothetical castration/impotence) – the female voice also suffers in this "mirror" negativity. It becomes the mediated oration and catacoustic expression of that displaced symbolic castration. As Dr.

Jean Fisher points out in her essay "Reflections On Echo – Sound By Women Artists In Britain" – this is the context of the "acoustic mirror" or speculum. The voice of the lesser male (woman) describing her hysteric (imposed) chitter-chattering, discursive, nonsensical prattle. Her "negative" talk is also in the context of (comparative to) patriarchal linear logic and its language. Women gossip, twitter; their speech is reduced to mimicry and/or emotional, drifting, illogical orations lacking the direct delivery of the male. Of course, the patriarchal context devaluates and dismisses the poetic or imaginary as inferior and defunct. This is quite strange considering our symbolic order actually exists in close collusion with the imaginary, only really escaping the negativity because it colludes with phallocentricity more.

As "her" writing is (in)eligible in its semantics, so "her" vocalizations are digressive verbalizations. But we shall soon see the new semiotic worth of "her" vocal output and shall investigate the position of the voice of hysteria, the voice of castration, the seminal pre-Oedipal (and *chora*-l) phonetics and the vibrations of the third space in greater depth.

The gaze, the look, is a phallic activity. Or is it? Blindness is castration, as myth and psychology have described to us. Male scopophilia is satisfied and domination is secure, or not! Woman is left cut-off from her OWN pleasure; one that is specific to her within the patriarchal order and discourse. In this context of specular logic, woman can either remain silent or produce incomprehensible babble (which her language would be if "outside" of the logic of the Same). Or she can become a mimic, which is a metaphysical approach that Luce Irigaray has utilized. She can mimic patriarchal discourse and language if only to snatch a little of her own pleasure in doing so; and she can be ironic.

Alas, because all theories and contracts involving the subject have been taken up by patriarchy and its expressions, when a woman becomes involved with them (as women invariably are) she sacrifices her very special and magical relationship with the imaginary. Because what a speculating, scopophiliac male cannot resolve is an imagining woman. If she as the object on which he is speculating is being subjective, she is not being a stable solid grounded object on which he CAN speculate. If she does not represent solid matter how can he be secure? How can he construct himself? To look at your mirror, in the hope of seeing a lesser man to satisfy your manhood, and instead encountering something which metaphysically borders on the limits of our consciousness and order, makes for a blindspot. Fluid ground where the man needs stable footing for his erections.

If woman is the Other of any conceivable, ordered theory, discourse, or speech – then how I am making sense (or not) here? Because, of course, "woman" is on the BORDER (and in the mirror), and "she" constitutes! Am I a woman? Then, is there any such "thing"? She can speak any context she has mind enough to contain. She can speak linear, and in fact needs/desires to do so. She can speak imaginary and needs/desires to do that too. Poetic, informative, deferring, signifying and opening up space. If woman was the complete other of every conceivable Western language, discourse, theory then I would be reducing her to an unfortunate essence. I would be pinning her down in the same way man needs to pin down her space by didactic definition. And if woman is given a space wherein she can use linguistics (stress plural) then there

is less chance of us disappearing up our own backsides in trying to define a female language or know "what is a woman?" in the first place.

To pull apart the context of the monolithic, unmoving patriarchal linear language, WITHOUT a new (semiotic/multi-contextual) space to operate in, is to be parasitical upon that language. To then try, and with that context still operating, to define woman is to essentialise her; skim her down to a bottled object. Conversely, a woman cannot pretend to be writing/speaking/singing in a post-feminist realm outside of patriarchy when all that is perceived is incomprehensible poetic mumbo-jumbo. What is the answer then? Damned, as women are, between using only patriarchal language or speaking something only the subject can comprehend. The answer may lie in a third space. And it is within that third space that I believe the women in this book operate. They undermine patriarchy by mimicking it and mimicking it with delicious irony; they speak spatially and poetically; polyglot; pre-Oedipal noise; and they are moreover multi-contextual. Withholding and existing in a semiotic space which has forgotten the binary oppositional power structure that lead to the either/or dilemma and decided to be of a certain "bisexuality". By this I mean utilizing and being utilized by myriad languages and also importantly temporalities. Now the undermining of patriarchal language and discourse can mean something. A new context. There will be no more unfortunate dilemmas of finding that the very language you have set out to usurp has in fact led you onto delighting in a Sameness; a speculative contract, as can be the case when woman tries to usurp through taking the piss out of male language only to find herself "shamefully" happy when she finds her likeness, as it were, within it. In other words none of the old backfiring that can occur when people think you are just a woman talking like a man; and not perceiving the irony of your imitation. Gone is the essentialism; gone the desire to define woman, who doesn't exist anyway, due to the old mis-representations of the monolithic patriarchal system. In comes a massive, vatic space that is no system. Gone also is the need to vex over definitions of female language or womanspeak.

For there exists a massive problematic. A woman can enact (re-enact) the specular representation of herself as a lesser male. She can mimic his discourse and in mimicking highlight the pitfalls and limits of patriarchal language with its semi-redundant binary oppositions, and linear, non-poetic progression. She can deconstruct. This deconstruction is an exercise, a process, rather than a theory in itself. But, as aforementioned, this mimicry (which is a form of hysteria being as it is a reaction against patriarchal language and a result of exclusion and non-representation) can often fail to produce anything new.

Also, by asserting that the conversely poetic "female" language is the answer, women will find themselves still engaged in binary oppositional positions with all the detrimental Otherness definitions still applicable. She will be re-asserting the negativity of woman. If our theoretical discourse constitutes the repression of female expression then also in explaining herself she becomes a patriarchal voice. So then just exactly who is speaking, and how is she speaking? The questions raised by Shoshana Felman in *Sexual/Textual Politics* illuminate this problematic:

"...Is she speaking *as* a woman, or *in the place of* the (silent) woman, *for* the woman, *in the name of* the woman? Is it enough to *be* a woman in order to *speak* as a woman? Is 'speaking as a woman' a fact determined by some

biological *condition* or by a strategic, theoretical *position*, by anatomy or by culture? What if 'speaking as a woman' were not a simple 'natural' fact, could not be taken for granted?"

Luce Irigaray, who advocates a womanspeak, is also very aware of the essential traps, aforementioned. In mimicking patriarchal discourse, as she does to deconstruct various philosophical and psychological "master" discourses, she believes the female can thus be read in the blank spaces between the signs and lines of her mimicry. Unfortunately, this often fails once more for reasons I have already described. In effect, what can also happen here is that this (self)conscious mimicry is an act. The mimic is "playing at" being the true mimic (which is a role many women have imposed on them). Miming the sort of miming that many women can not just affect to make a feminist point. Her move is a specular one in that she is mirroring all women, intending to undo phallocentric discourse by *over*doing it.

From all this the question of POSITION arises. The womanspeaker, or the mimic – where are they politically/socially positioned in order to make sense of this inexorable impasse. In concentrating so much on defining female language and femininity it is easy to forget that the basic polarities of our social order, and language, work against our doing so. By trying to effect a female-ness that has escaped specul(ariz)ation one finds the same language that has borne the negativity still operating. If "female-ness" is a space of body and language and psychology and touch and space then surely to "say" that, is to reduce it to an ordered Other-ness in our order.

But, Irigaray and also Hélène Cixous hold by a certain female-ness (although Cixous has advocated what she terms the Other Bisexuality in order to combat the metaphysics of sexual difference in language and we shall go into this later on).

Irigaray says gaze/scopophilia is foreign to female pleasure. I would describe gaze as not foreign to woman but certainly often particular to men. She says that touch is more pleasurable for females and posits femininity as plural/multiple (which owes a lot to ideas of multi-context such as Kristeva proclaims). She also holds that woman is situated outside all "property" (as in the Realm of the Proper – wherein men operate through categorization, classification and property). Again a return to a binary opposition; when what might be more appropriate to conclude is that men are more likely to operate within "property" because of varying psychological and linguistic dynamics; namely fear of castration and not wanting to upset the monolith of linear language structure. She also says the female economy does not work on an either/or model, and is hence not specular. This lacks the awareness of the initial sexual contract which women are irrefutably involved in; even if against their own will. Irigaray says "nearness" is more a female activity and operation birthing a "proximity" wherein identification with one or other is impossible; unlike any form of property this is not a possession – she claims. This might well be true to a point but it disregards exceptions or the position from which this supposed woman takes account of this non-proper space. And although she will not give an account of "womanspeak" she does define its style in an address which resembles a male negation of "femaleness" as an object. This is quite a difficult area, especially as Cixous, also involved in female language, advocates a fluid multi-subject tactic in her prose – which owes much to her own theories

of multi-context and the Other Bisexuality. But it has been pointed out that Irigaray cannot present this female morphology (shape/form) as if it were perceivable, without ideological mediation, as if this were a woman's social and intellectual existence. Again, a very tricky area considering the "writing (from) the body" prose that many writers, including myself, execute. But the expanded (processing) space that many writers who do "write from the body" open up is one of also incorporating questions about the nature of (many) languages; linear and spatial into the writing so as to open up a semiotic space and not make it appear as if woman were of the singular specul(ariz)ated object.

So we understand that one has to consider the historical/economic/social specificity of patriarchy and its ideologies in order to avoid these idealist categories.

And so to return in wonderful cyclic fashion to the positioning. On the border – this is what Kristeva posited as an answer to questions of how and from where does this "woman" speak. She is, of course, marginal. She is the limit and border between order and chaos, and consequently partakes of all qualities and frontiers.

To highlight this position let us view its genesis. The pre-Oedipal phase. The realm of anal/oral, life/death, expulsion/introjection and heterogeneous space and process. The pre-Oedipal mother is, in effect, masculine and feminine; she simply looms large for babies of both sexes. The fluid mobility of the semiotic reads the fluid mobility of the womb; later the non-split subject who does not comprehend (or know) of the cut-up of its continuum by verb, noun, linear time, or subject in relation to object, thinking as it does that it is still part of its mother.

So surely language should be heterogeneous. And we should move away from language as a monolithic structure. Should language not be a complex, signifying space rather than a linear system constituting binary opposition? There is, after all, no sexual difference in language itself (language itself is not sexist, it is the context we use that makes it read/speak so). But, differences can take us elsewhere through an ever proliferating network of displacement and deferral of meaning. In other words – a "shades of grey" space as opposed to the gap between two binary parts in opposition. A case of "more, less, lesser, least"; instead of simply "black and white". To open up a process of bouncing meanings off many many subjects/objects/concepts/phenomena, instead of closing the meanings. In this way semiotics has a link with the womb. As Kristeva has written, *"chora"* is Greek for enclosed space, but *"chora"* also has neither sign nor position being spatial and mobile. Anterior to figuration, etc., the only analogies are with kinetic rhythm and the Voice. The semiotic (*chora*) continuum thus splits if signification is to be produced. Once a child entered through into the Symbolic Order (via the Mirror phase) the *chora* is more or less repressed; only being but a slight pressure on the symbolic (experienced through contradictions, disruptions, silence, absences, etc.). The *chora* is a rhythmic pulsion constituting the heterogeneous, disruptive dimensions of language; that which can never be caught up in the closure of traditional language theory.

At the point of entry into the Symbolic Order there can be mother-identification occurring; which will intensify the pre-Oedipal components and bring about this marginality, dissidence, and to a depending degree – subversion. Or there will be father identification, and one will derive identity

from the Law of the Father and merge more fully into/with the Symbolic Order.

This is how "woman" will come to not exist. This is also how men will find their unease with the Symbolic Order too. After all, many men do not wish to reside in a social context (within a contract) whose metaphysics hypothesize a continued singular relation, of its existence, to property and the obsessional centrism of the phallus: invoking neuroses and restrictions.

What strikes one as bizarre is the lack of discussion about "language" and all that it constitutes. It seems as if even linguists don't question the field of their own study. That there can be a Voice in us that is repressed by the very language we use to communicate. The monolithic authoritarian linguistics go unchallenged even by the very people purporting to study language.

Kristeva suggests that the breaking of this deadlock phenomenon lies in the re-establishment of the speaking subject as an *object* for linguistics. To also be aware of the heterogeneous destructiveness in speech and discourse. That the process shifts in each individual and between individuals, and that this process be a process of multi-context; of studying myriad contexts. Maybe, too, if we realize that language is productive and not reflective, and that we can effect change. Feminists have argued that those with the power to name and construct our language are in the position then to influence reality. Unfortunately, women have lacked this power and consequently many female experiences lack a name. Often, of course, there is no need to fix with meaning (in order to use that fixture with aggression), for definitions can be constructive but also restricting. Fixed meaning, of course, brings us back round to the phallocentric urge to organize. But already in recent times we have seen many changes (many of them admittedly subtle) on our linguistics. We no longer have the same rigid views on what is "masculine" and what is "feminine". Already we understand that the issue of context(s) is at the root of our lingual/social problematic.

Now we have found this Other Bisexual, multi-contextual, third space, that disregards any sexual difference in language dilemmas as a problem caused by having the two (binary opposed) economies in only the one context (i.e. patriarchal language and its Other, in our Symbolic Order). Now let us return to the feminist issue of the female voice. To comment further on the pre-Oedipal noise (sound) and the First Voice, and its special relevance for the women in this book, I would like to go into Kristevan theory, again, regarding female temporality and its relation to feminism. Hopefully, we will induce the link between the pre-Oedipal phase, the mother identification, and the problematic of needing this *chora*/voice/noise expression. This process shall lead us back to the semiotic third space again.

4. Temporal Triptych

Two Generations Of Feminism,
Three Types Of Time
And The Third Space

As Kristeva wrote in her essay "Women's Time", female subjectivity seems to be linked to both cyclic time and monumental time. Cyclic time is best understood as the repetition of time in periods – as in inevitable monthly menstrual time. Hence women have a natural proclivity to accept natural rhythms of temporality, and that "what goes around tends to come around" or so the saying goes. Monumental time or eternal time, perhaps, gains its conception in our minds by understanding the death context in cyclical time and expanding it beyond our own lifetime of blood lines and consanguinity to a time that borders on the very edge of our understandings. Current quantum physics and discoveries into the Big Bang, with its occurrence outside of our knowledge as it is outside of our existence, help our insights into monumental time.

Our line of conceivable history has been characterized by linear time. Time as project, teleology, departure, progression and arrival. This sequential time is reflected in our language. Linear time can be seen as symbolic in that it adheres to the rules of the Symbolic Order but it can also be seen as discursive in that it does not fulfil all the requirements of the Real; in other words it can be represented. In short it is only one temporality although the most useful system for our society's continued existence.

The first generation of suffragists and existential feminists (generation signifies space not just era) demanded equal rights socially and politically, and fought for a place in the linear time of patriarchy. This can be seen as part of the logic of identification as in Irigaray's theory of Sameness. However the second generation of feminists (generally emerging in the late 1960's) emphasized woman's radical difference from men, the two temporalities especial to her, and demanded the respected right to remain outside of linear politico-social history. This second generation can be perceived as a "counter-ideology" wherein women sought (and still seek) a language for their subjective and corporeal experiences. Also, the desire for children had not really been properly addressed before, and that had left the area open to unreconciled mysticism. Women deconstructed their identity and created a "corporeal and desiring mental space" wherein individual difference existed because the irreducible quality of female corporeal experience (namely motherhood) was without equal in the opposite sex. This experience (and temporality) was plural and fluid and in a fashion non-identifiable. It had an archaic memory and a marginal time. We have read about the pitfalls however of this definition of female-ness. That patriarchy with its language and time still exists to eradicate its worth for women.

Finally then we have the mixture of the two. The insertion into history and the

refusal of the subjective limitations of this history's time in the name of irreducible difference.

How did this linear time arrive a such a restricting impasse? Language, as we know it, is hypothetically linked to an imaginary castration as we have already deduced. For instance, fear of castration is perceivable in the discourse of neurotics. The penis is the major referent in the operation of separation which we experience as we enter language and realize the symbolic with its distance between our nature and our discourse, and also our self from any other. The obsessional male who fears hypothetical castration will often attempt to "master" language and symbolically secure his potency. The female suffering from a separation from patriarchal language, and denying that separation, could be considered to have penis envy, and is a hysteric in Freudian terminology in that she feels unease or pain with patriarchy and its language system. Conversely one who refuses patriarchal linear time and language is a melancholic in the same terms. All this is hypothetical in that what we are really talking about is a desire or lack or fear. The fact remains that women will feel more akin to the unbroken *"chora"* or pre-Oedipal because of female identification and also because of their link to the mother in themselves. Not as Freud suggests because they are too immature to break away from the mother, and develop sexually. All this indicates the need for a sound state as in the pre-symbolic time.

With no expressive place in the socio-symbolic contract, and within its language not encountering a positive accommodation of the fluid significations of their relationships with nature and the body, women have rejected the symbolic. We already know what can occur when this rejection takes place. Kristeva also calls this negative dynamic a counter-ideology. Also we have the counter-investment which is in effect what mimicry and much deconstruction is. To take hold of the contract and enjoy it or subvert it, as we know, can invoke essentialism and misunderstood irony. Another type of counter-investment can be the exploration of the contract/symbolic order from a personal standpoint as a "woman". We have also encountered this before in the points about female language or womanspeak. This dissident activity to find a female "body" of writing/language which is problematic. As Kristeva points out, and as we have deduced, this need to find another (poetic/spatial?) language has to do with marginalization. Another problematic being female writing of an aesthetic which is a result of lack of narcissistic gratification for the ego, or a romantic depression. In other words a need to glorify the femaleness that a woman already feels bad about. Kristeva in her views on "female" writing can seem almost harsh, and I, for one, sympathize with the intentions of female writing, feeling it often forgets to think itself of the third space by calling itself "female".

Kristeva is concerned with the sacrificial contract which has come into play through women having to speak in a borrowed and inadequate voice. She expresses that this sacrificial contract is forced on women against their will, and that our society insists on the sacrifice of the discourse of dreamers and writers, and "savage thought".

Kristeva goes on to say that the revolt that women are attempting is seen as murder and this is why such strong monolithic resistance is erected. In short we have a situation that is a "war". It is of deadly violence, as it is also a cultural innovation. Kristeva points out the huge stakes, predicting that the deadly

violence and the innovation will probably occur at one and the same time.

Feminists are putting the pressure on. First, in socialist countries, then in Western democracies. For, inequality still exists, even in leadership power. It is as if the cause and problem has been understood but a great resistance has been erected to the actual change. What then often happens (as has happened here, in our society) is the parallel society; or counter-society. Unfortunately, this counter-society will take on the qualities of the society it opposes.

Also unfortunate is the manner in which women who have achieved a position of power in our society will then protect the established order. One does not have to look too far for a prime example of this in Britain's ex-Prime Minister Margaret Thatcher. The social strategy that allows a woman, who previously might have been frustrated or oppressed by that society, to enter into it and supposedly play a valid part in it, is a strategy used by many regimes. As Kristeva says – this is a paranoid type of counter-investment, in an initially denied symbolic order – moving towards levelling and conformism.

As far as the feminist movement goes – some may rejoice and profit in the move to a consolidation of conformity, and political parties will take advantage of this movement. Because, after a while, the protests and the innovations sought by women will be inhaled by the power systems and also accredited to the system's account. Any protest will also be severely diluted. So there is a great problematic in integration of the "second sex" into our system; a problem of counter-investment.

As aforementioned, more radical feminism refuses this homologation to any role with the current power system, and forms a counter-society. This female society can be seen as the alter-ego (the same womanspeak space which I have previously referred to as the mirror reflection). From a female point of view her society can be a place for real and fantasized opportunities of *jouissance* (an apposite Kristevan word usage).

Within this utopian space, plotted against the socio-symbolic contract of sacrifice and frustration, is imagined a refuge. What it really is from our society's viewpoint is a scapegoat that carries within it the threats to the society; hence undoubtably it becomes the purge of the society, whereby that society can exonerate itself of future criticism. The poignantly true cliché of blaming the "enemy" for the violent situation. This dynamic applies to religion, the foreigner, the other sex, and so on. In order to counteract this situation feminism attacks/blames back. Inverted sexism. We can clearly see that for feminism this violent situation is becoming massive. Almost half the population. And this terrorism and violence, as this is what it is, is simply rearing its head over and over again.

Objectively, because of this, we realize that the second generation feminism is not intrinsically libertarian, rather it is essentially a simulacrum of the society it counters. This is what we were saying earlier concerning the context of specularization, and definitions of female-ness. In fact, what we can see is that feminism is one instance of consciousness about the unrelenting violence (of separation, of castration, of sacrifice, of blame) that constitutes any symbolic contract.

However; what can occur is for a woman to counter-invest the violence she has endured and, in effect, make herself a "possessed" agent. We shall further

explore this idea later in this book. Her weaponry is her anger. Her weaponry might seem superficially disproportionate but not so in comparison to her subjective suffering, which is where her anger (against society's violence and anger) originates. However, sometimes radical violence (and terrorism) can be more sacrificial than the violence it combats, specifically when there is a radical group situation. I hope to illustrate the individual dissent of women in this book by highlighting their unique works, and the nature of their "possession". I also hope to raise the point of their anger at a liberal society which has exploited and tokenized.

Interestingly, many radical groups tend not to reproach an oppressive social order for its "weakness" but for failing to measure up to a good and lost quality. One which they believe they represent/house. As the social order is sacrificial, and that sacrifice *orders* violence, to refuse the social order is to run the risk that if the "good" be unchained it will explode arbitrarily; it will be chaos. The boundary of chaos and its unfurling is an issue prevalent in some of the work of the women in this book. This "logic of the oppressed goodwill" can lead to massacres in a group situation; murder in individualism.

It is fascinating to note that the political activity of exceptional women has often taken the form of murder, crime and conspiracy. I think, now, of Lydia Lunch's *Conspiracy Of Women* performances and recording.

Kristeva also notes (interestingly in comparison with Freudian theory) that a girl may collude with her mother, and will have a greater difficulty detaching herself from her mother (not because of sexual immaturity) in order to comply with the symbolic order as invested in by the (absent/separated) paternal function. However, a girl will never be able to re-establish herself with the mother, whilst a boy may through sexual contact in later life. But she will be able to re-establish herself through homosexuality or being a mother herself. And the big question must be – why would she *want* to detach herself, so as to enter a (sacrificial) symbolic system which remains foreign to her, anyway?

In "Women's Time" Kristeva goes on to say that if this belief in a good substance is a belief in a utopia with no frustration, sacrifice or break-producing symbolism then in order to disintegrate the innate violences between society and its counter-society (constituting a counter-investment), we shall have to challenge the myth of the archaic Mother. And Jacques Lacan adds to this his "scandalous" sentence – "There is no such thing as Woman"; in order to demonstrate that this archaic Woman does not exist as a possessor of unity, on which is based the terror of power and terrorism as the desire for power. Kristeva adds – "But what an unbelievable force for subversion in the modern world! And, at the same time, what playing with fire!"

In the past motherhood was considered alienating, but today more women consider the maternal experience invaluable to the variance of female experience and the complexities of joy and pain. The debate about motherhood still rages within feminism today, however. Many women refuse the paternal function in a rejection of the symbolic contract, choosing instead to be single mothers; some may deify the maternal role in doing this. This is all very troubling to our order in which politics and the civil tend to be male domains; familial and religious rights have been constituted more by women. Thus the rights of woman in the context of the law and civilities tends towards a blank. So it can be considered that concerning maternity women themselves can do more to

check the violence which children, later men, can be subject to. Can women do this? Can they stop the violence of hypothetical castration, for example? For many feminists the anger they possess, the same anger that society first victimised them with, and showed them, means this is not an easy or even possible area. But why is there a need for motherhood? Let us straight away skip Freud's theory of maternal desire as a desire for the phallus; and consequently the symbolic order. Today with the position we are in, we can understand that this is the radical ordeal of the splitting of the subject. It is a redoubling up on the body; within which there is a separation but also, importantly, anterior to this there is a co-existence of the self with an other. A feeling of narcissistic self-completion whereby the semiotic state is encountered within the self, as it was at the stage of the subject's *"chora"*. To then, in effect, launch oneself, and give birth, is to then encounter a rarity in experience – love for an other. This is not the love of one's own self; nor the love of an identical self; much less the sexual love for the person the "I" fuses with. This is a gentle, attentive forgetting of oneself in an other. To achieve this without masochism or sacrificing one's own personality are the stakes of maternity, it would seem. Importantly, this is a creation in the true sense. A literal creation.

At this point I would like to draw the analogy between this and artistic creation. It would seem that for women involved in the arts, particularly writing and the voice, this is a similar phenomenon. It is apparent that this is the process of revealing, within the voice of one's work and the voice of ones language, the otherwise repressed or unconscious space; the internal other-ness. And then labouring it out so that the subject comes to know the social other-ness of herself. And then, through her voice or writing, she will birth this *away* from herself whilst still being involved, and (during the process) forget/lose her ego; but only to the point, of course, of not eclipsing her social tongue or personality – which is, in effect, her mediator.

This is surely what is wondrous and enlightening about the artistic process? The voice (literary or expressive), and the language, reveal the repressed truth and mirror back upon the social contract by illuminating the unsaid. In this way it can play with the frustrating signs of the social order. Same can be said of the process wherein one encounters the muse; which can be an other-ness to the self, more welded to the self than any lover, and capable of invoking the "forgetting of oneself". Be this a muse that is of the interior sexual-other (animus), or ego-other, it is inspiring in that it directly relates to the subject-host. This is not just about the maternal penis (or potency) as it were, and an identification with it or the symbolic situation. Rather it is a lifting of the weight of the sacrificial. Personally, I see the creative process as a site of disturbance wherein woman deals with would-be masochism and annihilation of autonomy, etc., in her dealings and questionings of her text and language, hopefully coming through this process with the sacrificial lifted, able to name what has never before been named. In this respect, women's artistry not so much owes something to, but needs to respect the inspiration of men's creativity. Female creativity cannot just attack (patriarchal) language out of hand, as we discovered earlier on in this book.

This desire for non-sacrifice is possibly what leads feminism to religion and the need for a representation by matriarchal beliefs, in place of current

symbolization. Just when we thought we were starting to live without the anterior code of religion (Christianity, etc.) feminism seems to be leading us towards a new one. Is this because many feminists believe that to start with the idea of difference they will then be able to break the beliefs in the current "woman" and channel this difference into every element of the female bringing out the singularity and also multiplicities of woman? Can this work, or is this frustrated narcissism? Is it fitting for our times to call for this fluidity of subjectivity?

This obviously leads us back/onto the third generation, again. Not a movement, not really a generation but, as Kristeva says – "...a signifying space." A corporeal and desiring space. This attitude accepts the parallel existence of three temporalities, also interwoven, and two generations of feminism.

This third space understands that we live in an era of metaphysics, and this is where our man/woman dichotomy exists. After all, in our new era of changing identity, what does sexual identity mean anyway? Importantly though, this does not mean the answer lies in an easy peaceful bisexuality that effaces difference; rather that we should realize WHERE the difference is. What would be marvellous is to strip down this huge problematic of "difference" and reduce the dramatic "fight to the death" between rivals. And place the implacable difference EXACTLY where it operates – in the personal identity; the personal sexual identity; *in the person*. At this point we can consider Hélène Cixous' theory of "The Other Bisexuality" in context. As Kristeva expounds, this is not a bisexuality that effaces difference.

"...*other bisexuality*, which is multiple, variable and ever-changing, consisting as it does of the 'non-exclusion either of the difference or of one sex.'"
(Toril Moi quoting Cixous in *Sexual/Textual Politics*)

Here we can "*take into the personal*" (and localise) differences in time – linear, cyclic, monumental; differences in libidos – masculine and feminine; differences in realms of property and/or gift (the realm of non-classification and spatial-ness), and even of different hormones, as ALL existing in the personal/one person. This, of course, presents great risks to the personal equilibrium, and hence the social equilibrium. The person can become a site for disturbance, abjection even. But surely, the risks are not so great as the risks of taking oneself outside of society or attacking society. Unfortunately, it might *seem* like an attack to get this "skimming down" and interiorization to occur. The interiorization of the founding separation (and any links/collusions) of our social contract/order. In other words, we should all take into our cores the dichotomy between separation from (even denial of) language *and* collusion with/upholding of language. Then instead of our fabrication of the scapegoat victim, we shall have an analysis of the victim/executioner potential in each individual, replacing the identity as one or other of these states.

This is surely where art, music, literature and performance play such a crucial role in society. These processes help us de-seminate the symbolic contract and illuminate the rigid uniformity of our culture's language. To take away the mystery of.our monolithic language which we see as such an unquestionable "shield" system. These practises also bring out the singularity and individualism of each person, and more importantly, the multiplicity of each person's identification – be it with the family, the cell, the schizophrenic, the unsocial or

abject, the atom, the black star; according to the symbolic capabilities of each.

The danger we face in trying to make this space work is a danger of a "death". This is what will occur when an outside meets an inside, a self meets an other, etc. This is where again the literature, the expressive voice, can help – as a gauge, of sorts. This third space decrees that we each carry part of the sacrificial burden, hence lessening the burden for those feeling they are carrying the full brunt of a unyielding contract. We can each feel a little burdened, each feel a little guilty and each feel a little *jouissance*; for we will house all the components. It seems to me that the women in this book are already participating in dismantling the monolith and creating the third space. And with it a new ethics. They are aware of the risks, and they are aware of that "death" (housing it inside them as we all do). But, they are doing it. Still.

5. The Presence In/Of The Voice

What is the voice of the Other Bisexuality? How does it rise up without one of its aspects (or interior othernesses) being destroyed? How do we stave off the "death" in/of dis-equilibrium? How do we avoid abjection? Can we avoid the internal battle? The site of disturbance wherein our sexual differences, and hence other differences, are in constant agitation. What happens when the *animus* becomes involved in a repartee with the ego? What happens when the realm of *property* rises up in our throats and admonishes the absconding *gift*, waiting in our hearts to open up the terrifying and glorious space? How will the patriarchal discourse allow the femalespeak to translate/articulate itself *through* its structure, like a sciagraphic birthing? Will consciousness reach out and embrace its own borders; the margin between itself and its uncovered selves? There is no doubting that, even in the arts, this is an area that needs constant attention and work, lest we slip back to erasing within ourselves our own personal interior differences. But, I truly believe that this Other Bisexuality is possible. And I also believe that even if it does cause abjection (a placing of "oneself beside oneself", and a breaking down of the homology of internal Sameness, and a crying out by the repulsed ego when it discovers although its superego-id-master has told it – "this is what you want", it has then left it to be repulsed by the threat of what it wants) it is far more worthy than our previous stalemate situation. In the case of the *animus* or *anima* inside us all, this is also not to suggest that a constant sexual/lovers' (kiss) chase is the nature of this interiorization; rather a continued "revolt and embrace" that exists almost simultaneously. It is indeed the place where meaning collapses. An inebriation; delusion with clarity; a desire for that which our social self has expelled as the deathly scatology that its life *has* to withstand. We introduce into ourselves some-"thing" that our unconscious requires, and which our ego goes along with, but only then does the ego discover that this is a threat, a destruction of its parameters. A foreign-body it wants to embrace as it gags on its repulsive threat. Hence, what can arise is a gagging and spitting out of oneself. One's own desire.

Many of the women in this book involve themselves with this hard work. This is not to suggest they are "abjects", rather to illustrate their committal to their projects, and the profound and often "difficult" nature of their work. That they are all aware of the personal risks, as it were, I am certain. That they are also knowing of this being their seminal destination, I am also fairly sure of in my assumptions.

To return to the voice of the "lover and enemy", which we could consider this voice to be. As I have pointed out this voice speaks of no "passive" incorporation of anything "feminine", spatially linguistic or "female" by the patriarchal language and linearity we all use. Nor of anything relating to patriarchy being superior; but it will speak of the questions and internal dialogues invoked in the subject.

It will ask about this life and death situation. With all of the subject's life intensely focused on this moment. It will realize that an everyday banality can acquire the power of all we've seen or heard. The histories and myths and moral questions and pleasures of soul and flesh – will ALL arise in that one trite comment. It will recognize that between the body, voice, life and the word exists only a moment of osmosis. All aspects and all their articulations will be held briefly embraced in that moment.

I consider this the nature of writing, and the word and its acoustic expression. Hélène Cixous believes all writing and linguistic artistic expression is thus autobiographical and fictional. I agree that to say anything says "something" about the executor/artist. That this expression is shaped by our histories and our unconscious. This process, that we engage in, is a giving and nurturing process, but one which can cause a "death" of words and one which can also "do" us. In effect, the control of language will escape its inventor's manipulation. Thus, we have a process that to engage oneself in, is to realize that one is caught in a sempiternal activity of shaping and being shaped. One cannot force one's media to breaking point, one has to uphold and work with one's mode of expression to the point where often the media will speak for you unreservedly, and beyond your control. It will – "run away with you". Just as lovers do. Cixous aptly calls this process – "a love story with dreams". And importantly this process is not unlike the process the listener or reader will engage in. Then there will be a continuance of this constant process of production of meaning. I think of what several female friends have said to me concerning listening to the lyrics of, say, Kat Bjelland of the band Babes in Toyland. They are reinterpreting and adding their own thought/expressive translations, whilst still appreciative of Kat's own execution. Thus a wonderful wave of meanings (semantics) washes through us with great power.

Hélène Cixous says that a writing, or expression, from the body is the equivalent of a cardiograph. One hand on the body, another on the page – a wealth of activity between the fingers and the page. Importantly this is not just "automatic writing or expression" – this is a process that poses questions and as we know how the media can "talk back", also answers some of our own questions. In this way there resides in this process a certain liberty resulting from the demands of the expression, and this work can repair the gulfs between poetic and positional politics. The "writing/expression from the body" also re-embodies women; gives them a voice to relocate their bodies, and bodies to project their voices from, whilst also allowing them to speak through a patriarchal discourse that no longer has "masculine" connotations.

Here the "body" becomes a verb – allowing for a context of action, away from previous notions of the female body as passive object. The metaphor becomes literal, and women can use subverted clichés, and play with language as never before. With the area of phonetics and oration the Voice (within the voice) is always apparent; but we can also learn from third space writing which has, in many contexts, tried to execute texts that are for the Ear. Texts that Speak and don't just Read, to further ensure that women, or anyone disembodied through their marginality, can link this to their lungs, heart, bodily cavities and breath. Also, an emphasis on not trying to "sound" too "natural" because by doing so one will inevitably encounter an unnaturalness, that has nothing to do with the "spirit" of the expression. A "natural" sound is an ideal;

we are after an open process that does not suffer from imposition.

I have found that in much expression it is the "surface" music of the voice that is important. And the finest orators will discover and work with the "music" of the lyrics, even without musical accompaniment. Lydia Lunch's oratory work (and written pieces) very much deal with an awareness of the bodily music and flow of her words, and she seems to sing and soar and dip through and around her syntax and its meanings. Also, her utilisation of word-play is invaluable. Incorporating clichés and sing-song synonyms to highlight points in patriarchal language and to bring a sensuality to linear discourse. We shall further go into her seminal orations later on. It is a fine and difficult line to walk to attempt to sound life-like whilst having to cope with the continued disturbance of internal differing aspects – often showing the interior "deaths", or rejections, in the internal cycles.

The translated poetic voice could be considered to work at its best when literality is used, in other words when the speaker or writer is playing it as "close to the chest" as is possible, to *then* illuminate the word-play and encoded messages and poetic license. And it's always worth remembering that the corporeal voice was indeed the First Voice prior to identification with the other, and separation – hence it should best work in that context.

The rhythm of the voice (I think again of Lydia Lunch's spoken work) is actually not identical to somatic pulsations. It's safer to say that it conveys meaning concerning the body, but is not wholly similar to the life-signifying beats of the body. The silences and the sounds working together create an acoustic mobile tableau of the body in poetics. It again returns us via linearity and symbol back to the body, and the pulsions of the *"chora"*.

Cixous refers to this self-referring (and hence humanity-referring) truth in fiction as – "a fiction of presence". This state of being "present" in poetics is chronicled superbly in music, noise and oration by the women in this book. It is an illusion of verified presence, as illusion best describes what is like-life; life-like. However the one dilemma in this voice of presence is whether or not that illusion of actuality is destroyed in execution. Nonetheless, this voice could be said to somehow escape the self – a result of the subject's disturbance or Other Bisexuality, and existing as a means rather than an end to itself. A signifying voice rather than the master of the subject's expression. It cannot impose on language, or aspire to absolute meanings. This would bring us back to our monolithic patriarchal language, and in this way it is vastly different to the illusion of absolute meanings. This third space voice has to defer off of the selves that speak in a manner that encompasses lines and spaces that do not arrive at a closed end cul-de-sac.

Cixous has also spoken of – "...clusters of textual energy." The points in discourse or writing where – by use of idiom in a new context, or by playing with cliché or poetry in linearity, or by the depicting of a "death" or violence – some new meaning, something exciting, is born. For example – the barrier between subject/object and action is broken, and the name becomes a verb, and phonetically operates like one. Or a deferral takes place that posits the speaker in a million places all in one wonderful, terrifying, breath. The introduction of a myth (personal or social) into a place where it had never been before, or never been known before, to express the struggles of otherness internally, hence commenting on them externally. The discourse that understands its "surface"

and "interior" value. As Roland Barthes has said – *"écriture a haute voix"* (writing aloud); "... where aim is not the clarity of messages ... what it searches for ... are the pulsional incidents, the language lined with flesh ... where we can hear the grain of the throat, the patina of consonants, the voluptuousness of the body, of tongue, not that of meaning, of language..."

The discourse or writing from the body thus mirrors the forceful substantiality of a vocal cry or noise or breath and so on. When we project these noises we realize that there is a communal charge to them. There is a feel to them, that each listener can recognize as corporeal, as well as fictitious and expressive of the imaginary. We shall not just hear through our ears but through our skin and stomach; hence the sound is not an internuncio itself but is describing the body and psyche in tenses and inflexions beyond specularization and reduction.

The sound will thus illustrate the selves in a maelstrom of vibrations which are in continued flux and movement; never static. Then the body will not be a essentialised whole but will partake of myriad positions by the polyglot nature of the sounds emitted and transferred. Many female artist(e)s have executed sound work which allows them to change the focus of the perception from placing to placing and identity to identity, and so on. This fragmentation allows for a new artistic and expressive space, where voices warp and swell, in undercurrent or underflow, and layers of sound are built up – not unlike some current techno sound work. In effect this type of phonetic work, which layers voices and sounds, and allows fragmentation of subject-position, is an "interference" of linear speech, and one may think of sound interference, static and white noise when it occurs in our audio technology. This work disturbs the audio signifiers, agitating the fixtures of patriarchal oral/audio expression.

As in Diamanda Galás' vocal works – the voice becomes two becomes three becomes multiple. Alien syllables form a challenging neology. The voice works in circular, looping helixes; verbs become nouns; vowels become whole abecedaries; para-linguistics and crypto-linguistics; French, Greek and Latin bounce off each other in destructive and creative constellations and re-constellations; baby words take on the force of life and death; screams surge up with bile and re-absorb themselves with balm, and vice versa in this tintinnabulary, processing cosmos.

For these are the sounds of the borders of our society and our conscious egotism; and these sound-dreams figure the repressed. The marrowbones-and-cleavers space, indecipherable as it can be, allows our own desirous imaginings to take their fill, whilst still asking our participation in the challenging of our perceptions. It is a dreamsoundspace in which we re-encounter the repressed, the unacceptable, the unsaid, as the oscillations of our othernesses (be they subversive and marginal) charge our bodies and minds. This compelling space of marginal murmurs, shrieks and singsong-repetitions, in other words the clusters of semiotic excitement where we realize the other contexts of the lingual expression and mind, the *"chora"* we all still vaguely, or not, remember, are as Kristeva says, somewhat apparent in the interlinearity of discourse or expression. They can be found in breaks of silence, meaninglessness, contra-diction, disruption, etc.

However this space is surely not Freud's confessing patient's space. This is not merely the space of the hysterical woman, in derogatory terms (although we have found the great subversion and strength of the hysteric, in a wider

context). This is, rather, the space of the border with myriad languages involved in what is destructive, creative, energetic, hallucinogenic and seminal. This is also, as pointed out before, a move to articulate this space with symbolic language as opposed to without its necessary support. To make this space HEARD (as in felt and perceived). For this pre-Oedipal *chora* or cataphonic collective music-memory; this singular plurality or plural-singularity; is described from me to you through our post-Oedipal experience. And this perpetual creation of new meaning and difference within this itinerant process allows for new felicity to be issued to old ideas of hysteria, and melancholic silence too. To stubbornly refuse to "confess" to the Freudian figure of society can be as unnerving as usurping the homogenized nature of society and its singular language. In her essay, Dr. Jean Fisher describes and places the artist Susan Hillier and her sound/video work – "Belshazzar's Feast/The Writing on Your Wall" (1983/84), and Mona Hatourn's video work "Measures of Distance" (1988); commenting on the cryptolinguistic nature of their works, and the use of multi-subject-positioning, marginal sound and fragmentation.

The presence in the voice – a presence that shifts meanings as it shifts language; a presence that comes through one language with the headlights of another; a presence that breathes and expires; orally introjects and anally expels; rejects the festering "death" it must house, to then take it back in, knowing it will fall as a corpse if it expels all of itself; knowing that there will be internal murder, drives its death and birth in furious semiotic non-patterns; births itself as mother and father and child in fluctuating, interrupted and repetitive loops, and finds a certain *jouissance* in this semiotic space, inside and outside linguistics.

6. Euonymous Echo

We have spoken of the pre-Oedipal time, and the sequential occurrence of signification – whereby the subject will identity with the mother or father; but what of the mythic Oedipus himself?

Oedipus' self-blinding (as punishment) is most obviously a symbolic castration. And as we have come to realise this relates most definitely to a rejection of the phallocentricity constituting the linearity of patriarchy and its expression. Oedipus assumes the metaphysical female symbol of lack, as a lesser man. From this he does gain a certain INSIGHT, or awareness; a subjective perception of his psyche, the unconscious and internal othernesses. One might imagine that from this famous fable we might enlighten ourselves to the worth of insight, alas women's insight is not respected in the way a man's insight might be. Could this be as the performance artist Karen Finley has imparted – that men will try, once again, to rationalize even this un-rationalizable experience, and consequently be "higher minded" in their attempts to organize and dominate even that which cannot be dominated by linearity? That they will "think" it rather than "feel" it, completely missing the point.

Why is the voice of woman when she speaks of her insights and interpretations valued so little? Why is the female voice as a presence in itself considered inadequate? Why do we rarely hear female voice-overs or narrations in "serious" films or other media? Because the narrator is cast as omnipotent, transcendental; a simulation of a godly voice that can't possibly be female? Why do women in the media have more attention paid to their objectified appearance than to what they are saying?

Why do we have a whole cinematic history which continually perpetrates the stereotype of women as emotional objects to be silenced or protected (from themselves)? The thrust of a large proportion of psychosexual thrillers and dramas is to make the woman confess her "true" nature, as Dr. Jean Fisher has pointed out. What the film demands is the involuntary scream of the woman; to issue her involuntary scream thus signals her infantile, emotional and unrefined nature. This scream (which is the scream of "lack") is often disembodied. The woman has her personality and individualism stolen from her at this moment. This "hysterical" thriller scream – as the knife comes towards her, as the shadow makes her jump, as the world grows too much for her – is the scream of assumed castration; the scream of a "cissy".

Why do we still live in a social contract that renders women silent, or at best inarticulate and unable to speak with any determination or authority, even in the context of communication and the media? Why do we automatically presuppose the female "scream" as a negating symbol?

Diamanda Galás screams louder and with more determination and verve than almost any other vocalist and performer today. There is no mistaking the strength of her very being from that vociferous noise, and it is linked to the

pre-Oedipal in a differently interpreted and perceived fashion than the disembodied, inferior "scream" of the objectified male version of the female vocalization.

The Greek myth of Echo also describes how from a position of imposed "lack" a woman can turn her exile from expression to her own means. Echo, the story tells us, was condemned to utter only the last phrase of someone else's speech. She was an expiratory muse, paraphrasing and parodying but not producing her own meanings; bouncing people's expression back at them in mimeographic fashion but never grasping hold of her own declarations. Thus she as a body fades to being just another's borrowed voice. We could consider her an effigy, not a body possessed of herself. And as Jean Fisher points out in "Reflections On Echo", this position also presupposes Echo's EAR; the ear and the echo being all that she is in her role as a listener and audio receptacle. Her iteration depends upon receiving sound – and this "economy of the ear" in effect makes for a circuit. She is a transmitter, and her relation to today's technology, and female position in relation to present telecommunications is something we shall explore later on.

Multi-media studies today, including sound work, film, video and performance, present us with the opportunity for heterogeneity in subject identity and position. We can veer away from absolute translations and absolute interpretations which make for an absolute, fixed object that will mirror the patriarchal, transcendental ego, or its other. Instead, temporal studies and sound-work affect an ingathering of perceptions inducing multi-subjectivity and self-questioning. The mobility of perception procures the participation of the viewer, causing her/him to question and challenge patriarchal ideals. The wonderful mutability of voices, sounds and images, etc, signifies the variance of the participant's identities.

And this is what Echo, with her aural/oral circuit evoked. Echo's discourse became a new variant, ambient linguistics which placed her on the margins of the symbolic order where she could affect shifting changes to the contract. We have already spoken of the marginal position, and how subverting it can be. That she spoke *through* patriarchy, and also beyond it, is also a point already raised. Her non-place becomes a marginal position.

7. The Pitch Of One's Breath

"... Behind every little custom, every little way, she saw 'an institution', and one she herself would never have devised. 'Why do you even love me, if you do love?' I'd cry. And she'd think a moment and say, 'I love you for your breath.' Typically, the least substantial thing about me! 'Also the least colonized,' she'd say sweetly. Something unseen, indeed, invisible. Not my brains, not my cock, not my heart – no, my breath. But to her, as she explained it to me, my breath represented not only my life, but also the life force itself; and what this boiled down to in day-to-day reality is that she could, and did, kiss me all the time. We kissed for hours. Hours. She'd hold my tongue in her mouth and, with a shiver of pleasure that unfailingly caused me to rise almost beyond the occasion, she'd draw in my breath. Her own breath, sweet, delicious, the very essence of her soul's vitality, would enter me. ...It is a bond based on air, on 'nothing'; nothing you can see, or save or take off or put on, in any event; and I found it to be the strongest bond of all. ...The mingling of our breaths as we kissed for that second half hour, as we liked to joke, could nearly bring us to...ah...climax."
(from *The Temple Of My Familiar* – Alice Walker)

"Learn About Your Breath: Sexual and orgasmic energy travel on the breath. Breathing techniques can make sex much more powerful and satisfying. (It's possible to have an orgasm from breathing alone. Is this the safe sex of the future?) Rhythmic breathing is the best thing since the invention of the vibrator.
...Many people don't breath during sex, yet if you get really energetic sex going, it's the breathing heavy that makes you feel good – that *moves* the energy. I've been practising just breathing myself into orgasm – which I'm getting better at doing, and which performance really helps, because at the end of my performance, I use a vibrator and do a masturbation ritual. If there's 400 people in the audience sending me energy and I'm onstage with a vibrator – we're circulating energy. I have to (in 15 minutes) go into total ecstasy and (hopefully) orgasm. Doing performances put me in a situation where I had to learn fast, so I've gotten really good at 'breathing sexual energy.' Now I go into full body orgasm or breath orgasms onstage in a minute! I can do it walking down the street. Now I say that 'ecstasy's just a breath away!'
...And it's not a clitoral orgasm. What happens is: you start breathing it up until you reach a certain point where *it's* breathing *you* – it's doing *you*. And it's similar to when you're having that clitoral orgasm: when you're no longer doing anything; *it's* doing *you*. Women are capable of having 3-long hour orgasms..."
(quote from Annie Sprinkle [Re/Search number 13, *Angry Women*])

Luce Irigaray's work *Forgetting The Air: The Case Of Martin Heidegger* (1983), is a critique of what she considers Heidegger repressed in his discourse, namely the element of air. This is her point of departure as she deconstructs in her mimetical fashion this said master theorist's structural works, positing air as a

female element. She claims, probably quite astutely, that the imagery of this element in itself deconstructs the divisions of male thought. In a similar vein, she did likewise with Nietzsche and water – arguing that as the element most alien to him, its potential for deconstruction in his work was the greatest, although this disturbance was not in Nietzsche's case repressed. This idea can follow into Kristevan theories of the destructive element in semiotics (also to be found in the works of Joyce, Lautréamont, Artaud, as well as Nietzsche). Part of the interiorization of separation, sacrifice and collusion entails accommodating (or not) notions, imagery, and so on, that have the potential for destruction of the ego, or part of the self, and this is the point of departure for the counteracting repression of that threat. To meet within one's self the element which one most fears; one can either deal with the battle, which I believe the women in this book do in their various ways, or one can repress the cause of the battle. In this instance it is the imagery and metaphor of air. We shall go into the challenges within the semiotic, and the artistic expression of the threat of dis-equilibrium later on. Concerning air, we are faced with the element which we first come to know at our birth. Irigaray considers Freud to have ignored this special relationship in his work. Air can be seen as not unlike the unbroken *chora* of the womb, wherein the child is dependent on the mother. But it is air that enables the child to deal with the loss of the placenta, and thus the "breathing" that the mother has been involved in on its behalf. Air is the element that "catches" the new-born, presenting the child with its own separate life-force. It complements the anterior function of the now absent *chora*, in its unbroken, mobile, ambient nature. And whilst it may be considered an element of the mind, it is first and foremost the life-force in place of the mother. The breath, like the voice or First Voice, is a corporeal link to the pre-Oedipal, and the pre-social, and the primeval. Moreover it is without physical signification, knows no boundaries or borders, no fixed position or shape. Like the *chora*, air, too, relates to us in terms of rhythmic pulsion, on which we process much of our expression, desire for introjection, and so on.

The child will be comforted by the rhythmic inhalation/exhalation of the mother as she, in turn, will be anxious of the inhalation/exhalation of her offspring. And then there is the breath of labour, literally laboured or panting; the breath of orgasm, and the first drawn breath before the baby screams. The first breath.

8. Enough To Wake The Dead!

Who says that flat or tuneless voices are aesthetically non-pleasing or unacceptable? Who says that you can't sing? Who says that you can sing? Who calls that caterwauling? Who says – do stop making that terrible din? Who tells you you're tone deaf; out of key; out of tune; tuneless?

Why are so many negative judgements made about our voices as children? How many young girls were admonished for being "too loud", "too shrill" or "not ladylike"? Why were girls' voices hushed up, shut up, quietened? Why were we told not to sound so boisterous or noisy? Why were our alarum sounds and soniferous strains disallowed?

Why, when we were having rip-roaring fun with our friends, and our lusty, raucous, gut-vented roars and screams were soaring – did we find those belly-sounds squeezed out of us, or stoppered up, or whittled down into sweet little soprano vocals? Why, if our voices refused to be squeezed into sweet little sopranos, did we get the distinct impression the music teacher was frowning at our "bad" voices? Why were we told, if we didn't have a sweet little girl-voice, we didn't have a "good" voice? When our voices are criticised like this it is a criticism of ourselves, and this is an overall negation; so why do "they" criticise? Why did they say we had "horrible" voices? Why should we feel unmusical just because we can't sing in perfect pitch, or sing perfect notes in key?

Frankie Armstrong has worked extensively with the voice, experiencing a great deal of satisfaction from the voice workshops she has run for anyone to become involved in. She strongly believes that everyone can sing, and stresses her interest in the First Voice, and the rooting of the body in the voice.
"There is a voice of great beauty, power and depth in all of us."
(F. Armstrong from *Glancing Fires – An Investigation Into Women's Creativity* – Lesley Saunders [ed.])
There is a contact with the world through this experience. All our other senses bring the world "into" us, but the voice is the "sense" which comes from within and reaches "out" into the space. In fact, the voice will reach further than the touch. Also, importantly, as we discovered with the air and breath, the voice is a step away from the parent figure, and a crucial development stage for all human beings is the learning to distinguish (or feel) the sound (or vibrations) of one's own voice. Thus we realize we are individual and also through the voice we can re-establish needed communication, and discover the communal. Although the baby will cry from its separation, it knows that the cry will bring the carer or nurturer (back) to her/him. Even when that carer is out of sight, the loud voice of the baby will bring that carer close to hand. This primal power to summon is an early experience we all know; the fear, too, of not being heard, or responded to, is a feeling that we all are familiar with on an instinctual level. Thus, it seems that our screams and cries may articulate, even if non-verbalized,

what we ourselves can sometimes not express through our words. The clarion projections "out" into society that our gut-level voice can achieve are also sometimes involuntary, or semi-involuntary. At this point I would not wish to return to any Freudian attitude of a woman "confessing" her infantile, base nature through an involuntary "scream" but to widen the spectrum of sounds that we produce. Yes, it's safe to say that when we experience terrible fear or pain it can often not be contained – it has to be objectified, placed outside of the body, in order for the subject to bear that fear or pain, as well as to call attention. The same can be said of great joy or pleasure, as well as a multitude of other reasons and responses. This is not to suggest that this is a sign of weakness or inferiority, but that it can actually, in the multi-contextual where we have gone beyond what is masculine and feminine as we know it, be a wonderful "strength". And, of course, it is not just women who scream, as we realize in this space that has disturbed the binary oppositions of sexual difference.

Screaming, yelling, bellowing is a human reaction and action, and it comes about through myriad causes, and expressions.

In my opinion, anyone who can project noise in the manner of the First Voice has brought out into our society something that can only make us question our questionable society, and its ideologies, more. The tintamarre describes a warning; it is a siren that alerts us to the dangers of our society's sacrifices. For in that primal voice we will hear all the threats, embarrassments, dreams, nightmares, desires, that our structure has stolen from us, or that we ourselves have enabled our society to repress, and exile. That full-bodied cry, as the baby would cry – but then babies know "how" to cry. They put their entire beings into their cry. Movement, feeling and expression purge and project as one.

In primitive cultures where the First Voice speaks up through a society that invariably isn't cut-up by art, religion, magic, politics, etc. and doesn't operate the same sacrificial, symbolic contract to such an extent – but is more of a wholeness in that women are maybe others but not negative others – this is an accepted and natural phenomenon. Gods speak through shamans' mouths (incidentally irrespective of gender, the host [serviteur] is considered to be the gender of the possessing loa or god); and spirits speak through their mediums. The idea of the timeless, endless, primordial, primeval, First Voice is as natural as the earth, sea, air and fire of their given world to such peoples.

In her workshops Frankie Armstrong would have participants saying to her that it were as if they weren't actually producing the sound coming from their lips. As if, instead, this voice came "through" them, not from them; a voice of the primitive or primordial. And that they felt like channels or involved "mediums". Diamanda Galás has also described herself as such a "medium"; shamanistic, in that she is a bridge; a mediator. We shall further explore this element of her work later on.

And for those who have heard or produced such a sound the experience is more than a little strange. Even a little scary. We shall later look at many women who use this voice work, as I feel it is such an important part of this book's premise.

There is an Eastern description of how this bodily experience happens, and what occurs. It comes from the Kundalini chakra. The general understanding

being that the throat needs to be wide open and the diaphragm firm. The sound is, importantly, as any person who has used the voice in this manner will affirm, produced not with the throat or from the throat but "through" the throat. One has to feel solid, rooted and grounded.

A quote from a Chilean singer (from *Glancing Fires – An Investigation Into Women's Creativity*) says this very succinctly: "Even when reaching up into the heavens, the folkloric voice always keeps its roots in the earth."

To create galvanizing sound one must surely create a sense of power and energy, and this is undeniably why women have been silenced or unheard. And during reprisals for black rebellions in South Africa, whistling and singing, sharing communal vocal power, were punishable offences; so obviously the energy involved was not ignored, on the contrary it was such a threat to a totalitarian and fascist regime, it was banned.

Let us consider girls' and women's choirs, and the soprano voice. As Frankie Armstrong points out, this is but one use of the female voice in song, etc. It is also a mode of singing which, quite surprisingly, came about recently in historical terms. Because it is an artform, utilized in opera and in symphonic accompaniment, and considered "classical" our society tends to regard it as the finest example, and the most refined and perfected vocal art. This is not to suggest that there is no truth in the operatic voice as a quality artform, but rather we should consider from where our ideas and ideals of this "perfect" voice arose. Ironically, the soprano voice came about through the imitation of a male voice. The highest parts in early European church and court music were sung by young pre-pubescent boys and/or eunuchs (*castrati*). We still today recognize that the fine voice of the boy will last only until his voice breaks. Thus, for women to be accepted in this male domain, they had to pitch their voices high; one could say, in some cases, unnaturally high for long periods of time. When this initial pretext was forgotten, we were persuaded to regard this as the manner in which women naturally sung. Of course, many women can and do sing in a high octave. Again, I think of Diamanda Galás' wonderfully high, and powerful, voice; but Diamanda Galás also has a multi-octave range, which allows her a free run of many voices and vocal parts.

In India, about twenty years ago, the high nasal style of female vocalists came about through the prolific film (musical) industry, in which romantic female leads accompanied the lower voices of the romantic male leads. The heroines' high "whine" was decided by men.

Thus this aesthetic has crept into our societies and is now *the* accepted classical female sound.

And this aesthetic has filtered down through our culture – so that it is highly likely that those, for example in the school choir, who could sing in this manner were allocated the soprano parts, those who couldn't became altos, and so on; until we get down to the real "dregs" who were utterly unconsidered for "serious" music.

Armstrong, herself, wonders if men are threatened by primal female noise. She describes the commercial music scene here in Britain, and in Europe and America, as putting pressure on women singers. It seems that, even contemporaneously, men still wield power over how a woman should sound, and this exertion of authority has pressurised women and filtrated into dictating

female dress and image. It is undoubtably sad, and infuriating, that women today still have decisions taken away from them, and have to acquiesce to their music boss "puppet-masters" to varying degrees. The money-hungry business of contemporary music, with its perks, blags, media and hype, so often, as is society's wont to do, considers attractive femaleness a commodity. I agree with Angela Carter in her book *The Sadeian Woman* when she underlines that this IS the nature of society; society is a business. What I hope to do further on in this book is to comment on how female performers have made the ineluctable contract of "attractive femaleness as a commodity" work for them, or have subverted it by just not playing the rules of the stereotypical contract.

Today we tend to think more along the lines of stylizing and image-control, but should also remember that voice-control is also perpetrated.

Although women today have more role models, still, I get the impression, *something* (often in part) is sometimes stifled. Society, and certainly the commercial music market, do not encourage women to sing from the deepest part of ourselves. This Voice is still, as aforementioned, marginal, and perhaps as things stand at the moment, this is where it is best kept; away from theft, plagiarism, and diluting – to a certain extent. I think of what happens when the blues are brought out into the open by the media. Stripped are the original feelings, drives, pains and secret joys of the true blues and instead we are sold a lifestyle that is as removed from the blues as one can possibly get.

What good can come from having the Voice (that called on spirits, howled at funerals, shrieked at births and chanted at rituals, in captivity and in freedom) brought out from the margins of subversion, dream and nightmare – only to have it sterilized of its true blood and guts; so we are left, shamefully, wringing it out for our corrupt lifestyle exploitation. And so it is left a mere style that has nothing to do with its verified corporeality, or spirit. The media in relation to the women in this book is something I will dwell on later, only so far as I feel that it signifies the threat or subversion that the performer presents to the media lifestyle dream or the patriarchal symbolic contract.

9. Storytelling

A Need For Nostalgia Or A Stepping-Stone To The Future?

"If you don't know your past, you don't know your future." In traditional Africa women reigned supreme as givers and sustainers of life. The woman met the most urgent requirements of the family, and underscored her concern in creations of verbal art. She crooned soothing lullabies to the newborn; rocking tunes that were comforting and soporific. She composed verses to praise the son or daughter, to encourage them on through their formative years. She led the bride's lament at her daughter's wedding. She taught and instructed the children through conveyable tales of morality and knowledge.

In order for us to fully appreciate the importance of this tradition, we have to remember that this culture is other than our Western society, in which the maternal role is denigrated and feared. In traditional Africa the maternal role was respected and revered. Maybe no maternal role can be fully liberating to women now, when we realize the need to satisfy potentials outside of the home; but in a society where the family is the most important aspect of the culture, to be the respected matriarch holds a different gravity to the one which we know in contemporary times.

Hence, in this context, the woman became a medium for the words of history. She carried the history of her people and passed the maxims onto future generations; in order for them to know the nature of their ancestry, and from what social climate they had arisen. She created ancient images, on behalf of loved ones; and through this process she would move them to a sense of well-being – producing harmony in the home. This oral communication was of paramount importance historically and socially; the passing from mouth to mouth (*virum volitare per ora*) of knowledge, crucial to a culture with no pen, paper or books to refer to.

The classic and inescapable image of the wife-mother rests at the core of the female literary person in this mid-African social context. There is an unmistakable domestic stamp to most oration and literature by Africa women, even today where it is being subverted, to a degree, by women who exist outside of just the home context, and are career women too. This is because the matriarch holds such a respected position, and therefore is a seminal base on which women can build other personas, and roles.

In African language "sweet" connotes concepts that embrace notions of happiness, harmony, grace, spiritualism and charm. The inference of this word is different from Western cultures ideas of "sweet" as twee, pretty and often ineffectual; residing in a realm of being almost derogatory and limiting when applied to adult women. A well-observed ploy by some men being the utilization of words as adjectives and nouns in such a way as to, when applied to a woman, insinuate that she is something "good enough to eat" – i.e.

consumable and powerless.

When the word "sweet" is used in African literature and oratory expression it is referring to the human responses these qualities elicit, rather than qualities in things or a woman as a sugary essence. And sweet responses thrive in the nurturing intimacy of the household, where they feed directly on the pulses of human life. For example – good food, a visit from a friend, a moment with a lover, an affecting voice, a well-executed song or story. Even so, despite the different view of "sweetness", this quality evoked in and by the matriarch has turned strident. Having this powerful "sweetness" at her disposal the woman can use it with aberrant irony to make a point. Mocking verses and political work songs and ballads, for example. Many female African orators and singers use their voices in this way. Satirical festival tunes and songs for women's societies have all given ample expression to the aches particular to women. And, of course, coming from the standpoint of the female as powerful voice to start with, how much more cutting these ironies, sardonic creations and political expressions become. In short, they are very much noticed. So the word "sweet" can hover between sincerity and mockery; and I should point out here that the irony, cutting as it can be, still tends to leave the ideal sweetness intact. A very clever way of illuminating social problems without usurping the power of matriarchy itself.

In much African literature and storytelling women serve as barometers measuring social health. For example the mother stands for traditional society trying to uphold standards against the corroding influence of the West. Again this is very different to a similar process in the West. In a story a wife reduced to servitude represents the cruelty of badly managed polygamy, and so on. Behind these "wrongs" women suffer there looms the spectre of social disruption. Often in stories, the female protagonist will battle to restore life's sweetness.

And so the female voice evolves in response to social change; addressing the issues of the day as they come round.

Oral performance, or Griot, is thought of as "good" and "beautiful" in African society; even today it is considered an artform, as well as being socially relevant. A good performer needs to persuade her listeners and her position also requires that she has a good command of historical and traditional themes, characters and images – in order to combine and blend these aspects to make a fine tale. She must also be sensitive to the interests of the audience as her performance can shape minds, keep certain attitudes, change others and by lessons prevent social disorder. In the past the prose such as legends were the basic education. A child would learn about morality, in tales of good and bad youngsters; courageous men; liars and truth-tellers; domestic animals with speech; ceremonies held by wild beasts and triumphs of good over evil. Most stories ended with admonitory warnings. In this respect such tales were vital to learning. Important too, were the female protagonists peopling the stories. Heroines restored the "sweetness" and spiritual balance, and the stories were noted by the absence of political, bullish, warring masculine heroes. Rather, the heroine's power emanated from a superior moral conscience, extraordinary intelligence and zeal.

Importantly, myths across the African continent credit women with the

founding of civilization, long before men established their present administrative supremacy. Later, when the men did take charge it was still women who were the force behind the social order, who intervened when things went wrong and put them right.

It might be true to say then, that the positive images of women in the stories were formed by the society from whence they came. If we look to Muslim myths and legends we see far fewer positive female images; we also hear fewer positive voices.

As the carriers of the oral tradition women controlled the audiences, and still do today to a certain extent. As storytellers they invent fresh elements to bring new life to the characters and add feminist interpretations of old stories. They are skilled in impersonations – assuming roles by subtle voice change, posture and expression. The idea of women as mediums (often defying gender by opening out their own "Other Bisexuality", as well as their ability to be animalistic, godly, secular, spiritual, informative and poetic) is something we shall explore in more detail further on.

Women would train and specialize in specific genres. Often this varies geographically. For instance, a woman might distinguish herself by gaining fame and respect for her praise poetry or wedding songs. She would be elevated to near-professional status with a large repertoire and a large audience following; although she would probably have started out performing for her family, learning from the female elders in her home.

Such a performer would receive payment in a multitude of forms from money to tobacco. In West Sudan women as professional praise-singers and historians command quite a high price for performing. In parts of Niger and Nigeria the *marola* (the praise-singers), among the Hausa people, specialize in poetry that honours women. Malinke, Bamana and Wolof Griot traditions (in West Africa) embrace a variety of female artists. Cult priestesses, herbalists, diviners and midwives became performers whenever the role required that they train young women through a body of verse. Usually, women were domestic, unspecialized poets centred in the household and village life. In some parts of Africa, the transmission of praises for the family was always a female duty, and is still. However, this is not to suggest everything was highly stuffy in its moralizing – in Kenya the Oigo women would sing love songs when they were courting often rife with ribald comments and sexual innuendo; and there can be great satire as men and women assail each other with mocking verse filled with erotic abuse. This seemed to be very prevalent around harvest time (a fertile marriage time). In Mali women tease men about circumcision and ridicule male sexual desire, in song and verse.

When there is a death it is nearly always the women who sing. Funeral dirges executed by women are also extant in parts of the Middle East. At Akan burials women soloists chant threnetic dirges to mourn and eulogize the dead. This spiritualism that is specific to women, again, highlights the lasting vestiges of a matriarchal system – where women were omnipresent in all of life's major events.

So, Africa's singing and oratorical women were spokespeople for their sex by choice of story, song and interpretation. But the traditional woman is now under attack from her modern female descendant, much the same as she has been in the West. New Western influence is welcomed by many African women,

especially in major urban areas, but this influence is also scorned. There is a saying that the traditional woman is "enslaved by the tradition she extols".

There has been a wave of feminist rebellion; its credo being the "anti-sweet". Women began to examine their roles critically and frequently denied these old roles. Thus, it can be said that a new "sweetness" came into being. From the previous synthesis came the antithesis or rebellion which highlighted a vision of a new place. So a woman could symbolize old Africa with its "sweetness" and security but with a fundamental independence and personal pride. This shift has brought with it dilemmas. Many would say these new women personified the shifting values and colonial disruption and corruption of society. Sadly we get a picture of a tortured landscape peopled with wanderers – and a female who is at once agonized mother, abandoned wife and sterile temptress. This became the symbol of the female body (and hence her voice) when Western influence (remembering that this was then the enemy in the truest sense of the word) first invaded Africa. From the 1970's onwards this symbolism was thankfully abandoned for social realism. The erosion of feminine well-being is an extremely popular subject for women in Africa. As the ideas (and ideals) of love and marriage changed and individual freedom came to the fore, so, of course, did the work mirror this. The writer Bessie Head covered much of this in her heartfelt, poignant and superbly talented literature.

Man also seized upon the "free" woman too, and prostitutes challenged the norms of sexual politics and roles. Ostensibly, the symbol of the prostitute became very important. There is a saying "All are prostitutes in a world of grab and take." These women are heroic and altruistic but also angry and dissatisfied. Many women writers and speakers argue that change (i.e. prostitution et al) is illusory unless it also touches the domestic world.

"Until that new golden age, it should be expected that the sweeter voice will for some time to come take on a sharper edge with repeated honing against the grindstone of modern life."

I consider it fair to say that the filtering through of the Western society has presented a problem to the power of matriarchy in Africa because what is filtering through to the peoples there (specifically the men) is a patriarchal system that does not value the maternal and the female as old Africa did. Thus the problematic seems to be not merely the changing of the women stepping out of the domestic realm if they wish but the changing of the attitude of young men back to respecting the maternal; and leading to a state when both the patriarchal and matriarchal can be harmoniously embraced.

Nonetheless, I consider the voices of these women in Africa very important to the premise of this study. These women had social and affecting voices at a time when the Western woman seemed frighteningly hushed; even obmutescent. These women were story-telling and delivering fables and legends, having grown up believing that they could do just that and were born to do so. Politics aside – the African woman spoke so stridently, so persuasively, so informatively that they expression was far ahead of any bedtime storytelling going on in this country.

The Griot (or gawlo, the Toncouleur word for such a singer-storyteller in Senegal), before colonialism, was the king's speaker and was thus fed and sheltered by royalty. As the keeper of histories (crucial as many couldn't read or write), secrets and heritage the Griot was highly revered but was also a person

of the people. I think this underlines the great worth of the storyteller or orator. Someone respected for their voice; someone admired for their verbal skill. Someone to whom the people would throw gifts.

It has been said that a female proclivity towards storytelling is a yen for nostalgia in a very negative sense. Maybe it is from this presumption that society erects its negation of female oration as chit-chat, gossip and so on. The women of traditional Africa seem to cancel this myth by the very nature of their talking, which is absolutely vital to social documentation and education. As aforementioned, that women also tend towards the sense of sound might also suggest that the women excelled in this communication field as young neophytes listening to their mothers and elders; readying themselves for their own oratory work.

I should like to add at this point, in contrast to what I have already said about the tradition of the African female orator; that this is not to promote the ideal that female oration and voice utilization in Africa unequivocally precedes automatic feminine liberty and libidinal equality; or vice versa, that this oratory expression results from a replete integration of "female" into all realms, including the political and economic, etc. This is not the case.

However, it is true to say that the "matriarchy within patriarchy" situation has afforded African women a positive spiritual, sexual-differential, foothold/ stepping-stone to an expressive point; but due to the polemical contrast between domestic and spiritual matriarchy, and economic, socio-politico patriarchy – much has still to be reconciled or altered.

This is especially the case now that, due to (contemporaneous) Western influences, the African female – as domestic ruler, religious leader, empirical speaker, medium, priestess and historian – is so under threat by secular usurpation, undermining and exclusion-as-inferior. In the global economic market place – in which essentially the black man has to keep his "masculinity" alive in the realm of labour and goods – the black woman has died. Of course, the black man is as inferior in global hierarchical terminology as ever, but he is still evolved in the equation. The black woman has been reduced to the "home" in terms of misogynistic Western standards. One may argue that parts of Africa were always as denigrating of women as anywhere else in the world, and I am not going to refute this.

The black woman anterior to slavery was observed, by the white missionaries, as "amazing" in the hefty workload she carried, as well as her upkeeping of the home. However, what does strike me as especially poignant is that the African woman, of certain areas, in a traditional sense once had a very strong, resonant *voice* – that was not disrespected.

For further information on the "stolen" black woman, and how she was sexually degraded, please read bell hooks' comprehensive book *Ain't I A Woman: Black Women And Feminism*. bell hooks points out how black men were not "de-masculinized" *per se*, and were still able to promote the (dis)equation of sexism even whilst living through the most terrible racism; for black women however the trauma was terrible on both counts of racial and sexual identity. This is important to the points I have made about the black female voice. Later, I hope to explore the black female voice today. Why do we find something aesthetically pleasing about specific, codified, black female backing singing in a patriarchal white-soul (white "negro") or rock-ballad context?

To return to the above points concerning traditional female oration, and how we should realize the exact context in which her power reigned – which is not in any context which travelled, translated or prevailed in a politico-economic sense. bell hooks makes the ineluctable point that the concept we have today of the black woman as a strong figure of great spiritualism and integrity should not be confused with a signification that these qualities automatically change or overcome the very real oppression of the black woman. In other words – what is this romanticized strength in the face of continued oppression? Necessity, of course – and the black woman has always realized that; but the strong black woman by being strong does not singularly alter her oppression, and we should try to see through our romanticization of her. This romanticization of the black woman and her voice, as I have said, is something we shall return to.

Another, conjoining point that is worth illuminating in relation to what I have suggested is the differing position of the black woman in terms of feminism. The black woman has come to feminism in a radically different way historically. I myself, as a black woman, feel individually, that my feminist objectives are the objectives of most post-feminists. The exploration of language and sexual-difference, which I feel allows for the "stranger" to address his/her position in our order of language, which ultimately is our order of society. However, in the early suffragist days of female emancipation, in the U.S.A, the white woman spoke solely for the female end. The question of the "estranged" *other* wasn't analysed as an otherness that related to the self – hence we are speaking of considerably more distanced and hostile polarities. The same applies to binary oppositions of masculine and feminine. In this way the black woman, secondary or ignored in the racial struggle of her menfolk, was not part of the field of action (or even, reaction).

In America the black woman dealt with the keeping together and feeding of her family – an occupation which nearly always compelled her to become part of the labour market. In this way the black woman's history into feminism was as someone who had been forced into the place which the white woman had already ideally left – that of the housekeeper/homemaker and low-paid blue collar worker. In fact we still tend to think of the low-incomed black woman as the perfect mama – mammie – domestic drudge. The ideal liberation then for the black woman was to become like the white woman in terms of being a kept woman so that she did not HAVE to drudge. Thus in the advent of feminism black and white women came from different points to feminism. Black women were more likely to have kinship groups or a strong female culture established by the unity of fellow female workers. They were more united and not as dependent as the white woman. They were, of course, likewise oppressed sexually but they were not dependent in isolation, like their white middle-class counterparts. In this respect, as Toni Morrison extols it was THEN almost impossible for the black woman to respect the white woman. True the black woman was the ultimate "slave" in every sense; sexual and social. But unlike the white woman she had neither whiteness or maleness, nor ladyhood, to fall back on. All these elements being long since stolen from her. And if black men aspired to white men; black women could envy white women, fear them their economic power, even love them – but there was no actual accomplishment or quality for which they could respect them.

Of course I am talking of many years ago, but it is worth remembering this history of the earliest roots of Western feminism for black and white women – for it does still relate to how we perceive the black female voice; which is, it has to be said, one of the most prevalent (and utilized) "voices" in music today. Have we forgotten the female queens and priestesses of Africa; and how they became the slaves of the West? How do we hear those voices today?

"For years in this country there was no one for black men to vent their rage on except black women. And for years black women accepted that rage – even regarded that acceptance as their unpleasant duty. But in doing so, they frequently kicked back, and they seem never to have become the 'slave' that white women see in their own history. True, the black woman did the housework, the drudgery; true, she reared the children, often alone, but she did all of that while occupying a place on the job market, a place her mate could not get or which his pride would not let him accept. And she had nothing to fall back on: not maleness, not whiteness, not ladyhood, not anything. And out of the profound desolation of her reality she may very well have invented herself black women have always considered themselves superior to white women ... Black women have been able to envy white women (their looks, their easy life, the attention they seem to get from their men;) they could fear them (for the economic control they have had over black women's lives) and even love them (as mammies and domestic workers can;) but black women have found it impossible to respect white women. I mean they never had what black men have had for white men: a feeling of awe at their accomplishments."
(from *Women And Madness* – Toni Morrison quoted on black women in the USA)

Of course, today we are faced with a reality in which women of many different descents and classes know a feminism which is no longer an underhand situation of whether the black or the woman (in historical terms this was always the white woman when race was omitted from the description; inferring that the white woman was the only woman) try to pip each other to the post for liberty, etc. Today, we realize that feminism is about building an expanding structure that recognizes all who are making counter-investments or are sacrificing their differences or "strangenesses" and asks of us all to re-invest our multitudinous natures to reflect and be reflected by a multifarious system that is no longer (in redundant stagnant monolithic terms) a system but a process, everchanging.

10. The Myth And The Voice

Let's Sing An-Other Song, Boyz

I should now like to turn to the subject of myth. The myth of both the black woman and the white woman in the Western world (predominantly in North America) and how this has affected the voice both literally and symbolically.

When the civil rights movement occurred the black woman became something of a scapegoat. Both white patriarchy and many black men decided that she emerged from slavery too dominant, too aggressive, too masculine and above all – too castrating.

Strangely, or perhaps not so strangely, the black woman was blamed as one of the main reasons the black man had never taken hold of, and overcome, his situation in America. White patriarchy fuelled this belief, for obvious reasons. The consensus was that the black man would never have the strength to fight for his rights whilst he was being undermined in his own house.

So, it was to the black woman that he turned to lay the blame. And she had a history (his history, in effect) that seemed to him to substantiate his claims. She had had sexual relations with the white master whilst the black man had been de-masculinized (castrated); she had taken jobs when the black man had not even been offered any – she had driven the black man to drink, drugs and destitution – whilst she ruled the house with a matriarchal rod of iron. This is, of course, all part of the mythology perpetuated by our Western society. What failed to be illuminated from the context of this otherness was – the rape of the black woman; the view of her as chattel; the view of her as a "brood mare" to produce more slaves for the master; the concept that she could not win either way; that she was expected to do "man's" work as well as "women's" domestic work, and be beaten and whipped like a "man" as well as being sexually utilized as a "woman" and so on and so on.

Now, today, we can see that this history of poor sexual politics between the black and white man was a history told in patriarchal contexts. We see we can accept no one truth as the great truth about what went so terribly wrong between black men and women.

We can also see that just because the black woman kept the family going with her labour does not mean that she was singularly a strong woman. Yes; she may have been strong but what good is this claim to black women who felt just as victimized by slavery with its rape, degradation and violence? Her strength was just one facet of her personality. A personality that had become a myth written about by others and rarely told firsthand by the women involved. It is safe to say, although heartbreaking, that many black women cringed to be called this "monolithic", "invincible" woman with her largely IMAGINED strength. This is still the case today. Yes; black women are often very strong but we should never forget that their strength is worth little in a society that uses this claim as a means of assuaging its own guilt. Conversely we do not want

black women to be stuck with the antithetical title of victim in a society that would have its victims perpetuate their own feelings of helplessness.

Western society chooses to continue to view black women as beasts of burden (mothers that slog endlessly as perfect "mammies") or sex toys; both assumed roles are residual memories of the myths brought about by appropriation slavery in America, and fear of the Other or xenophobia in Britain with its set views about *its* perfect and submissive women (when I say women I refer to white women as this was/is the considered feminine norm).

What emerged, for black women, from these myths (I stress pluralism here, in order to highlight the myriad binary oppositions reinforced by patriarchal hegemonic discourse) about women is a suicidal masochism – to fight against their otherness. The black woman is not the "perfect" white woman. She will never be this and in a new feminist context does not desire to be so – with no disrespect to her white sisters. She has a history of racism as well as sexism to attend to. Being either a beast of burden or a sex toy is to be innocent and sexy which is nothing less than suicide – as Michelle Wallace points out in *Black Macho And The Myth Of The Superwoman*. She is quite right. When facing reality these myths about black women – that she is always somehow evil or whorish or just plain drudge-like – inevitably have the power to destroy. And there is no avenue to protect her – emotionally or socially.

Interestingly – even the legacy of our Jungian psychology (which derives from many myths) has the Shadow figure of the collective unconscious; the anti-social otherness; painted as a same-sex native or dark-skinned archetype. We can thus assume a white woman's anti-social archetype is a black woman. Does this apply vice-versa one wonders? Things are slowly changing.

"Sapphire. Mammy. Tragic mulatto wench. Workhorse, can swing an axe, lift a load, pick cotton with any man. A wonderful housekeeper. Excellent with children. Very clean. Very religious. A terrific mother. A great little singer and dancer and a devoted teacher and social worker. She's always had more opportunities than the black man because she was no threat to the white man so he made it easy for her. But curiously enough, she frequently ends up on welfare. Nevertheless, she is more educated and makes more money than the black man. She is more likely to be employed and more likely to be a professional than the black man. And subsequently she provides the main support for the family. Not beautiful, rather hard looking unless she has white blood, but then very beautiful. The black ones are exotic though, great in bed, tigers. And very fertile. If she is middle class she tends to be uptight about sex, prudish. She is hard on and unsupportive of black men, domineering, castrating. She tends to wear the pants around her house. Very strong. Sorrow rolls off her brow like so much rain. Tough, unfeminine. Opposed to women's rights movements, considers herself already liberated. Nevertheless, unworldly. Definitely not a dreamer, rigid, inflexible, uncompassionate, lacking in goals any more imaginative than a basket of fried chicken and a good fuck."
(from *Black Macho And The Myth Of The Superwoman* – Michelle Wallace)

As Wallace points out – out of this web of myth comes an image of the black woman as someone of inordinate strength, able to endure all manner of hardship and pain. She is more masculine than most men but at the same time she is more of a mother earth figure than the white woman. Now when we

think of the black women working with the voice – through the blues, R'n'B, soul, jazz, pop and so on – don't we still see some of these myths are applicable to our view of the black woman? I think, sadly, we do. We still see the black woman artist as singing about or reciting all the things Western society wanted to project onto her.

In any mythologizing such as this, there is a horrible, quite cruel, consequence. Wallace has suggested in her book (which admittedly deals with the myths only up to the 1970's) that it is like allowing a child woman to inhabit a jungle in which she feels she is invulnerable without letting her know her actual capabilities and weaknesses. Is it not cruel to let her believe she has special powers? Especially when she believes her wounds are proof of her strength.

The terrible thing about these myths is that black men and women believed in them. Black women desperately hoped that their menfolk would come back to them if they stayed homemakers and keepers and had babies for the revolution. Racism had set men and women at each other's throats as enemies and black dismissal of sexual politics didn't help any. Sexism had also set black and white women at each other's proverbial throats – because neither had the resources for their own objective (or subjective in some cases) analysis. I am not consolidating a specificality of blame here, but attempting to describe one consequence of myth-making at the time of the civil rights movement and afterwards, in the U.S.A.

But what would it be like to hear a black woman sing out about these myths to her own end? And to read the myths, decoded of the negativity of their binary oppositional semantic placings, in a counter-hegemony that takes its bearings from semiotics? How can the black woman subvert a mythology for her own creative expression? Both explicitly celebrating certain aspects of her inherited history and quashing the inaccuracies in one fell metaphoric swoop.

"My skin is black/My arms are long/My hair is woolly/My back is strong/ Strong enough to take the pain/Inflicted again and again/What do they call me?/My name is Aunt Sarah/My name is Aunt Sarah/My skin is yellow/My hair is long/Between two worlds/I do belong/My father was rich and white/ He forced my mother late one night/What do they call me?/My name is Saffronia/My name is Saffronia/My skin is tan/My hair is fine/My hips invite you/My mouth like wine/Whose little girl am I?/Anyone who has money to buy/What do they call me?/My name is Sweet Thing/My name is Sweet Thing/My skin is brown/My manner is tough/I'll kill the first mutha I see/My life has been rough/I'm awfully bitter these days/Becos' both my parents were slaves/What do they call me?/My name is "
(Lyrics for "Four Women" sung by Nina Simone – featured on the album *The Best Of Nina Simone*)

In contrast we also have a myth (concerning white women too). While racism was being dealt with and effectively ignored and countered – white women also had the battle of sexism which they fought with early feminism. Now we can see how black women were also pitted against white women and vice versa. The myth of the white woman was the dumb blonde white skinned princess. She was turned into a weak sexpot put up on a pedestal, while the black woman was the strong amazon working in the kitchen. I think of the Victorian

era when white women were turned into paragons of virtue (to protect the men) at the boundaries of chaotic sin and depravation. White women were positioned at this boundary or frontier because they were, in effect, partaking of some of its negative qualities!

One has to ask. If black women were so strong how come they allowed themselves to drudge in someone's kitchen? If white woman were so virtuous how come they were also forced to embody the "original sin"? How come we are all still "sinners" and "virgins"?

And white women looked at black women not considering the tough time black women had within their own communities; and black women looked at white women in their parlours unseeing of the sexism rife in this situation. Both women felt guilt for various reasons. Many a black woman felt racism should be her primary concern. This allowed the black man to project his self-hatred onto her quite effectively. Many white women felt they should be grateful. The cycle of abuse went on.

It is amazing, and also telling, that in the 1960's black women put a great deal of energy into fighting against the women's movement. Some black women in some ways wanted to be kept women; this is not to suggest that many sisters did not strive for years to counter the various myths, antagonistic of their unquestioned authority and seeking independence (in a context that disallows independence from our lingual patriarchy and its unrelenting arbiters) from the presupposed meanings.

But many black women stayed politically silent whilst their brothers spoke out. They kept silent whilst Eartha Kitt spoke out in her distinctive voice about Vietnam and Nina Simone and Miriam Makeba were virtually banned from performing in the U.S. Without feminism and politics and consciousness-raising and becoming responsibly involved – the only option was to have babies.

Now today, of course, things have changed but I still feel there is a great deal of the myth-making remaining as inheritance for both black women and white women. True to say many black women have left the myths way way behind, using their fiction and voices to expose the hypocrisy and phallacy of the binary oppositional law of the father, but some still react to the myths by blaming others for their undevelopment to the point of never getting over the wound of their history (a history that was not really theirs) and the dependency of their expressions on a system that has already betrayed them; instead of investing in progressive formulations of an analysis of language and non-elitism (but phallocentrically usurping creativity). This is a polemic issue and an area of some contention. I would never advocate dismissing history in any way but as Wallace points out – one does have to take responsibility for the future and not feel powerless to affect change.

Society still can't recognize women in terms of feminism. Or the recognition that has come for black women is one paradoxically of invisibility – which has arisen out of strident anti-racism. Only now I think we can see that women were terribly conned by these myths. Black women and white women were played off against each other to a terrible degree. No one could challenge these myths because no one fully knew; it was a time far removed from multi-media and the word of the white patriarchal historian was the one and only word, and the law. Women and blacks hadn't written their own history; it had been written for them. Now in the 90's I hope we are all more aware of the importance of media

analysis and the role of storytelling (i.e. history) for ALL groups of people.

Then we can see that with racial difference what we have IS a mythology. Blackness is not an essential category. To illuminate this point I can refer to the question of the Afro-American and the African; who face each other over a gulf of some 400 years. In this context the Black Britain fulfils a part of a similar equation. The Afro-American and the Black Britain are not essentially "different". Both have lived for generations alongside their fellow countrymen and women. We have a multi-culture that is no longer a case of "them" and "us". No one culture is unchanged by black and white coming to live in the West together. James Baldwin remarked that the Afro-American (Black Britain) is a hybrid; whose every aspect of living betrays the horrific memories and imagined happy endings; and who finds reflected in his white compatriots his own tensions, terrors and tendernesses – thus it falls into perspective the nature of the roles they have played in each other's lives and histories. They have loved, hated and obsessed and feared each other; therefore he cannot deny them, nor can ever be divorced. Something has changed.

Blackness isn't an experience empirically distinguished from other racial experiences. In this same fashion – whiteness is also an invention of the West to combat the Other within. This as you can see takes us back to the polysemous polyvocal self we encountered at the beginning of this study. And the dread of this which people harbour and project.

Today our children know as much about black culture in the West as anyone. They often like black music more than white music (if we have to classify it at all). Many of our younger generations know without strenuous deliberation that there is something to be said for multi-culture and diversity.

Unfortunately, the myths of the past are still entrenched in some of our cultures. This past and contemporary phenomenon extends to include all women (not just women of colour) and other minority groups likewise. The man-hater; the ball-breaking career woman; the diesel dyke; the sophisticated bitch; the bimbo or sexpot; the submissive (house)wife – the list goes on and on far beyond my powers of remembrance or even at this point personal caring. It is a quality of "the proper" (i.e. classification, categorization, property and appropriation) that simply wearies me to sigh "yeah, yeah, yeah" – whilst simultaneously invoking my antagonism and determination to press forward with my work. And it is this recurrent and renovated labelling prowess(!) which provides me with a fear of the continuation of the fabricatory (or projected) models of patriarchal ideology, and a desire to deconstruct the weaponry of the monolithic binary system into shreds of semiotic mutability that disallows (in that it simply contradicts) the dominating phallic resurrection that will again render invisible or worthless feminist creativity.

White boys can't rap! White people have no rhythm, and on and on. Truth or myth and, to whose end?

I believe the black female vocalist is the supreme soulful singer because of her history and also, of course, because of her present which is still undoubtably somewhat unreclaimed. Thus she needs to sing and voice her own future. But I also believe some of the greatness of the female black voice is due in part to the myths. Now some of these myths we may find had a great deal of verity to them; and women may re-establish their substance from diverse and mutable angles that shed varying lights and echoes. And I believe that women need to

re-voice these myths from their own positionings but it strikes me that there is an unconscious mythos to society's creativity that requires this voice in a psychological manner. Whether or not we shall come to realize as a society exactly what we do project onto the black female voice is another matter. When we can appreciate some of the more personalized truths that she can express is also another problematic.

Why was Billie Holliday the great blues singer she was and what was due to myth or her own reality? Yes; the black woman can sing to project her pain but how much of the reason we "get off on" her soulful heartbreaking ballad is our own projection? How much is it patriarchy pushing its own female blackness (and white patriarchy does have its own hypothetical female blackness!!) onto the Otherness of the black female singer? How much does society want her to mirror its own sexual, racial turmoil – so it can keep its guilt-disturbing Otherness objectified *away* from our white-patriarchally-related "homogeneous" selves? So that it can continue its unaffected establishment, knowing that the otherness is merely a song, and even if that song partially constitutes ALL our histories, it is only, at the close of day, a sad black woman singing her pain. And how much do we want to be reminded of that guilt; if guilt is in question?

Today there is a healthier visual abundance of black people (especially black women) involved with popular music; and actually artistically and, importantly, financially profiting from it. In the past countless talented black singers died penniless and exploited.

We are no longer indoctrinated by music charts and radio stations that exclude black musics. Yet black women have always been present in all vocal musics, from the earliest blues, both folkloric (I think of Blind Willie Johnson's wife, whose name, I'm afraid I could not discover) and urban. Blues that originated as coded communications requisite for escaping slaves. From jazz, R'n'B, gospel and soul through to contemporary pop, rock, dance, disco, garage, Hi-NRG, Balearic Beat, house, deep house, acid jazz, hip hop, even indie music (although it still stings me how few black women are involved in playing instruments, and experimenting with female-orientated noise, neo-punk, and other strains of underground music); and the list goes on. The black female singer always had her voice for expression, even when she couldn't afford a sax or guitar – she could still play her voice like a flute or sax, or even drum.

And rap music – wherein the black female voice has directly confronted the characteristic sexism and misogynistic consolidation of the men, still caught up in the actual and mythic de-masculinization of their past selves that they are too angry too overcome in any context other than blatant reinforcement of a black macho myth (and I hasten to add – there are almost as many myths for men in their own victimizing system).

House music, that too especially, has seemed to need, to almost crave, the black female voice for its powerful high-inducing, trancing, primal, rhythmic surges.

But my intent in this book is not to list all the great black female singers and vocalists and performers. Not only would this take forever, it is ostensibly at some odds to my initial reason for writing this study.

There have been many, many fine female singers of colour. And although I have professedly decided to acknowledge that to "say anything says something"

about the artiste and that to project one's voice reembodies oneself to a degree – I cannot condone the plethora of female vocalists who perpetuate myths; except when they appear to be questioning those myths through use of irony or mimicry (an area I touched upon earlier). Therefore I do not consider it pertinent to include analysis of female singers who sing about romance without questioning their position as someone seen/painted as submissive to its negative connotations. Yes; there are many great romantic and soulful singers and it is often a joy to hear a great love ballad but my interest lies in women who truly challenge the derogatory female myths. In this respect some blues artistes illustrate my point. Bessie Smith dedicated much of her artistic life to trying to overcome the "weakness", as she saw it, of attempting to live up to a romantic ideal or attempting to counteract the counter-investment she found herself making romantically, emotionally and sexually.

"In her song nothing melts, yields or seduces. Her voice is harsh and coarse, undeterred by everything she knows about touring in tents, street fights and casual sex. She isn't trying to please anyone. The habit of submission, of letting yourself be used, comes too easily to women. In Bessie's voice is a full-hearted rejection of any foolishness. the strength to do so comes from the big voice itself, with the growl and rasp of a jazz trumpet in it.

Her phrasing was unhurried and subtle. She knows exactly where to place an extra syllable, where to stress a word. And always, under the sadness, lie a sense of freedom and the triumph of her own courageous spirit.

> "I'm a young woman and ain't done running aroun'.
> Some people call me hobo, some people call me bum,
> Nobody knows my name, nobody knows what I've done.
> I'm as good as anyone in your town.
> I ain't a high yellow, I'm a deep yellow brown.
> I ain't gonna marry, ain't gonna settle down,
> I'm gonna drink good moonshine, and run these browns down."
> (Lyrics by Bessie Smith)

We have many young black women making their mark on the music scene today. Many of them are street-wise, politically-knowledgeable and know their histories. They also know their sexual politics. They have invested in their own black language and contemporary black culture and know where they are at.

I wonder how much their sassiness, strength and assertion will be allowed to socially flourish, and in what way society *is* allowing it to flourish. More so in the music business than in the arena of literature and performance poetry – how much have these singers re-defined their identity for their very own selves as opposed to for their male companions and music bosses. And is this "sassiness" and street-credibility another example of society saying – "now, there's a strong sister" to compensate for its reluctance to actually help her help herself become of a socially-recognized strength – i.e. educationally, sociologically and psychologically – in terms of career, position, finance and social power. I desperately hope we are not turning circles in that this strength will once again be a myth to be used against her – and to fob her off questing for further strength. Yes; black culture at the moment is terribly vogue. Young people (of all colours) are impressed by, influenced by and influencing the black music

scene. And there is no doubting how this understanding of cultures can filter out through our monolithic social system. And although Public Enemy, with their token spokeswoman Sista Souljah, are an inspiring rap group and a seminal symbol of pride for young blacks – just what exactly are they advocating? Can they convince women who are still suffering beatings from their men and are still working the menial, low-paid jobs that nobody else wants to do – to "stay strong sister" and really make any difference? Nobody is really expecting anything revolutionary from popular music or "trendy" music anyway, surely? Nobody that is but the kids who have yet to learn that pride in one's culture takes a long time to filter through the reinforced monolith of our social discourse, which presently only patronizingly accepts the lesser threats to its erections and fights the greater ones with something akin to outright hostility, condemnation and plain fright of emasculation of prized assets.

In this respect – literature and its theories are streets ahead in the realizations of what position women really are in and how to really deconstruct and/or rattle the foundations which are our lingual heritages and systems; exposing the differences and othernesses. This is more of a war from within.

This is not so that writers and poets can become whingers and pessimists but so we can all see just how much work the black female, or any female, has to do. Current *popular* music, sung by black or white, can be fine as an uplifting or rallying anthem but not (in its present form with few exceptions) I feel, as any kind of feminist manifesto. There is (as comparably there is in literature) a huge phallic "rock" hegemony to be deconstructed first and foremost, and popular music has come nowhere near to completely achieving this. This is why it is our POPULAR music scene (I include well-known, commercialized, rap music and "black" music in this description as it has become considerably more integrated in recent years and also constitutes the common denominator of patriarchy; in the same way popular music is patriarchal).

11. Seen And Not Heard – Heard But Not Seen

The Other's Other, And The Differences, Speak Up Through The Black Hole Cold Star Gaps

It is inevitable that at some point in the maintenance of conjecturable ideologies and the unchallenged singular-history of phallocentrism, which we have inherited, one must oneself explore the appropriation of myths and ideals in order to expose the patriarchal discourse that is constructed on binary oppositional powerplays. It is formally these powerplays that superinduce myths. Myths (or stereotypes) rely on phallic signification of all that is negative to attributes of "property" or collusive with the affirmative and logical superiority of the phallus.

The question one surely must ask is whether working with these myths (innumerable as they be) justified the misunderstanding that one is perpetuating the substance of stereotypes. I think not. It has always been a personal motto of mine that one must acquaint oneself with the "enemies' weapons" and I believe deconstruction to be vital to any contemporary innovative counter-movement, which as I've mentioned before cannot dismiss the old institutions out-of-hand, without taking responsibility for prior involvement and new actions; nor simply reconstruct an-other "phallic" ideology in the previous site (sight).

In order to analyse the master discourse (of the phallus), which is imperative to its deconstruction or should I say expansion and, somewhat, diffusion – one must take issue with the binary positive/negative characteristics of our language. And in the case of the black female voice (or black female character's voice) this involves commenting on the hypothetical (and often actual) negativity of one's position in order to reflect the same negative dynamic at work in our phallocentred language. The problems of the black female voice must also be the problems of our language. Our patriarchal language is a system built, after all, on an able-bodied, assertive, drive that follows logic and forces one to submit to its phallic force (it wants to "ride over you" and penetrate you with its absolute truth, in other words). All this without ever allowing itself to be questioned, without ever questioning itself, and without engaging in a spatial dynamics of traversing and absorbing othernesses nor desiring that its reader engage in a similar semiotic experience of "coming to reading or listening" in the way one would "come to writing or oration" (i.e. to enter into a process of drifts, poetics, varying libidinal drives, reading between the lines, etc.).

"Difference is not difference to some ears, but awkwardness or incompleteness. Aphasia. Unable or unwilling? ... You who understand the dehumanization of forced removal-relocation-reeducation-redefinition, the humiliation of having to falsify your own reality, your voice – you know. And often cannot *say* it. You try

and keep on trying to unsay it, for if you don't, they will not fail to fill in the blanks on your own behalf, and you will be said."
(Trinh T. Minh-ha "Difference: 'A Special Third World Women Issue'" [1986-87])

In the area of popular music, as aforementioned, there is no shortage of black female representation – but it is as if this commercial visibility subvenes the lack of substantive black female power – in fields of politics, knowledge-production and analysis (especially of our language structure). The commercial black female singer is a symbolic substitute for the social invisibility.

When it comes to knowledge-production, analysis and creativity black women have been denied visible forms of intellectual subjectivity.

Michelle Wallace in her essay "Notes On Negation And The Heresy Of Black Female Creativity" refers to black female creativity at its most advanced, coded and cathartic as the Incommensurable, or as Variations on Negation. By highlighting this exasperating translatory impasse Wallace describes, using the model of social lingual hierarchy (phallocentric discourse and its negative oppositions or margins), the "precarious dialectic of a creative project that is forced to be the 'other' to the creativity of the white female and the black male who are first 'other' themselves".

This is a wonderfully clarifying summation of a potentially insurmountable problematic. But as we have already discovered – "woman" (regardless of colour) is no "essential" otherness of man and "blackness" is not in actuality a separate essential "otherness" of "whiteness". Hypothetically, though, these myths again fulfil their function as impassive halves of a dualistic equation that underlies our language and expression.

Barbara Johnson (in "A World Of Difference") proposes that black female discourse be represented by the lower-case "x" of radical negation. This is useful in ascertaining positioning; black male as a racial "other"; white female as a sexual "other" and black female as a double negative; but I am wary that this may consolidate essentialism without questioning its need to do so. In other words, without continually subverting the existence of essentialism which it is setting out to expose. One could also be drawn into a never-ending matrix of the "other"; the "other's other"; the "other's other's other" and so on – without rediscovering the causality behind this unrelenting counter-investing chain.

As we discovered before – the deconstruction element only works if one realizes one's dependence on it, and by drawing out this chain of otherness one could lose sight of that. One has to return to check on one's relation to the centre from the margins. To suggest there is a margin beyond that margin is an accurate assessment. But it also disrespects homosexuality, physical and mental disadvantage and/or difference, and many other human qualities that the centre names "otherness" and that many people may possess, often not in the singular. I do not always consider it the positive thing to do to separate out our "othernesses" and name them as the centre would have us do – except when one is clarifying position, or deconstructing. Difference, as we have already ascertained, like the semiotic, is a everchanging *process* of deferral and when judging who is most different we must surely challenge our relation to the language and positionings as we do so.

This is not to suggest that black female creativity doesn't have more differences in relation to the master discourse than white female creativity; or that it's a voice of radical negation – is just the Incommensurability that it is. But I am wary of suggesting white women are closer to the master discourse than black women – because in my experience of feminism, this is often not the case. Black, white, disabled and homosexual – all have reasons to "break" up the assertive flow of phallocentric discourse – which has (although often racist) shown no hypothetical signs of colour in its structure other than that our dominant patriarchy is white, it therefore is read as "white". Yes; it misses out black experiences and cultures but this is not a sign of "whiteness" merely of a dominant culture.

Our language, therefore, establishes dominant white supremacist ideologies through the metaphysical figural. Figurative speech, and language, serves this purpose; the devices used allow the (metaphysical) presence of certain privileged peoples, and disallow the presence of others. Either that or these others may be brought to language in fragmented parts, or as non-intellectual bodies (as opposed to intellectual figures) that would seem caricatures of lowly, bestial, somatic savages, incapable of the white man's civilised Logos.

Also conducive to our system's language are other devices to accommodate the identifiable, differentiated, singular white male subject. Omnipotent and omnipresent emblems, symbols, signifiers and metaphors. Overall, of course, there remains THE signifier (the phallus) which is the measuring rod for all signification, specifically geared to protecting white male property, propriety, and the identity of patriarchy (in a whole and non-castrated, threatened or lacking agency).

The black man is included in phallogocentric discourse but with his huge, mythic penis, he is also disingenuously demoted due to his putative savagery, and non-intellect. Here, we see how the phallus is separated from the penis – to further protect the omnipotence of the phallus. If the black man is so well-endowed, how come he isn't coming to phallogocentrism the way the white man is? Because his phallus symbolises his savagery and his low intelligence, and further more, it is in his instance a *bodily phallus* (which might seem a contradiction in terms), compared to the metaphysical and cerebral phallus of the white man. This device of separating the penis and phallus is something we shall return to later on. At this particular point in the book we should however remember that the phallogocentric white patriarchal man is a man who is a *figure*, and not a *body*. The black man is therefore a penis but is not a phallus. The phallus is constantly present to itself, constantly erect, and like a "womb" to itself. We shall also further discuss issues of reproduction as regards this concept. The Phallus is the communicator, the orderer, signifier and signified. Unlike the mythic black phallus it is not rapacious, or feminized (in that it is bodily). One could also posit that this black phallus is the border phallus protecting the white man from his own body, bodily actions and inability to intellectualize, or rationalize. Therefore, if the black mythic penis becomes too threatening with its imagined huge dimensions, it can always be regarded as the uncivilised, and indistinct appendage of the savage; or the shadow phallus of the alter-ego.

But to return now to the questions of female creativity, and black women and

language. It is true that black feminist creativity has to straddle the creative analysis of the prior claims of white feminist discourse and black male literature. This is a problem due to lack of its own analysis more than a question of there being no room for a further oppositional discourse beyond the "other". When through textual analysis one realizes the problematic of "otherness" one simultaneously realizes that "otherness" is a relativity and mutability that should not then remain a constant within one's self. By this I mean that a white feminist textual analyst, on discovering the binary "otherness" powerplay within language is unlikely then to construct her own monolithic system of considering her discourse oppositional to a black women's; rather she will have opened up the space of deferral wherein her language is no monolith on which she can construct this arbitrary binary situation. She will be aware of the poetics of her discourse, in that she will be aware of the unconscious drifts, flows and gaps in her language – whilst also being aware of the patriarchal discourse at work in her own work, so to speak. I hope that I am not being idealistic in my opinion of feminist textual politics – in my experience this is exactly what is going on within the work of contemporary feminists today, regardless, but also respective, of colour, culture, ability, sexuality, etc.

There is, of course, a tendency (which we all exercise) to rely on figurative language to persuade. Our (in)formative texts describe the able-bodied, logical language of our inherited fatherhood, as well as utilize the idioms of these (linguistic, libidinal, genderized and sexual) attributes. But we have come to reading/writing and realized (and made personally real) the perennial gaps in this discourse which actually describes *itself* as supremely logical (infallible to un-sound [heard!] reasoning) and universally true. This arena of our realization we can call – the TROPOLOGICAL. (A trope is also a device; in this context it is "device" as an agency for the exposure of constructions within language.)

The TROPES (or gaps) in the "master" discourse constitute the signposts where the bodies of those negated are buried. The gaps mark the discursive wildernesses (virtually unnamed terrains where lingual travellers tend to enter at their own personal and cultural risks); and the footpaths of the abjects and poets. Those who drift from the linear into the spaces that divide our comprehended lingual (threatened) sanity of categorization and phallic-security or reaffirmation from the terrifying schizophrenic *chora* that cannot by its very nature chart a linear chronicling line. Thus these gaps in our phallocentric language (which are largely ignored or scoffed at as inferior insane forays) are actually poetic windows that can open onto the chaos outside of our society which our society would guard itself against. The madness, the amoral, the uncontrollable *kismet*, The Unthinkable. And so people of the spatial margins will so too partake of these qualities – which render them abject. Their socially moribund bodies rising up like all our skeletons in the cupboard.

If writing and discourse (and I also include the creative or challenging "voice") are the primary currencies of knowledge power in society then how does the black feminist voice or creativity surface? I consider this a direct semiotic re-link with the third space we have already encountered and entered. This is surely why (as Michelle Wallace insists) it is imperative that it propagates (as it is propagated by) criticism of itself. In the past and still today – black feminist creativity has been forced to mainly focus on economic survival, censorship,

silencing of its author-ity and voice, and support of its brotherhood.

With the tropological we can diagnose the discontinuities in our cultural hegemony. Sometimes this can simply re-consolidate the very SAME hegemony. For instance – this has happened when black male critics have sought tropes that signify the lack (or negative presence) of the black male in the master discourses. This is also the problematic that Kristeva (see: "The System And The Speaking Subject" in *The Kristeva Reader* edited by Toril Moi) has addressed in relation to semiotics which sets itself up as the language of language (a metalanguage) – only then to confront the issue of a re-constructed model of Sameness (or homology) and not a mirror expansion of heterogeneity or "uncharted" differences (which Deconstruction itself cannot deal with being more tethered to a function that cannot describe heterogeneity or negative drives; much less abjection) which is its intent.

I am grateful for, and inspired by, the visual suggestion that Wallace presents as an on-going and poetic process for black feminist creativity, or any extremely marginal (subversive) and negated expression. She describes the trope(s) as a black hole. It is this very concept of the unfathomable black hole that delights me with its resistance to (upon challenging the order of language and deconstructing it for all "abjects", *then* reconstructing another order) – the Order of the Other. It simply appears that for many feminists this desire to traverse language is merely a desire to erect one's own monolith (namely radical feminist matriarchy or separatizing black nationalism) although I have to add that these counter-monolithic orders could be seen as a "balancing out" (or lingual/cultural "revenge") *before* the next stage of the process which still must remain heterogeneous. Or conversely we could consider an ongoing impasse of our patriarchal language, which inevitably as resistance grows and articulates itself over and over – bringing further poetic and subversive artifacts to the spaces in between – simply ups the muted "glory" of the abject – who never truly desired the order to be usurped in the first instance, knowing that to destroy one system gives leeway to the radicals who desire for it to be replaced with an-other which will not demand sacrifices of or separations from their most treasured communal, egotized aspect (namely an alternative phallus or phallic signification).

An area of space in which gravitation is so intense that no light can escape; such is its nature that it appears absolutely black. However, black holes are FULL and not empty. They are unimaginably dense stars surrounded by an event horizon. This "membrane" prevents the unaltered escape of anything which may pass through. Once it has entered, the mass of the thing or energy is infinitely compressed. Objects are squeezed down to zero volume. One could surmise that the energy could pass through to another dimension whereupon it reassumes the properties of visibility and concreteness, again in maybe another dimension.

Thus we can comprehend the black hole as a process. A phenomenon marginal to our understandings of static relations of the subject to the object, or to the thetic stage of the symbolic order.

This illustrates, as Wallace intended, "incommensurability" as characteristic of black female creativity, and also in my mind abject creativity, which has as its founding drive negativity.

This analogy – that black female creativity has next to nothing to say on

classification, interpretation, language and analysis – is described to us by the invisibility (from the "outside") of the black hole, specifically its entrance process (the point of no return at the membrane of the black hole) or point of translation, articulation and lingual analysis.

I would like to stress here, in conjunction with what Wallace posits as a problematic, that, for myself, the importance lies not with classification but with a self-analysis that is the subject-working-as-an-ongoing-process-in-psychology-and-semiology. In other words, the black feminist voice should not concern herself with the context of classification of her(self) works, as this is a return to phallocentricity, and can only redeem itself by working in deconstruction which less deals with negativity than Sameness. Thus semiotics, by enbosoming negative drives, rejection, negation and heterogeneity – can subsume classification and its binary opposite, deconstruction.

We can see how black female creativity is virtually nonexistent (to the extent that the arts exist as a by-product of acts of analysis – a mental process that may be conscious or not) and because of the invisibility of the subject-process also itself an "unconsidered" process. The creativity is as nonexistent as black holes were until they were discovered, and both processes share the quality of the one-way mirror. To enter the dimension one must pass through the membrane that is rendered "invisible" and socially threatening and undesirable. When there is no desire – there will be no drive. Thus this black hole is a dense accumulation without explanation. The outsider will regard black female creativity as a dark hole from which nothing worthwhile can emerge, and everything will be forced to the assume zero volume of Nothingness – resulting from the intense pressure of being the wrong colour, race, sex, class, etc.

The black feminist voice is routinely discounted by a cultural hegemony that is perfectly comfortable with knowing as little about her as possible (so it can then project and specularize/speculate) and requires the space to interpret her participation (or lack of) to ferret out her "meaning" (or essentialise her).

The problems of language (and context) that Wallace discovered when *Black Macho And The Myth Of The Superwoman* was criticized – concern the fact that she described many myths (i.e. many halves of binary oppositional equations) under the rubric of one large all-purpose myth (the superwoman); in the process ignoring the function of the myth which is to deal in superficial and market binary terms at every turn or at every supposed quality of the black woman. Wallace still maintains the myth of the superwoman as the cruellest of all in its huge sweeping (contradictory) deadlocking prowess – of which a black woman could not win either way – such was the totally encompassing patriarchal universality of its damnation.

So how can the black feminist voice be heard? I can present an example from literature. The writing of the characters can convey the problematic of heterogeneity in narrative discourse through other narratives and the ensuing dynamics, sojourns, journeys and traverses.

One can undermine the facile dualisms and *open them*. The disorder of language (poetics, tropes, illogicalities in linearity) explains the perpetual and profound invisibility of women and black women. This is cyclically returning us to the third space once more, where we realised the potential for writing/voicing BOTH linear logic and drifting poetics. The process of radical negation or doubling and tripling the difference which much feminist creativity uses provides

a way to reformulate the problems of subjectivity painting the trails and looping journeys of the subject-in-process. Thus we can encounter the meaninglessness outside of binary white Eurocentric patriarchal discourse and by encompassing (passing through, absorbing, meeting at the truest point of the drive) the semiotic mutability of the process – voice the process in voices that speak of the truest heart of each drive be it negative, logical, deconstructive, poetic, etc. For black feminists, creativity that speaks out in the voices of the other's other completely, in itself, turns on its logical head the binary oppositions as it is the voices from the space that contradicts the universality of the patriarchal equation.

By voicing the differences over and over and over from varying standpoints the expression drives the semiotics pulsions, the gaps of "death", the pulsions, the introjections and expulsions in a mutability. Kristeva maintains that textual negativity masks the self's death-drive which is perhaps the fundamental drive or pulsion. I agree. Enforced social death CAN be linked to an abject's desire for a thanatoid "elsewhere" that is characterised by a death-drive, or desire for a point where the order will collapse and one will be able to take account of this glorious "death/suicide" which wretchedly one would not for one would not have the meaning to signify the glorious explosive death/arrival in Nirvana that lights up the abject's heavens. I am not advocating a pessimistic outlook rather a very lucid overall view of the abject. Neither do I intend to glamorise death – the abject knows that there is grand or EASY joy in this death which is a last resort and wretched predicament – hence abjection.

Thus we do create a process not a system that highlights the subject's own process of abjection, *jouissance*, acceptance, rejection. One can bear to be abject as long as one can attempt to express and work through one's expression in a never-ending requisite catharsis, especially in a repetitive, although progressing, analysis of one's own internal Strangeness or Otherness.

The poet and performer Sapphire has written and performed work that underlines this process. Her expression, in itself, contradicts its phallic legacy and in passing through and absorbing and expanding finds in itself a black (w)hole-ness. Sapphire, as described in the Re/Search book *Angry Women*, has a "clear, beautiful voice" and gives "electrifying performances". What fascinates me concerning her approach to her work and her thematics is the semiotic process that she as a feminist and performer seems to constantly engage herself in.

Starting from the premise of the social mutilation that a person is forced to go through – the self-loathing inherent in our fascistic ide(al)ologies – and the annihilations and self-annihilations that this provokes – Sapphire has claimed back (a) resonant voice(s).

"I was an impulsive talker, so to get a note sent home that I wouldn't stop talking also meant a beating" she claims, in *Angry Women*, in relation to her expression as a child. She also remembers other instances when "paradoxically" she would not get a beating. There were emphatically no rules as to what warranted a beating or not. The dysfunctional family, whilst abusing her horrifically, strangely allowed her some "misdemeanours". This is part of the veneer and front of the dysfunctional, abusive family.

Sapphire's father was "a Dr. Jekyll and Mr. Hyde figure". She was never

daddy's little girl, fondled and touched and then, abused. She was the victim of brutal anal rape; dread at night, near death at night and then eating pancakes in the morning. As she says – *nothing happened*. On no level was anything honestly owned to or acknowledged. It just did not exist. Not a word.

Sapphire decries how she came to the truth through writing. She felt compelled whilst writing her moving poem "Mickey Mouse" to write "paedophile". She says – "This revelation is partly why I trust my writing so deeply." The voice of expression cut through the mists of illusion which we all collude with to varying degrees.

She claims to know the lies when writing or performing. To find the gaps and othernesses, one could say. Whilst admitting that there are times when she is shoved back to little girlhood; forced to smile and go along with the social murderers, holding hands with the perpetrators – there are times when she is writing that she KNOWS.

To descend into the *heart of darkness* for the cruel truth or threatening insight – this is what pushes her through the world of illusion.

A great deal of Sapphire's seminal and insightful work deals with denial. The denial of the perpetrator of abuse, violence, fascism and violation and also the denial of the liberal self-righteous society to realize the damaged mind of the victimizer. Invariably the damaged adult was once a damaged child (who had no choice) and the pattern of victimization perpetuates a cycle of abuse.

Therefore there is a need to understand the enemy and not to freeze people into roles of victim and victimizer. The polarities give power to the victimizer, as we know, and divides both parties into a reductive equation. Sapphire, in her work, works herself out of these roles. She claims it is vitally important for women and black people – (two groups most victimized by their enforced *roles* as well as their positions) to show they can play ALL the roles. She cites Alice Walker's work as doing just that, as we have already discovered. She comes across as a magnificent subject-in-process/progress, exploring through her expression the Oppressor in herself. Coming out of denial to face these aspects of the self is a torturous exercise/exorcise. However, as there is a "compulsion to repeat" the victim has to know and own to the victimizer – or as Wallace suggests, she will stay a victim forever never clearing the hurdles of her progression.

Sapphire expresses what society does not own to. "We are a rape culture". We are a culture that finds at its root the dysfunctional family where the father does his worst passed off as his best. A culture rooted in misogyny, fear of the other and fear of death (tied into fear of female blood) which self-aware feminists are less likely to feel in realizing their own death potential and death drive. A culture that would stave off its own death by killing or raping everything that it fears.

"You kill what you're afraid of –
Are you afraid of me?
.....
.....
Hips, tits, lips power."
(From the song "Big, Bad Baby Pig Squeal" by Silverfish – sung by Lesley Rankine, former lead singer with said group)

When asked about the linear scientific approach of our society Sapphire adds – " ... but they don't want *us* to understand that *they* understand their system doesn't work." Their theories are unproved, but reinforced through a brutally, bordering on and, spilling over into, murder. Thus we are sold a reality that is based on a narrow phallic theory but Sapphire isn't buying it.

"I don't want their language. I'm trying to find the blackest, bloodiest female-est form of expression ... I'm aiming to find the heart of darkness – the very thing they've tried to suppress ... which they claim is ugly and valueless - yet spend half their time trying to imitate and murder ..."

The answer lies, for Sapphire, in a force greater than herself. A force which white male culture vehemently denies in its arrogant and misguided beliefs that it, itself, is god, and over and above nature.

"God (not to be taken in a Christian context) is over us and in us."

Above all Sapphire believes that we can no longer perpetuate the phallocentric legacy of separatist and binary dualist labels. We can no longer take as absolute meanings what we know to be a linear and narrow monolithic system – when we are multi-aspectual beings that came from a semiotic *chora* and will always require its non-structural, non-fixed fluidity in relation to our unconscious and conscious self. We need the gaps, tropes, contradictions that remind us of the semiotic *chora* (i.e. that which cannot be fixed anywhere in our lingual or symbolic order and therefore presents itself as the disruptions and pulsions consubstantial but oppressed).

As Kristeva affirms – "neither a sign or a position, but a wholly provisional articulation that is essentially mobile and constituted of movements and ephemeral stases ... Neither model nor copy, it is anterior to and underlies figuration and therefore also specularization, and only admits analogy with vocal or kinetic rhythm." (From "Revolution In Poetic Language")

In the classic song "Walk On The Wild Side" Lou Reed narrates in laconic tones the tales (summarized life story extracts) of several of Andy Warhol's people – drag queens, hustlers and junkies. All have their stories told (for them), and what does he announce on approaching the trope after the verses? *"... and the coloured girls go – do do-do do-do do do-do do ..."* – letting these "coloured girls" speak their own cryptolinguistic, attitudinal rhetoric. The verbal signifying of a neology (or soulful "acapella" musical language) that could mean everything and nothing.

In the context of the song – they literally voice the trope and abridgement. They sing an attitude, they sing a black vocal history, they sing "soul" as white folk can't (or so they say), they sing a discursive pre-lingual/post-lingual noise and they sing invisibility and, as Wallace would say – "incommensurability". They have no words of their (re-positioned or tripled difference) own, as such, to use without investing time (that a four minute song doesn't have) in opening our minds; but we all harbour an idea (projected, specularized or otherwise) of what they infer. One could say that "what the coloured girls go" instils this song with a (w)hole-ness. That they signify a musical history that the white man cannot begin to describe with his white phallocentric language – even in a musical context. They might sing black female harmony that cannot translate but can

only fill gaps in the master-speech. They also might present an-otherness which disrupts or questions the verity of Lou Reed's speech; then again they might just be the black "hot mama" stuff that complements the white master-singer. It might all be just a pop song and of no real cultural significance. Is it a shame that these women don't speak the master language? As I mentioned before there is no point to gobble-de-gook out of context.

But this seems to be set in a very strong musical context which has long had a musical history harbouring a musical language for black people that is perfectly articulate in its context and in the poetically, semiotic analogy of rhythm and, most importantly – The Unspeakable, in other terms. A language of pithy blues patois and scat, of dub poetry and slang, of Jamaican patois and inner city speak. This has all in its way contributed to the modern day musical vocal language (which is not formal, much less faithful to the lingual or grammatic rules and signification required by the symbolic order), and the use of verbal expression in music. The ballads, the pop songs, the rock numbers – all still rely on the "attitudinal" emotive expression that has its bases in blues, jazz and soul, to name but a few strains of music, and poetry.

12. The Schizophrenia Of The Role In Acclaimed Shamanism

Aliene Appetens

There is no Transcendental Ego, here. The transcendental ego has de-transcended itself by its own abject function. Thus "we" have no Universal Ego – the mystic searches for no universal ego – for to encounter that EGO insures that there is nothing transcendental about it. What "we" wish for is a universal unconsciousness, a collective *semiotic* unity, but also importantly dispersion, that is beyond comprehension. "We" may be already there and simply do not know it. What a terrible thought! Yes, because "we" Thought it; Realized it; "we" are farther away from it than "we" would be in our ignorance. To express ourselves "we" adhere to a system that claims to be that *transcendental ego* – claims to be the supreme universality – but being aware, like a *spasmodic* beast (with its acute sense of smell) is aware, "we" know "we" are failing; flailing; falling. The "transcendental ego" – the consummate little unit that it is – is at the mercy of this ego's id; this ego that is so self-conscious and so homogeneous it seeks its own self out over and over – perpetrating the system – smaller and smaller. But "we" are a "speaking subject" that is *an object for language* – discourse, poetics, speech acts, foreign languages, linguistics. "We" are not centred but "we" are sometimes centred. "We" are not divided but sometimes "we" are divided. "We" are not differential though sometimes "we" are differential. There is no transcendental ego of language, here. An ego which disallows polydifferences and contradictions. Negativity, rejection and shamanism. Shamanism as the ego who forgoes its selves in order to contradict its selves – is after all an ego that has transcended itself but is still aware of itself thus it has not fulfilled its function – but may well have tasted of the forgetting of some of its symbolism whilst still being a mobile mutable fluxing *presence*.

> *Accoucheur.* Cha. Accouch. Assist. Cha. Cha. Chariot. Crib. Cradle. No really I jest. I am the jester. That time forgot. I am here – coming coming coming coming. Long eyes and forked tongue. I hear a small child and I hold that child. I hear a small croak. Boo hoo. Voo doo. Bless you. Bless you, child. Let our enemies be torn into many many pieces. We say. Loa loa loa. Voo doo. Doo. Cut into pieces. Dear father. Law. Dear daughter. Spear of lack cuts into many pieces. But we are whole again. Black hole. We are back in the whole of the shaman again. Back in the mama hole. Now we call it the presence place with no place or sign. O.O.O. Like dear dying. Not unwanted death. But desired Death.

> Polypetalous. Loops and breaks. Loops. Polysynthesis. Poly. Poly is usually more than one. Diffuseness. Spatial. Amplification. Sonic. Cloud of words. Poly. Polyglot. Poly.

Schizophrenic. Polyandry. Having many husbands at the same time. Having many voices at the same time. Being mediumistic. Bridge between diffusion. The polymonody of Satan. The polychords of the medium bridging myriad positionings. Many many positions. And so to discursive diffuseness. In a spatial chora that isn't dictated by space time sign or symbol. Impossible. Symbiosis. So we cannot talk about it. We cannot talk any more than we can realise it. Though we proclaim in euphony and dischord polyphonism. And sing and shriek full of it. "Kill energy" for our enemies and stertorous quadro-voices siren out of shamans' bellies and fly as our bodies fall. The lupine growl and feline sound and the shaman speaks with forked tongue; like many tongued polyglot.

Interieur. Interior. *Sono l'Antichristo. Sono. Sono. Même. Même. Cette nuit. A la nuit tombante. Cette nuit.* O God, the Law of the Holy Father. Abject one. Lamentable. *Le malheureux. Lamentable. Cette nuit. Ah, cette nuit! Le ordre d'exécution. Le ordre d'exécution. L'arrêt de mort. La morte. Cette nuit. Ah, cette nuit. Cette nuit.* Medusa. *Même. Même.* Jamouretch. Bisexualautodesideratum. *Cognito.* Hysterie yeowlar. *Cette nuit.* Yeowlar. Desideratum. Sea. *Tenir la mer.* I made myself look clarice. I made myself ask. I looked inside Ngambi. With insight. Haven't I bled? Our sacro-blood. I looked inside, I did, my diva lord. My eyes closed. Do I not deserve to see the blessed promised abject land, that lieth over the border of meaning, ego and recognition?

Joseph Campbell, in *Myths To Live By*, suggests that we should update our myths and religions to accommodate our contemporaneous ways of life, or they will cause psychosis. We can in some ways consider that "psychosis" is a term coined to describe the condition of not being at ease with the order of our given society. Given that many so-called female maladies (such as hysteria) are now recognized as conditions arising from sensivity to, or rejection by, our social order – can we not move on to reassess some myths and religions and carry their dynamics and social functions with us into alternative or expanded realms of heterogeneity?

I consider Diamanda Galás to have done this with her usage of religious texts and reapplied poetics. Fully aware of what we term "mental illness" Galás has cleverly usurped and subverted the dynamics of religious texts that advocate or elicit damnation of sin and immorality. Galás operated with her own binary structure, breaking up the semantics of "extremes" whilst still keeping to the religious context, to turn meaning on its head. The saviour becomes at once Satan (in the sense of the abject angel who is the one burning witches, decadents and social sinners cries out to for terrible mercy) as well as Jesus, the Christian or Orthodox redeemer.

"Oh Lord Jesus, do you think I've served my time?"
("Let My People Go" – D. Galás)

There is violence to Galás' work that is coupled with revenge in the oldest, epistemological sense of the word. Revenge that "calls to arms" and demands of our Christian religion the right to retribution (of the oppressed, marginal or abject), and moreover if the demands fail, there is, in Galás' work, the inspiring strength to TAKE revenge. "An eye for an eye ... "

Here, God is no mealy-mouthed do-gooder but a fighter; a warrior. One who will fight to the last with none of the fatalistic acceptance of one's wretched destiny that some religious fanatics would have us believe. Galás applies attributes of mercy and understanding to Satan. Whilst simultaneously using the metaphoric darkness of the fallen angel as the cloud of horror (and by this I signify true-real horror and not indulgent "play" with horror) that can befall persons with AIDS and/or the HIV virus; to whom all her work is dedicated, and for whom her *shamanistic* work and vocal power lets itself be known.

To fully understand her "role" (I do not use this word pejoratively but in the context of what I am about to posit as its fullest function), I would like to delve into the positions of The Shaman, The Hysteric and The Schizophrenic; by trying to unfurl and unleash their semiotic, bisexual, sometimes abject and painful capabilities, and our society's relation to and categorization (hence creation) of them as hypothetical and mythic figures but also appropriated, inescapable, innate, imposed or misunderstood roles.

"The original nature of woman's voice has always been tied to witches and the shamanistic experience – the witch as transvestite/transsexual having the power of both male and female."
(Diamanda Galás – Re/Search 13: *Angry Women*)

Stealing and flight. Theft, appropriation and rising up as a phoenix. Things coming through; traversing, embracing drives and impulses.

"There is a voice crying in the wilderness, Catherine Clément and Hélène Cixous say – the voice of a body dancing, laughing, shrieking, crying. Whose is it? It is, they say, the voice of a woman, newborn and yet archaic, a voice of milk and blood, a voice silenced but savage."
(Sandra M. Gilbert in the introduction to *The Newly Born Woman* – Catherine Clément and Hélène Cixous)

And let us consider Freud's Dora. Was she also not a witch who spoke in tongues? And what of Emily (Dickinson) and her "hysterical" possessions by a nameless master (animus)? And she uttered for "him" the unspeakable; she verbalized the unutterable, as she spoke of the "it" that was herself; himself; all her selves in the "it". "Why make it doubt, it hurts it so." The "it" that is the eye in the hurricane of my own desire – and beyond that to my *jouissance* and the pleasure pain of describing that which can not be described for the meaning of "it" exists where meaning ceases to exist. But sometimes in the "voice" it will speak itself and imagine.

A little bit like that volcano of explosive magick who was called Regan (*The*

Exorcist); she who spoke up from her own bowels and rasped and cursed and fired her verbal gun.

The etymological root of the word "hysteria" is the Greek *hyster*, meaning womb. An inescapable link to the body, and creation, procreation and importantly death. This destiny of the woman is programmed by anatomy. The sorceress is a witch who both preserves and destroys culture. She is a midwife assisting Eros and Thanatos.

The Other, the Hysteric – embodies somewhere an incompatible synthesis. A bisexuality. As we have already whispered – The Other Bisexuality. In defining the "anomaly" we encounter "it" in the faultlines of the general system. On the outskirts, on the borders, in the tropes but always still within the system. We relate. We also Other-ize. However, societies do not succeed in offering everyone the same way of fitting into the system. And even to our mythologies and our role myths we find that there is that certain symbolic mobility.

These Others are in a kind of class but also classless. They are situated within yet often pushed out. Their mobility is lethal *and* productive for our social order. This mobility (as Catherine Clément posits in "The Guilty One", part of *The Newly Born Woman*) affects the structure whose boundaries, borders and limits it reflects.

And so these people have to compromise. They are compelled to simulate imaginary transitions and to embody incompatible syntheses. They themselves do embody these metaphysical (and also libidinal) bisexualities. As Clément describes:

"Madmen embody the impossible configurations of a return to childhood.

Shamans lay claim to fictitious voyages; transitions between here and beyond; the ego and the id.

Circus tumblers perform inaccessible, marvellous but inhuman figures with their bodies.

The abject one tries to speak the tongues of the others within calling from the promised land.

Shamans turn into birds; tumblers into serpents; madmen into stones and abjects into myriad bloody tongues.

Is it bizarre that women incarnate these anomalies who reflect the tropes whilst simultaneously embodying the norm (reproduction) – or do we not regard that as normal? Should 'we' make up our minds? Are women's periods the epitome of paradox and disorder or absurdity, or are they regularity itself? Intensity or mundanity?

The sorceress embodies an unrealized compromise wherein she connects all the loose ends of our culture which we find hard to endure and thus cures the afflictions that resist the domination of the church."

What does this sound like? Let us imagine the sound from the sorceress' lips. Elsewhere the hysteric embodies the incompatible synthesis of An-Other Bisexuality. Herein, or elsewhere – women are threatened by the reverse of mobility – that is the inherent repressions that limit the effects of our symbolic dis-order. And what is the sound of the dissidence? The cries from the vast depths of the very social abyss.

Accordingly there are two forms of repression (or integration). The anthropoemic function ensures a protected space – namely an asylum, prison or

hospital. Maybe, joyously, sometimes a stage or a page. To find that place in the depths of cultural activity is namely the anthropophagic – and we can clearly see that this is not our system. However, it is my belief that this can be our Integration. This anthropophagic space where the one is elsewhere called an anomaly – can put her/his embodiment to use and function as a cultural mediator, or ambassador, within the realm of the arts, including theoretical knowledge-production. However, the history of the sorceress (as she is thus named) decrees that she oscillates between two poles and ends her role's existence, or social function, as a prisoner-lunatic.

This type of repression, as many women know, doubles the movements of the abject, or marginalized one. Swinging from pole to pole from centre to margin; but importantly there is also the sign of movement into the system as one who is wholly, wholely there in that system. In other words the painful re-exodus back to the centred whole. Clément, like Kristeva, notes that these "anomalies" have a fictive independence. As Kristeva would suggest – they are not fully autonomous. But such is society's desire to fictionalize the anomaly, or abject, as an autonomous subject. This would suggest a certain grand amorality. The anomaly knows no such grandeur; "merely" debilitating punishable immorality. There is no inglorious amorality or autonomy as this would suggest an independence – and would de-cry the very special relationship (incest) that occurs within the filigree threads of the system. Ultimately ALL must relate back to this system and All, in fact, DOES. This is all very interesting when we consider the roles and myths that "come before"; precede; the anomaly. It is perhaps these "circus", "carnival" roles – Hysteric, Sorceress, Anomaly – that form the grounding for this certain dynamic and constitute the perpetration of the mobility that our society now needs with for its enlarging signifying process and desire for monolithic semantics. This economy ensures that all will be reducible to its own terms. Beyond that irreducible.

Whilst I fully understand the ethical problematic in owning to some attribute, or condition that is not apparently one's own – I feel that today we should strive for a hypothetical embrace with one's othernesses. One might posit this appropriation as self-satisfying, or self-promoting in the field of politics or the arts; but in line with the situation of the black Britain who is no longer the person he/she would be in another situation, having changed because of his re-situation or emergence within a white society – so I observe a similar diffusion of the boundaries of what one is supposed to "stand for" in a politically-correct political context. I am not suggesting one should literally "take on" a position but that rather one might strive to realize and symbolize the hypothesis that each individual can, despite one's surface stance, embody more than one's surface stance. I think of the current situation of our AIDS crisis, and the artists who feel they have the right to speak for those who are HIV positive, or have AIDS – this could be a good example of suspect appropriation. But next I consider the black person who has in fact, despite social stance or standing, a white heritage. I think of the feminine (in the context of gay lingual inference) woman whose actions are according to our society very aligned with masculinity (this time in the context of heterosexual lingual inferences). I am then drawn to the woman who is feminine in appearance but realizes her masculine attributes, who is born of mixed parentage but raised in a white household (although there is no doubting the colour of her skin), and who is repelled by the drives that pull

her towards a masculine libido and clings fervently to her female drives, whatever all these attributes and realms may be in any, or all, the most diverse contexts one can consider. And also realizing that she is not this "thing" they call woman and so maybe she doesn't speak for woman – no, she only speaks for herself.

And what of the "anomaly" or abject or hysteric – why she is surely the fencing around our society. She is the pressuring boundary that keeps our society IN. As Catherine Clément accurately suggests – she is "taking up the slack existing between the Symbolic and Real; carrying out, in the Imaginary, roles of extras – figures that are *impossible at the present time.*"

One very interesting question that arises at this juncture – bearing in mind that I am focusing on several female performers in relation to what I am positing – "is whether female abjects repeat our past culture, anticipate the culture to come or express a constantly present utopia?" This is a query that Clément has dwelled upon. I would like to substitute *jouissance* in place of utopia, as *jouissance*, in a Lacanian tradition, accurately denotes a pleasure that is unrecognizable from pain in its extremity and thus better suggests a continued disturbance of the "subject-in-process/progress". If we do consider there is a constantly present utopia we must in this case consider it to be a utopia that is suppressed by our very existence as beings in the symbolic order who can never return to the pre-Oedipal semiotic, except in the advent of death. In other words the spaceless space wherein and whereby we cannot be consciously aware (through the symbolic order) of its utopian quality; except in the brief instinctual flashes, semantic contradictions or textual clusters encountered in poetics and "shamanistic" performance.

We shall return to this infinite conundrum many times in this study.

It is possible that the "sorceress" figure bears our histories of the past in the present. This concept illuminates the power of what is repressed; the force of the anachronism (that many women embody); the imaginary displacements and resistances of the past cast their shadows to shift and disturb our current systematic patterns and models. Catherine Clément also asks – is our disturbed system re-established by making the symptoms disappear? Or does it annul the innovating force which has now become the Other in our present?

What should seem bizarre is that the "hysteric" continues to be a hysteric – making a mockery of the function of psychoanalysis – which should by all accounts "cure". Again we realize that this "hysteric" whilst becoming more appreciable, i.e. a feminist heroine, is also never to be reducible or more than a "sum of her parts".

Thus what we encounter here is the relations between the Imaginary acting on the Symbolic and Real. By inscribing the Imaginary IN the Symbolic the anomaly fails. This would be seminal and semiotic process constituting the Imaginary which does not translate. Because this is especially true of language we can see how the "hysteric" is plotted against her own demise. What we inherit are hysterical symptoms inscribed on the body of the woman and then analogized into the system. In light of this multi-directional "murder" we can conceive of the subversity attributed to the return of the repressed, bearing in mind the lack of power it has OVER the symbolic. As Clément adds – this is now only pertinent to the extent of the witch, sorceress or hysteric being references

or models. To consider the sorceress, for instance, as one specific individual case of one woman belies the manner in which society is wholly involved in a conflict with its own unconscious "repressed", and seeks to make light (or sense) of its past through analogy.

Clément concludes that the answer lies in a passing over to actions – of formulating an inscription of the Symbolic in the Real, to produce structural transformations.

In a way this is what female performance has done, and we will, of course, illuminate examples of this further on.

Clément goes on to postulate that the body does become a theatre to display these symptoms of repression and analogy. Given that the body and womb gave "birth" to *hysteria* (*hyster*) this is almost a double displacement (*double entendre*) and a returning of the blame that can become a re-appropriation of responsibility, and hence, with the *individual* now involved, an empowerment. It is worth bearing in mind that the power still resides with the desire to see/ability to see the Sign, but this is almost like acknowledging a symptom that binds the role but by use of semiotics can free the individual. In the case of viewing the hysterical "role", society as an audience can partake without fear of contagion. Clément suggests that the circus and the cinema are institutions of hysteria. When the "role" is appropriated by the individual, and the rules of displaying symptoms are broken, (i.e. the wrong signs are given) the audience is once more under threat by its own repression and by its transference. Diamanda Galás, in her work, claims that she IS the plague (the contagion) belying the "role" and transmitting a transference of a kind. Conversely this might also work by adhering to our concept of the sorceress, or hysteric, having to purge herself of a foreign body. It might have effect by suggestion of contagion or by breaking rules of the certain symptoms being part and parcel of the "role" and not the actuality.

Figures of inversion often tend to manifest our mythical repressions. The two extremities of the body invert – head and bottom, hair in both places, cheek and cheeks, neck and neck of womb. Thus in our mythologies The Repressed are fantastic acrobats and perform gymnastic contortions in their festivals and exorcisms.

"She laughs, and it's frightening – like Medusa's laugh – petrifying and shattering constraint. There she is, facing us. Women-witches often laugh ..." ("The Guilty One" – Clément)

Clément sums up her piece "The Guilty One" by suggesting that the sorceress (who is parthenogenetic) and the hysteric (who desires to escape the family the sorceress never had) prefigure in myths that we must rise up out of, and ultimately leave behind. Anterior to our vision of this flight – there was another notion of bisexuality from whose ashes arose the phoenix which was our immortal self. This concept regarded the male protagonist as having to pass through the experience of womanhood, in the guise of the hermaphrodite, to become the avian creature who engenders himself.

Does this not make even less of a woman's ability to give birth amongst blood, amniotic fluids and other carnal factors? And is not this myth heavily anchored in a Judaeo-Christian context?

The sorceress engenders herself without a father and rises up as a living

product of her nature; a psychological trauma; splitting her own psychological caul as a supreme mediator. The hysteric battling her masculinity and femininity simultaneously; her role of "woman" and "man". She enacts the struggle to rip her dress off whilst clutching it to her; both the aggressor and the restrainer.

Clément wonders how much greater these women would be if we left the roles behind. And left the circus. And quit the show.

Bisexual women whose gestures contradict the possible yet anticipate the impossible. The roles no longer exist. They are no more. One could pick up their figures and "put them on" to further subvert their role. Clément suggest we keep our bisexuality but aim towards compatible syntheses – a state that is not contradictory. Bearing in mind my thoughts concerning abjection and *semiotics*, as the process in which we as objects are immersed, I am hopeful but do not foresee a state of utopia. I do fully agree with Clément's notion of this new flight. I also consider the "putting on" of a new circus conducive to this flight. I believe the old circus wherein women were exploited and murdered to be over, and the contemporary spectacle to in itself challenge the word "spectacle". But the many drives (the death drive especially), pulsions and desires of the semiotic lead me to believe that whilst "roles" are one thing – individuals, and their language, with the huge lack signified IN the Symbolic; the huge Desire that can never be assuaged – all leads me on to further spend time on that Desire which no compatibility can stem. Desire is "born" on entry into the Symbolic Order through the Mirror Phase, as Lacan expounded. Thus the unconscious is "born" (or rather split off as the Unconscious) – and we glean insights into this desire through contradictions and pulsions in language, etc. The desire *is* the unconscious, for anterior to this psychic transformation we were undifferentiated in our continuous state of simply "being". Thus this is what we desire. This Unspeakability for True-Real being; as the being who existed in the *chora*.

The phallus as THE signifier occurs when the child leaves the mother's pre-Oedipal acquaintance and enters into the Symbolic which is a denial of the pre-Oedipal, and a phase when son must completely "part" from the mother figure or risk castration by the father; or conversely the daughter must align herself with the Law of the Father, or stay closer to her mother – partially rejecting the phallocentric law. However lack is not solely concerned with the lack of the phallic or the complex that goes with neurotically retaining, protecting or envying the phallus. Our greatest lack must surely be what our greatest signifier lacks. In this respect the phallus, in the Symbolic realm, is a symbol of the lack of the ability to return from the phallocentric to the unified, timeless *chora* of the pre-Oedipal that "houses" all that constitutes the unconscious. It is the lack of imagining a real utopia; the lack of total unification with the cosmos; it is the lack of the Imaginary realm in reality. The unconscious is the primary repression of the desire for symbiotic unity with its creator.

The nearest we can get to ending our continued desire is to go forwards to our demise: towards the timeless continuum of death. Towards the Black Goddess' hitherto unknown depths. Death therefore heals the split subject, as in a re-capturing of the lost unity or utopia. As there is no other object which can *be* what we have lost forever – there is no final satisfaction since there is no final signifier.

13. Murder And Mythic Word

Shamans And Schizophrenia

The images and fantasies experienced by the schizophrenic can match those of the mythological hero when he/she embarks on a journey. So let us continue our occupation with myths and debark on our own voyage of aligning mythic experiences with personal experiences and their interpretations, causalities and consequences, especially regarding social pressures.

As I mentioned earlier on in the book Luce Irigaray considers the arena of feminist creativity and mysticism a very seminal realm. She proposes the space of the mystic as a space the feminist abject can occupy if she wishes to encounter a certain subjectivity. Irigaray calls the space at the margins and in the gaps a derelict space – which I wouldn't completely agree with seeing as we have discovered that the semiotic encompasses all spaces in its veritable spacelessness and all are necessary for the subject-in-process. However Irigaray is speaking of a dereliction occurring from denying women a sense of self within the Symbolic Order. A worthwhile-ness for want of a word! She suggests mysticism as her answer to the subjectless-subject in the derelict space. This is of course interesting ground. Lacan also posited a similar theory regarding mysticism; suggesting, like Irigaray, that this loss of subjecthood (and also therefore inevitably objecthood) is akin to the loss of the subjecthood in *jouissance*; similar to our ideas of the unifying space of the semiotic, or death. Lacan studied the statue of Bernin's St. Theresa in Ecstasy and found her divine subject-less ecstasy to be the transcendence of pleasure into its painful state (or vice versa) that leads to the almost indescribable state of *jouissance*.

So to the "hero's" journey; wherein universal, archetypal psychologically-based themes and motifs seem common to all cultures' mythologies. The very same symbolic figures arise spontaneously from the "broken off" minds of individuals suffering a schizophrenic breakdown (as we would term it).

We can describe the stages thus: 1) The break off, break away or departure from the local social order context. 2) The long, deep retreat inwards or backwards into the psyche (as in time). 3) A chaotic series of encounters and terrifying experiences. 4) If the patient is lucky the encounters will be of a centring kind; fulfilling and harmonizing, bringing new courage, and solutions to problems. Then: a return journey of rebirth to life.

The universal formula of the mythological hero also follows this pattern. 1) Separation. 2) Initiation. 3) Return.

Dr. Perry suggests that the best thing (in relative terms, concerning our Westernized culture) is to allow the schizophrenic process to run its course. More in-depth analysis of the situation (dynamics, negation, foreclosing, fetishism, abjection, etc., included in the long-term) would lead to the deduction that the most positive aid should arise from helping the subject in the process of disintegration and reintegration, bearing in mind the subject's relation to our

symbolic order to start with. It would seem only pragmatic that we should realize that if the subject suffers as a result of the symbolic order the subject should not be coerced into forced change but should be respected for his/her individuality. I think, at this particular instance, of a woman in feminist counselling, who was taught to be at ease with her mental anguish rather than forced to change, as it was her very unease with the patriarchal order which had caused her suffering (a denominator that is constant) and which should not be posited as a normality to which she should adhere. This is, of course, the basis of much "female malady". It becomes a question of personal morals and ethics. In the context in which I am currently speaking schizophrenia seems also to suffer from miscontextualization. Hence, we should consider that personal progress should be measured in terms of personal relativity to the exterior, in our case the symbolic order; which we know is but one, although the only fully operational and near-real one, system.

This view of individuality, of course, makes a mockery of electric shock treatment and the like, and rightly so. Our fears of "madness" however, attest to our limited questioning of how "marginality" manifest as "insanity" should be related and treated. But what if we were given help to understand the imagery of our darkest minds? What language would we use? As long as the mythological language is seminal and accommodating, then this might be a good starting ground. In this context; the myth can be useful as opposed to detrimental. The signs that the "patient" (I am somewhat at odds with my own language here and am loathe to use such odious nouns; although I also realize that the very odious-ness of the semantic-ality attests to what I am about to posit as a means to an end and hopefully I will be able to usurp the derogatory flavour of such words by myriad context usage) who is out of touch with "reality" (i.e. rational communications and thought) is trying to bring forth – should be helped, and encouraged. How do we not know that this individual's testimony is not valid to our reality?

We fear madness. We fear anxiety. I fear my own anxiety; my own neurosis. Why? Because I believe I should fear my own neurosis? That which they call my "neurosis". But every so often; yes, regularly in fact – it arises. I am mad. I hear voices. I am about my daily business and I shake. I scream inside. I cry inside. Then I stop and I circumspect myself. I circle myself, and I am mad. That is what they tell me. And that is what I fear above all fears. I fear madness. I fear I am THAT woman; the one who rocks to and fro and mutters. I rock to and fro and mutter. I fear the day when I will be fully disjointed; because I have seen that day. I have seen that day. It is black and red with blood. It is black and red with the blood of my scratched arms. I fear my own madness. Every time a lunatic passes me in the street I grit my teeth because I have an invisible badge pinned to my heart that only lunatics can see and I know that that lunatic will pick on me out of every other person waiting on the tube platform; I know he will pick on me – come up to me and mutter and scare me so badly my legs will be too weak to walk and I will hear my own heart. Only because it is my madness. My madness. I only fear the madman because I fear my madness. As close as a hairsbreadth. "Why do the nutters always pick on me?" my female friends say. And – " ... there but for the grace of God go I ..."

The journey inwards and backwards is the journey to recover something lost and/or to restore balance. What if it is never found. What if this "thing" that is sought is never found. *That* is what we fear. What if the thing we find is a mirror? What if the sound we hear is the scream of our own voice – disembodied, wretched, frightened, disreal and ostracised. What if we find we have given "them" exactly what they wanted? For "they" want us mad and screaming (even if it frightens them). They want us dulling our senses and our intellect with hum-drum activities; with narcotics and alcohol. They want us to self-destruct. They want us to implode with anxiety and neuroses. What if "we" don't tell "them" about our journey? What if we travel and go afar and use our own signposts and use our own judgements?

In primitive hunting-people the mythic imagery and the rituals of ceremonial life derive from the psychic/psychological experiences of shamans. The shaman (male or female) is one who, in early adolescence, underwent a severe psychological crisis, or psychosis. Usually, in such cases, the family will call upon an elder shaman to bring the youngster (neophyte) out of this crisis. In cultures where this crisis resolution is tolerated, the "abnormal" experience is beneficial to the individual, cognitively and affectively; he/she is then regarded as one with an expanded consciousness. In our rationally ordered, phallogocentric culture there is no such guide for the schizophrenic, and thus she/he suffers over and above his/her original anxieties.

There is a tale of such a shamanic experience that I would care to impart to you. It goes something like this:

An Caribou eskimo called Igjugarjuk, in the North Canadian tundra, when young, was visited by strange and vivid dreams. The family sent for an old shaman, by the name of Peganaoq, who placed the youngster on a sledge and in the depths of winter (on a dark, freezing Arctic night) dragged him out into the lonely Arctic waste and built him a small snow hut. Inside there was barely room enough for him to sit cross-legged. The youngster was not allowed to set foot on the snow, having been lifted from the sledge onto a piece of skin inside of the hut. He was instructed to think only of the Great Spirit, who would presently appear; and he was left for 30 days. After 5 days the elder brought lukewarm water. After another 15 days, he was brought another drink and a bit of meat. The cold and fasting was so severe that "sometimes I died a little". All that time he was thinking, thinking of the Great Spirit. Towards the end of his ordeal a helping spirit did indeed arrive, in the form of a woman who hovered in the air above him. He never saw her again but she had become his helping spirit. He was the taken home and told to fast and diet for a further 5 months.

Such fasts, in this cultural context, are the best way of attaining a knowledge of hidden things. "The only true wisdom lives far from mankind, out in the great loneliness, and can be reached only through suffering. Privation and suffering alone open the mind of a man to all that is hidden to others."

One might be dubious of this practice, but who are we to say – with our shock treatments and our outrageous ostracizing of the one who belongs to our order only so he/she may point to us that which we dread to discover.

Shamans live in perilous positions. When things go wrong they are to blame. They imagine he/she is working his/her magic. Of course, some shamans invent

tricks and devices (we are aware of this through our views of the charlatan-ism of witch doctors) and mythological spooks to frighten off neighbours, or trouble-making citizens.

In Nome, Alaska, a shaman called Najagneq believes in a power called Sila. A spirit upholder of the universe, weather and all of life. Sila's speech comes through storms, showers, tempests (all things feared. even in our society to some extent), but also sunshine, calm seas and innocent children who know nothing. When times are good Sila has nothing to say and disappears into the infinite nothingness. Thus, her/his place of sojourn is – with us and infinitely far away at one and the same time. He/she/it is the soul of the universe and never seen; but the voice alone is heard.

Gentle, like a woman – so fine and gentle that children cannot be afraid. (We should see a link with this concept and the maternal voice which I shall write about further on.)

The voice says – "Sila ersinarsinirdluge" – Be not afraid of the universe.

It would appear that this concept, in general, is believed by most respected mystics. In other words – there is a common human wisdom that is a consensus, whilst it is also a deeply felt personal belief.

Ostensibly, there are (in Western psychological praxis) 2 types of schizophrenia. There is essential schizophrenia, in which analogies with shamanism appear; and paranoid schizophrenia, in which the subject remains alert and extremely sensitive to the exterior world and its events.

With essential schizophrenia the subject withdraws from the impacts of the outside world, narrowing his/her focus and directing it inwards – as in "insight". As the object world falls away invasions from the unconscious overtake (overwhelm) the subject.

With paranoid schizophrenia the subject interprets all in terms of his/her own projected fantasies and fears; whereby a sense of danger from assaults arises, from these projections. It is thus difficult for the paranoiac to decipher anything valuable through the onslaught of such terrifying experiences. Thus because the assaults are actually from within the imagining world is everywhere on watch against him/her. Unable to tolerate this inner terror the subject projects prematurely (an aborted crisis solution) and unable to work through his crisis finds himself at large in the field of the projected unconscious.

Schizophrenia thus incurs a life/death battle (inside or exterior) with the apparitions of unmastered psychological/psychic energies.

The difference between the predicament of the essential schizophrenic and the trance-prone shaman is merely one of situation and social assistance. The primitive shaman does not reject the social order or its forms as it is by virtue of those forms that he/she is brought back to rational consciousness with valued information. Often on returning the inward experiences reconfirm, refresh and reinforce many inherited local forms. Or not, as the social case may be. Which demonstrates unerringly why we should surely ensure that our social realm harmonizes with our other realms of consciousness and experience. Alas it often does not; hence our social dialectic of "madness"' discourse. In some situations however dream symbolism is at one with cultural symbolism – in other situations the established discourses of our system are terrifying to the lost schizophrenic

who is frightened by the figments/speeches of the imaginary; finding himself a total stranger but paradoxically NOT a total stranger – an abject.

The ground-posts; the boundaries and markings; must surely move as our post-post-modern (semiotic) society moves: then we can better visualize, or describe, the relation of the mechanics of schizophrenia, mysticism, drug-use (i.e. LSD and MDMA experiences) and the antinomianism of our youth who are often the first to personally expose our monolithic social structure, bringing to it as they do, new or revised opinions of normality, legality and acceptability.

In fact the LSD retreat and inward plunge is comparable to essential schizophrenia and the antinomianism of youth comparable to paranoid schizophrenia – in so much as the younger generation does not and in fact cannot read the signs of our system in the same way – having been born into and nurtured by a changing set of *denominations/denominators* (paradoxical as this word-use may seem). The symptoms of a young person being unable to find the words for the charged-up feeling; the feeling that there are no words – again demonstrates the "illness" that is the subject who realizes (in Lacanian fashion) that he/she is not the master of the monolithic language structure but is in fact a mere object TO it. This is of course – abjection. That that monolith is never-changing (even in this multi-contextual age – where children grow up part of differing cultures within differing classes within a shifting society) does not of course affect one who has learnt to accept society or has grown too apathetic too care. "When you are young you believe you can change the world." The optimist youth and the abject (who knows a change comes only after a "suicide" but perversely still craves) are merely flipsides of the same "torn apart" subject. Torn apart – as in the various stages of shredding a page of master language – from the first onset of tensile pressure until the final minuscule particle has been ripped asunder.

I think of Punk; punk; anarchy. I think of punk at its death at the moment of its social realization; I think of grunge or what I used to (ten or more years ago) know affectionately as "noise" and I think of riot grrrl; Riot Grrrl. An attitude (a verb, not a noun); a feeling; violated for refusing to name itself and then put on trial for naming itself so that others would know; could make real; could real-ize an idea a woman had/conceived, and could then turn back around (out of arseholes) and condemn for daring to use those naming tactics. I never wanted to. It never existed. Just words in my mouth. I said I wasn't any of those things but still they kept on asking me "what is it?" – "name it so I can understand". I never named that which has no name. Girl; grrrl; grrrrrl; is your name. I never preached I simply said what I was not and because I said what I was not you hated me preaching you say. I have nothing to say on anyone's behalf. I am not this serious preacher but I do know a lot about murder.

LSD and yoga are therefore considered as means to an intentionally achieved schizophrenic state. But what may be the differences between LSD and yogic (or mystical) experience? As Campbell elucidates by use of an analogy the neophyte LSD user, with maybe no knowledge of how to deal with the experience, could be a diver who cannot swim, as opposed to one who on diving into the waters of the unconscious – can swim. The mystic or shaman has a master's instruction, teaching and guiding. The schizophrenic has maybe fallen, unprepared, and is

drowning – the acid user has intentionally plunged but is also in danger of faltering.

The "waters" of the universal archetypes of mythology may vary from culture to country depending on local flora fauna geography, racial features etc, but are still essentially similar.

As Carl G. Jung described the archetypes of the collective unconscious as being common to all mankind, and not products of individual experience – and indicative of an instinct system of our species at its basal level. (We can, here, conceptualize the animal who acts instinctively.) This is our inherited biology – expressed by the collective unconscious and mediated through mythology. The personal unconscious (let us consider a Freudian interpretation of infant fears and personal fetishes, etc.) is often interwoven with the collective – so as to be almost indistinguishable to us. For instance, most dreams derive from the personal. But occasionally, even the inchoate self-analyst may recognise that they have dreamt a "big" dream – i.e. one that is a manifestation of the collective.

In schizophrenia the plunge descends to the collective – where the imagery is the order of archetypes of MYTH. Here, I find a fascination in the usage of the subject of myth again. Within this context working in a very different way (from cultural ramifications of patriarchal myths – as in myths about women) – to align us with our own species and its history.

We are well aware, however, that nature's instinct is often frighteningly hard and does not make for an easy life; hence surely our need for psychological guidance. Innate Releasing Mechanisms constitute our nervous system making for our responses to specific stimuli and are inherited with the physiology of our species; i.e. this constitutes our instinct.

Campbell posits that humans are born twelve years too soon – meaning that we experience, on average, twelve years of dependency due to the fact we have no instant wit to survive. During this period we are taught the elements of our social order, not of our natural order (i.e. instinctual functionings). Yet many impulses activated are instinctual – thus we can understand that every mythology is an organization of the natural and the cultural. Even cultural signals (things we learn to fear for example) motivate culturally imprinted IRM's. From this it becomes apparent just how closely intertwined nature and nurture really is. That we live in a "zenith" of confusion (political, economic, sexual, etc.) is indicative of the reality that we have not sorted out, or indeed even can sort out, the relation between nature and culture. We have yet to balance the two or fully understand the importance of an intertwined relation between the two; that exists aside from our patriarchal denigration of one of these phenomena (namely our suspect view of "nature" in relation to women, for e.g.) to the detriment of a society that should function to the benefit of all its participants.

Campbell expounds a functioning mythological symbol as an energy-evoking sign that affects images. The messages evoked do not go TO the brain, he claims, but go THROUGH the brain to the nerves with the brain interpreting, or misinterpreting, or short-circuiting en route. One may grow up to respond to a certain set of signals not present in the environment, therefore.

The problem is one of ensuring that the mythology (signs, signals, energy-evoking signs, affect images) we present to our young delivers directive messages that allow them to relate to an environment *present*, not past. If not

what will result will be a "wasteland" situation where the world does not talk to the subject and the subject does not talk to the world, but is thrown back on his self (short-circuited) – i.e. schizophrenia. I would posit that the unyielding system of language which "talks us" (which we infrequently remember is a subject to us as objects and not the other way around) needs to be worked with semiotically, as the basal force of the problems arising in a social mythology which I believe does NOT function as healthily as it should, and hopefully could.

Let us consider the functions normally served by a properly operating mythology; as put forward by Campbell:

a) The mystical function should evoke a sense of awe in relation to the mystery of the universe; so that the subject does not live in fear of it but equally realizes her/his proportionate participation in it. (This function is obviously failing in our society where religion is merely a means of control, often not allowing growth; and our patriarchal ego has overtaken itself in its belief that it is "above" nature – positing anything ostensibly akin to our concepts of nature and instinct as halves in a binary equation which must result in its negation or in a brutal, violated victory.)

b) The image of the universe must be in accord with knowledge of the time – sciences, etc. and not dragging behind with out-of-date religion. (Again this function appears to be failing in our religious interpretations of disease and illness as sins; and our apparent inability to realize ourselves in relation to the universe knowing now what we do about chaos theory, the big bang and quantum physics – to the extent that we can not plot our feeble notions of time and existence against the "time" of the universe, nor believe that our ego dominates our cosmos.)

c) The functions served by our mythology should validate, support and imprint the norms of a given order of a given society. (The instances when our myths do not correlate with our times are endless. Opinions about women, or minorities, or Others/others are shamefully ignored or disregarded by the turning of this maxim of normality against such peoples. To read Kate Millet's *Sexual Politics* gives one some idea of how deeply rooted our patriarchal "normality" is and how this "normality" will not allow itself to be challenged despite much evidence to the contrary that it is only one form of "normality".

d) The functions normally served by a properly operating mythology should guide the subject in health, strength and harmony of spirit.

Of course, I have to take issue with Mr. Campbell and his concepts of what is normal, what is proper and what is strength – to mention only a few dubious (because they demonstrate that they are relative terms) word uses. However it may be safe to say that whilst Campbell unfortunately falls into a trap of his own making by reinforcing that which he ostensibly criticises by his phallocentric slant on categorisation and patriarchal judgement on "normality" (which reads patriarchal normality) – I cannot deny that his intentions to better understand the schizophrenic, or shamanic position, seem rooted in some sort of understanding of our patriarchal problematic. And by presenting us with such knowledge he does stir up a desire for modern-day shamans to help us change our reading of sign, symbol and, importantly, role[s].

I am very intrigued by the concept of the human being born twice, or re-born; through an awareness of the inner waters of the psyche. However, I am also suspicious (as Catherine Clément expressed) that this birth will render human

female parturition as a lowlier experience, rooted in blood and flesh and not in "higher" spiritual matter. Is this not once again man attempting to denigrate a female function (one of many, of course), only to replace it by a birth that is at the root of the intellectual, spiritual realm that patriarchy so prefers and considers its birthplace, and resting-ground? However it seems to me that man can make many attempts at this re-birth only to discover that no re-birth can occur unless he challenges his own phallogocentricity, unless he abjects himself, unless he returns to the realm of the maternal, unless he poeticizes himself; and makes real the feeling that he cannot erect his previous laws until he HAS been born again with a new insight. I see little evidence of true rebirth amongst most set religions – I believe it can only occur with the schizophrenic, or poetic abject.

Campbell suggest set-religions encourage people to stay in the womb they provide, literally as children would, or moreover babies. This again raises contentious issues. This is a fairly far-removed simulacrum of the maternal realm, or the abjected *chora* that defies language, place or time. So far removed that to me it is not a pre-birth place (how can it be?). It is a kindergarten for the obedient children who abide by Father's Law. That is all. We shall look further into the Voice of the Maternal in a later chapter, and fully explore the only discernible quality of the choratic which is the power and timbre of the sound waves produced by the mother; as an enveloping sweetness or suffocating cotton wool pitch, depending on the subject's relation to the symbolic or imaginary.

14. The Last Syllable Of Recorded Time

Sounds Of The Pelagic Space

The first experience a sense of splitting. Hearing that scream rasping some distance. On the shore above the breakers, the sirens crying hoarsely. Siren straining on the fragment; the exuviated limb moving away. I tear away from myself. I have myself by the throat; wrench myself away. From myself. I watch myself in a different place. From behind a translucent film of myopic lucidity I watch this dismembered self. I attempt to speak for both of us. I contradict at every turning point and angle. I flow and clog. I watch myself the puppet master. Laughing inside myself. Knowing what they don't know; what I do not know. As language speaks me I read my othernesses between each gap and gulf; each sex. As I am torn to frothing gums by master-linguals I alone know where the bloody black flows. I await below like a deathless deadhead a body that has transgressed itself. Ripped the throat out of my clutter and gulp the glowing stars down here below. The black jester who quietly preens for them on the boundary fences where she sits crow between two worlds so she can warn them of their incoming madness; protect them from the vanguard of obsession, fetish, masturbation and superheroes I know. This witchen sham; this magick wolfen; bitchen hun – this strange-eyed obsidian-skinned jack-booted queer one inside inside inside hears the cries the omigods omilords rocking gospel. This is what I hear the holy gospel rocking of her screams and the unholy harmonies of my thirteen women all singing overlapping, crashing, overlapping, fragmented as one. I regress. I travel backwards on a fast black train down wells, deep slimy wells that echo. Like echo. Echo over and over and over and over again. My voices off the walls; off the walls; off the walls. Here I am-m-m-m-m – it whispers. Over here over here over here – she blows. I am the black voodoo loa kali – the saviour and I alone know it. Pre-chosen.

I leap. I fall. The mightiest FALL. I FALL THE MIGHTIEST FALL OF ALL. Back to the *chora*. Back to the place I cannot speak. The place I cannot conceive. I cannot speak but I hum and murmur. Bawl. I make the noise of the white black light. The noise of the space that has no limits and also has no space. The sound. I grrr; I grrr; I growl; I grrrl. I howl, I howl and cackle. I snuffle and yawn. Yee-oww. Ohhh mur-mur. I am every sound in the blue of mur-mur voice. I boom boom thud thud wheeze patter patter click tuum. Tppppp. P. P. On my knees I tttppp. Grrrrr. I feel great fear. To fight this fear I must not fight this fear. Great fear. Great pain. I am the space that has no space, nor time, nor place. I cannot say. I cannot say. To have come through this is my only articulation of this. To have emerged from this is my only conception of it. This is my only language of it. I touch the river bed without touching. I touch the floor of the sea ssshlp. I hear the floor of the sea that is not there. Sssspll – I whisper. Hurrring. I rise back up. I shoot up. I rise back up without the bends. I ravel the blue canal. With my loas with me, and my demons. I rise up courage.

The first breath will be my first breath. I have no words to describe what has not allowed itself to be described without a loss of meaning which I cannot real-ize.

From being terminally excluded I rise up re-centred. My breath sounds in – out – in – out – in – out.

The schizophrenic on regressing to the level of an animal may acquire its inherent powers. Sharpened senses. Acute smell; strength of haunch. Desire to mate. Ability to fight, defend itself, and frighten enemies. Ability to smell others, react to/with them on a body-language level. A human when in severe danger and knowing itself overcome by its attacker will freeze. This is an animal cry of surrender which states very clearly to the enemy I surrender. Do not hurt me any more. In the same way an animal will arch its neck and lay back its head in mute surrender. Some people can smell fear – some people know how to soak up and feed on others' fear to empower themselves.

The schizophrenic may move onto the next level. One above our level of perception to a plain of heightened awareness and esoteric knowledge. He/she may feel invisible energies (gods) moving about him/her. Around him in the asylum were people who had died but awoken – but the thought of the enormous load of pain that was required for the top level. The level of "godliness". Therefore – god is a madman. Everyone has to go through this terrible suffering before they can rise up through one level to the third. Maybe there are more levels. Who knows? Who can bear to know. Madness, next to AIDS, is the medical phenomenon (or human condition) that the West fears the most. We are petrified of even being reminded of OUR OWN MADNESS.

And so our suffering insane god (in his/her role as god) inhabits the summit. This is the role that is too much for the ego to bear. To be aware of this greatness, greater than self – like a great tormenting wind.

And to return. To re-surface. One focuses on the ego self. The self-image with its place in society. One sees the self-image in social "normality". One has not identified with any of the invisible godly/demonic powers of the seas and has decided to return. One has remembered the service to others and the will to life. Everything is more real. Brighter, sharper.

"Can we not see that this voyage is not what we need to be cured of, but that it is itself a natural way of healing our own appalling state of alienation called normality?" remarks Dr. R.D Laing in *The Politics Of Experience* (New York: Pantheon Books, 1967).

Whether it is the inward journey of the mythic hero, the shaman, the mystic, the schizophrenic or, I would posit – the poet or feminist who has known severe hysteria, abjection or melancholy; through an inability or disinclination to fully accept the supposed "absolute meaning" of the phallic system – the principle or consensus is similar. There will be; there will occur through this process (of the "subject-on-trial" as Kristeva would say) a "twice-born-ego" no longer bound by its daylight world horizon. A subject's ego no longer mediating the same systematic non-challenged information; but in a Freudian context to have an ego as a better arbitrator evolving to further mediate the id, or unconscious; *and* to challenge the superego, which represents social or parental influences upon the drives of the subject (drives which we can consider to be largely libidinal or sexual).

As a reflex of a larger self the ego's fullest function is to carry energies of an

archetypal instinct system into fruitful play in a contemporary space-time, daylight situation. The ego to the id is the rider to the horse – as Freud analogized. Better mediated we come to realize that while there is nothing to fear from nature, or nature's child (our society) it is still at the same time monstrous. For it has to be or it would never survive. We can see what isn't functioning in our society's psyche when we consider that our ego has not reflected fully and our superego has been fed retrograde information. Information about our sexuality; information about our death drive; information about our histories. To compensate for this the self has aggrandized our self-image (our phallic image, or in my case lack of it!); our ego-image. Thus phallogocentric society believes itself superior to nature – because nature reads desires for the semiotic, the maternal, the bisexual feminist, the mystical, the poetic, the inglorious abject, the chaotic, the sometime immoral, the eros erotic and the thanatoid.

I am not making light of the journey of the shaman, or similarly of the abject who is forever caught between two states that cannot reconcile themselves in relativity; the journey is fraught with dangers. There is the danger of drowning, falling or shipwreck; and there is the danger of "inflation" – that one will identify oneself with an archetype believing oneself to not just be a saviour, but The Saviour; not just be a mother-figure, but The Mother. It is, however, a tempting, though hazardous idea!

15. The Role Of The Shaman/Cultural Mediator

In societies where the shamanic profession still survives the shaman can perhaps be viewed as the most powerful figure in that culture's history, and therefore responsible for the shaping of that culture; gravid with the requirements necessary to influence ethics, morals, and the symbolic systems that go to make up the business that is society. It is as if the shaman partially decides on the cultural "currency" that is to determine what means what and much that meaning is worth. As is noted in *Apocalypse Culture* in the article "Art In The Dark" (Thomas McEvilley) – the shaman is poet, visual artist, musician, medical doctor, psychotherapist, scientist, sorceress, undertaker, psychopomp and priestess. It is inconceivable that such a person could be these people in one in our western society. Less conceivable is that this person who has the "sickness vocation" should be imbued with such a powerful role; as aforementioned these are the people that we lock up for their psychotic outbursts, afraid to hear what they might espouse rather than welcoming their "uncontrollable ravings". This is the way we have ordered our system of meaning and thus control of the people. One can imagine how just a transition from the shamanic society to our society might occur. As society enlarges and advances technologically so the demands for internal order become more pressing and complex. Thus the one role of orderer and mediator is split into many roles. Thus no one person has total unassimilable power and freedom. Thus largely the shamanic role has been shunted (sideways if you like) into the arts where its expression can occasionally still be heard to echo. The Romantic period attempted somewhat to reconstruct something like the shamanic role. Poets became the imagined gifted geniuses with powers that were considered somehow different. Here we encounter the myriad factors concerning the artist as vampire or healer or prophet with transcending gifts of power to be used against even the own artist's discretion. The whole ideology of artist as possessed; wretchedly cursed with the gift; suffering for his art; writing or painting his better self into his work; sacrificing much for his gift of insight, and so on found its renaissance with the Romantics – whose work mythos and approach to the arts mirrored the early abject/genius ethos and also crasis, in the belief of the body/spirit dynamics found in dualism and also, to follow on from this, idealism. This heuristic journey for the formation of an ideology and mythology continues today with many progressive and searching artist(e)s.

The area of self-mutilation and self-altering; of pushing oneself to physical limits to henceforth unfurl mental limits is a practice which has seemed to become extremely popular again in a sub-cultural context. And it would also seem that this practice is filtering out into youth culture and music cultures as well. This has always been a standard feature of the shamanic role. Induced into a trance-like or ecstatic state the shaman would slit open his/her belly to reveal the innards (a lesson in anatomy and super-bravery all in one fell swoop it would seem); and more interestingly, for me, the male shaman would imitate a female

by dressing in female dress, marrying other men and castrating himself. It would seem that these shamans were very sexually political in their work, and it was common for the shaman to use sympathetic magic; to touch his own femaleness/femininity.

Akkadian priests of Ishtar and the Aamakrishna in 19th century India also dressed like their goddesses. The Sanskrit religious text instructs one to "discard the male in thee to become a woman". Many tribes advocated the mimicry or miming in ritual of menstruation and parturition. These practices of imitation and also self-mutilation are explicit in Aushalie, and in central Australia rites saw the vulva-like opening cut into the urethral surface of the penis.

It may seem bizarre to our society but it appears that disturbed children, for instance, have been observed to fantasise variations on these practices. It seems in many archaic religious practices the attempt to combine the male and female powers towards a whole embodiment was very common. Common enough, over many periods of time, and in many nations for it to have serious psycho-sexual, sexual political and social implications. The emphasis on mutilation of the male genitalia seems in particular to frequently crop up, as does the worship and offering of blood (supposedly symbolising menses).

It would appear that these taboo acts recurrent in ancient religious rituals of shamanism are actually occurring in contextual parentheses latterly. Within the contexts of art and religion a bracket of insightfulness can take place because it is contained within the context of ritual replay and simultaneously margined on either edge so as not to spill over into the ordered society that book-ends it. This would seem the only dynamic that is considered safe enough to allow its existence. And within these realms of ritual transgression from the putative norm the inversions of acceptable social practice can occur. It is as if this arena (and arena is the apposite word here) acts as a negative image of society; a realm wherein what is repressed can be acted out in ritual. The only place for a man to express the desires FOR his own female-ness in a physical, emotional (even), or religious manner. And it is necessary, society itself has realised, for this purgative to be realised in order that there should be a balanced sense of completion, which is kept in check by the dimly-lit arena walls; where we the public sit to view that which we dare not do ourselves for fear of insanity and thus exile.

Hand in hand with this bisexual ritualization comes the courting of dishonour and contempt balanced by the shaman's belief in special status which actually rises her/him beyond conventional judgement or ability to break any transcendental boundary.

And so to the work of our modern shamans. What courting of contempt in the belief of a ethos beyond our patriarchal order's are they involved in? How dimly lit is their arena? How large is the audience which watches from the tiers of the social boundary? Is there any audience? What are the shamanic performers hoping to bring to their audience? Or what knowledge are they seeking to impart – to bring BACK from the depths of their painful and glorious insights and exiles? Are they doing it for the greater "good" of a society (that believes it lives in light whilst the shaman believes it lives in half-light) or for their own egotistical or masturbatory bent?

Rachel Rosenthal describes her performance work as – "sucking diseases from society."

In the area of the modern performance arts the dynamic or concern of the dynamic is often a demonstration of an act of will. The will to power, maybe; whereby this exercise in itself contemplates itself and is involved in the study of its own effect. As McEvilley notes – appropriation art (and Vow Art) concerns itself with the aesthetic, or artistic study, of choice and willing rather than conceiving and making. This of course gives birth to the question of the artist's autonomy; and we should bear in mind the integrity of the artistic expression and experience inherent in specific art-making or performance. Diamanda Galás involves herself in a will to power experience wherein she evokes her chosen area embracing it in no easy "receivership and execution" dynamic but rather becomes involved in a demanding arena that deals with the ability to affect change and progress. Although I have personal views about autonomy and artists (see: "Dread and Desire – Abjection In The Arts" from *Bridal Gown Shroud*) I nevertheless acknowledge that, frequently, artists such as Galás exercise tremendous personal strength in carrying the weight of subject matter and artistic projection such as they do.

I would consider Galás' work to be similar to Vow Art, although I do not consider the label necessarily enlightening or beneficial to understanding or embracing such a unique artist.

However one outstanding quality of Galás' (of which she has herself spoken of) does make her work synonymous with something votive – is the personal sensibility active in the choice of the area of our cosmos that she has decided to explore and expound. How much of this is her personal CONSCIOUS autonomous choice is not for me to say, I would consider my view on this arbitrary and utterly misplaced, considering that I cannot claim intimate knowledge of her psyche, nor would wish to. The issue of autonomy being a conscious drive is really an issue separate from what we are discussing here, and one would have to be a psychotherapist or more (!) to know whether one's votive intentions are wholly conscious or driven by deeper impulses. Safe to say that what we are concerned with at this moment is the rigour and dedication with which the vow is maintained. Galás has many a time confessed to a rigorous training of the voice which she likens to the training of a prize boxer, in its intensity, sacrifice and drive. She spent years, inside, working at her voice when others were out and about socialising and so on. Doesn't it seem that although this is a sacrifice the results MORE than compensate for any loss of socialising, going to parties, or hanging out with the in-crowd? She knew this. I have always considered it pointless to be out wanting to be seen – when one should really be home working diligently on the very things that will make you special. And one has to work at the craft, be totally devoted to the perfection of the execution AND its form, EVEN IF one is gifted in that area already. I admire and identify with this attitude and it summarises the best qualities of a votive dedication; that is also characterised by the subject's own individuality.

The greatest boxer in the world, born with a natural flair, still knows that, to rise through the ranks, he has to train beyond most people's comprehension, or he will grow flabby and undisciplined. One's sensibility, one's own empathetic leanings, will always govern the direction but devotion will ensure the result.

McEvilley also rises another angle concerning the artists application to his/her art – the "suspension of belief". Let us consider *subject matter*. Does the act have any value in itself? Often not. Linda Montano (see: Re/Search 13) spent a

year tethered to a companion. They were joined by a length of rope and spent a period of 12 months this way. Pointless in itself, maybe yes! But to concentrate so wholly on the PURITY and the consummation; the overwhelming absorption and dedication of that and only that. Yes! One does have to have a link to sociality or society in order to later contextualise where one's craft, and how one's craft can best be used, appreciated and shared. But – in the tradition of the shaman the insightful journey (or sojourn) has to undertaken fully. This activity in itself is idealistic (although of course idealism is abject and never obtainable) and therefore says something about the mindless pragmatism of our society which is somehow driven to doing things which are recognisable (recognisably worthy) within the order. I would posit that much seemingly pointless dedication enlightens us to the underlying worth of a "religious" shamanistic dedication. Could this dedication not be "dedicated" to the people who find little dedicated to them within our order, which only seems to glorify the rat-race or the spiritual sexual sacrifice, or which calls the counter-investment a move for the betterment of patriarchy? The Buddhist paradox of desiring not to desire – requires a motivation to perform feats of motivelessness. This seems to me to be a type of poetry. Perhaps it doesn't advance technology or constitute our beliefs in our western society but at the very least it can be food for thought. A comparison. An arena where we can safely go to watch the struggles of our inner selves in the lion's den of humanity. It is not politics in itself and it is not claiming to be – but it can be "political". It has been said that the highest cultures are the least pragmatic – and I make no further comment on this statement.

But let us consider – Galás, I would suggest, uses metonymy to divulge her feelings concerning AIDS. The parallels between the psychological and the linguistic devices used (i.e. non-verbal sounds, screams, sighs, the resonance of polyglot, etc) blur. One is not placed above the other in her work. Her expression seems to pertain to what she is experiencing as a shaman, or prosopoeia of the "plague". In short, what she verbally and physically expresses purports to what it means. This is integral when representing such inner states in such a serious yet lyrical manner. Thus, then, all Galás' metaphors or, if you like, signifiers, act in this manner – as if the expressionistic direction and what is expressed actually have a relationship OUTSIDE of mere monolithic language, BUT importantly, too, also have a relation, even if it is abject or involved in our prejudiced, narrow, in this case homophobic and manically ascetic, interpretations – WITHIN language. It is as if the signified and signifier (the symbol or metaphor and what it represents) were now at the same level of imagery and her involvement with them has caused this substitution to shift and thus give the sense of a relation outside or alien to our linguistic, causing much abjection, estrangement and re-interpretation of symbols and what they stand for. We can still connect, however, the series of linked connections between these metaphors, etc, within our language and that is of course why they are especially potent.

To return to the abjection possible in this shamanistic expression. We have surmised that this exercise of decisive will performed by the shaman is seen as an absolute (or transcendence), to then break up or disturb the everyday motivations (which can be viewed to be similar to, if not the same as the disruptions caused by the multi-contextual, non-positional, pre-symbolic,

therefore indescribable and pre-moralistic *chora* – in that it is a similar continuum of (irregular, spatial, "schizophrenic" pulsions that pressurise or exist as the pendulum to language or our order) and create thoughtful or scornful openings. The fact is it is no whole transcendence. There is no such thing. One cannot be wholly transcendental and wholly forget one's ego simultaneously. Ecstasis exists in fragments – mere glimmering fragments. Unfortunately, or maybe fortunately, for us there is no (belief) system that can chart this phenomenon, or these phenomena.

Therefore the only yard-stick or appraisal or judgement we can effect – is how far from the margins of the order is this art? How far have the boundaries of art been dissolved? How far from the category of art and into the realm of the conscious social everyday order are they creeping? How are they expanding or dissolving what we know of as (just partially affecting, mostly harmless for our voyeurism) art? Perhaps this is why performance art is so extreme in its actions and vows. And also why the extremity is relation to the era? The constant abrasive action that threatens to overspill. And which must continually change as society changes.

The effacement of the ego by the normalisation of experience can be destructive to the self-image. Bearing in mind that the ego is in a close relationship with the superego or conscience – which sets up ideas of ourself to ourself of how it should act, and so on. To court dishonour is to offer oneself as a scapegoat to the superego, (that relates to parents and society's ethics), and this, it would seem, is what the shaman of the past did, in order to draw calamity away from the tribe or community. As aforementioned the shaman could be protected psychically by the arena of religion, allowing the shaman to contextualise this experience. It would seem that performers today – have to, in a manner, keep their taboos within the realm of the arts, for us to observe them there, to ensure of a type manageable insanity or objective grasp on majorative sanity or contextualised calamity. Today's breaches and journeys into what is disallowed or covert simply replace the function of shaman in the "drawing away" of the professed threat (and abject uprising).

The preparation of the body. Again I think of Galás. Painting her body in blood. Stripped to the waist in a long black skirt and covered in haematic fluids. Virtually flooded in a red deluge. Her sculpted, honed and defined body. A magico-sculptural object ready for the evocation. Again we realise the necessity of purporting to what you actually infer. If you are going to be the blood of Christ, the blood of the Devil, the blood of the burning witch, the blood of the sacrificed, the blood of the woman and the blood of those with the AIDS virus – then – sport blood. Real-ise it as fully as you can.

The Australian shamans were covered in blood as a symbol of their arrival from the netherworld, with decorative patterns of bird down (significations of the flying id) fastened with their own blood. The African shaman was covered with human bones and skulls and surgically altered his/her body. Likewise the Voodoo people of Haiti who used human bones and animal bones to evoke possession of themselves by a *loa* – which incidentally could be of either sex, rendering them spiritually bisexual. The Asian shaman had a skeleton suit with mirrors on it; how better to signify the object/subject distances and gender transformations? Tattoo-ed, scarified, painted. This is not the doodlings of some of our urban modern primitives who are absorbed in their own sub-culture of

vanity and attention-gaining – blind to the true usurpation of sexism.

The incorporation of a bestial sympathiser. To take on the power of an animal species by detailed imitation and the adoption of animalistic identity. To duplicate the sounds of the animal. A stage in mental or nervous breakdown? Or the realisation of the *nahual* soul that we house alongside our human soul. The inner bestiary. Understanding animal language; adopting the instincts that are not so distant from some of our own. To personify the impasse between nature and culture; for culture is surely nature's child. To communicate with the dead or the dying. To wreak revenge for them. To talk to the souls of the dead. The Beast Vow.

Among the Pasupatas of India a male practitioner commonly took the bull vow (the bull is a very common shamanic animal) and behaved for a year like a bull. There were very precise vows – the snake vow allowed slithery movements only; the frog vow – hopping movements only, and so on. Again we see that there might be evidence of seeming aimlessness or pointlessness to these vows; but again I raise the point that this is a belief that it is creative to do anything with such will that it is creative in itself. One option or action becomes as meaningful as another action with this type of execution. This however is not to lightly suggest that anyone screaming for 13 hours a day is on par with the singing of Galás. Patently not; when some activity is so obviously redundant and suffers from interference by social mores, vanity and effect-seeking. As Galás, herself, has said – when one views and hears the non-stop rantings of a patient in a lunatic asylum and it goes on and on – just someone banging their head against a wall over and over – you do realise redundancy as opposed to someone who is training herself for a certain will to power. I would therefore posit that some Endurance Art (of the Endure Genre) doesn't work – whilst obviously some does make a valid point. Personal interpretation, social influence and personal intelligence all count; on the part of the performer and of the viewer/listener – it is a relation I liken to Cixous' "Coming To Writing" which I have expanded and called "coming to reading" as well. The endeavour that the writer engages in, all the questioning and dilemmas and thought, must be balanced by what the reader engages in – to the point where one could read a book which questions itself and question its own existence and workings making you as the reader feel you too are writing the book. However there is no doubt that Vow Art (and Ordeal Art) at its best can evoke a link between art and religion making us consider the actions of the ego and superego, and maybe even the id; among many other facets of our psyche which require ritual to invoke them. Behavioural vows can undermine conditioned responses making us reconsider the mythology of our time; as Campbell suggested – this can help us in understanding and avoiding neurosis by making sure our myths and ethics are more in line with the times.

It would then seem strange but also not terribly surprising that today's shamans (of which there are few) generally seem to be aiming for reduced vows. Vows although unpragmatic seem to be undertaken for the pragmatic (ultimately) good of society. The shaman seeking to efface his/her ego or to fly (probably not literally! This was likely to be a search for the unconscious self) or to find salvation – all working from the premise of their respective communities (with specific belief systems) with an enlightening goal in mind. Maybe because today we realise that there can be no transcendental ego – i.e. an ego to be

transcendental could not BE an ego which is pinned down by its conscious will and self-ness – and because we have found this fault in many religious belief systems to have them replaced by unsatisfying new-age propaganda – we also doubt the role of the modern-day shaman. I, too, am sceptical in my hypothetical abjection, but maybe also because of my hypothetical abjection and desire for a semiotic reality where meaning and ego dissolve at the precise same moment they also describe and consciously experience (a wretched impossibility in itself) – I am still mesmerised by a very few shamans today. Diamanda Galás is one. Some of the others I shall call writing-shamans.

16. Catamenia And Shamans

"What we consider 'madness', whether it appears in women or in men, is either the acting out of the devalued female role model or the total or partial rejection of one's sex role stereotype."
(Phyllis Chesler, 1973)

We can consider the opposite of yogic meditation, zazen or samadhi contemplation with its calmness, to be the aroused and hyperactive state of shamanism; which has always been a spectacle for social purposes, carried out in an arena which draws a public speculation. The rapture in which the shamanic situation is danced out or chanted out is a dramatization; but a drama which is of social relevant; a drama, which is a drama, so that the glass wall between observers and participators is defined and functional. If the reactions to the introverting and enlightening experience are deprived of meaning or function then that is surely what presents us with "madness" as we so often know it. From this we can observe two reactions – the schizoid or detached kind, and the frenzied, participatory, "hysterical" kind.

George Devereaux concurs that menarche (a woman's first menstrual period) is the time when a woman irrevocably becomes a shamaness or witch. The Lepcha of India believe that after menstruation comes upon a woman, a divinity "peculiar to women makes love to them in their dreams *each month*." Amongst Mohave Indians menstruation is considered to contribute to an awareness of the dream personality.

There would appear to be every actual proof of the inclination that women experience of an inward journey during menstruation. Sensitivity to the outside world coupled also by vivid fantasy, dreams and meditative powers.

Let us consider pheromones (ECM's) – the powerful chemicals that act physiologically without our conscious awareness. The transmission of these chemicals can occur externally between people; even being passed by breath. The "schizophrenic" with heightened "primitive" senses is likely to detect these before others can. To smell them in effect. To have an olfactory awareness like that of an animal (remember that identifying with animals and bestiary aspects is common in those experiencing psychic crises). Thus a "schizophrenic" can hear what people will inform him/her is true whilst smelling quite a different story. Sniffing out a lie, really doesn't seem improbable.

The sense of smell is apparently high at times of ovulation but goes inward at menstruation. Imagery-wise we sniff out the inner depths of the in-sight. States of hysteria are a repression of bodyconsciousness; transformed in the shamanic context into altered states of possession. I would also concur that hysteria is a half-way, deadlock fight within oneself that vibrates between repression (and suppression) and self-expression. The shaman would use hysteria to "perform" this possessed internal incompatible bisexuality; acting out the struggles between the dualism inherent.

It becomes remarkably easy to picture the comparisons between other cultures and our own with an assessing and critical eye for what is oppressive, and hindering to carnal and psychic awareness. In short what is damaging and damning to personal and anatomical subjectivity, and autonomy. Strange powers become neuroses, and fits become fits of "hysteria". The prophetic trance becomes the inner turmoil of the mentally ill woman. Magic holiness becomes the unholiness of the menstruating woman; the workings of the very last taboo. Perhaps we should in the meantime consider the taboos at work as barriers to safeguard us from gross invasion (from patriarchy's opinionated doctrines and labelling; leaving a taboo as a last resort for some to find alternative space within) – but this would seem an insultingly reactionary manoeuvre, as the taboo itself has already been labelled for us. However strategic steps of progression (like keeping barriers up whilst self-education takes place) although not objectively positive might well be the best way to gain our ground. As I write this I am struck, once again, by the sadness of this statement, and my own desire to not partake of such strategies. I see this occurring too with the fight against racism. Self-education for black people, for themselves by themselves, is regarded as counter-revolutionary as it is often seen as a separatist move to those who consider the "fight" should take place from within. My opinion is that unless one knows the mechanics of the fight and is well-prepared – joining the majority order can often turn out to be a too-early manoeuvre, which simply leads to counter-investment (as socialist feminists found out decades ago). I am struck by the war-like language of my expressions here, but it remains an irrefutable fact that counter-investment, subversion, usurpation, oppression, reaction et al – works just like that. I am struck by the notion that the "taboo" might exist to safeguard against phenomena that are not acceptable to the order, leaving women and people of difference to work harder at finding acceptability. This notion breeds a feeling of masochistic suffering; a masochistic suffering that is paradoxically inflicted on one who may feel ambiguous about whether or not she/he should be suffering. It seems that it is often the case when one has no other otherness of existence or knowledge of it; no ideology outside of, alternative to or co-existing with our symbolic order. For how can we have anything other than our system – when everything we know and feel ostensibly IS our system and even what we may believe constitutes a pre-symbolic or other-symbolic time or realm comes to our social consciousness and our language THROUGH this system. An insurmountable problematic, it would seem. This is the issue Kristeva has addressed with her work regarding semiotics. Semiotics exists as a process that can expose the rigid system of language – but by being a language ABOUT language; a language that itself deals with language – it is irrevocably entwined with a homogeneous model of sameness, unable to transcend its own equation, or remove itself from the mechanics of its relation/relative. That it deals with poetics and pre-symbolic hypotheses also further underlines its relation to our symbolic order in that these phenomena are only fulfilled with meaning because of our symbolic order. They are in effect constituted by it. Thus we can ponder the imponderable – the spaceless, rhythmic continuum of poetics that could be semiotics would seem a limitless process within which the ordered linearity of language exists; however semiotics seems to be, instead, a pulsional flash that disrupts the subject of language, bleeping out an abject call that does not translate outside of its

wretched impasse and means only what the subject of language can stretch to managing contextually. Thus it would seem that the devices of language occasionally rupture with the pressure of semiotic energy allowing it to be a subversive but parasitical presence – and this would seem not particularly seminal to a desire to see semiotics as the expanding ongoing process that can exist as something of complete difference in its own right. We shall return to these concepts later on – when we further explore the semiotic *chora*, the pre-symbolic and pre-Oedipal, maternalism and abjection.

Let us return to the abjection in rejecting sex-roles with emphasis on the menstruating woman and/or the ovulating woman. As we have posited – rejection of traditional roles can be interpreted as the basis for mental anxiety; especially when the mores of society do not change with the (r)evolution of gender politics. Ambivalence concerning sex roles in relation to gender identities would seem to naturally frighten (if not even consciously) many women and therefore self-destructive behaviour can begin early. This is what I was saying about not knowing one's masochism. How can one know of one's masochism? Whether or not it is imposed; how it is allowed to be projected onto one; how it is allowed to thrive; who feeds it; how it is regarded as something so "natural", so inherent it seems to "go without saying", and so on. Masochism it would seem can be considered part and parcel of the human condition – so deeply entrenched in the psyche of society – and of course there are many types of masochism. I would suggest that masochism is a valuable mechanism to discovery and expansion. I would further suggest that great strength can arise from concentrated analysis of each individual's desire for pain for from this concentration comes the masochist as supreme centre of attention – especially in intimate sexual and emotional adult relationships. I would also suggest that all the threads of masochism are interwoven in some way. But I would posit that the kind of self-destructive behaviour that people partake of (unconsciously) in situations of repressed abjection is a case apart – simply by virtue of its unchallengeable nature. By virtue of the fact that it existence is putative; that it simply is not. There is no proof that female suffering depends directly on sex role stereotypes, for sex role stereotypes don't seem to our society a particularly "serious" area. Why make such a fuss about it? Furthermore our patriarchal society is so entrenched, and as aforementioned WE ALL KNOW that it would be like admitting the whole of our society was wrong and a few women were right, such would be the force of the threat. Furthermore, paranoid conspiracy theories abound on both sides of the mirror. Other women, other people of difference concur that there is nothing wrong in the limiting roles of patriarchy – betraying others on the deepest level possible. Other women manage high powered jobs, seek to further themselves in areas of knowledge-production and raise families with no difficulty – quite happy to work with "the boys" and respected as intelligent women in the meantime. The system is rooted on every level.

Yet it would seem particularly telling that even women who fully act out the stereotyped female roles are also given labels and denigrating ones at that. Would it then not seem more like a total and utter scam and con; when not only are the bad girls who "deserve it" degraded, but the good little women too?

To continue on the path of the binary good and/or bad woman I would like to apply this duality to the values of ovulation and the values of menstruation respectively. These two extremes (polarities) are traditional, in the case of ovulation – which signifies the realm of motherhood and domesticality – and unexplored and taboo in the case of menstruation and menstrual values which threaten and distress an ovulation-value-society.

Let us explore the symbolism of the menstrual cycle and its acceptance and/or censorship in various cultural insignia. Whilst I am highly sceptical of much new-age, earth mother, "goddess" religious practise and belief, there, however, does seem to be a wealth (of sorts) of philosophical, mystical and psychological import to be thus used by women today when reclaiming body-images and awareness. And this of course I can not dismiss as regressive non-pragmatic. "religious" fervour. Indeed, it would seem counter-productive to disregard the myriad images and beliefs that, as a conglomeration, can seriously build up new and subjective anatomies for women. Whilst my scepticism leads me to reject many philosophies that define women as nurturing, loving, child-bearing paragons of virtue – simply because of the possibility that may arise from seeing women in such a light, and ONLY such a light (when I myself see me as someone who is not just one faceted or wholly nurturing by definition) – I do accept that these facets should be utilised BY women – in building up a larger body-image. I feel that this is ONE grounding for expansion into realms not seen as constituting the "good" woman.

It would seem that the single eye emblem of the goddess is widespread in many (older) cultures, and that this correlates to the birth cone (a conical shape) of the cervix, the tip of which is the point where the earthly meets the other world; as well as being the place where everyone has gestated as a single cell and passed through as a baby. A romanticised image of matriarchy – it may be – but when viewed as a metaphorical structural representation of our ideology of language and its psychological basis, it quickly moves away from the arena of new-age clap-trap into an arena where we have a certain kind of proof, in our everyday process and system of language. The cone becomes slotted into the matrix of epistemological association and linguistic metonymy. The psychological acts associated are parallel to the linguistic device, and thus seem to have a strange relation outside of language as well as inside of it – which is quite a wonderful and bizarre contemplation.

Thus this axis of the matrix (like a point on a spiral that returns as it contemplates itself as it processes/progresses) spreads ever outwards accumulating great philosophical power. The cone or mountain or mushroom – the world tree haunted by serpents. The tree the shaman climbs to meet with god(s). The aperture of the cervix is lined with a complex branching system or corrugation called "arbor vitae" or tree of life.

The sun festivals of the sky – the festival of Hysteria and Aphrodisia. The solar eclipse – the shadow of the moon on the sun which can make for gold horns or the hull of a boat. Bisexual. The sun's halo in annular eclipse (totally central) becomes the white of a huge eye (I can think of several cyclic emblems in literature that bring this to mind – Bataille's *Story Of The Eye* and Roland Barthes' accompanying essay, for one). The shadow of the moon – a great dilated pupil – a huge cycloptic eye – that doesn't terrify. The shaman feels a flood of body consciousness.

Judith Higginbottom (a film-maker) noted the changes before menstruation – to be viewed negatively as PMT/depression or positively as a powerful state of consciousness. 1) Increased creativity – ideas/decisions concerning work are made; confused concepts become clear. 2) Senses are intensified – the world may seem a riot of colour, sound, touch – often almost unbearable. 3) Emotions are heightened – often an almost unbearable phenomenon. 4) Thought processes become instinctive – seem to be experienced PHYSICALLY – the dualistic split between self and environs, or self and body, disappears. 5) Increased sexual awareness – again, due to our social mores, this can be a perplexing experience or feeling. 6) May be experienced as visionary/ecstatic state of reverie and meditation – almost trance-like – menstrual dreaming also a positive meditation and vision.

It seems to me that what is continually on my mind (when re-referring to this book's inception and life-source) – is the concept, ideology and instinctual feeling that *Catamania* is a celebration – not so much of subversion and dissent, which are qualities open to debate about parasitical dynamisms and polemical sexually political strategies (and which may be the most progressive or regressive) but a celebration simply of working in a menstrual state. I do not apply this lightly and I certainly do not presuppose to dictate the intentions of the women mentioned in this book – but I do believe that MY intention is/was to illustrate, for my own part, the founding drive I felt on undertaking this project – which does seem to be well-embraced by the notion – and which was a *menstrual drive*. I then looked to others' work to illuminate (to light up) this drive. I make no apologies for my projection (which seems more of an interiorised projection – a case of projecting others into me) – and as I have stated, I do not presuppose the anatomical state of other women.

But to effect the discourse of subjective female "blood" expression and "redness", and to add to the imagery I am involved with – I should like to draw attention to the polemical poetical verse as written by Jarboe (singer and musician with the groups Swans, The World of Skin, Beautiful People Ltd; and solo artiste in her own right):

RED

red is the color, there's no other, red velvet, tap your veins
red is the color, red is the lover, red as dripping stains
red as the lips the wet tongue licks, red as the eyes that weep
mmm the bridegroom's red-devil cake, red as love, red as hate,
red as anger, red as rage
red as playing games, red as coming home, red as rain, poppies,
fire, and pain
red as you and she, red as ecstasy, red as racing cars, clinic
cards, nirvana
red as a rose, a barfly's nose, back Alabama road's, the Grand
Wizard's robes, red as China, rubies, leather bridles, stirrups,
sticky gooey syrup
red as cavier, Mars, red as hell, Red Stripe, life
red as Jack The Ripper's surgical knife
you're better red...

red as cherry, power, armies, jelly
red as Kahlo's "Birth," mud, sand, and dirt
red magenta, Georgia clay, placenta
"red and black – venom lack," red as snakes, I'm crawling down
your back
red as a clown, Circus Mort, red as your way out, red abort
red as pleasure, traitor, red flavor
red as walls, smog, red silos
red stone, read Keats, red as sheets
red sunset, nuclear accident
red sleep, red wings, red emergency
red candles, insects, trance, cannibals
red sea, pussy, red shock, executioner's block
red laughter, slaughter eaten by carrion
Sharon, Bateman, fate, and Al's hair
red sardonyx, red fingernails
Little Red Riding Hood, matador, crucifix, red is good, red
as Red, red as stop-red as stop-red as stop, red as stop-red
as stop, red dicks
you're better red...
red as parties, sacred altars, Lola's dress, rubber halters
red as war, red Xmas, red as a temple, red as your next meal
prostitutes, preacher's suits, red mama's boots
red alert, red sex, red dessert, red hex
red as crimson, scarlet, vermillion
red cactus, a virgin's mattress
red as sin, red as ink in Ted and Norman's skin
red candy, toys, red box, munition
red as flesh whipped into submission
red as the wounds of Christ, Bluebeard's wife
red as meat is, red as Foetus
you're better red...

Women shamans and witch doctors used the menstrual state as a source of power. Diamanda Galás seems to use a very non-procreational stance when effecting her work. She is by her own confession a woman who finds nothing appealing or valuable in the role of the procreator. Childbearing is anathema to her. She prefers women warriors. She paints a picture of a society of beautiful strong women. One could fantasise that the warriors play one part; the childbearers another – in a make-believe matriarchal land. Galás is wholly into the role of the bisexual shaman and gives great expression to the masculinity and femininity of her body, psyche and work. Whilst this exercise is bisexual, she nevertheless points out that it is usually a woman who is bisexual. She claims that she cannot imagine a man producing the sort of "possessed", channelling, mediumistic work that she does; and I am prone to agree.

Dream imagery – sea and water – sea creatures – red objects – the red dress – powerful male animals – hirsute virile lycanthropic lovers – the self as male –

the animus – sexual dreams – vampires – powerful orgasms – death – warrior women – visionary dreams that reveal solutions or esoteric knowledge.

Menstruo meretricis is the whore's blood. Mary Magdalen's non-procreational sexuality.

With these dual culminations we have the realm of birth, the social husband, social values, social symbolism and manifest contents, phallocentricism, public speech, logocentric linearity...

Of the Other realm we have – menstruation, uterine and clitoral feelings, sensuality, inter-female values, prophetic speech, poetic speech, shamanism, space, alternative and fantasy lovers, bestiality, latent content, "personal" metonymy, the unthinkable, death, a female-subjective anatomical untranslatable "ideology", a not-quite definable disjunction, difference, the multiplicious subject that cannot fit back into the order except in symbolic or social parts or fragments...

Of course BOTH "sides" have been perverted by patriarchy, as patriarchy is our only mode or device (device-inducing) social reality. This is why nobody believes or recognises feminism, mental illness, difference, alternative belief systems – to be valid orders – being as they are dis-orders – marginalised from the totality of our homogeneous symbolic belief system.

I am very anxious to expound that whilst postulating on these supposed menstrual qualities I find myself in the inevitable trap of "romanticising" women into the role of Nature-tied, Earth Goddess, Others. However my intention is to not only posit that nature (if women must be bound up in its supposed qualities) is not merely a nurturing, rather naïve, force but also a fearsome, warrior-like, intellectual (a rather anthropomorphic projection I realise – to use the word "intellect" may give the impression of a human consciousness at work) and undeniably complex force. And to also posit that culture is after all nature's child – nothing humans do can thus be unnatural, rather anti-SOCIAL-order.

Thus – I like to think towards a culture that realises and makes real ineluctable female events and experiences that are first and foremost fully understood and employed by women; so that women no longer consider themselves and their subjectivities to be anomalies, transgressions or *invisibilities*.

The sun is always itself. Present to itself. The moon is periodically its own opposite – or more importantly myriad mutable aspects of itself. It can be devoured by its own shadow – conceptualised as a wolf, jaguar or huge frog (a creature who in its amphibious quality partakes of both land and sea – solidity and fluidity – consciousness and unconsciousness).

Phoenixology – renaissance – rebirth – metamorphosis. In this context – rebirth has little to do with the biologistic birth into the patriarchal order, unless in terms of separation from the continuum into the castrating order. This is something that we now only conceive of in hypothetical terminology, imagery and subjectivity.

But a "rebirth" can be that which transgresses the order and takes the psyche (if not always all bodily sensations) backwards, away, over, beyond. In a directionless, timeless, positionless, non-trajectorial experience. To the animal in herself. Into the belly of the beast.

"... the rains themselves are 'the menstrual flow of Woman Shaman' – the prototype shaman from which all shamans derive their powers..."

" ... the divinities of one religion become the devils of the next ..."

How do we get away from the theologising, religicising of our subjective, anatomical selves? Are we condemned to forever translate our experiences in terms of mumbo-jumbo, metaphysical, supernatural suppositions? Can we use this belief, of women as nature-related mystical beings, to our own greater purpose? Can we revel in mysticism? I believe we can to a point. Whilst we realise – as we do – the position we and our subjectivities are in.

The Festival of Hysteria. The serious psychological function. The wild-haired, dancing, rouge-covered 20th Century maenad has discovered this appropriate celebration of a new, sexual personality. She stands on a stage – she uses many microphones. She trances. She awaits her muse like a diva. She makes her audience wait. Then she sings and each person hears a different voice. A different tongue. She warns us of AIDS. She informs us of the dysfunctional nature of our religions; religions who cannot think outside of their own out-dated monochromatic belief systems; their binary ideas and their transcendental egos; the white male gods in their own ego-images. She tells about the deaths of young men in bath houses and about the ignorance of our governments. She tells us about institutions and mental illness. She tells us about abuse and rape. She tells us to arm ourselves. She tells us she is god and the devil.

She tells us that "... Jesus died for someone's sins ... but not mine ..." She tells us "... there's a war inside my head ..." She tells us "... suck my left one ..." She tells us that war is menstrual envy. She sings multi-octaves. She recites poetry. She asks "... were you a witness?" "There are no more tickets to the funeral." She says we must arm ourselves. We must use "kill-energy" in our voices, in our writings, in our music, in our works.

Laing tells the story of a 14-year-old girl sent for treatment as a schizophrenic; because she stared at the wall for hours and hours and not the T.V. She lost weight; she washed in cold water. She didn't eat.

She behaved as one would do if embarking on a meditative journey. She was descending inwards. She was resting herself; calming herself; emptying her system; tranquillizing her mind.

Fairytales and fairystories. Fairytales and mythopoeic stories, that come to us as children, could be the remnants of shamanistic visions. Little Red Riding Hood and her bloody lined menstrual cape, and the big bad lycanthropic creature, who glimpses her cloak, and wants to see her in the dark forest, wants to hug her and wants to bite her. Wants to eat her. The little Princess who kisses the metamorphic frog and gets her own fantasy lover. Sleeping Beauty – a woman in a deep meditative state of reverie – lost to the world and entombed in her own world – woken up by the kiss of the male. I always consider these male protagonists, in these age old stories, to be most emphatically their women's men. I consider them to be the animus, or the fantasy lover. The one who does not exist other than in the realms of the female subjectivity and imagination. The Only One who knows his woman. The One who is internalised; more hard, dark, exciting, mesmeric than any Other. Who is not repulsed by menstruation, nor intimidated by his female's sexual appetite or desires. Who knows every little thought or feeling.

Being In Love Within Yourself! What excitement! What turmoil! What daring!

Ostensibly it is a Jungian fact that the man who quashes his anima will seek in actuality a passive woman – for such is the threat of the female. Therefore –

a woman who is "in love" with her animus (supposedly having many masculine qualities herself – although I would argue that who is to say certain qualities ARE masculine) is more likely to be un-threatened by masculinity and able to stand up to patriarchy. I would also for my own part suggest that the animus makes for a very hard act for any man to follow – but that is my little problem! It really becomes quite fascinating when one delves into ideas of one's animus meeting and relating to someone else's anima. What if you look at a man and see only his sublimated anima? What if a woman sees your animus? What qualities do these archetypes really have? Supposedly the animus is logos-centred and aggressive. The anima is loving and giving. I admit to finding these rather simplistic and of course utterly patriarchal definitions out-moded, singular and limited. Could it not be a question of libido? The animus would have a phallocentrically linear drive – the anima a spatial traversing drive. I can presuppose and contemplate little more.

We "know" more than we think we know and shamanism is the technique for recovering this.

The character Regan in the truly disturbing and hugely enjoyable film *The Exorcist* (whose amazing voice was supplied by actress Mercedes McCambridge) was "possessed".

Drawings of the winged energy of lions. Sculpted bird demons about to take flight. Possessed by a nefarious and garrulous male spirit.

There are many instances of girls in tribes being married to "supernatural" beings at the time of their menarche. They acquire the power to converse with their "husband". He can be a special deity or a guardian spirit. She acquires enormous power. If she ever dreams of disaster she is likely to be put to death. I while ago I wrote a novella. It dealt with the subjectivity of a young girl. It questioned its own drives and impulses in its text. It questioned the death drives of the narrative, of the poetry and also of the young protagonist. The cyclic theme for the book was the young woman's "marriage" to her own animus. The lovers' games they played; the courtship; the tensions; the arguments; the sexual chemistry. He was a dark, alternative, powerful and bestial lover. He was also a vampire and a wolf. A loup, a garou, a loa.

The young girl, Arden, was a shaman. Likewise, so was Regan, and so is Carrie from the eponymous film by Brian de Palma. Regan's possessor cannot conceal his sexuality. He is unashamedly male. He gives his name back-wards; from interior out. "I am no-one." Jungian case studies of sub-personalities have been known to communicate in backwards speech. "I am no-body," he says. Note that he doesn't say any-body, but specifically no-body. Of course, he doesn't have a body of his own.

Are these filmic depictions of possession the only possibilities for female shamanism today in our 20th century Western society? Scandalous and transgressive women who need to be exorcised: who need to be "cleansed" by our psychologists and clerics.

Women can become "divergers". That is, someone who looks at facts without the conventional prejudice, doesn't take anything by hearsay and doesn't plump for an imposed or singular role. Who doesn't take on any role without thinking freely. Someone creative. Someone who knows the mammoth, near impossible, task of acting outside of the social reality order. Someone who knows that language is maybe the key to expanding the currency of society by gradually

using words and devices that can maybe refer or defer to what they mean in a poetic and semiotic fashion. Meanings that won't foreclose their futural significations.

Someone who knows the development of the animus is as important to self-awareness and self-love as the development of "androgens" which simulate masculine structures. Someone willing to accept the almost irreconcilable differences within one's own bisexualised being, and can demonstrate that femaleness is not constituted by "weak" negative qualities but by qualities that have, in their real-true subjective anatomies, NEVER REALLY EXISTED.

17. Psycho-Babble And Babblement!

The Voice Of The Mentally Ill

"... listen to me, listen to me ... talk to me, talk to me ... listen to me, listen to me, please please ..."
("Waking The Witch" – Kate Bush)

Misogyny makes women mad, Mad, mad as blazes. Anger is madness. Madness becomes pathologized. It makes one mad although often one cannot say. Say quite how it makes one mad. Depression is interiorised anger and frustration.

Through naming us as the Other, through the reinforcement of patriarchal discourse or ideologies, through depriving us of true power, privilege and independence, not just as token pacifiers but as real attributes. Or misogyny causes us to be named – as mad. Unreasonable, illogical, fanciful.

Don't be unreasonable! Don't be silly!

Labelling women can silence their voices. Rantings are invisible, inaudible or scoffed at. We dismiss in misogyny.

On the other hand, I have my own role as one of the silencers. One of the oppressors. Certain psychological knowledge and rhetoric makes me an authority. I present a book as the author-ity. Like many other feminists who have looked into the areas of psychology, I am aware that all I have learnt is up for questioning. I am one who has studied the supposed rules of the psyche, and simultaneously fell victim to its maxims. Theories, therapies, treatments and studies have to be deconstructed. But we then have to reconstruct. I cannot disseminate out of hand all practices that ostensibly help women in mental or emotional distress, to then leave all therapies and theories torn asunder – when there are women like myself who suffer such distress. In aspiring to become an ivory tower expert in certain studies do I suppose that that is the cure to my abjection?

Madness is an emotive term. A signifier in the contexts of labelling, control and order-keeping. With its long history, it has a definite and often malign function. Unlike individual diagnostic cases of anxiety, depression, etc, madness makes real its own stigma, and using that stigma keeps women as the Other, whilst ignoring everything that might cause the individual disturbance.

When we deconstruct this terrible signifier, realising just what signification it involves – we realise how our symptoms have become the Illness itself; how our disturbance is a disturbance wholly reliant and present to itself, and how the signs all become signs that are face-value signs in themselves. Thus is born The Illness. It's already there, we are told. Its proof is all too clear, we are told. Shining out of rictus mouths, and present in every tear, drop of cold sweat and (stifled) scream.

That madness is a description and immediate "real" presence of our fears, a box for our pain and frustration – marks us (like stigmata) as the Other who can never challenge the One. Even with spell spots and castrational fears and also BECAUSE of them, and witch's marks and third nipples, and all the witchy things I adored as a young girl – turned into a huge casket of "negativity" to be read as a landmap of Madness.

And so to the arenas of psychology and psychotherapy and psychiatry – for whom are they therapeutic? Whose needs do they serve? Jane Ussher addresses such issues in her book *Women's Madness: Misogyny Or Mental Illness?*

Hysteria, as aforementioned, assimilates (and reduces) itself to the body of woman as its site; and as the site of the "feminine", the body and hysteria are all but one and the same phenomenon in a pre-destined synchronisation. As Jacqueline Rose observes in "Sexuality In The Field Of Vision" – this site of body is outside the patriarchal discourse and silent, at best dancing (undulating belly-type dancing) for the spectatorship of patriarchy. A silently flickering early black and white (polarised) movie.

Women and madness share the same territory. They both spiral around a helix and the central magnetic rod that dictates that spiral is male normality. And if feminists, like myself, see insanity as something we can use; then it also uses us. But if spiralling makes us dizzy – then surely the one who watches us like a mirror will feel unstable also.

"Like some insidious virus, insanity therefore invades the mythology of woman, finding therein a semiotic fluid that IT may use for the purpose of self-definition."
(*Madwomen In Romantic Writing*, Martin, 1987)

In short, feminists have utilised "insanity" to describe what cannot be described – whilst elsewhere insanity uses (and uses up) many women.

And I have done this too. For my own subjectivity. Hysteria can be a semiotic language. It has to be – for us to deal with its tenure. We have to use it, for our own purpose, for what we cannot express; and make our own sense of it before (and often whilst) it uses us. A delicate and dangerous dynamic.

I would also like to interject, at this point, my thoughts about a "thanatoid" discourse – which I suppose has arisen from the given patriarchal discourse which concerns itself with definite endings (phallically) but cannot seem to reconcile itself with its OWN given ending, i.e. death. Much as patriarchy seems to constitute its structures of meaning and statements on the narrative which culminates in a definite and absolute premise (of which war, rape, murder and destruction are social signifiers) – which causes a re-possession of one's own trajectorial narrative – there would seem to be no acceptance of the death drive in the contexts of repetition, abjection, passing through death, and accepting the drive to "nothingness", the abyss beyond phallic meaning, or a semiotic hypothesis of the pre-symbolic order and the castrational fears concerned. Hence why the death drive is staved off – projected onto someone-thing else. A semiotic language that touches on and melds with subjective cognitions of death would also seem to me to be speaking to patriarchy in the same way the (dually appropriated) madness does. I say "dually-appropriated" meaning appropriated by two "discourses", namely the "unspeakable femaleness" and the speakable patriarchy.

Death as a symptom. Rather than the accepted or rejected ideas of torture, murder, S&M or violence (activities of both men and women) – a thanatoid discourse would concern itself with symptoms of withdrawal, depression and rebellion – giving vent to an alliance with or yearning for the pre-symbolic, or subjective other-worldly or unconscious.

Within this uneasy alliance bisexualised feelings and drives (brought up from the id, or other-world), abject feelings and melancholic feelings could express themselves better as part of the human condition. Patriarchy, of course, would see self-indulgence, romanticised inclinations towards an otherworldly fiction and stigmaticised "suicide" wishes. However, it would seem to me, there is nothing indulgent about a tendency to desire to experience the further reaches of the human experience or expression.

However through an anatomical AND metaphysical feminist discourse we would see and hear the rising up and out of the body to beyond (and maybe what we call mysticism) whilst taking the reclaimed and assertive with one! The symptom should thus be seen in this instance as protest, not indulgence.

But there is no singular explanation for madness, anorexia or witchcraft, especially not as singular symptoms which read insanity. But they have been singularised by pathologisation, suggesting a fault or weakness inherent in female flesh. Medicine invented the invalidism justifying its misogyny by the description of women as inherently, innately sick. In the epidemic of this illness women have accepted that their sex is inherently faulty and that it is endemic solely to them and their "like" but have also found ways to rebel against imposition by utilising that which makes men fearful, judgemental to the point of "blindness" and oppressive.

The feminist "rub" is therefore – whether feminists should reclaim the "madness" and venerate the "madwoman", as it is clearly a site which is a dubious foundation for a feminist or female pantheon. But where else to start? All female role-models and heroines of our past were dismissed and discarded. Why not start at the oppressed and maligned site itself? For do we not all reside in and with this "symptomatic site"? As long as we understand it FOR OURSELVES.

"... those mythic masks male artists have fastened over her human face (serve) both to lessen their dread of her "inconsistency" and – by identifying her with those "eternal types" they themselves have invented – to possess her more thoroughly ..." (*The Madwoman In The Attic: The Woman Writer And The 19th Century* – Gilbert and Gubar, 1979)

Yes, the mythic roles – whore, madwoman, witch, hysteric – were invented for us – so we could then be semantically and bodily possessed, but we have our own versions of these "roles" which are not fixed and cannot be possessed in body or metaphor or the same meaning. These are surely the semiotic and empowering versions we should utilise personally for ourselves. We cannot escape the untenable fact that many of us consider we are many and more of these figures in fluxing, contradictory and ambiguous histories.

And whilst Freud maintained the concept of penis envy, as the little girl realised

her clitoris was inferior and envied her father/brother, whilst resenting the mother in whose image she was formed – so we can also utilise the notion of envying not the penis, but the phallic power constituted by it – and to which it erects itself; then envying not the phallic power but being angry that our own unique power is oppressed.

So we see this in a symbolic context – so we must see other dynamisms too – in hypothetical or symbolic manners. Freud conceptualised the biologisms – today we deal with the metaphoric meanings and displacements of meanings. Today we know we can overide (but not dismiss) the Freudian explanations of ourselves. We are happy with our bodily parts, especially with our delight and *jouissance* in our sex that is not singular. We do not want a penis but we do want a power that is our own and is respected as such. This idea does not make us "mad", *per se*. We feel for the women who were mad as hell at this misogynistic premise.

If Freud and Lacan saw the phallus as the necessary principle controlling writing and individuation, the order, sexuality and language as we know it – are there not myriad other factors? Lacan did discover that the physiological/ biological factor (the penis) had in fact, because of patriarchy, become socially inseparable from the symbolic factor (when in actual fact it is often really very separate, especially in today's society) but still seemingly did not take this revelation further.

So, if these men assumed (for us) that we were linked to a differing system in which we were what was Lacking – it was left to us (as perhaps it should be) to build for ourselves. And we found we were fighting a benevolent enemy who smiled and petted and got cross with our attempts at chipping away at the monolith. Patronised, humoured, laughed at us and then, like so many fathers, would tolerate no more. We were Bad Girls. Despite the fact Lacan introduced the symbolic element (which would expose the metaphysical aspect of penile/ phallic power) we were still biologistically determined.

Lacan claimed that the phallus did not act equally for both sexes (or indeed genders), privileging the masculine, as it does. Thus we have the phallus as signifier – THE ordering principle. And what it orders is not only itself in the flesh (the penis has to strain to live up to the constantly erect, invulnerable towering phallus) but all else. It has even battled with the mammoth cloud of language and thought itself the victor.

We need to invest significance to other phenomena. Our sexuality and our bodies and psyches can then involve themselves in a play between self and other without the full-stop of phallic (dis)closure, or even with the full-stop if so desired.

Pansexuality. The retention of the pre-Oedipal gives us scope for a dis-disclosure with no rigid ego. The rigidity of the phallic ego becomes a brittle monolith. We can see that, so rigid is its form, it is liable to break, crumble, crack, give way – it is, in short, vulnerable. And many men know this – rejoice in this. For many it is the castration come back to haunt them.

In a Freudian context, the Oedipal complex disappears when the superego (mostly societal) becomes heir. As a boy first feels the threat of castration (from mother or father) he overcomes the Oedipal phase entering into the Law of the Father realm. His first love object, although lost, is no lack for him (or rather is allowed to be no lack to him). This primary process is deemed not painful to him

(only in so much as castration fears do not return).

Supposedly, a young girl with a less severe superego (or societal relationship) on discovering her "castration" enters into a breast-penis-baby process of substitution – her love object switches from the mother to the father and she becomes, for want of a word, a vagina. She has nothing to lose and has nothing to defend. Later on in this book we shall further explore castration, fetishism and disavowal as regards the Oedipal complex (both from the negative and positive points of views as regards women and men's positions).

For Cixous and many feminists, including myself, this above-mentioned negating and misogynistic account of sexual growth denies the *jouissance* and negativity (in a Kristevan sense) that marks the differences and *différance*. As Cixous points out – there is no place for female sexual pleasure – pleasure that involves all of the female body (and psyche) – neither vaginal, especially not clitoral, or of the breast, skin and senses. No place for all or several or none or many of my female facets. Singular, multiple depending on personal choice. So as society today asks The Female Question – what do women want? so women themselves are forced to ask themselves what they want for themselves, and how to go about it – which is no mean feat in our patriarchal society in which it seems we can win either way. For there is no sexual or symbolic or psychological space to find (the) answer(s). Except within the interiorised within, which is not represented. *Jouissance* may be one answer, but we are searching for its representative and also its symbols. It defies/denies symbol, as symbol has defied and denied it. This makes women crazy with rage. This certainly makes me mad after a fashion. It also makes me realise – it is solely up to me to build my own meanings.

With our inherited envious lacking histories (so we are told) to display anger at such a travesty of female being is not to be a woman. Hence – I am no woman. My angers are all labelled as violations of the norms. This is dependent on societal and cultural values. Madness has worked, in that an act or behaviour which in one context is acceptable – in another context is emphatically insane. A woman who neglects her children, drinks, and enjoys a lot of sex – is mad. A man acting the same will at best be called a rake; may even be venerated for such behaviour.

Symptoms of madness are consistent within cultures or contexts but not necessarily between them. In our society, they are marked by a capitalist, patriarchal, Freudian-inherited scenario, wherein we are constituted by the polars of the One and the Other, subject and object. To maintain otherness (and hence to maintain the One) we have scapegoats. Women, homosexuals, people with different sexual mores, peoples of racial, and religious differences, people with physical or mental differences and abilities, people of different ages, people who are ill (especially those with terminal illnesses, markedly those with AIDS), people with different lifestyle or morals (criminals or prostitutes, etc). It's worth noting that the sharpest polarity within a culture remains with those "in" the culture. Even whilst suffering oppression and sexism, women are forced to (and will) remain alongside men of the same colour, creed and race – as mirrors for those men. Thus we find greater alliances between women and men of the same colour (despite oppression) than we do between white women and black women, for instance; although such matters, with the progression of feminism,

are slowly, slowly changing. As aforementioned – we then find the phenomenon of woman as other and a woman from another race or culture as "double other" and so on.

We have analogised gay men with the otherness of women (and also imbued them with the same Freudian ideas) – especially as the phallus is now symbolic to itself. And our fascistic ideas concerning illness again brings into play a prevalent feeling of the ill (e.g. someone with AIDS), being seen as both the victim and source of his/her own pollution.

There are many areas of mental healthcare, and many differing views held by those who work in this field. The politics of positivism bring to us the belief that observations can be made without the contamination of belief-systems, politics and subjectivity. We can, they say, observe the mentally ill objectively, without and separate from the pressure of our misogynistic society. It would seem to me that the science that claims pretensions to total objectivity is not fully thought out. Many believe science to be apolitical, and mental healthcare likewise. Seeings as we are ALL part of a definite belief-system and that a huge institution such as mental healthcare is founded on and by the politics of our time this seems particularly misguided, if not rather insulting to those with a personal or vested interest, and certainly naïvely utopian. The notion of positivism *in itself* would thus seem to be political. Disregarding the person (patient) as an active, social being/agent who is defined by class, community, history, race and gender – would seem a repression effected only by an institution with power!

But how many experts are willing to expose the inadequacies and failings of their own training, and therefore their power as an authority? How many would exercise dissension within their own house? Thus we have the mysticism and elitism of the expert, and the disregard of the individual who does not fit into the prescribed category of symptomatology and treatment.

This sort of positivism would also seem to reinforce the notion of unreason. The mad person is a model of cause and effect, being made to act in such an unreasonable manner with no control. Wilful deviance is a crime (this is usually applied to men). Unwilful deviance is illness. In the case of a male killer. To kill a prostitute is bad, *but* understandable. To kill an "innocent woman" displays lack of reason.

The upholding of the ethos of the order can be seen as a mystification of itself to those of us "not in the know". A mystification of reality. For the "sick" individual the location of the problem can only be within – as society shows no signs of sharing the burden nor of causing the ill. Thus in our capitalistic society illness is oppression. And further more "we" are oppressing ourselves, so we are told. We are told to "get over it" and to "shake out of it"! That the sickness of the individual is sustained by the sickness in civilisation is never admitted to and the confliction between personal needs and the needs of society (the "good" of society) grow in disproportion.

That of which one cannot speak – we are told should be kept silent. It is not fitting! It just isn't fitting! Then ... how much silence and at what terrible personal (and ultimately societal) cost? I believe it is that which is unspeakable (unthinkable even) which must be said (if only for one's own self) in poetics and

mad prose. The poet and the madwoman must speak – it is precisely that which many of us should hear.

Isn't madness (frustrated anger, hurt and disturbance; or an alternative angle on reality) culture itself – working away at the inner self – updating itself (archetypes of outcasts have changed over the centuries) for us to learn from?

And if we do see the mad solely as romantic poets, or dissidents who are latterly glorified, or misunderstood geniuses, or thwarted suffering artists – does this not tell us something? Yes, we have glorified their sufferings, as we have also confined their protests through the bonds of nosology and labels; but in the end, romanticised or constrained, we must listen. Scientists and doctors often prevent the expression of creativity; on the other hand other institutions revel in the *art brut* and writings of the mad as protest (symptom as protest). Often neither is particularly helpful to the individual suffering. But I personally am interested in the concept of creative work (specifically writing) by those ostensibly mentally ill. In the same way I have admired Sylvia Plath, Leonora Carrington, Charlotte Perkins-Gilman, Bessie Head, Emily Dickinson and countless other writers who wrote of their subjectivity and told me of their unusual or exceptional realities. I find comfort and enlightenment in these works, as I do my own. Not as therapy – but as an activity that drives me. And is it not a voice? If only for the self or a few. A voice that can express the inexpressible, teach and flow semiotically.

Of course, psychotherapy has also had its critics. Is it offering adjustment rather than liberation? Is it offering a brainwashing, patriarchally mother-blaming solution – that herds us back into roles we only fit into *when* brainwashed and docile? Does it not demand the acceptance of the therapist's view of society? Did it also not spawn "family therapy" wherein the mother was often to blame? Or the sort of therapy where all problems were reduced to the recidivism of the female and her straying from the righteous path of womanhood and maternity?

Again, it is quite obvious that therapy often does not work in various ways, for various reasons and to various ends – but for some individuals it most definitely does work and we should therefore not dismiss its value. And we shall cover later on – feminism has made perhaps the greatest contribution in this field for the good of many, many women.

Most importantly, feminist therapy does away with the previous notion that seemed to often prevail – that the patient was gender-neutral – that sexual difference didn't exist.

The feminist agenda and the feminist critiques showed us how women could not win either way. If first we had, within the Fallen State, Eve and her symbolised sin; relegated now to a sick powerless problematic – we then had her in her redeemed and restored feminine role as Mary; normalised in weakness with a physical mien that needed preventative medicine and constant check-ups. Lydia Lunch has also commented on how much patriarchy likes us to be on drugs, drugged up, restrained, forbidden our own pleasures, made docile and also made self-destructive.

And it is telling how these two stereotypes are still so endemic and ubiquitous in today's culture. But with the large-art of romanticism's mantle breaking down, we have veritable hordes of therapists, liberal gynaecologists, counsellors *et al*, to ask all the questions (and provide few answers) – the most consistent

of those queries being that of the Woman Question. If on the one hand the question is localised into the individual, comprehended as the site on which to "work" – then conversely nothing is achieved in the direction of viewing the larger picture of societal problems and their force on the woman. And vice versa. If psychology, in the past, failed to consider the individual – then the psychological dissenters' analysis seemed to consider the woman or women by default. And if the feminist or biological reductionists claimed women were mad, were they also not viewing women as a homogeneous group with some common denominatory factor that allowed no exceptions?

It is true that the discourse of madness (like misogyny) somehow relegates all women – but some of us are more likely than others to be positioned or posited within it. Hence it is a case of labelling theories and diagnostic classifications which are immutable.

If madness is a social construction dependent on the currency of language, definition and essentialism – should we not consider that schizophrenia is not clear-cut amongst women, instead looking at its categorisation before we judge?

What are interesting are the nosological categories that have been ascribed women who were actually archetypically feminine. The Victorian maiden – hysterical, anorexic and melancholic – actually aspired to the heights of femininity. Somehow the sick woman *was* the normal woman. Those who embrace the stereotypes are as mad as those who reject them.

Madness thus functions as a mirror of female experience, with penalties for being feminine, as well as desiring not to be. Therefore, this binary situation allows *no* woman to be "normal". And it is her anger that is pathologised. Freud's analysis of Dora is a classic and terrible example. Dora was pathologised for not desiring to be the Freudian "vaginal" woman, and rejecting a man's advances. And that this man was an unwanted man, about to assert himself over Dora – is not considered by Freud, who seemed to regard this episode as an opportunity for Dora to be grateful for the sexual attention. She was blamed for her own distress.

A few years ago the rap group Public Enemy told us the true story of Tijuana – a Black American woman who claimed several policemen had raped her in custody.

"... *And they try to say that she's a liar* ..."
("Revolutionary Generation" – Public Enemy)

Regarding Dora; Freud saw it as pathological that she should react to her opportunity for sexual pleasure in receiving a penis (any man's penis) with revulsion. The implications of this are of course horrific. It is nothing short of a go-ahead for rape, with the belief that woman should be grateful for, and always ready for, penetration.

And so the depressed are blamed for their own misery. The sexually abused for their "seductive natures". The "constant" that provides society with this information is, again, the "body as feminine" "the feminine as a passive vessel, awaiting fulfilment", showing symptoms of its own which speak of the female as source and manifestation of madness, unreason and sin.

To blame is to control. It negates anger and power. Prisons control men; madness controls women; with its pathology, its ECT, its hospitals, its drugs, its

lobotomies, its brainwashing and, maybe greatest of all, its terrible fear.

Jane Ussher details the negatives involved in mental healthcare in her book. She includes chapters on Therapy as Tyranny, and covers all aspects of power relations involved in professional healthcare. She includes information on sexual therapy – which can be in some cases an invidious phenomenon. Much sexual therapy being based on penetrative, heterosexual models (as if masturbation, lesbianity, oral sex and, importantly, the clitoris and an active sexual role for women, never existed). Simply because society still believes on many levels in phallocentric functions as an unquestionable determinate regarding sexuality and therefore sexual therapy.

For certain, feminism has proved the biggest move forward in mental healthcare. Whilst we may have differing feminisms we cannot deny the worth, overall (and also specifically) of feminist perspectives.

LIBERAL/EGALITARIAN FEMINISM gave us knowledge of sexual discrimination in the workplace, as part of the economy and the basic aetiological significance as exemplified by Simone de Beauvoir and others. Liberal feminists decreed that men and women were equal and that given the right opportunities and equal rights women would succeed. Women should thus subscribe to the male view of society. Biology wasn't viewed as an insuperable obstacle to liberation; not a specific factor in misogynistic oppression, but a factor that might automatically be eradicated by social change enabling women to fully participate in societal functions. (It may be worth noting at this point that de Beauvoir herself believed that women could never truly be compatriots, that the only common point women had between them, was not love for each other, but antagonism for men.)

Thus this belief in structural societal oppression engendered by roles of passivity with no autonomous existence prepared women for lives of subservience and conformity. Given education, changes in childhood socialization and institutional structures, women would be free. A liberal utopia will triumph based on individual ability and not gender. With this view in mind – the liberal feminists thus decry psychological theories which they believe address fallacies concerning women and deny autonomy. Madness in this context is seen to relate to societal structures and institutions, and once re-addressed the problematic of oppression will disappear. Legal statutory change being the foremost change in assuring women be taken as equal members of society with no difference. Equal opportunity in the workplace, childcare, free abortion and contraception become the means by which women achieve freedom.

This all obviously (simply) carries a great deal of truth to it, generally speaking. But I am concerned by its simplification, not least by its apparent dismissal of any kind of allegiance between women (an area that feminism across the board fails to address to my complete satisfaction, considering how many women are more likely to collude with patriarchy for their own gains and at the expense of other women). The issue of allegiance we shall leave for the moment, as I have personal problems with the issue of any kind of feminist allegiance when there are so many differently intentioned women, and sadly so much animosity between women.

Regarding liberal feminism; whilst I would never dismiss a utopian bent, out of hand, realising that any utopianism is just that – a dream message to reality,

and believing utopian ideologies reflect the desires of a given people – I, like many feminists, who spoke out after liberal feminism, believe that to eradicate all difference in an attempt (and a premature attempt) to ensure emancipation for half the population means also that all the differences and individualities fall prey to eradication and vanquishing beyond repair, and at the detriment of that society.

Whilst liberal feminism reared up out of the "free market" of the bourgeoisie, so its child, socialist feminism came forth from a political belief in capitalism as the root of all evil. Following on from a Marxist maxim of ownership of the means of production equalling the cause of power-abuse, it would seem a mirror reflection of liberalism in the eye of the context of economy. However Marxist accounts of oppression do not in themselves account for misogyny. Sexism is rife wherever men and women interact. In short – everywhere. Be it the proletariat, where there is no access to property, goods, resources or power, or otherwise. Sexism is its own small (but obviously hugely significant) dualism. No matter what class or race. And class and race have been utilised as factors contributing to sexism – which is true in many contexts. However, it would seem that there was and is a constant. No matter what, men still other-ise "their" womenfolk. Be it a capitalist regime, a socialist regime or a fascist regime. The woman is directly involved and kept stiflingly close (in a binding dualism) to the men of that given society. Thus, as aforementioned, women are closer to the men of their class or race than women of other groupings. The dynamic of sexism may be emphasised and magnified by societal influences, and many women may attribute their "madness" to it but, for my part, it is not, I believe, the root cause of sexism and misogyny. For we are viewing a diagram of a man and a woman, whom regardless of other factors, are locked in a polarity that is unquestionable from most standpoints, and within which the woman serves to protect the male from any psychic disturbance. We have two people either side of an incestuous looking glass, and this is a figurative signifier of the role woman plays to man's ego reflection in a universal phenomenon beyond societal objectivity. No institution today has attributed its cause to society in terms of society's sexual psyche being at fault or part of the cause. Except that is for feminism, and some areas of psychology and semiotics. We blame the job market, the economy, the politics; but whilst they can illuminate (and also aide the bind) they cannot fully expose the crux, for they are for the most part given over to concealing this Unspoken Bind. The oath that no woman ever made but which was inherited. The unspeakable bind of otherness which cannot be exposed because all our languages and structures are geared towards veiling it. I should interject at this point that it is the very fact that within our social duality one half always dominates (and often destroys) the other, in order that meaning should be placed, which is the problem, not just polarities *per se*.

No wonder feminism has had so many backlashes (and many of them from women). How do you fight an "enemy" who only shows the world its supposed benevolence. You go mad. You go mad in your attempts to explain that which you feel no one can ever understand. Funny then how the words for this eternalised, normalised societal insanity (insane on the part of patriarchy, that is) were never given to us to speak of it. And many women and men tried to speak of a certain condition, even made up their own words and spent their whole lives working as strangers to language, on language.

The huge monolithic power. Who would want to give up that power? In the face of what we are told is an ego-challenging, castrating, unreasonable, witchy, confusing womanhood. And the reason this dualism is so unspeakable is because we must not speak IT. But many of us are trying and succeeding. I already know the situation, not just because of my own "madness" for then I might have thought it was all just me (although I believe I never lost belief in myself) but because other women did speak IT. After ages dedicated to working with our language – they finally find a way of letting me know that it was a huge huge con they were exposing which few could see beyond, and didn't want to see beyond. All our histories and tenses and senses and words and structures and functions protected it and it alone. But some people worked so hard at the currency that is language – they at last spoke, and in such a way. Then we realised some people had been speaking for years and years only it wasn't allowed to get through to us. It couldn't be denied. But whilst many went on denying it others built up such a flowing dictionary that no one could con our way with words. Our communication. Working by breaking the rules but still using the rules. And playing the rules in a deadly serious game and using the rules.

So now I find the work of women (and men) who utilise the most perfectly refined linguistics at the same time they use "mad" poetics, and with every other word in parenthesis and italics and words from France and little signs open up and subvert in intelligent pleasure – that which wasn't SAID.

What was invaluable as regards SOCIALIST FEMINISM was its concern with speaking to all women oppressed; distinctive from some theories and feminist policies which could in themselves speak only to the privileged few. However, there is the concern that in speaking to the masses one ignores the nuances and drives of some female intents and the personalised interests of the single woman by popularising feminist rhetoric. This would seem to be the point where misogyny has the opportunity and of course uses it to then attack feminism. The point where a theory hasn't been thought out at the highest level and on all levels, and is presented in a rather simplified way leaving itself open to a backlash. It is my belief that such theories need to be worked on until there is no point or angle that they can be criticised on by patriarchy because for each criticism there will be an answer. Idealist maybe – but with the current state of theory and action – not completely out of the question. It would be a case for fighting the enemy with the enemy's weapons as well as with alternative ideologies; and I am a great upholder of ivory tower theoreticians for it is they who disseminate that which can subtly be used against us, to make it work for us.

If liberal and socialist feminists focused on social divisions and an equalising effect – the RADICAL FEMINISTS, who separated themselves from phallo-centricity, argued for the differences to be regurgitated and not ironed out. In short, to be respected for being very different from men and not to be seen as secondary men, or women willing to fit into being just that. However – it is my opinion that the greatest misunderstanding within feminism concerns the issue of radical feminist intent. Acknowledging and researching sexual difference is highly important. Also acknowledging that women are still within (albeit marginally) the social symbolic order and have to work with that reality and

order of language (which is after all OUR system too, like it or not) is the factor I feel is overlooked by critics of radical feminism. Radical feminists work with language realising as Kristeva pointed out so expressively – that they are in effect strangers to language. Why else work so diligently at language if not to improve it and our understanding of its dynamisms? Because even when working semiotically one still uses, or is used by, the language we know. Radical feminists therefore *do* address the issues of being part of the social system. In the coming to reading of radical feminism, and with my own work in a similar vein, there is often an address made to the issue of woman not existing in isolation but as part of the language order and therefore society.

Difference doesn't automatically read separation in totality. One can critique and deconstruct phallocentric patriarchal discourse but still realise to do so is to address ALL of us who have maintained that order. I realise this is not true of some radical feminist work. Some work can be very parasitical. Pulling apart and not replacing the deconstruction with a new reconstruction; completely separatist in that it believes itself to be right and all else wrong.

I believe this can be an opportunity for personal deconstruction, as we all inherit a patriarchal language and sign system. If radical feminists see themselves as superior is it not in respect to an extended process of deferral that goes beyond binary oppositions, but also does not exclude them? For binary oppositions are the starting point and reference point for communication. This is the manner in which knowledge production works with regards to the areas of language, semiotics and feminist theory. One has to challenge the means of signalling, signification, communication so that will then filter out to others. The ivory tower theorist should not be criticised as she is challenging the male ivory towerist. Her ideas reach other women through a process of translation.

However, to return to the issue of radical feminism. There are criticisms to be made, of course. However I wish to add at this point that I have viewed radical feminism as the woman-centred space needed to bolster belief in femaleness before the return to the fold of society.

Radical feminism rejected the assumptions of liberal feminists that social factors determine female oppression. Looking to biological differences as the root of misogyny, they aimed to reconstruct female biology as a positive and empowering force. Mary Daly, Adrienne Rich, Susan Griffin, Andrea Dworkin and others produced a plethora of woman centred influential works of all kinds. There came an overdue rush of poetic language and rhythmic rhetoric but what became apparently dialectical for many women was the issue of essentialisation, an area I have covered earlier in this book. The notion of a "special nature" whilst invigorating and uplifting in some respects became its own enemy. Alongside a belief in a superior biologistic realm and an emphasis on reproductive prowess – which proved increasingly problematic as feminists battled (against themselves) to attempt to contextualise these ideas. Whether these ideas are as truly liberating as they presented themselves to be – or was it a case of in fact feeding patriarchal ideas that women *were* reducible to the essence that was the problematic reproductive womb-man?

Men can clearly be the enemy as regards radical feminism of this sort. However language was a foremost issue and the belief that women must reject phallocentric definitions of reality and labelling strategies was highlighted. Daly urged women to "embark on a psychic voyage". Language was intensely

"worked at" in order to reframe female experience, and reclaim the magic radiant power of text and expression. Textbooks and critiques on madness must be written in "our different voice". We had to claim back the derogatory words – witch, bitch, hag, hysteric, etc., and use them positively. Alternative meanings and reclaimed minds.

One of the strongest arguments was the critique of heterosexuality, the power of the phallus and the objectification of women through sex and their stolen sexualities. Sexuality was a key word used to objectify and pathologise women and the penetrative act often enforced the powerlessness of women and the power of men in all spheres. The blame was at the bedroom door. Dworkin claimed that intercourse occurred in the context of an already established power relation. Whatever the meaning of the individual act – the context still signified total male power in a pre-established discourse of control. Therefore women should remove themselves from this context (turning to other women) in order to cease this perpetually duping phenomenon. Other woman-centred feminists looked at mothering (which we shall cover in greater semiotic detail further on in this book) as the root of hatred – the initial threat to masculinity which frightens society into hypothetical castration, denial, oppression and control. The female creativity of childbirth, and the envy of men; the coveting of this creativity – initiates the matrix of men envying all female creativity in all its forms. Woman is the creature we fear and desire – the lost object and the present threat, who has the power (hypothetically) of life and death over us, and in whose reflection we see ourselves emerging. The creative mirror whose blank face could hide good or evil. She is thus closer to infinity (godliness?) and men will detest, revile, humiliate and shit on her in their fear and outrage. Men will reduce her to three orifices through which they can pillage and take pleasure from. Reducibility being the operative term. For she already has the power that she brought them forth and thus men will balk at allowing her any further power, especially *their* power. Whether one reveres motherhood or not – feminism in this way has suffered from both glorifying and essentialising reproductive powers, and from romanticising woman's ostensible "special cosmic nature". To suggest that women should turn from heterosexual intercourse, is to dismiss the pleasure women may find there and also their abilities to be assertive, active, pleasure-taking and mentally involved in their own fantasy scenarios. Likewise regarding pornography. Yes, some porn is abusive and exploitative. But some porn can be exciting, liberating; and the idea of women producing pornographic material on their own terms is something I welcome. The female sexual imagination should not be barred or censored, rather it should be allowed its own expression, as it will serve the double function of also educating society as regards what female sexuality can really be about.

I have found pleasure in the notions of woman-centred body celebration, but I also strongly reject an essentialisation of the biologistic to singular functions and moreover a compartmentalisation and concentration of my body regardless of my intellect, other creativities, psychology, emotions, drives and numerous other qualities that make up me and me alone. Yes, I find menstrual celebration rich in personal potentials. Yes, I am guilty of claiming "special nature" qualities. But yes, I also claim to be selfish, aggressive, enclosed, violent, abusive and rather "phallocentric" at times. Maybe this is also part of my "special nature"? However I make no claim to having been duped into adopting or inherently

possessing these qualities. In short – I am more than the sum of the parts that would have me define myself as a prospective-life-bearing, nurturing, caring female being. As the lioness is neither completely softly caring or altruistic – neither is she fiercely violent to the point of amorality. And she is an animal and I am a human being – so these analogies don't say much for women in the (foreshortened) end, it would seem.

If women claim to be closer to nature (and of this I am also guilty!) – then ironically that is what men have already used against us. If all we have to do is revert to a bodily plan to freedom (presumably making a love of nature top of the agenda as regards educating men) then what does this say of all our differences as individuals, perversities and psyches. That we all share the same mind? Be it a moral superiority or a biological one – as wonderful as it sounds – it is just too simple!

The PSYCHOANALYTICAL FEMINISTS rejected our Freudian legacy – but not out of hand. With their deconstruction came a new feminist perspective and reconstruction built up from many Freudian premises and they exposed the presuppositions of many psychological views of women as misogynistic falsities. They realised that to understand and challenge oppression one could not afford to neglect it. The dissatisfactions brought about by earlier feminisms with their inability to explain the perpetuation and continuement of misogyny despite equal opportunities, realisations of the internalisation of the patriarchal discourse by women, and inconsistencies and inadequacies in solely concentrating on biologistic arenas gave way to psychoanalysis in a feminist context, as a means of understanding the responses and drives of women in a society such as ours. With the roles of sexuality, power and ideology (or discursive practices) in the subordination of women (and subsequently madness) psychology can be seen to provide the framework for quite a rounded investigation, exploring the internalisation of subordination into our personalities. If cultural feminists looked at celebrated motherhood (quite idealistically) then psychological feminism addressed itself to issues of language (in greater depth and with greater understanding than the radical feminists), sexuality and the *ambivalence* of motherhood. Moreover it brought the "woman question" into a site of individuation – where one could take into account social factors, economic factors, the underlying currency of meaning terminated by language itself, the body, psyche, conscious and unconscious, as well as the history of the personality. It was to address the sole subject and the grouping of women – benefiting both.

I am not suggesting that all feminist psychology is successful, and unfailing. I am also not suggesting all other mental health therapies and practices are damaging; countless women have gained help from discursive practices, drug treatments, hospitalisation and so on. But many women have not been helped, and feel powerless to ask for help, or powerless to ask for a different kind of help.

If feminist theory fails today – it may largely be because of the homogeneous structure that it can present. In being feminist (like many feminist practices) it supposes that all women are involved in a model of sameness. As we know women are often as different from each other as they are from men. The balance between similarities and differences has to be delicately met. To assume

biological sameness reads overall sameness is as naïve as to presuppose all women have the same psychological make-up, history and circumstance. Feminist psychology today at least addresses this complex issue and seeks to posit homogeneity with heterogeneity. With the important introduction (by Freud, later by Lacan, later by Melanie Klein, later by Kristeva and others) of the significance of the unconscious (with its drives, impulses, and its subsequent suppression, repression and sublimation by the superego and ego) this feminist interpretation of psychology, linguistics and culture with its phallic Freudian theories dethroned, deconstructed and reconstructed – we are more or less back where we started at the beginning of this book. A semiotic and also personal understanding.

For what is surely of paramount importance concerning the area of madness is the voice of the one who is mad. The voice of the one who isn't the One but the Other. The Other who does not speak. For outside of the order there is of course no language, *per se*. And on the margins things blur and start to turn to babblement and chaotic schizophrenic speech. Subjectivity and the pre-existing position wherein we become I the subject, is a male domain. We obtain our "I" at the expense of a sort of alienation from ourselves.

The space we have now found to speak in and from and to – holds phallocentric language in its spaceless non-figurative womb or matrix – so women and men can speak phallically and poetically; and importantly women have voices. We can speak through our bodies, through re-embodiment, but not through our symptoms – our bodily symptoms of imposed illness. Musical rhythms borrowed from songs that someone used to sing before we were born with heartbeats and breathing. Voices in today's experimental music scene recreate the pelagic-blue *choric* and semiotic pulsational sounds that we know through having passed through symbolism. And the individual who was mad as hell and scared stiff has a voice that can ask for help, can demand to be heard, can demand acknowledgement of existence in its own right.

Maybe now we are beginning to see an age when a woman can say "fuck you!" And her stance and her inflection won't be like those 80's adverts of pouting ladies whose pseudo-arrogance and refined power-dressed veneer almost hides consumerable cleavaged flesh waiting to be exposed and used, and who are really saying – "fuck me!" Even when they don't mean it. For up until now, as Lacan pointed out – women were destined "to be spoken", rather than to speak with their own power.

"... speech ... we are beginning to speak our histories, and as we do it will be to reveal the burden of pain and desire that formed us and, in so doing, expose the terrible fraudulence of our subjugation ..."
(Valerie Walkerdine, 1990)

With any deconstruction there must be reconstruction if progress is to be made, but sometimes I prefer not to theorise in such terminology and simply get on with my expression. Whilst figuring just what is deconstruction and what is reconstruction – a lot of valuable dynamisms may be lost. I believe nothing (phenomenal, conceptual, imaginary, or symbolic) is pulled apart completely – nothing fully disseminated. Post-Freudian theory has not utterly demolished

previous theory; it relies after all on it as a foundation. And nothing is reconstructed without some sort of "looping" effect; some sort of overlap or touching back on some previous point. The simplified concept of deconstruction/reconstruction would seem rather phallic in itself. We knock down one tall tower to build another one in its place. Rather we should extract parts from myriad sources, listening to them through a semiotics which traverses disciplinary boundaries. Then I believe that the fear which we harbour that we may reify madness and madwomen will be disproved by a multi-contextuality, and importantly the woman herself will speak unprevented. Utopian maybe? But this desire exists for a reason and my belief for a semiotics is already here for some (admittedly for those in privileged academic positions or avant-garde artistic circles). This is of course not to be confused with a post-feminist era. The post-feminist era is NOT upon us yet, and I hope shan't be for some time. Not until the misogyny has stopped. There are people working in artistic areas (namely within music's more contemporary areas) who in their vigorous new-wave-no-wave-girls-and-boys-bisexually-together hedonistic stance fail to realise the disservice they do many women, and men. Not content with criticising those women in the music business who still believe in continuing feminist endeavours – they inform us we are (or should be) in a post-feminist epoch. Post-feminism (or the belief that we no longer require feminist thought, theory and action) is a pacifying, patronising, placatory controlling ethic (and empty mindless gesture) that informs women (in this instance by insinuating that cool, trendy girls are naturally post-feminists) there is no longer a need to examine misogyny and the way it still works its invidious control today – for "they" themselves "lurve" women, and besides they don't want to hear girls on the independent music scene keep harping and carping on about it! I address these remarks in reference to certain boy bands on the current independent music scene (although independent does not read liberating, subversive or groundbreaking regards a bit of guts and substance any more it would seem). There are many who believe a twangy ditty about a state of androgyny eliminates the oppression, rape and woman-hatred perpetuated by other men. So keen are they to assure us of their support and their gynaeolatry they urge women and girls to stop being feminist. That could well make a young woman mad!

I would like to interject at this point, that I do believe in a certain post-feminism. This may seem paradoxical. In fact, when I was asked to categorise my first book publication (something I was loathe to do), only so it would be easier for bookshops to know where to place it on the shelves – I labelled it "post-feminist". What I hope to address in the latter stages of this book is how I describe a new post-feminism as a state that is determined only on feminist grounds, not on phallocentric grounds. A state which concerns itself with the Symbolic Castration of men, the eradication of sexual difference (on phallocentric terms), and the arrival of a belief that it is only phallogocentrism (with its metaphysical Absolutism) that keeps women and men from liberating discursive subjectivities.

"... mental illness ... for women (is) often a form of logical resistance to a 'kind and benevolent enemy' they are not permitted to openly fight. In a sick society, women who have difficulty fitting in are not ill but demonstrating a healthy positive response."
(Charlotte Perkins Gilman, 1892)

As our parents affected us, as society affects us, even as our peers affect us and our bodies (and as they are fragmented and stolen from us) – so we must speak about it. Aloud to ourselves on a platform on a street on a page through a microphone even when it appears nobody is listening, just speaking for yourself. To use one's voice automatically assures one of one's existence. It is the only sense that can reach out further than a limb, or even a bodily smell. With the aid of one microphone or many, or a recording or a book – it can reach further than the eye can see.

18. I Mean What I Say!!

I am not merely presupposing a "communication" which becomes a position-taking; a phenomenon doomed to conformity and fragile rigidity. After all, in a Barthesian context – language is everything – literature and the spoken-word are its translatory under-forms (even objects). It becomes not what we say, but how we say it and also how we are spoken by it. In this sense, I too, find an "aesthete's posture" as a listener of oral artforms (specifically by women in this instance, but also of work by men) – wherein I am swinging between dissatisfaction of *everything* in my alarming distress at my beloved lost objects and undreamable dreams, and pleasure in *everything*, regards what I read, hear and can cognitively project upon or delusionally apprehend.

My taste alternates between great inclusive delight and sorrowful betrayal and subsequent indifference, by means of a technique of assuming artificiality, aesthetic appreciation of object, and importantly, appreciation of my (subjective) loss (having posited myself as the "divine" receiver or ear).

In this way, I feel, I appreciate the drives of writing, vocalisation and performance *before* it is fixed by systemised ideologies and monolithic structures and absolute phallic meanings; thereby understanding my (own) abjection.

And in a vain attempt to "outplay" (Barthes) the signified, the law, the repressed – I detach *myself* and also passionately re-avow *myself* as the perpetrator of (polysemous) meaning in the "compassionate" belief other readers will do the same, as inventors themselves. Or else, and also, I am on some wildly self-referential sojourn of personal signification – which I also do not apologise for. This is not a drive for ultimate de-personalisation (indifferent denial to all ends) (in the long run) of any artform – but I invent meaning for a neo-communication seeping from the fragile eye of a dis-closured phallus into a pre-ceding *choric* polyphony. I only call it "my own" on behalf of others although I have evidence it is shared by other beings.

Différance, in a Derridean sense, we know, is a not quite definable or even speakable disjunction. We know it encompasses tropes, gaps and the semiotic. A non-principled principle of discontinuity, in which we can recognise (one of the few ways we can recognise it) how it makes or is made through fragments, pulsional bursts, silences, illogicalities – which would seem, really, a more realistic perception of individual social experience, subjectivity and language use.

A loathing for transcendent presence. I find this idea in relation to poetic performance fascinating. Yes, a loathing of the phallocentric "right" to claim singular whole presence inside of a linear statement or ideology or discourse, and then assume a rising above to some godly level, strangely precipitated by a phallus that is more than just a symbol or flesh part but is archangelical in itself as well.

However I am also thinking in terms of a poetic dis-course wherein the

transcendence would arise from a continued deferral of meaning which (with its unconscious attributes) is the nearest the poet can come to (unconsciously) going beyond the presence of being. This is not just to suggest that the author as the creator of all her/his meanings becomes godly – but rather that the poetic deferral of meaning in itself can lift the poet without her/his will being involved. To consciously realise is to realise "with ego" therefore no actual transcendence occurs. There is after all a huge illogicality to the phenomenon of the "transcendental ego" prevalent in much mysticism. It is a contradiction in terms. But presence then again dogmatically suggests an ego. Let us subvert this way of thinking and tie in these thoughts to an Irigarayan concept of mysticism.

If language is an endless process is it not the process we are dealing with here. The process and not the end, or phallic tip – pleasurable as that fixed meaning or thetic end may be. For we are all susceptible to the pleasurable end to many discourses, or narratives. But to be aware that this end is no absolute again reinforces my belief in the continual semiotic as being nearer to a transcendence. And also to a metaphysics. That there is no transcendental signified (in itself) again leads me to the endless semiotic for human susceptibility to what is beyond the physical ego. The only metaphysics I can speak of is tied to the physical in abjection, and continually travelling in a disjunctive function that if it does veer towards something egoless is nevertheless tied to the ego and/or then becomes unbeknown to the ego for the ego to then speak of it in recognisable fashions. In short – this mystical implosion in the promised land occurs at the cost of any meaning with which we would know of it. Thus this abjection is all I can know of this primarily Derridean polemic; but one which Kristeva has worked on in extensive and comprehensive detail and taken much further. However, as a writer with an ego I can somewhat aspire to a "godliness" in view of the points and traverses when I am alogical, bodily, poetic and "mentally ill".

Derrida fancied that writing was further representative of experience than the spoken word – which he claimed was the word of Logos and the Word of God (in a phallogocentric system). This is for the most part fashioned after many truths, simply because it has mostly been men (and officiating men, at that) who have participated in public speaking, and oration. However, poetic performance, the sort of which I am dealing with in this study, does also aspire to experience and not to a definite singular patriarchal end as does much speech (which in the past has concerned itself with didacticism, informative diatribe and phallocentric rhetoric). The spoken word, in an oratorial tradition, has been utilised in a phallocentric manner by those who wish to play on speech acts (and figurations) of the oratory (which serve to fortify the given dominant system) and apply the "I" agent of the spoken word in an unequivocal context. The word of Father, who claims, I know; I say; I tell. I ...I ... I ... The "I" that brooks no argument with itself (much less with others) and does not and will not deny itself, not traverse itself nor contradict itself. "I am absolutely clear about this," the voice says. "Let me be absolutely clear about this," the voice continues. There would (this voice/ego believes) be no respect for the fatherly voice that speaks in a poetic, semiotic way, or of the underling who will not listen to reason. It is the "I" of the politician, of the boss, of the father, and of the god. The "I" that is

so singular it would not even argue with or undermine itself. Much less allow others to even infringe or impede on it, or not listen.

What is obviously different concerning poetic performance and the oratory works of many women is that the tradition of the orator with the "I" still much in phonic evidence – is the traverses and absences of ego or phallocentric ego *alongside* ego or phallocentric ego. What is different are the contradictions, the ambiguities. The points that explode, or implode, when someone says …. blissful, flashes of energy, perfectly sweet poetic points. I don't know I don't know I am at these moments aware of all the other voices in me that whisper yell and barf something like … mmm yeah well I don't know I don't know I feel angry I beseech I explain I tell it like it is at this moment in this context aware of all the others belying my I my I is only one point or many in a dialogue address monologue or soliloquy. I am and am not certain and sure I am sure in brilliant bloody flashes. The I that speaks with irony. The I that is automatically usurped by body language and inflection and timbre and raised brows and stroboscopic laughing or crying eyes.

I dispair/despair … I can't really tell you about existential(istic) elements because in the moment which I speak I'm not there. I have my own eye/"I" which speaks from so many pulses in my being who can understand? Pornographic, hungry, violent, loving, selfish, imaginary and projected. This is something like poetry. I understand when someone like Lydia Lunch (a modern-day orator) speaks but I also realise I further embrace her inflections, insinuations and energy than merely accepting the given word she throws me (that is thrown to her) to chew on. I further digest the meaning behind the phrase which implies that this I (me) do some of the terrible work she has to do. This is an element of Lydia Lunch's work which she frequently addresses.

"C'mon help me out … so Jesus Christ I don't have to do all the fuckin' work myself here."

Then this eye/ear can glean something of the nature of what she is addressing. The dynamic of the author *not* as author-ity, or if posing as a macho authority realising the ironic and abject dynamic involved with just that. Something added to the wonderful ebb and flow and pulsional starts of her direct vocal address.

And I myself understand the frustration (impotence) of telling someone about myself (my subjectivity, emotions, personal cognitive and discursive experiences and opinions) to then delightfully realise that what I've said has been partially understood, and what I haven't said, what I can't say, has also been met, in part, by someone else's semiotic intercourses. It's marvellous, poetic, blissful, and painful. Painful and de-light-ful as only the human condition can be.

In this respect a Derridean attack on Logos is an attack on the metaphysical signified, in so much as the metaphysical requires the logical ego to make sense of its ostensible metaphysics. In short, it is a paradox in itself – which also says something about poetic abjection, in a manner similar to that which I have expressed. This *metaphysics of presence* is associated with a physical, able-bodied, logical presence. Being fully present to the relevant discourse (namely a singular discourse). Once one has broken with a logocentric presence in the

discourse (written or spoken) one no longer sees oneself as fully present. Instead the one (or other) is painfully aware of the points where one does not fit in, where one is absent from the mainstream and the alogicality or illogicality inherent in one's supposed assumed presence. This can be due to many reasons, such as sexual, somatic, or because of psychical ability or inclination.

Derrida picked up on a Freudian concept of the "trace". An idea which I believe has evolved (largely through feminist theories) into concepts of drive, libido, absence, presence, *jouissance*, "schizophrenia" and abjection, etc – as someone like myself would apply them. In the act of writing, the "trace" survives the text (and the text's impositions of absolutism). The trace is thus the repressed, the (sexual) difference, the *différance*, the re-remembered, the *déjà vu*, the *déjà entendu*, the alogical, the unconscious or subconscious desire and the drive (in a "schizophrenic flow" or deathly repetition). Emily Dickinson's work is hence not concerned so much with an "I" that has presence but an "I" that is associated with a repression that threatens presence (of the reader, writer and authority). An "I" that speaks in metonymical, abjectly female terms of an self that mocks, dreads and desires the normalised "I", with its poetry of personalised metaphor, and signifiers that work in a way that is "palatable" to many women but nonsensical to many others. It is a mutable I which "speech acts" (verb) the subjective bliss of Dickinson's own world. The magic occurs when her metaphors, for various reasons (namely to do with her literary skill) become signifiers to a signified that touches others' metonymically similar poetic drives.

Derrida never really touched on the possibility of spoken language denying the authority of the Logos, in the same way written texts have. But I feel that art and performance has reclaimed and subverted, most definitely – (through various channels of expression and mediation; punk, neo-punk (feminist punk), post-modern oration, "noise", time-based studies and contemporary performance art) the legacy of the spoken word of the father. And it has happened in myriad ways, for myriad reasons and to many intents and purposes. I do not believe that it is only in writing that the Logos can be circumvented; no more than I believe certain speech acts in oration and writing are neatly divided into the Logos and the non-Logos.

I also do not believe that Logocentricism reads phonocentricism; although I am well aware of the aural/phonetic dynamic. This dynamic would have the listener passively receptive to the sound. Passively penetrated by an aural force or at the will of a phonic phallus. I realise that there is a dynamic of speaking and listening – but believe many phenomena (namely in areas of poetry and performance) usurp this type of passive listening (simply by realising that semiotically we can all hear our own meanings). It would seem that there is not merely an ear which passively received the word of god – there is also a brain that interprets what is heard and a mouth that can answer and dispute and a consciousness (and wily subconscious) that can hear what it wishes to hear, or how it wishes to hear it. In this respect – although our ears are somewhat vulnerable to penetration – it is passivity we are questioning, the right or not to be an authority and maker of meaning, and not just the organ that is the ear and its aural function.

Someone says something to me. I lean forward – seemingly perplexed and say, "Sorry?" They repeat what they said. But I heard perfectly well the first time, give or take a word or two. I just needed time. What I really meant was, "I heard you but I didn't really take in exactly what you were saying. I didn't catch your inflection, your drift, your context." Either that or I refuse to take on that contingency, or agency. So, I'm forcing you to repeat yourself. The onus is somewhat reversed. Say it to me again – if you're quite sure you want me to hear it.

I listen a lot to loud music. Harsh, discordant noise that rocks a kinaesthetic dissonance. I close my eyes and can't hear specific lyrics. Or else I hear them and use them to my own accord. I hear the drive – the push – the trace – the emotion – the impossibility of believing what I thought I heard. I make my own narratives. The whole phenomenon becomes rather solipsistic. But within that solipsistic state I am multiple; describing my own characters – lovers and bass players, and with my own lighting effects, echoes, mixes, crescendoes, tears, whoops, loops. I make up my own words. I become the bass male voice. I become the voice. Loudly. I sing along. I scream along to all my favourite tracks. I am Mahalia Jackson in church. I am Katie running through the woods in red shoes. I am Esther in a blue smoke room telling the man to put no headstone on my grave. I am Diamanda turning into a loa. I am also myself. Singing words that sound like other words, and picking up on other words. I listen to gospel music although I am no such religious person. But just for the drive of it. The joy that for an instance goes beyond the word but also carries the dear word. And I am also carried by the word. The implication. Or else I actually use the poor word. Later, when I someday for some reason it behoves me to read the lyrics that were sung – I'm aggrieved, amused, unbelieving, dissatisfied and satisfied. Sometimes I feel I catch the right mood – sometimes I catch the right word (someone once sung – holy day ... blue mountains ... deep sea ... lilac ... return ... superstar ... sonic boom ... dead dog ... sensuality ...) – sometimes I make up a whole song. My imagery differs. It differs from theirs. A song about abject impossibilities of transcendence, discharges, street violence and retribution is to someone else a song about someone they once knew and manic street preachers. I listen to a lot of loud music. Noise. "Noise". Gospel. Neo-punk. Lyric-less acapella. Dirges in foreign languages. Polyglot litanies. Sound effects. Requiems with texts different to my *différance*.

There is the punctum prick that repulses and entices my own fantasies. The desire in the searing dilemma and conflict within my own sensibility. It would seem that no one who fully and wholeheartedly empathises and enters a sensate phenomenon can analyse it – she/he will only exhibit or describe it. Likewise, one who cannot enter or know a phenomenon cannot truly know it. It is, for example, nigh impossible for me to speak of the black hole of my depression from outside of it. I simply forget the very sensations until I find myself (and it finds me) within the darkest depression once again. Much of my descriptive language simply fails to travel with me into that dark hole; and even if it did – I doubt I would always have the energy to even pick up the pen or raise my fingers in signification.

Conversely with the tug of abjection – one's analysis is tinted with the

otherness of objection and the understanding of subjection. Modified by my repulsion, my sympathetic/empathetic sojourn this enables me to sketch (often in poetic sound) the histories and narratives; the topography of a given sensibility (in this instance a paradigm of poetics through sound). This paradigm – set as a model of the phonetic agency – isn't total, yet it is aware of its *différance*. For totalities (like absolutes and phallic metaphysics) rely on metaphors and figurations – which are often misleading to myself and those I am in intercourse with.

Within the arts and the conscious (specifically performance arts or time-based studies) it would thus seem that the agency of the aesthetics of Silence – demonstrates the dynamic of abjection. Let us consider, hypothetically, and within the context of art – this phenomenon. Firstly, let us lay to momentary rest the notion of women as being silent in real life – we can return to this later to apply the model(s) of silence to, especially in the contexts of aspects of the unconscious, and subjectivity and fantasy.

Art is no longer mere expression. It is no longer just a modernist typicality of realism that we concern ourselves with. Rather, we now relate art to the mind's need or capacity for self-estrangement, i.e. – our ability as (self) critics to distance ourselves from our creations, and assess our objective eyes in correlation or conflict with our projections; be they expressive, conceptual, automatic ... etc. Thus art is no longer the consciousness expressing and (re)affirming itself. It is an activity which harbours other elements of our psyches to reflect themselves back to us – to our conscious eyes and our unconscious desires or repulsions. Therefore, art has evolved from consciousness as its antidote, or catalyst, or analyst.

In estrangement the projectionised distance of mind to hand to media to form ensures conflict or pleasure from this mediation. With the self-critique it denies the realisation of any transcendence (unless the transcendence is one arising from the actual agency of abjection and the energised futility of transcendence occurring within a discursive practice or from an ideology). In this way I will and have posited that transcendence only occurs in an atrophied fleeting burst as the transcendence of aiming for transcendence! Abjection constitutes the self as aware of the eye's desires in conflict as both a goad and a melancholic stopper; and/or that which repulses the eye but attracts the hidden self. Its pivotal trope being the superego, or even sometimes the ego itself. This goad to the superego or id would seem a spasmodic flash of abject transcendence – never to be realised, of course.

Artists and performers have contemporaneously been tempted, therefore, to sever a dialogue with the audience. I think of Susan Hiller's 3rd area works. Silence is a further extension of this reluctance. If one is attempting to disqualify the arena of projected fixed meaning (in a try at something beyond the [social] consciousness of art) silence is ostensibly the means to the end, sometimes maybe the end. But, it isn't, hopefully, a disclosed cul-de-sac but an expansive and expansible space of potential. Of course, post-modernism has concerned itself with this dynamic in recent years. Or, maybe the artist will perform and speak to the audience but in a manner in which the audience cannot hear. A move to unintelligibility, invisibility, inaudibility – as an aggressive act *against* the

audience and its fixing of ego-ed meanings.

However, it is known that most digressive artforms (like the use of silence, unintelligible language or subversive poetry and performance) do not have lasting impact on our social canons. What once subverted or violated the given sensibility, becomes with the passing of time and the intervention of more challenging works – legitimate. This is obviously a concern of our 20th century. Our ability, as a social body, to steal the soul from challenging works or become immune to their powers.

From being invisible *it* becomes visible. Ugliness becomes beauty. Fashion dictates the day. Whether this is through compromise and from whom is the compromise extending – is a complex problematic. However, as we wade forward with our theories, that which was once transgressive becomes directly aggressive becomes allied (or familiarised to the point of powerlessness).

With the artist's aims at "unacceptability" she/he almost implicitly and inversely states that it is the audience with their voyeurism and projection that is unacceptable to the artist. Paradoxically, it would seem to be an intent of many artists to eliminate art. Maybe in favour of life. Or otherworldliness. However, it is blatantly obvious that the quest (brilliantly burning of itself) is for an agency of artist being wholly present in art and vice versa to the extent of total awareness of the dynamic of creativity and its translations. This paradox illuminates the estrangement that art needs and which the artist requires. I feel the desire to be literal, knowing of the fluke of literality and maybe because of it. The desire to actuality, knowing of the whims of mediation. This can drive the drives to negation. Or conversely, negativity (in a Kristevan context). A move closer and closer to silence.

The sensory, conceptual gap/space of the missing dialogue (the dialogue of abjectly supreme awareness): the ruptured dialogue (with oneself) – in which one fully knows all of oneself in actuality – short circuits a route back to silence. The artist is too proud to give and receive – to an audience that does not (ful)fill the ruptures or *différance*.

Susan Sontag, in her essay "The Aesthetics Of Silence", also mentioned such concepts of silence in the context of the art aesthetic. Silence as a decision. A suicide. Silence as a punishment. A self-punishment. Sanity is mortgaged at the price of transgressing frontiers; through silence. Silence as a penalty. Being silenced through censorship.

But, silence does not literally exist. For self or audience. It is no such property. There is no such thing. To look at something "empty" is still to be looking. Likewise, to hear silence is still to be listening; tuning in. To perceive of what is full one must retain a sense of the emptiness which marks it off. Vice versa, with emptiness – one must perceive other zones as full. Silence implies its opposite and obviously depends on it for its presence. The identity of silence – as a 3rd dimension – is always perforated by noise.

Thus artists must produce something dialectical. *A deafening silence. A full void. An enriching emptiness. An eloquent silence. A deeply resonating silence.* Again, we are dealing with the non-acceptance or non-belief in absolutisms, unless they come hand in hand with their own tragicalities.

Silence as a form of speech; within speech. One can recognise the imperative

of silence – but one may speak anyway. Even with NOTHING TO SAY one finds a way to say it; to signify one's staving off of abject silence.

If we take art to be an expression that there is nothing *to* express; nothing from which to express; no power to express; no desire to express – *with* the obligation to express – we encounter, what I consider to be, a wonderfully exciting premise. If we recognise the expression as an act that facilitates its own doomy pointlessness as at the very same time it verifies its existence, simply because it does exist – we can move to a desire for the aesthetics of the death drive – which also denies any absolutism of consciousness, but functions as its own reward, its own master. We have (like the artist) nothing to express and no desire to express, because we realise the abjection arising from others' fixed meanings and projections; but we are driven by art – for art itself has an obligation to function. Thus, the rhetoric of silence ensures we will encounter a rush of further critical appraisal for art and its mediations.

Language is a good metaphor for mediation. Speech however is immaterial. A human activity with an apparently essential stake in the project of transcendence (as Sontag mentions), because it aims to also move away/beyond the singular and contingent realising all words are abstractions. So in this respect – as language speaks us, it causes us to have a stake in its own moves to the beyond. Interesting – but also not utterly convincing. If language speaks us – and moves to the beyond (I'm not suggesting it reaches that "place") does it not also take us as ego-ed objects with it (and with it being the subject)? Also of course bearing in mind that language is for us impure and contaminated. Its double character – that of abstractness and the fullness of history – limits and liberates. I would posit that although speech itself is immaterial it arises from the "material" of language as its subject – and that the impositions we imply and the limits implied by it are sometimes correlating, often in conflict, often alternating, fluxing and changing. Thus the artist has her own meanings and/or lack of them, and can have a set of second hand meanings or fantasy meanings, that extend from the bands of being merely a object to the subject of language. I feel this is as true for written language as it is for the phenomenal and spoken word. That second hand meanings have been spoken for us/by us compromise language and also compromise us.

Silence engenders a STARE, Sontag posits. Different from a LOOK, which is voluntary and mobile; its focus taken up and then exhausted; its function carried to a conclusion. A stare is fixed, unmodulated; with no release from attention. Silent art. (Of course one could also posit that in comparing a look and stare with, respectively, a sentence or statement terminating in a thetic premise, and a semiotic space – one also does not have to conclude a discourse or even word with a thetic end nor consider a "stare" to be rigid or fixed, as in the context of a fixture of meaning. But for the meantime we shall take the "look" and "stare" proper as they are above described.)

Regards Silent Art. There is apparently no soliciting of it, no accosting, entreaty, request. It would seem to me that concerning the look there is also a visual narrative function that is concluded; with a marked beginning and a marked end, or thetic closure. Conceptually speaking, the stare has no mark; it

is thus closer to an infinity (in terms of a visualisation) or eternity – the closest ostensibly that art can get to such a phenomenon. Perhaps the SONIC stare can function similarly. Whilst ostensibly immobile (i.e. not making a trajectorial progress) in comparison to the more fleeting look – it is its functioning (or rather dysfunctioning), its lack of thetic end or punctum, that is indeed, on the contrary, very mobile. Mobile to no end. It is the camera which never fully locks into focus nor takes a static picture. It therefore represents an infinite soundspace, that displaces meaning before meaning can fulfil its function, and it disrupts the thetic before it can conclude.

In this respect, silence is a metaphor for non-interference (i.e. of meaning or stasis of meaning) whilst being static in dialectic dis-stasis. The only interference one can speak of would occur as the interruption of the finite. Again, a dialectic. Traverses of silence by other phenomena would destroy the totality of silence and its functioning.

Silence hence deals with absence. It demands that it does not demand the listener's significance. It annihilates the perceiving listener. It will not allow any meaning from the sonic voyeur. A sound barrier drags after the silence displacing given sound.

The performer (of silence) asks that we do not add anything to this silence. In contemplation we are entreatied to forgo; we must forget the self in self-forgetfulness. This "ideal" plentitude (of infinite) silence cannot be added to. Nothing can be added. Nothing reduced. If one does add – one dismantles one's self – one sets one against oneself.

If all objects are full – the listeners cannot speak once they *really* listen. What would they say? How would they even know what to say? How would they know how to say what they don't know to say?

The concept of the plentitude of silence (and this has to be a concept for as we have realised silence exists alongside noise not as a separate totality) as a full space – a deep space – becomes impenetrable. The silent person is opaque. Full and present to herself. Spiritual vertigo is induced – in a sadistic power play that is manipulative and one-sided. The silent person can be thinking everything or nothing. We do not know. The silent one could be secretly laughing at our futile attempts to explain and justify our speech. No narrative exists for our reference or even deferral. The only remedy – senseless noise – is only for the very ego-ed brave to attempt. Who wants to relate to someone totally silent? It is an activity that mirrors back on us our self-consciousness. How does one relate? The silent person is free of anxiety – free of the driving bonds of language with its absolutisms which limit us and speak us. The silent one is not in fear of putting her foot in it! She makes no Freudian slips!

In these terms of aesthetics, the artist is liberated. The silence is a mystical prophetical phenomenon. In actual terms, of course, silence is often imposed on women. Often we are silenced because the words speaking us are not the ones we really wished to choose. But in this paradigm of the aesthetics within a performance context we are concerned with the female artist/performer.

Language can therefore point to its own transcendence in silence and not through any phallocentric metaphysics or signifier. A speech *beyond* silence is dreamt of.

And as language points to its own transcendence in silence, the silent artist

can be its agent. Language becomes silent through us. We are the small silent objects of its tenure. In this instance, because we choose. A Speech Beyond Silence. Everything thought can't be said. Why would we wish it to be? Nothing said is true.

In the cases of silent women (not deliberately working with silence through the arts) we see a need to speak to waver the limits of our imposed supposed collective or homogenised subjectivities. In short, to speak before the words are put in our mouths for us. To speak to describe the abjection of the problematic of speech and language itself. To speak so we can disprove the projection of our stereotypes (or utilise them!). And bearing in mind that when we speak we are also spoken – we take the risk – because what is gained can be better than what is lacking. We will not surrender until we can speak our own discursive and cognitive subjective realities. But often this is not the case. We remain silent because we will not counter-invest to language and its systems. We instead become possessed agents – closer to infinity. We each must decide our paths. To speak or to be silent. When, where and how? I am not suggesting, however, that there is anything valuable or alternatively lofty in the aesthetic or function of countless women in society remaining silent. Silence should be a personal/personable choice. There is a huge difference between being silent and being silenced.

For speech can be helpful, integral, enlightening, relieving, and ... confusing. We practice giving speeches in our bedroom. We pre-enact the address, and account of ourselves, we wish to deliver. Often it doesn't come to fruition. Sometimes we grab the opportunity and we speak clearly. Often our words are taken the moment they leave our mouths and twisted up and thrown back at us. So we work very hard to be so careful and precise ... sometimes we wonder how all this semantic, communicative work is needed to put across one small point about ourselves. How come one is still not understood?

"It" can exalt, antagonise, stun and hurt – as Sontag points out. Language is used to inspire action, after all. Speech acts are invaluable and some statements are acts/actions in themselves. And action is vital. I swear! I plead! I deny!

Wholly within silence, the language system would, of course, fail. Meanwhile within language, silences has its uses. It provides space for thought. And as speech tends to a closing off/closure – conversely silence can keep phenomena and thought open. Silence signifies a completion of thought, however, insomuch as one can find final answers but in such a way that they aren't fixed or speakable. Silence expands speech; pauses make enable words to carry more "physical" weight or density. A speech with pauses would seem to feel the body's presence more. It can provide a trope that signifies the absence of the body, so signifying that the body is somehow involved. Or it can signify the pulses of the somatic being, and the pressures of the semiotic. Silence also undermines speech in that speech is often disassociated from the body, and its experiences. This is obviously highlighted by trivial-speak. It somehow can seem to run away from the body. However, a poetic non-linear, less-phallocentricised "I" speech, also re-embodies as it allows for ruptures and contradictions further towards a subjective "female" bodily expression; often by highlighting the absences of the "I" alongside the presences. What obviously often does *not* re-

embody women is a singularised phallic metaphysics of presence.

Do people want to say everything which can be said? Certainly our more current fashions towards the ethos of therapeutic practices with their encouragement to speak – would signal that many do want to say "everything". However, I would suggest that it is more a case of a desire to speak in a way that enables one to realise one's presences and absences concerning one's speech. I'm not suggesting women want to reach a reversal of the phallic metaphysics of presence through endless speech – but rather a re-embodiment which is possible through speech and speech acts that expand on singularised speech. I'm also not suggesting that women aim for a "female speak" that claims total constitution of the female body and experience – as this would merely be a version of the phallologocentric-speak. But, towards a poetic speech, which in itself appeals to the issues of absence, difference and myriad narrative. Statements which engender actions themselves (to be questioned), statements which deny actions – pauses which accentuate – pauses which signify a fullness "elsewhere", not susceptible to issues of phallic absolutism but of a beyond-speak which isn't gendered but appeals to issues of gender. And as society becomes more complex, so too must our forms of address reflect, not so much *all* elements in their totalities, but the dynamic of the complexity of such a notion.

If we lack words, we also have too many of them. Hence silence is reduced (to signify the gabbling woman, damned dumb) to a mere event before and after the important "masculinized" speech narrative. Poetry gives a depth to silences around words; spatially around, through, over and under words. Today's critiques of consciousness (namely within the arts; its theories, psychologies and semiotics) lays the balm on language. Admittedly, it does appear to have become rather questionable that all debates lead back to language, full stop. An interesting premise might be to destroy continuity! The building up of memory upon memory – continually piling the new onto the old gaps. Instead, to go to the end of each narrative – where one could ostensibly encounter *silence*. However, I find that I cannot "take on" this concept.

Narratives, be they master narratives, collective narratives or singular narratives, are interwoven like so many tiny gossamer threads and strands, that make up larger strands that make up larger wires which constitute the flex itself. Whilst some end, some overlap and some start up again. It is far too complex to reduce to the linearised concept of narratives starting and stopping (in singularity); for us to terminate them at a given point of "fullness". Whose termination and whose fullness are we discussing here? And to what purpose? One has to be thinking in a rather phallologocentric manner to believe that one is Full and Present, to then end a narrative. And whilst we can break down narratives (master, historic, social, psychological or subjective, etc) we cannot end them without due concern and without a given responsibility to the outcome, or an alternative angle on deconstruction and reconstruction. To destroy continuity thus, even for the purpose of embracing silence, is too much a case of polarity; as if there could only be one phenomenon, ideology or belief-system or t'other. This is a binary set-up – too much like phallogocentricism. I prefer to think in terms of embracing pulses of silence, *feeling* pressured silences, merging narratives and silences and a far larger multiplicious experience.

Language is its own concern. It is a mystery. When we talk for the sake of it, or rather to demonstrate its power to speak us – we perhaps make the most poignant point. But we can do that within the realm of the temporal arts, which often advocate a repetitiveness and verbose nature, and also aim to refuse linear constructions, and the role of the self-important (but unfortunately not the *self-conscious*, as this would indicate the agency of a semiotic self-awareness) I.

Thus, I wish to stress that the appeal for/of silence doesn't dismiss language. It has a high regard for it. It is simply respectfully cautious of its agency and the accompanying ideologies. In the same way poetics regards/respects the symbolic order, whilst, of course, attempting to subvert its monopoly.

A drive towards an irrepressible, interminable, inarticulate discourse. Maybe a reduced discourse, or inversely an expanded-semantic discourse.

To talk oneself into silence – as Sontag said.

The aesthetics of silence alongside the abhorrence of the void. A murmuring muttering talking of oneself into silence, also wards off the silence. What is left is a low-frequency, or soft high-frequency, or white noise drone or hum. Whilst written language may exist (or rather has be seen to always exist) in the visual (although I hope I have also given descriptions of how it may exist in the aural, imaginary, semiotic and elsewhere); oral speech exists in the auditory, and the latter has a psychic link with certain sensibilities. The sensibility of the pelagic spaceless space hums with vibrations. From this we can also form visuals.

The link between fixed sentences and silence. The link between the *choric* and the symbolic. There is no doubt that the spoken word can be as dogmatically phallocentric as the written, and vice versa. What we are discussing here is the linearity of the discourse or narrative. The fixed ideological (state) apparatus that constitutes such phenomena. And the fixed present I. Circular speech, loops of sound produced by using many microphones and feedback/repetitive techniques – reflect the equivalent, in auditory terms, of the new poetry that utilises broken lines, spaces, mixed grammatology, mixed or deferring signifiers, columns of different texts, unusual or poignant metaphor, etc. And is also wholly aware of the phallic signifier principle and can use that too – in pansexuality. To abandon meaning altogether would produce altogether *too much anxiety*. Meaning is – the use of. It is using. We need to use – as we are also used. Anxiety thus occurs when things are displaced but anxiety needs to be displayed and known. We should face anxiety, even if we cannot overcome it. Silence, paradoxically, although infinite, makes itself known to us through an absolutism. That absolutism is a plenum, of sorts. Same as we absolutise the *chora* (which ostensibly refutes absolutism) so we absolutise silence as a transcendence we can consciously know. Thus, again, I posit that to know silence *and* noise – is the issue. We should feel the push and pull of to-ing with the given and rebelling. That signifies our abject attempts at transcendence or even absolutism.

As Sontag points out – there is therefore a LOUD silence. This concerns itself with the unstable antithesis of *plenum* or *void*. It is sensuous, ecstatic, translingual/translinguistic; its apprehension of the plenum is fragile for it sees the terrible collapse into apocalypse, into madness, into the void that can occur. It is to see the end, to OUT live it and to set a date for the exhaustion of the discourse.

It is the abject who sees the flame of the abyss where consciousness and ego dissolve at *the* very same time as she realises that all meaning has collapsed for her to then speak of it.

This is the terrifyingly seductive and fearsome flash of brilliance that characterises this loud silence. Silence as the antithesis of the plenum, is to be taken to mean "antithesis" in the context of rhetoric (or dialectic), the juxtaposition of contrasting ideas to the effect of a balance. For example – "... as my words fly up, my thoughts remain below ..."

This is the razor edge – the powers of horror – between full void and empty negative void. Between the promised land (beyond) and the inability to even exist to even/ever know (speak) of it. In short – abjection.

I would posit that a performer, using poetics, can deal with a "metaphysics of presence" with a difference, and *différance*!

Each disclaimer disclaimed; each disclosure, disclaimed and unclosed (each ideology seem as an imagined relationship or a relation based on only a few actions of the significantly able); each Logos statement exposing its own fallibility – as in the phallus, which signifies the soft vulnerable penis fellated by a myriad-tongued mouth wherein each "absolute" ends with a *period* – demonstrating its own metaphysical inadequacies of abstract meanings – in its absence of fullness of blood – its variant meanings – its absolutism (in abstraction) estranged from its soft flesh, or turgid flesh, from the scream that follows it in indifference, denial, disavowal, repulsion, and delight – *for has not something de-lightfully magical occurred*?

A silence happens. Swallows. Beyond straining ears. The hum. The transcendence that almost fools. But for the presence absence pretence absent – ego egoless – continual play plot blissful play. Now, maybe this is a transcendence. An abstraction of presence. A somatic absence?! A subjective confusion?! An abstraction in phenomenon.

Multiple openings and closings. Differentiation. Entailing a serial of sequences, arrangements of fragments. Somewhere between an abstract presence and a play which seriously acknowledges its own absences. Even, its own absences from absence! In this way, I believe, the bisexualised being (through a constitution of abjection, as well as a finer state of pansexuality) can experiment with a paradoxical transcendence; of standing on the brink of personal fantasy with one's own neology and imagery, one's own hysterical fantasies of ideal lovers' bodyscapes, mystical schizophrenia, whilst being "mad with joy" at the pleasure in a subjective "beyond" where one's fantasy sexes cavort and fuck, and where one makes love and plays lovers' games with one's self; one even rapes oneself, and it is the ego-ed right of one to believe in this verity, coupled with the wretched disbelief in its actuality, or conversely the repulsion of its actuality.

Or, fearfully, a driven ego-less (impossible!) sexualised transcendence (impossible?) in the contexts of the multi-subject who is the I and is all the eyes never heard or seen, and whose meanings shift continuously on contact with The Meaning (picking up and dashing down its ego). Round and round in a thanatoid whirly-gig. In death drives – not to the inanimate but to the *chora* and

beyond, in repetition like nostalgia and memory. Like *dêjà entendu*. Something you thought you once heard – but you can't actually think it. You only sound-smell it – only knowing of it when you hear it again – when it comes again. When *it* hails *you*. *Dêjà entendu*. My abstraction of absence is constituted by my own fantasies. As surely as my metaphysics of presence is constituted by a collective by a collective fantasy, which I am also responsible for maintaining; as well as my own.

FANTASY – imagination unrestricted by reality (although many fantasies, of course, have a keen relationship with the superego, either being hindered or considerably spiced-up by a sense of imposed/self-imposed morality). A fantasy world. A creation of the imagination. A series of pleasing mental images, serving to gratify a need not fulfilled in reality. A whimsical or far-fetched notion. An illusion. A highly elaborate imaginative creation. A musical fantasia.

And Below
Kristeva asks of language that it be "incomprehensible" poetry, shamanistic, underscoring the limits of useful discourse – exposing what it represses – the PROCESS that exceeds subject and communicative structures.

For who would one wish to tell one's sexual or insane fantasies to? Although it would seem a contemporaneous necessity (a demand made of us) that we do speak our fantasies, dreams, reveries and what is (unacceptably) unspeakable. We are forced to confess. Confess to our subordination, inferiority and, as we have already discovered, our insanity. Psychology, in its filtered-out mass societal form – seems to inform us that we should communicate. It is this desire (society's desire) for all to speak of the unspeakable or the insanity – which worries me. To whose end are "we" supposed to speak, and speak, and speak – until we are "cleanly" purged of our maladies and conditions? If it is truly to the good of the individual woman, and also in another context, for the good of womankind, or anyone of difference, then I do say – "speak". But, I am no dictator – and realise that often to speak is to have the words twistedly appropriated for the good of the establishment's utilisation. Is it not also the case – that for the marginal to speak is for the centre to re-establish its own sanity and superiority of ideological systemisation and apparatus – in a mirror-ed effect (as we have also discussed earlier) regarding specularization and castration-anxiety?

So, at what point does society tolerate the manifestations of the signifying process in its poetic/esoteric forms? Does society need to know of my secret libidinal fantasies? If it does – why? To better understand "me"? To better align, lineate or judge me? To help me? Obviously it can be a case of all, one or either. I do not deny "help" out of hand. Neither so I presuppose that my fantasies won't be mediated. That they shall end up removed from the sight of production and I will be cursed by a castration from what should be my own attribute or self-production. I will be forced away from my own site of production by my desire or much needed inclination to speak of my own production!

However, I understand that mediation in all its forms has a basic function of translation (and loss) which is a necessity to peoples. However, it is the removal of my right to claim the site of production, through a desire (imposed by my

Catamania

superego or societal forces) which is problematical to me.

Kristeva asks – under what conditions does this "esoterism" in displacing boundaries correspond to change, or revolution? i.e.- when does it mirror social change?

This "esoterism" corresponds to social change when a communication is made between the relevant parties or peoples. Only when a mediation is made. How else would one know?

One could suggest: it is a sign of the times, in a multi-contextual, self-conscious, post-modern situation. My esoterism is also timeless in its (non)essence. It mirrors social change when it encounters and traverses the narratives or non-narratives of others, with which it crosses, melds with or bounces off of. Social change occurs when a people speak the device known to the central system, or reflect something that the system can recognise – then social change takes place, by a revolving (not in essence a revolution)) evolving expansion. It corresponds only in so much as it shares the repression that gives rise to the drives of others. We all have different value systems (or ideologies), but must adhere to given ideological apparatuses. Minorities (and women are not a minority – they make up half the population – but are ideologically regarded as a "minority") do not share the same agenda. Therefore we have to address the issue of sexual difference. But, also, we do share similar (pre-destined) dynamisms. We are brought (born) to the same language system; like a cloud that hovers over those who are aware of its power.

Following on from these ideas – I would like to reiterate issues concerning the "schizophrenic" esoteric poetic subject. And, to deal with the "shattering" – which is assimilated with the multi-subject (in my eyes). This(These) standpoint(s) (as such!) reveal to us how our capitalism (with its margins and its exploitations, for its own regeneration) doesn't itself remain strictly within linguistic norms. This we have noted previously (in varying forms). Capitalist structures, thus, often CAPITALISE on marginalised concepts for the continuation of profitable generation, *and* also on esoterism, minoritisation, and diffused or shattered societal ideologies. However – such a Capitalist Means remains still part of our system; which highlights the economic/political means by which *our* patriarchy regenerates and remains somehow beyond real infringement. The ability/capacity to take (or leave), but remain part of, its own constituency, and contingency.

So, to further back up what we have acknowledged, we realise the effect of schizophrenic esoterism or a fragmentary "shattering", in the arts describes a production of SUBJECTIVE SIGNIFICANCE/SIGNIFICATION. The marginalised sector can also, in other contexts, be what was named "sacred".

For the abject schizophrenic or esoteric poet, it is a case of "replacing" the *chora* or an experience similarly *"choric"*. I mean that this is the starting ground for all loss, desire, lack or split/breaking for such a being. Fair to say – many never acknowledge this phenomenon; it presents no pressure on some people's expressions. And the issue of loss (specifically this primary lost object. It is traceable to an object, although it is in my case experienced as a phenomenal and also subjective loss) is one which we shall address in the Maternal Voice section of the book. The abject poet with her violent drives NOT blocked or wholly repressed (say, through artistic means), will exist as one whose driving

drives flow through. So what replaces the bodily, phenomenal, societal OBJECTS those drives pass through is NOT a representation, memory or sign. The *chora* is already displaced, as we know. Displaced through the symbolic order; we only know of it through the order which is not its true-real existence. We know of it only because we exist in a reality that can name it. At the moment of the *chora* we could not real-ise it. Thus it can have no objective sign or memory constituting it. Any memory is a mediated memory (which is perhaps partially and poignantly true of many memories, as we tend to embellish on even those memories we can CONSCIOUSLY recall, let alone those we cannot recall except through current ideological systems). If we find our *chora* passing-through a thing-ly phenomenon – that thing becomes invested with the *chora*, and becomes the *chora*; for we know not of its inception/conception in symbolic terms. That is a contradiction in terms; and that is the abjection of the *chora*. Thus, what I know to be me, and my experiences, is a serial sequence of often contradictory fragments. All invested with drives. For my early part these drives are simply drives. A colour is a good colour but sooner rather than later – that becomes meaningful in itself. It becomes a subject that speaks me. That signifies me. I become an object to it. It is an experience in itself, an ideology – it is invested with all the power (and somehow more) than I gave out, in my gushing, semiotic, amniotic flood (that knows no signification).

A sound – that I thought I once heard – but know – for sure – I didn't – I only desired to hear it – becomes a sound desire in itself. When I hear that which my drive has passed through – why surely – I tell myself – that is the real thing. It is *dêjà entendu*. Sweet *dêjà entendu*. I've heard that before. A song – a tune – a beat – but it was simply the lilt I was waiting longer than a lifetime to hear. *Dêjà entendu*. Mnemonic sounds.

The subject in process – Kristeva would say. The subject in progress, regress, loops, circles and on (self) trial – I reply. Not a unity. O, a unity albeit multiplicious is still fixed. No, a plurality of totality (I am after all one medium-sized female being) but one with an-other which has NO identity – other than the place/site where the drives apply. What a thought! What a terribly sweet thought!

This "body" (to myself; regardless and regarding of imposed ideas of self) cannot fit together again. But of course not. I was dropped. Broken. Thought it would be alright. Thought a phenomenon would occur by which means I re-constitute myself. But, I am set in motion, ONLY by the practice that encompasses the signifying process. Gathering sand and water through fingers which grasp and clutch but allow (how?) grains and fluids to slip through again and again. On and on. A small child running on the beach trying to fill a moat of meaning with the same waters. Running from sea to shore and back again in my attempts. My signifying practice starts at this juncture. Of fragmentation – in correlation – moving to drives.

This practice has NO addressee who can understand it. Why, I don't even address myself. Pointless – not part of the dynamism at all. It SWEEPS ALONG. Everything belonging to the same space. I collect fragments that remind me of MY (subjectively significant) self. Units in process.

Although this damned story does not relate to the readers, as being a "one" or a whole body of readership – it is conducted by one who is all. What else can

I be? But, all to myself. And whilst I have delusions of being the almighty subject to the masses (at frequent moments in the room of my own) I am aware (if that is the right word) that I cannot instigate being such a godhead – but I include others in the upsurge of transformation and subversion.

I know that you are not my fantasy lover (I wouldn't even allow you to be – I learned from that mistake aeons past) but ... you remind me of a fragment of a lover – so the possibility for play is there – so why not come out to play?

In enunciation (the narrative based on "I") there is room for other contexts. Thus we have the matrix of enunciation which radiates towards other components of productive space. Anyone can produce or reproduce (fantasy, narrative, discourse ...) after a fashion – capitalism has at least given us this much. Thus, the basic cogs of signification can be touched by us all. I can have my animus fantasy – you may understand – I may be reproduced in yours. And on. This production/reproduction in a way colludes to aid the survival of the schizophrenic. It broadens the human experience beyond boundaries, but, importantly, it is still connected to those boundaries.

The DREAM OF THE NON-EXISTENT GOD. In this way – schizophrenia is synonymous with atheism. Or even agnosticism, as I have noted in my book *Bridal Gown Shroud* within the essay "Speaking In Space".

No absolute godhead exists (for me), conversely, the godbrain that does exist (my own fragmented, libidinal drives) is un-mediated, non-represented, and an impossibility in those terms. And I cannot fully convince myself (though I can dream), seeing as, although I am invested with a "collective" consciousness or ideology (even though individual egos *and* superegos do differ), and even collective unconsciousness (of course) – I/we/it/they do not know whether my FULL present psyche could be god. Given that godbrain should have no "human" ego, superego or id dilemmas to attend itself with.

Let us consider four signifying practices.
Narrative. Metalanguage. Contemplation. Text-practice.
These are paradigms of signifying dispositions. Narrative and contemplation are devices stemming from transference neurosis; hysterical and obsessional. Metalanguage and text-practice are allied with psychotic (paranoid and schizoid) economies.

These devices are implementing devices (devised by Kristeva) and should be seen only as such, for a means to a process. Let us look briefly at metalanguage, to then compare with the "schizophrenic flow".

Metalanguage can be seen as the suture of the signifying process. By eliminating the negative charge (i.e. in the semiotic *chora* we have a process of charges, drives and stases; we have helixes of anal and oral etc., which ultimately lead to a state of non-identity as we know it). This is such a negativity. This is not to be muddled with philosophical ideas of negation. Negation differs from negativity; negation being the act of a judging subject. This type of negativity which we equate with the semiotic is also not to be seen as the judgely negativity used in other contexts.

Metalanguage subordinates negativity to affirmation. Instinctual dyads are reduced to positivity (this helps constitute the real object [hence symbolism]) and the negative charge then withdraws into the symbolism. Thus the object is only real if disassociated from the positivity observing it – ABOVE it – HOVERING above it (like any phenomenon that is "meta"). The object is cast out and inaccessible; with no existence of its own and known ONLY from a position above. This is how we know of the object – through looking down. Hence, metalanguage works a similar dynamic to metaphysics. One could say that the object is known only through being raised by metalanguage through affirmation (an affirmation bestowed on it already) by being *observed* by it.

Thus, metalanguage subsumes the individual and even the clan or family. Its enunciation is a "we"; an anonymous "we" of the State, who doesn't question the intervention of this metalanguage, or how the object emerged from material discontinuity (with the aid, of course, of negativity) – because this emergence is produced by the very same negativity that the logos of the subject (of the State) represses. Because, supposedly, heterogeneity is eliminated along with negativity, the addressee is an indifferent subject, or a "we" who is ostensibly everyone. An undifferentiated totality NOT in process, or on trial.

Diamanda Galás has utilised the word "metalanguage" with great irony and deliberation, in her works (in fact her own record label [company] was called Metalanguage). We can take her use of it to indicate how the metalanguage in a biblical sense (this refers to her use of excerpts from the bible, alongside her own biblio-speak) can be usurped, subverted and also used as it stands; as a "we" that we know has denied us the negativity (and difference/*différance*) "we" know does not exist!!!

By using the meanings of "good" and "bad" in a metalinguistic manner – Galás sings the good (and bad) that has arisen from the repression of heterogeneity.

And by using a "schizophrenic flow" – she shows us, not the "looking down" on the object (which has emerged from elimination) but the negativity which is withdrawn into symbolism to then emerge the other side – in the Down Below (this *Là-Bas* [Down Below or Down There] is to be taken in a poetic sense, as used by Huysmans, and also Kristeva and very much apparent in the works of such writers as Céline, Artaud, Baudelaire as well as an underlying theme for many feminist writers such as myself).

This Below (as opposed to the Above of metalanguage and metaphysics) then, concerns itself with the individual. In Galás' case, the individual with the HIV virus and/or AIDS; and the individual who opposes the given reality with his/her own esoterism. A poignant comment on the dementia often afflicting those in the latter stages of the AIDS illness. In this instance the Below is not to be associated with previous associations of Romanticism/romanticism, but is a painful reality of abjection and suffering. A reminder of the real damage done by our imposed affirmation in signification.

"Schizophrenic flow" – derived from modern literature, and now present in much performance work – exists through and ONLY through language; appropriating and displacing the signifier to practice WITHIN IT the heterogeneous generating of a desiring machine.

The semiotic *chora* only acquires its status *after* the break (instituting the symbol) has been established. The semiotic *precondition* of symbolic/semiotic functions within signifying practices are a result of symbolic transgressions. As we have already established – the semiotic that "precedes" symbolisation is only a theoretical supposition; justified by the need for description. We know the semiotic is indescribable without symbolisation – and we feel the strange relation between the need to describe and the indescribable.

As the semiotic can never overtake the symbolic – it makes itself known through textual practice in the form of semiotic pulses/pulsions. Releasing the pulsions is a predominantly anal activity of *expulsion and rejection* (although another activity may, of course, be oral). In textual terms, this is negativity. It masks the "death-drive"; probably the most fundamental pulsion or drive. Analysable through absences, ruptures, breaks, contradictions and certain themes that seem to preoccupate the author/speaker; for example – thanatoid obsessions, repetitions, obsessions with waste products or expelled bodily phenomena, nostalgia, yearnings for fantasies that overtake the possibilities of reality regarding secret "other" lovers or otherworldly states, intense emotional obsessions or paranoias ... etc.

Expulsion of a fixed "I" is apparent in many performers' works. The thematic reoccurrences of rebellion, ostracism, subversion, dissidence, marginality, sexual difference or "anomaly", preoccupations with anality, fecundity, repetition and death; the drive to a state not known to the order (either pre-symbolic or post-symbolic); preoccupations with "apocalypse", necrophilial interests or translations; satanism (in its philosophical and not cultish terms, for the true abject always stands alone!), black holes, poetics of nearly all kinds, Ecstasy (in personalised, philosophical terms, although this may correlate to religion or the use of the drug MDMA as used by "dance" or youth culture). Again, this is much more truly applicable when referring to an individual drive and not one necessitated by the masses or a specific group, clan or tribe. Transgression for transgression's sake and more; negation of ideologies, negatory ideals or tactics and politics. Third space endeavours. Terrorism for terrorism's sake, etc.

Many of these phenomena concern themselves with outside-ordered transgressions, and many with true-real individual transgressions. A transgression has more impact (for the individual) when it is only the individual who is transgressing. Let us not get mixed up with pseudo-political subversions of those who merely transgress, in order to re-align themselves with a "fashionable" or *outré* party. Like abjection – this kind of activity is not to be muddled with amorality, or even immorality – except in extreme cases. And so too is the negativity at work in language not to be muddled with counter-groups who utilise negativity's apparent "pluses" for their own ends.

So, this is negativity. But, as marginality differs so does acquired negativity. All marginals do not share all "common" ground, or drives. "Schizophrenic flow" markedly makes this distinction.

The explosion of the semiotic in the symbolic is not a negation of negation. Nor is it something that suppresses the contradictions caused by the thetic established in place of an ideal positivity; restoring pre-symbolic immediacy. It does not function itself in a way that could be said to be negating. Negation, as we know, is the act of a judging subject; therefore to *negate what negates*

suggests that the symbolic itself negates and the semiotic simply negates that.

The semiotic is a transgression of position. In supposing the thetic, it de-synthesizes it. In extremes negativity seeks to foreclose (hinder or prevent) the thetic. After a while of explosive semiotic motility there may result a loss of the symbolic function – as in schizophrenia. However, this is an extreme. For most of us the contradictions caused by the thetic in place of positivity is something to obsess us as negativity obsesses. We realise it does not make for a pre-symbolic experience – we wretchedly revel in the fact that the semiotic comes to us – like negativity – through the symbolic.

The subject of desire – confined within two boundaries.

Firstly, residing in the intermingling of drives in language – as opposed to the repression of drives *beneath* language. In this event, in the economy of "poetic" language, the unitary subject can no longer find his place and the drives tend to proliferate.

Secondly, the second boundary is constituted by the stopping of desire to the extent that the subject has attempted to remain on its path. The subject stays on her path with her drives. And those drives must "go" somewhere. When language is not mixed with desire, instead what is required, is the extreme repression of the drives' multiplicity and/or their linearisation in development of the unitary subject. THIS results in the culmination of the subjugation under the Law of the Signifier, in which the living person becomes A SIGN, and signifying activity ceases. This masochistic moment *par excellence* is an auto-castration; a suicide in living death. The final mutilation, not unlike its theological/spiritual comparison.

It is the body as a "calm block here below fallen from an obscure disaster." (Mallarmé)

It would thus seem that the subject can intermingle her desire's drives within language: most people can do this. Most artistic transgressors choose not to. They go further – the unified body can no longer be known; too many absences, thetic stoppages and foreclosures – and so the drives spread – maybe sometimes, diffuse. Some are still not content with this. This is what drives one "mad". Then, one either has one's drives' multiplicity repressed (i.e. one finds that language cannot accommodate ALL of one's drives at any one given time) or/and one finds that the journey of the subject (multiplicious but still unified) is a journey down. Underneath the laws of signification – one becomes the ultimate signifier oneself. One becomes any or THE word of meaning and (self) recognition. This is acquired through the sacrifice of the self. Abjection is almost played out. This is the space Down There which we cannot speak of. If I go there to tell you of it – this fearful, apocalyptic, pyrotechnic gamble – I do not return to tell you of it. And the messages I send you mean nothing without the signifier, and I am the great signifier-lost. The catatonic body of the clinical schizophrenic. "The pound of flesh that life pays in order to turn it into the signifier of signifiers..." (Lacan)

For myself, personally, this is the price of much transgressive poetic work (and also *some* feminist work) which I largely interest myself with today. This is also the pressuring price of my own work. I need say no more!?

If negativity is the mediation between the "ineffable" mobility AND its particular

determination (in our system) – for we only know of it through its determination – then, negativity is the organising principle of PROCESS. In this respect, negativity is the expression of the objective process. Having to make all our *déjà vu* dreams and memories, and all our *déjà entendu* hearings, actual.

Desire is one moment that constitutes self-consciousness. Let us feel. My desire marks me. Stigma. Self-consciousness is negativity. The push and pull between my all-out-drive ... yes ... yes and the realisation of my goal (gaol). The point where I self-consciously realise I was seeking some kind of death-drive to oblivion.

I desire the object (or other). At this precise moment my self-conscious denies this object. To desire is an eradication of the self and ego (the self is not whole, not quite enough, incomplete ... whatever). The other is negated (or perversely the object can be projected onto) and reduced by a judgely eye (I). The eye cannot believe and will not believe that this object is really a true-real (desired) part of the self. If it is really desired for the self – than how come it is "out there" and not in here with me? The self returns, retracts ... then reaches out. In and out go the tentacles. Negation, affirmation, denial. Because we all have that thing out there. The thing – the "thingly" thing, the object we lost. Have always lost. We pretend we don't want it. Men pretend more than women, it would seem. Women can dress up and be that thing – they can even become that thing. That primary object of desire, the mother. I'm not implying one's actual mother (although you can get onto that tip if you so desire) I refer to a hypothetical mother (a pre-symbolic pre-mother mother) but somehow a true-real mother. Women become mothers and re-establish the scene of primary desire. This time they give birth to the little object/subject as if doubling up on themselves.

Desire will detour – via negativity – to a re-unification. Desire unifies and sublimates the schizoid rupture. Yes – we all desire. The schizophrenic desires her own dreams – her own *Là-Bas* fest. BUT desire itself *is* separation; me from my mother, from my lover, from you ... from myself.

The changes between self-consciousness and desire flux continually. Oralisation – the orator – the oral – a long-held-out-for-reunion with the mother's body (which is not motherly as we know it, but simply a huge pansexual entity). The mother's body is a vocalic body. It is throat voice breath breasts lungs heartbeat: music rhythm prosody paradigms poetry paragrams and the matrix of the prophetic parabola. It is "The Thunder: Perfect Mind" (a gnostic revelation by the entity of supreme polymorphity and pansexuality/bisexuality). And this referred to pansexuality is not sexual as we know it but pre-sexual in its pansexuality!

Only now do we know of it through separation!

Therefore what replaces the bodily social objects our drives pass through is NOT a representative, sign or memory – in an objective sense. We replace the *chora* – our violent drives to her are not blocked by the thetic sign or such. For the *chora* is already displaced. Out of place. We know it's not the womb or the crib or some pseudo-religious nirvana (although we may dream it constitutes these phenomena). Because what we knew of before "the before" we can only KNOW of now. Hence, why the *chora* transgresses the representative or sign.

Hence why the schizophrenic – with her body down below without a recognisable body – swings down below like a pendulum with the force of negativity – as if in a phonic timeless spaceless place that somehow (although this may be just my fancy) yearns for a LOUD death(drive). To be inorganic? More likely to be perhaps elsewhere and beyond. Solved. What is sought is maybe a combination of fragments invested with drives. Drives ... like some of our desires that flux between embarrassment and glory.

19. Lend Me Your Ears

Rock's hegemony has always been indubitably phallocentric. With exceptions there has always been a virile pelvic thrust to rock (and other musical genres), supported by phallic guitars, organs and drums played with the "masculine" vigour and sweat of the most machismo-ridden testosterone-producing hero. The heavy rhythmic coital thump; the male singer addressing the envious men and desiring women in the audience. Rock has also based its mythos on a certain misogyny. The men are active; the women are passive. Boys play guitars; their girlfriends listen. Whilst musical genres such as rock and heavy metal have always been male bastions, in other genres such as pop, dance music, indie-music, soul, etc., women have always been more active. But then some "law" has always decreed that rock was serious music for the boys and pop was throwaway trivia for the girls.

How did "rock" and also heavy metal become so entrenched in its own perpetuation of phallocentricity; so absolutely self-absorbed in its own symbolism of tight jeans, strutting dances, long hair, raspy voices, skulls, leather, and other sad paraphernalia? It's doubly perplexing when these male rock "gods" sport the assumed contrived appearance of drag queens (trousers so tight they look like tights, long thick hair and high screaming voices). Gender is bizarrely awry within the rock world; unfortunately, with no scent of irony on the horizon. Whilst there is undeniably a plethora of female rock singers and musicians (after all "rock" is a confusingly broad category) it somehow differs.

Rock's lyrical content is also wide and vague; a good thing in itself. But what has not changed is the persistence of the supposition that the enunciator be male and unquestionable in his expression. This is strange when one considers that rock was born from the rhythms and beats of R'n'B, the blues and early soul (gospel too, for that matter). None of these types of music could safely be called phallocentric, although male bravado often featured in blues and soul, which although often scornful of "the woman", nevertheless arose from an abjection; a paradoxical sense of uncertainty and the need to find oneself within one's music. A re-affirmation of life; especially to the soulful singer whose pain initiated the music. But it was never a confirmation that was so boringly absolute in its narrowness as to eclipse other sides of the story. The female singers would answer back; describing their side of the social and sexual story. I have always believed that there is an undeniable issue concerning the human condition to much blues, soul and jazz music. It's there in the realisation that blues music was sung amongst slaves to keep up morale and pass secret coded messages. It's also there in the rhythms of swinging jazz; or the cries of suffering in ballads. Like true Greek tragedy.

The discourse of such music is thus in "the undefinable"; it is in the possibility of the music playing you, rather than you playing merely the music. It is truly poetic in that myriad meanings open up for listener and singer. The points between delivery, interpretation, projection and reception blur. For this reason

gospel has always fascinated me. I prefer not to take the lyrics at face value; I have no interest in a subjugation before the Christian Lord; but I have a great heartfelt interest in a subjugation to my desires which themselves sacrifice me to a power I will never understand. But I allow the lyrics to weave their own meaning from my presence in the face of gospel. I hold a fascination for a state of higherness, a *dénouement*, a grand retributive finale – that knows it can only sing of its greatness whilst the musical poetry lasts. That in order to reach this "Lord" I would have to end my subjectivity; my ego. It is the knowledge that I have to *utilise* gospel music to make my own religion because I lack the gravity of the faith of the true believer. Because I'm always having to mediate; except at rarefied moments when I truly lose myself in another's woman's gravid voice.

It is the fervour; the otherworldliness; the belief that arises from pain or necessity that flies above the mortal word yet hangs strangely tethered to the word, which is its master. The music itself is a lover who betrays you; seduces you and yet stabs you in the back. It is a two-faced friend. It is oxymoral; a beautiful tyrant.

So my pleasure is never so great as when listening to Mahalia Jackson, Marion Williams, Dorothy Love Coates, or Cora Martin; or any woman who has suffered and has bided time, singing so gloriously about their belief that their time will come. And of course, it also makes me cry. It seems that the male "Lord" whom they address isn't the same as the Christian Lord in many Western churches. Rather he is signifies a state of supreme re-affirmation in a new freedom. He becomes the metaphor for the point of "calling in all the injustices against the woman", for she has been bearing the brunt of others' sins for too long. In this respect, it is strangely realist; and psychologically significant. And any bowing down that they may do before the Lord becomes a bowing down in front of their own liberated selves. It fascinates me how a misogynistic religion can have its signifiers changed to become a religion whose Lord signifies feminine suffering: a Jesus who was in fact a woman, but is only seen by men as a man.

Let us now move forward to contemporary music. In the past few years I've attended hundreds of "indie" or "underground" gigs. Mostly U.S bands. This "scene" presented itself as subversive; as did punk. And both scenes were subversive to a point. Punk gave us many expressive, authorial female performers. I personally never want to forget that punk was above all optimistic. It was "dangerously optimistic". However, in general (*pace* Slits, Clash, Rotten) it gave little consideration (but then again why should it) to the subversions forwarded by young black culture in the 70's and 80's. Black youth brought its own dress-code and subversion; however there was no appreciable cross-over until many years later. Sports-wear and the specifics of black dress-codes meant little to punk. Punk didn't appreciate the disco hedonism of the 70's; it was only in the 80's that casual-dress was appropriated by the "underground-indie" scene.

However, the punk backlash gave us "middle-class, white boys" fighting battles with their rich fathers; and women who had to subsume their discursive powers of femininity under a mantle of boyish rebellion, which is seminal in itself, but loses impact when one realises that women had no discursive powers to surrender to androgyny in the first place. I will discuss these issues towards the end of the book in more detail. In short, women become boyish before they

were fully respected for being individually female. It's the "melting-pot" syndrome, only as it is applied to gender rather than race. An eradication of difference *before* difference is accepted, in my mind, leads nowhere. However, I wish to stress I am not by any means wholly dismissing punk's contribution to sexual politics or female expression. That would be premature and plaintively misinformed.

The "underground" or avant-garde music scene that rose up out of America in the late 70's and lasted through the 80's also assumed radical subversion in its anti-credo. I regret having to write about a "scene" or "movement", as this obviously detracts from individual work, and most performers do not set out to be part of a movement. However, for the sake of quickly communicating a point, I will resort to generalisation, in the hope that the reader take into account the fact that my generalisations do not commence at a point of rashness. At that time, it seemed I was the only black female in London, regularly attending "underground" gigs during the 80's. Correct me if I'm wrong.

After a while, during the late 80's and early 90's, female friends and myself noticed that men still predominated the stage and women were still placed in essentialised roles within the songs' subject-matters. After a while women became "popular" and moreover desirable within indie-pop-rock (it's amazing how one can anticipate a "fashion"), but one could also anticipate a Fall approaching.

Women still attended gigs on the arms of boyfriends who paraded them like fillies or mannequins (albeit "subversive-looking" mannequins). When Riot Grrrl hit the U.S and Britain and several women tried to hand out fliers and information (regarding female networking) to other women at gigs, they were to find the male companions of these women complaining (scrunching up the leaflets before their female companions could read them; threatening-off the leaflet-ers, or becoming aggressive that they didn't themselves receive leaflets). The shock of realising this "subversive" scene was in fact determined to prevent "subversive" women was almost overwhelming.

I hasten to add that the opinion of the male audience obviously often wasn't that of the singers and musicians (who were performing during the 80's). It was as if the male listeners were continually missing the point; and according to the opinions of many of the actual performers of the time this was to prove an ongoing frustration for them.

However, many listeners had known that sexual politics had always played a large part in the subject matter of the music. Many of us had listened to the early works of Nick Cave, Lydia Lunch, Foetus, Sonic Youth, etc. – who always addressed the issues of sexuality, be they pleasant or not so pleasant. These works were exposés, documentations – they were not purely mindless gratuitous forays into the areas of misogyny and abuse. Other American bands followed but even they could not stop the myopic, irresponsible, head-up-their-own-arse, wanking tactics of some of their male (and female) "fans". Those parasites who sucked the juices from the performers without adding their own contributions; wearing insignia to conform to something they also paradoxically claimed was non-conformist! So delighted to be *outré* that didn't realise they were just the

same as every other sad fucker who wishes to be *outré*.

Just as they did it with the Sex Pistols so they did it with the Birthday Party and, most notably of recent years, they did it to Nirvana; despite Kurt Cobain's pleas that he wished sexist, racist, homophobes would get the fuck out of his gigs.

But one of the largest, and also paradoxically the most underhand (hence understated), media backlashes was to be against Riot Grrrl by the largely male music press. Silly really when one considers that Riot Grrrl was never a "movement", never a claim in itself, simply a "verb" by which women could identify each other and network with each other. Because of the continued failure to extract a manifesto from several bands, that had young feminists in them, the music press turned to sour old tactics of prejudiced judgement.

Riot Grrrl remains a confusion in many minds, probably because many people expected a movement and not a "verb" (i.e. a thing any woman could *do*). But many women suffered from the invasion of the music factor. Afterall, Riot Grrrls were never solely occupied with the music scene. And we weren't all teenagers either! It was whatever one wished it to be.

It is doubly ironic to consider the music press using such tactics on the current favourites (who are largely bands with boys in). There are always *current* favourites! BritPop/Britpop is, I suppose, the new indie-scene in this country. There are many women involved in the scene. Many women who want simply be in bands and not to have those bands dubbed as "girl bands". Of course, that's understandable. But until sexual difference is re-addressed – the audience and the journalists will apply those same rules.

Some Riot Grrrls tried to make Riot Grrrl riot the way punk did at the very beginning before its inception was ever debated or vilified or bastardised. It is still my belief that the verb Riot Grrrl can riot in just such a way. It can be cruel, indulgent, subversive, and esoteric – and optimistic – just like punk. I am forced to say I believe that Riot Grrrl suffered from women who were fearful. Fear will always play a part in subversion (as it did in punk) but it can be a *balanced* fear. I still believe that there will be women who will get up and sing and perform the sorts of terrible nightmares and glorious shamanistic rituals that many women need to perform. I believe music can move in that direction. I believe that women will get up on floodlit stages in appropriated costumes and sing mad operas, multi-octave operas, accompanied by repetitive basses and drums, until the audiences are stunned into believing they are seeing women's heads changing into a hundred different roles. I do not believe women have to hum along to the latest music "fashion"; only if they believe they can do it very well and *for themselves*.

I believe things are gradually changing. People respect Patti Smith, Exene Cervenka, Debbie Harry, Siouxsie Sioux, Lydia Lunch, Lesley Rankine, Kat Bjelland, L7, Courtney Love, Kim Gordon, Bikini Kill, Liz Phair and many others – for being individuals; aside from journalistic opinion, I hope. Many like Diamanda Galás have set a new precedent, to my mind.

It's a shame that I am *not* surprised by the male backlash. It is a male bastion; and fortresses (on which selves and egos are erected) must, it seems, be protected. All too often it seems that record companies hold up paradigms of "successful" women just to prove that they are really giving women a chance. The answer is therefore to form your own record company, production company, publishing company, management company, band, co-operative or whatever. Pipe dreams maybe, but not always, as many women will testify; myself included.

Is it true that women who make it within the "pop" world are only *allowed* to do so? Only if it's financially viable; a good investment; a fashion that "they" (the bosses) can exploit. Are women puppets of corporations? Are they clothes-horses and vessels to sell the latest "feel-good" lyrics? But they surely know life is a merri-go-round of P.A's, contracts, short T.V. appearances and designer coffee-table albums, don't they?

They get paid – we get the sounds; the double compilation album to play at parties. Pop is a whirly-gig of sensuality that you don't want to keep around for too long (only unless it's a band that's *masquerading* as a "pop band", in which case *their* pop is extra sensual because you know you have to grasp that goodness all the harder!)

It's the one-night stand of music.

The blues will haunt you. The blues is "the husband" who keeps coming around telling you what a mean bitch you are and demanding to see your beautiful children. You're experienced, so you know all about the pain, and you know the score.

Soul is the "well-hung lover" that you dress up for; who keeps singing in your ear and taking you to late night jazz spots; telling everyone how fine you are.

Indie-music (as it was in the 80's) is "the criminal"; you get in a fight with him and smash the whole bar up between you, fling insults at each other to arouse each other. Or else you never meet; instead you just write poetry to each other.

Pop ... pop is the fuck you were never really holding out for. It was the one you ended up with. Not dangerous but so very sweet. You felt obliged to take him back to your place; (you were tipsy and he seemed nice). Come next morning you wanted him to just have a cup of tea and then leave. Your "brother's friend", unsexy in the daylight, someone you did silly dances with (which you now laugh about).

Later, when you're much older you get to thinking – he really was very sweet. That's the point when *nostalgia* hits you. And I kind of miss him. All uncomplicated and shit. Pop music is nostalgia. A lot of dance music is also nostalgia but its sexual politics are also like those of "soul", as I've described above. For instance, there's 70's original disco – it's your childhood-lover come back to haunt you, only now he's looking like some mean sexy gangster (all those remixes and shit). And then there's other dance music – techno, garage, ambient, etc.

All those lovely lurid, flourishing dance rhythms in the late 80's and early 90's – they were all sexual courtships too (cross-sexual, bi-sexual, pansexual, homosexual, androgynous, heterosexual, sex on lots of funny levels!). Even more

so than ever, because of the drug culture. Repetitive techno becomes the expression of the "waiting-game". Has the inclination for *sensual foreplay* ever before manifested itself so emphatically in Western youth culture? It promises multi-orgasm, whether it delivers depends on the individual. Men and women move rhythmically for hours on end, arousing themselves by repetition; adoring every move they make for themselves. Preening and preening goes on for hours and hours. Sex is almost a subsidiary to the dance. I firmly believe that dance culture (in its most intense form) is the future of the breaking-down of sexual difference; only in so much as the intense dance and music (coupled with the accompanying drug culture), somehow often induces a situation wherein men cannot erect their full phallogocentrism. They can exert their sexuality; as can women – dance music is often the most sensual and physically affecting of music – but men cannot assume the "old" roles of masculinity. Too many factors work to disaffect the male ego concerning dance music. The rhythms frequently change frequency. There are no ordered linear trajectories. The music may carry you along and then stop – leaving you standing like an idiot in the middle of the dance floor, before it lifts you up again to follow a new and more exciting rhythm. It requires an accommodation; a poetry; a generosity. It requires, dare I say it, a soul!

But let us return to pop. Pop is disposable but it haunts us. This is the real rub. We are haunted by our own vulnerability and self-consciousness; because these songs, these tunes, these regurgitated samples *only* relate to us and our memories. The agency of pop is therefore enormous and quite duplicitous. It doesn't care if it makes fools of us. And because of its nature there is no dignity to its seduction of you. One can understand the problematic of losing the self in the blues and in soul music. One can forgive oneself for being swayed (literally) by indie-anthems.

But can one admit to oneself, let alone another, the blushing (and excitement) caused by our attraction to the pop-song? Well, pop forgives us – so why can't we? And more than anything, as most of us realise, pop is a modest soul.

Nowadays, we are lucky. We are saved! Pop comes to us in the borrowed jacket of its *big brother* (the big brother [or cuter mate] is, in this instance, "dance music"; be it techno, Balearic, garage, rap, breakbeat, swing, etc., or indie-pop) and so we don't look quite so desperate (even if it is all a bit watered down) when we're walking down the street with him (under our arm), or dancing to/with him in our front rooms and bedrooms.

Pop is iridescent, flamboyant, catchy, malleable and throwaway (and boomerang back). Its ability to make us remember outweighs literature, art, cinema and other media. It's the first love affair. Your first kiss; cigarette; sleep-over; disco. It's premature ejaculation, displaced adoration, the first realisation of something lost. It erupts in tiny sequined bursts of penny candy; ends abruptly! It makes everyone grin and look around the pub table at their collection (selection) of friends and go "aah" when it comes on the jukebox only to become terminally pissed-off with said song a mere 60 seconds later! It's the reason Nick Cave did a duet with Kylie (well, perhaps not the *only* reason)!

And you do get over pop. Until, that is, you hear *that* song again. Female pop-singers are part of a sweet fetishism. And the boy-popsters part of an even

greater fetishism. Fan-dom avidly devours its pop-stars. Its sublimated frenzy is as much a displacement as an arousal from a pair of stockings and suspenders, but infinitely more horny as most women who had a teenage "crush" will testify. Going through the rigours of projecting onto pop-stars. The very fact that young girls do not actually know the pop-star, of course, enables the projection to work. The pop-star is open to fantasy. He can be just the boy or man the fan wishes him to be. A signifier in her psycho-sexual growth. The separation of (or from) meaning, concerning pop, is its integral essence. The projected image, the kissed photograph, the made-up scenario that is highly manipulative on the young girl's behalf. Over-production, air-brushed images – these all signify access to a dream, that allows the girl-child to experiment with her new desires. The signified itself is the teenage mind; that is the short-circuit point; the end and beginning of meaning. It is unutterably solipsistic.

Most adult rock is therefore merely sad. It's only the indie-pop and hedonistic hypnotic dance genres that remain interesting. However, we are no longer pre-sixteen and pubescently open to an encouragement to use our imaginations. Or are we?

"Grunge" (as journalists labelled it, for us) brought us the dysfunctional masochistic anti-hero (ready to castrate himself from old values) – but many women had presupposed the bastard long before the press decided to critique his dialectic anti-discourse. We knew him before anyone. Wasn't he already *us*? One woman's "sensitive" shoe-gazer is another woman's tattoo-ed anti-christ is another woman's androgynous alien rhetoric is another woman's boy-next-door. I believe we had imagined them long before they appeared before us; like a case of retrospectivity. Like an internal examination. And these imaginings weren't essentialised but liberated from patriarchy; they were everything that women wanted them to be themselves.

Therefore, women, in their own way, most definitely do speculate and project. And music allows that.

VOLCANO

YOUR LIPSTICK SMEAR ACROSS YOUR FACE
NOW TOSS YOUR HAIR IN DIRTY GRACE
PINK LEATHER STRAP ON YOUR GUITAR
NOW SPREAD YOUR LEGS, HOW BRIGHT YOU ARE
UM M THEY'LL ALL KNOW YOUR NAME
COLLIE, CLAW YOUR WAY TO FAME...

there's a star in her eyes and she knows it
a star in her mind yeah and she shows it
there's a star in her eyes and she knows it
a star in her mind yeah and she grows it...

and every evening the sun comes up when she goes down
yeah every evening the mud fills up her bridal gown...

THE LITTLE GIRL INSIDE OF YOU

HAS MADE ALL HER DREAMS COME TRUE
AND TONIGHT YOU TAKE THE STAGE
YOU WEAR A DRESS OF BLOOD AND LACE
YOU'VE LEFT A STAIN WHERE YOU HAVE KNEELED
BUT, COLLIE, YOU'RE STILL INVISIBLE...

there's a star in her eyes and she knows it
a star in her mind and she shows it
there's a star in her eyes and she knows it
there's a star in her mind yeah and she grows it...

and every evening the sun comes up when she goes down
yeah every evening the mud fills up her bridal gown...

YOUR LIPSTICK SMEAR ACROSS YOUR FACE
NOW TOSS YOUR HAIR IN DIRTY GRACE
PINK LEATHER STRAP ON YOUR GUITAR
NOW SPREAD YOUR LEGS JUST LIKE A STAR...

AND I'D LIKE TO EAT HER BREASTS AND KNOW GOD
AND I'D LIKE TO TASTE HER FLESH AND GROW HARD
I'D LIKE TO EAT HER BREASTS AND GROW GOD
AND I'D LIKE TO SUCK HER BREATH AND BLOW HOT...

...

20. Lost In Film

Within this chapter, I would like to concentrate on issues of loss, especially as they manifest within the cinema and the filmic event; framing our views and dictating images and voices of women. Film often seeks to relegate woman and her voice to a dark, non-authorial recess (or interior), signifying a bodily, vocal and discursive impotence. In order to effect masculine potency as regards film (and this refers to both sides of the camera) women must pay the price. I wish now to explore in some detail – quite why women have been forced to carry the burden which then enables male potency; and importantly, what exactly that burden is? On discovering the "cost" and the dynamics of the burden – we shall then move on to, I hope, a resolution. We shall move on to examples of film and paradigms of theoretics that point to a female discursive subjectivity and a female authorship (which I shall point out now, is not a replicant, or flipside of phallocentric authority).

In past classic cinema, and even in modern cinema today – film often induces "woman" to confess. There are nameless examples of this. But what is "woman" forced to confess? And how does cinema operate to carry out this endeavour? It is not as simple as filmic scenarios of woman being driven (down) to points of emotional collapse, hysterics and frightened crying, or displays of gender-inadequacy; although as I'm sure you will agree, these *are* paradigmatic of many films. Whilst the inducing of woman to confess to "something" or to cry and display fear is a terrible misogyny in itself, I should like to delve deeper into the psychology of the filmic event – paying attention to why this occurs and also why the entire genre of cinema (with it apparatus, its visual components, its soundwork, its directors and producers, its crew and its respective mediational dynamics) seems indicative of a certain psychological drama. In short – let us look behind the scenes, to the site of production – as well as in front of the camera with its visual/phonic representations.

In her book *The Acoustic Mirror* Kaja Silverman makes many crucial observations concerning the psychological elements of film and its relation to women. I shall refer to her book often, as she displays a vast knowledge of film theory, and ties in these theories with feminist and psychological theories, in a way particularly useful to my propositions as regards such subjects. Whilst unfortunately I cannot, in this book, cover all the aspects of film theory I should like – I will nevertheless attempt to refer to the basic tenets of film theory as a foundation to my ensuing comments on women's representation, and later on, women's participation in cinema and filmmaking. I should also like to comment at this point that whilst I may discuss women's representation visually within film – I hope to show I am not drifting, at any point, too far away from our concern with the voice. As I hope to show – the issues surrounding female vocal authority – tie in strongly with issues of discursive authority as regards representation within film. And,

importantly, when I reach my discussion of the female director/*auteur* – it should be apparent that the voice is an integral element to my hypothesis.

Many films induce woman to confess without her conscious participation. Cinematic history seems to carry with it a fascination for the sounds and meanings generated by the female voice; for that which is projected onto her. The voice is included within the "normative" representations and functions of the female body. What I (and other feminist critics before me; namely Silverman) hope to achieve by exploring these filmic phenomena – is a critique of the voice that is increasingly flexible and commodious of subsuming a myriad of vocalisations (so that we can find ourselves) and to address the problematic of authority after the event (as it were).

At times filmic texts (as well as other texts) assume a metacritical function – but they also read "symptomatically". Castration precedes the recognition of the anatomical self (the sexually different self); a castration to which all cultural subjects must submit, since it coincides with separation from objects, and importantly the entry into language. I wish to comment (with Silverman's, Kristeva's, and other female and male theorists' help) on the important relationship between SYMBOLIC castration and the traumatic discovery anatomized by Freud. It may be helpful to the reader, if I, at this point, stress that I plan to further Freud's theories out of the realm that relates to the male as main participant and into the realm of the girl-child, and adult female.

One of the reasons I choose to include the filmic event within this book, is because I feel that is says so very much concerning the re-activation of the psychological trauma of symbolic castration; especially regarding the viewer. Importantly, we shall discover that sexual difference acts as a DEFENCE against the trauma of sexual difference, as we know it. It serves to protect the phallogocentric male.

Filmic events have been utilised to project male lack onto female characters, in the (dis)guise of anatomical deficiency and discursive inadequacy.

Film theory is haunted by the spectre of LOSS and ABSENCE at the centre of its production. This loss threatens and secures the positions of the viewer. It carries the possibility of displacement. Silverman, astutely, comments that the absence would seem to be the foreclosed real. By "real" I refer to a Lacanian term signifying that which is beyond signification. Death, sex that which CANNOT be signified or represented – fully, or REALLY. We are ostracised from the true-realness of the filmic event. We suspend (or not) disbelief. Thus, we equate this lost "reality" with the site of production (the behind-the-scene-reality); but it can be inscribed through the body. The Body Of Woman. This primary filmic lack seems to automatically find its representative in "woman". Identification with the female body COVERS the issues of the absent real. In this context – the female comes to represent what is lacking within our symbolic reality; the absent "real" and the foreclosed (retrospective and/or lost) site of production. These losses are absolutely incompatible with the phallic, by which means men usually identify themselves; know themselves.

Thus, a preoccupation with lack in film theory becomes a preoccupation with male subjectivity. It informs what is known (within filmic events and filmic theory) as "realism" or SUTURE. It is, as we shall discover, protected by a

monolithic heritage of disavowal and fetishism. How strange a word – SUTURE. Sewing together all the wounds – that I shall now unpick, to retrospectively reveal as very sore wounds!

Many critics in the past have actually wanted the issues of the unreality of filmic production to be addressed. After all, we all know we are watching, hearing – a simulacrum. Or do we? We should be (especially because of film's misogynistic and racist past) aware of the *production* of the visions we view. And the sounds we hear, in accordance with these representations. So, we should be aware of this unreality of film. Film is defined by the distance that separates it from our phenomenal order (that is the order of our social reality). There is an absence of reality, in so much as flesh and actual relations. No object or referent in physical actuality. Its relationships are therefore discursive (concerned with reason obtained through knowledge) rather than existential (concerned with human experience and being). In short we are dealing with symbolic representatives.

On the other hand – the camera traces the profilmic object and an existential bond does exist to link the cinematic image to the phenomenal world. This is obviously how we come to make "sense" ideologically of film.

Transitions from shot to shot disrupt our relationship to film. One image may suddenly be replaced with one – giving rise to an "artificiality". An arbitrariness. Montage transforms something real into something imaginary; and also substitutes absence for presence.

Silverman posits the query – can the photographic image be the object itself? A continuum of image and object interrupted only by syntax and metaphor? Is it a duplicate of narrational language?

What we have to consider above and beyond all else – is the issue of lack. Lack is intrinsic. We are, afterall, considering the loss of the real (that which needs no mediation). This is implicit in any realist choice. It allows the artist to use aesthetic convention; introducing it into the area left vacant (by mediation and lack) to therefore increase the illusion of the chosen form of "reality". One answer to this basic predicament is the physical presence of the actor – to carry the weight of necessary mediation, or continued illusion.

We should believe that the viewer and actor are never actually in the same place at any time. How can they be. No matter how much I wish to climb into *The Piano* (as Ada or Baines, or whomever) I CANNOT. I HAVE to consider (if not as a enraptured viewer, then, at least as a retrospective critic) the impossibility. Cinema thus becomes the theatre of missed opportunities; be they expected or retrospected. The failure of the meeting between voyeur and exhibitionist/ protagonist. There is a point of NO coincidence; unfortunately/fortunately. And unlike theatre, cinema is double simulated. Illusions through illusions. A representation of a representation. In short, we have lost the true-real event.

I mourn the loss of Ada, as much as I am glad of her distance; as much as I am angered by how she is spoken – for I dream of a "place" where I/we/she/ they do not have to think of her so apart from us. However, in order to desire her – view her beauty – I MUST be mediated from her, and her from me!

The transition from referent to cinematic sign, as a surgical incision. Film, in this way, is amputated from the phenomenal order. The object is severed.

Oppose the usurping of referent by sign. See MONTAGE as the agency of usurpation. Little fragments (then I can find her and me) and the chopping up of film (all over the editing-suite floor). Disrupting the expected unity that is natural to people.

Castration. Let us consider the viewer coming to the cinema. And cinema's structuring LACK. It foregrounds the viewer's personal stake in loss of object. I have lost it. I love it; it excites me; I identify – but I lack... I lack it. I therefore protect myself from this trauma through defensive mechanisms. If I can't quite accept this lack – I WILL make up for it by convincing myself otherwise. A female friend recently said to me – I cannot just let films wash over me. I challenge. Most people cannot do that. They want to believe.

And whilst a viewer might not QUITE believe, nonetheless his "belief" (disavowal) takes precedence; even though s/he knows full well s/he is kidding her/himself. Strangely, whilst we are never wholly convinced or deceived by a filmic image we are nonetheless credit it with a bizarre 3-D-ness. The screen seems to reflect the ebb and flow of our imagination; which feeds on a reality for which it plans to substitute...

Disavowal is facilitated by the construction of a fetish. A surrogate becomes the pre-condition for pleasure. Whilst estranged from true-real Ada-ness, I put in her/my propinquity a fetish of music. I am not sure if this is possible theoretically. But, I try to make my voice sing piano. I sing the piano-pain of fetishism.

Critics may suggest that a "good" artifice (within film) can be in itself a fetish (to compensate loss). However, Silverman points our that this posits a situation where there is NO suspension of disbelief, i.e. – the film crew accede to the loss of real, themselves.

So what we are left to work with is an IMPRESSION of reality. A standing in for the absent real; made possible by the ebb and flow of the viewer's imagination; i.e. – where a fetish is not only a substitute for the absent real but is confused with it.

The desire to find assimilitude speaks to the imperative of discovering a substitute to cover the absent real. It would seem to me that the music within the film *The Piano* is a sort of fetishistic substitute for women, and that furthermore, Ada's WILL and other-language (sign-language) bridge a loss, that filmically would otherwise be lost! However, normatively speaking (in the contexts of classic cinema and mainstream cinema), the fetishist(viewer) requires a distance from that which secures pleasure. For, this is true of all fetishists.

The lit-up brilliance of this theatrical representation enables The Glance. The fetishist does not make real his stake in cinematic representation. Fetishism is constituted by disavowal; hence the fetishist does not include himself in the realisation of the dynamics of representation. The relationship of the work and viewer mustn't enter the awareness of it.

However, as Silverman points out – regarding this impression of reality – there is no problem of the object which isn't also a problem of the subject. No loss of cinema, that isn't also a loss of viewer.

A child's entry into the symbolic order is obviously made at some cost to the child. Not just parts of itself but a sacrifice of being; a sacrifice of what was itself before it was established as a subject within language. The first separation occurs at the Mirror Stage, when the child gleans its initial perception of itself, through the internalisation of a culturally mediated image which is external. To simplify this – we could imagine the child's perception of itself being achieved through seeing itself in someone else's eyes. This also gives the child a sense of otherness; as it catches a sight of its own reflection. This process is one of subtraction, i.e. what is left when mother (a familiar object) is removed. There the child finds himself/herself. Subjectivity is therefore predicated on the recognition of the distance separating self from other. It is important to remember this in lieu of what we shall be examining later on in this book. And also to remind ourselves that this is an experience that is retroactive from within the symbolic order. We know of it now only through the symbolic order.

So the child enters into this stage which is an anticipation of self-mastery and identity. The child's grasp on its own boundaries becomes more defined with the severance of objects that it previously thought were part of itself. The mother's breast, the child's faeces, the mother's voice, even a loved blanket – are prime examples of these objects. However, these objects can retain a haunting presence even after their absence has been signified. They therefore become, as Lacan observed, objects with only a *little* otherness. It is as if they were carved from the subject's flesh bearing witness to the terms of entering the symbolic order, and to the divisions of identity and the world of objects outside of the subject. It is therefore a truth to say that the partitioning off of these partial-objects equals a castration; as these part-objects are bound to orifices of body (breast to orality, faeces to anality, etc.). These part-objects therefore go to constitute the subject; they are that which s/he cannot be whole; that which s/he yearns for. At the same time, abjectly, cultural identity demands separation. The object must be lost so that the defining "outline" of the subject can be found; so that the subject can be coherently found, and can find himself within the system. There is thus something irretrievable concerning this phenomenon. It is a juncture at which the object is irretrievably lost as the subject is irretrievably found. As I have already mentioned the loss is greater than this. With the entry into language comes the loss of the real being. Signification takes the place of this real, but somehow isn't motivated by or reflective of what it supplants. In short, we lose the real-ness and come into the symbol. The signifier is then the non-representative representation. The only representation. The dynamics of this is, I feel, very much what haunts the works of writers such as Luce Irigaray, and Hélène Cixous. The loss of the real, and the loss of the being as one becomes a subject.

And language taking the place of the real, in actual fact means it takes the places of real for the subject – so that the child then comes to a signifier and identifies through the closed circuitry of signification. There is thus no way out – although there are exceptions in the disruptions upon the symbolic by deathly and sexual phenomena. The Kristevan semiotic deals with this occurrence within/upon language. However, within the field of signification all elements (including the first-person pronoun) are defined through the play of codified differences. I could comment at this point that in a binarised "play-off" the victorious signifier takes up a very different position to that of the over-come

signifier. Often, the play of differences, or a play-off, induces a state of negativity, or a state wherein it is hard to locate the subject. In a continuous deferral of meaning, a falling below may occur (which I have already mentioned regarding schizophrenia) whereby the subject becomes subject-less and may become the signification itself.

However, no element is capable of reaching beyond to the lost real. Lacan said the opposition of language and phenomenal realm is the choice between meaning and life. It also paradoxically is the difference between meaning and subjectlessness; and I'm not even sure that that can be called death, although I will call it that.

Therefore cinema seeks to find for us what is lost. To amend the irrecoverability of the real, the present object. The moviegoer, Silverman says, misses life. Cinema gives us the illusion of life in its fullness. The artificiality presents us with the larger than life involvement element we believe may be the real. And this real is importantly the viewer's own life. As if the umbilical between image and actuality had never been severed. As if we were pre-subject. I would interject at this stage that this could be said to be true for music in some respects. What we lack is sought for in the magnificent sounds we hear to the point where we believe that this must surely be the phonic reality we ordinarily miss. The superreality of our favourite music now plays with notions of repetition, memory and *déjà vu,* and importantly retroactivity, as if to tease us with the knowledge that we only knew to miss our favourite music when we had heard it again (maybe playing in the background, incidentally, on some jukebox that we just happened to hear) to then realise that this surely must be what we'd always longed to hear (again) so much!

The life line back to the fusion and non-differentiation could thus be the indexical relation of camera to object. The relation of the camera to the filmic event restores the object to the subject. The camera's ability to reproduce whatever is placed in front of it almost makes one believe there could be/should be no human intervention. It is the camera which brings us to the realm of life, not the cameraperson, for example. This is of course fanciful thinking. The presence of the subject decrees the absence of the (lost) object. Furthermore, this kind of thinking denies subjectivity. However, importantly, lack always returns in the cinema, be it through editing, visual quality, whatever. Cinema is therefore a language.

Whilst cinema may evoke desire (for the object) it also precipitates the subsequential trauma of loss. And loss is castration. Castration as the breach induced by language, since language marks/designates the division between signifier and alterity of object.

Thus, disavowal and fetishism are accurately named strategies deployed by cinema for covering and also revealing loss. Film glosses and shines over the loss with its simulation of reality. More importantly, let us consider how, psychologically, it works to rectify the viewer's lack; restoring him to wholeness. We shall see how sexual difference plays such a large part in this simulation.

The lacks that haunt film are mobile; but the displacements seem to follow a path. The loss of the object becomes the foreclosed site of production becomes the representation of woman as lacking. This manoeuvre (within much

mainstream cinema) assures the displacement finds its final expression in impotent femaleness thereby predicating a coherent (whole) male subjectivity.

Therefore the subject is god-like. Seeing everything and grasping all, in a superreality. But the pleasure of possession is jeopardised because the cinematic object is fantasmatic and belongs furthermore to the order of the signifier. Just when one "reaches" out to claim the event it fades to blackness.

Theories of what is called "suture", however, describe the realm of this dynamic as something pleasurable concerning film. The mythic moment becomes a "dyadic relation" of viewer and cinematic image which affords *jouissance*. A step further and the concealing of the image into a frozen letter signifies an absence during its advent. Cinematic signifiers (like their linguistic counterparts) are activated thus only within discourse, and that discourse always requires an enunciating agency. In this way, films are *spoken*.

With the introduction of auteurism and in reaction against privileging the individual voice theory took pains to distinguish cinema's enunciating agency from the figure of the director or scriptwriter. The result being a greater emphasis on the productive role of apparatus and for concealing the apparatus from view. Filmic articulation was then traced to a complex of machines and to certain codes responsible for generating meaning. This runs counter to dominant views of authorship and is covered over by what Silverman calls "a harmonizing representation". Because of the identification of the camera with the human view the camera therefore supplies the harmonizing representation. There is achieved, through use of apparatus, an anthropomorphism; the camera as eye and ear in a transcendental function.

However, this does not account for the fact that cinema's enunciating agency is absent from filmic construction. It occupies a different site, like the profilmic event. The point of the discursive origin is still hidden and exceeds the viewers who lacks access to it. Silverman refers to this unseen "speaker" as the Absent One. The speaker is, we imagine, the one who speaks *to* the foreclosed site of production.

The moment when the viewer notices the frame-line of the film s/he becomes aware of a visual constraint, limitation and the unseen force of a controlling agency. The spectacle is thus drained of its fullness and becomes an empty signifier for the invisible enunciator, and the involving coercion, that the viewer is subjected to. The absence of the site of production from the diegetic scene is disruptive of the viewer's pleasure. As I hope to later illustrate, there can be a filmic event wherein viewer involves herself/himself in a subjective authority in much the same way the auteur should do; in short, an address to the projection of both parties; a concern with the author's projections and the viewer's projections within a new feminist context.

However, for the meantime we shall consider the absence of the object for the viewer. And how this inevitably leads to the discovery of a field/agency beyond his gaze. Hence, a loss of visual potency on the part of the viewer. A dispossession that is conducive to the viewer's sense of authorial insufficiency.

Classic cinema (and much mainstream contemporary cinema) is measured by the degree to which it substitutes fictional elements for absent ones by use of (ostensibly) adequate surrogates.

Technically, for instance, a "shot/reverse shot" manoeuvre can be deployed. The 2nd shot purports to show what is lacking in the 1st shot; so that together

the 2 shots appear a whole, i.e. cutting from one character to another and then back again. One shot may depict someone looking (whilst someone speaks), therefore the reverse shot depicts the object of the gaze. This exchange symbolises the scopic exchange that occurs behind the production of image (i.e. the crew, etc). It supplies the imaginary version of the absent field, and associates authorial view with one of the diegetic characters. This character then stands in for the invisible enunciator. The viewer is thus repossessed of visual/auditory potency and believes his gaze suffers no constraints. His gaze becomes the agency that can move from subject to object and back in correlation, so to ensure the wholeness of his being.

Some critics are concerned with the suppression of the object; others with the viewer's exclusion from site of production – for them the trauma of castration occurs when the viewer recognises his discursive impotency (which is realised when the axis of the gaze is of another spectator who is unseen). We therefore have to consider, as the most important elements of past and present filmmaking the issues of castration, disavowal and fetishism, which are motivated by the cinematic exclusion of the lost object and also most importantly, at this point, the realisation of the viewer's subordination to a transcendental Other (invisible enunciator). Like the symbolic order, cinematic meaning carries a trace of the Other. The absence finds its locus in the subject (who lacks in actuality and symbolic mastery).

Let us trace the losses. The 1st loss is disavowed through the "impression of reality" that film purports to present in the place of the barred object.
 The 2nd loss is one of dispossession: concealed through a fetish, a character, a technical manoeuvre, from which images and sounds seem to emanate. This character is thus equipped with authoritative vision and speech.
 Inevitably in much cinema this compensatory representation which covers loss is male. In order to examine quite why this sexual difference should be indicative of filmic dynamics – let us look at psychological theories, commencing with Freud and his theory of the castration complex.

Regarding castration, it can be said, that the little boy learns to fear ONLY AFTER he has seen the female genitals. As he assumes all are undifferentiated in his own image (i.e. all have a penis) he at this point of threat makes a distinction between girls and boys. The female is thus different because she lacks a penis (rather than acknowledging her as a person in her own right she becomes a lacking subject). However, at this early stage he disavows what he sees (and it's important to note the *visual* nature of this "revelation"), probably because he still inhabits a world closely akin to maternity and femininity. Only later will he have cause to make a sexual distinction when he is threatened by castration for a forbidden activity – i.e. he will lose his penis, if he does not separate himself from the mother. He at this point recalls the mutilated creature that is woman and is forced to consider himself akin to the absolute constituted by phallocentrism. Irigaray, rightly, describes how this ensures the continuum of phallogocentricity wherein woman is simply a castrated man. This castrational complex at this point directly addresses the arrival of the Law of the Father.

Let us introduce the issue of fetishism. It is extremely fascinating because whilst it is rather abhorrent to many feminists it nonetheless says a great deal about the economies that exist in the wake of the Oedipal complex. A fetishist is one who is incapable of accepting female lack. He will continue to disavow (as if at that stage BEFORE he had to separate and differentiate). He refuses to see that woman does not have a penis. At this point I would like to interject that this can retroactively be seen as a refusal to accept woman does not have phallic power (although we know that the penis and phallus have been and shall be separate). However, for the fetishist, his refusal to accept female penis-less-ness could also be seen as a refusal to accept that the women who surrounded him in infancy were not powerful (as they would latterly be represented as powerless within a misogynistic symbolic order). However at this stage the boy-child equates penis with power, as he has yet to realise penis as a small flesh piece and phallus as equal to a metaphysics. Therefore the fetishist equates the missing penis (in woman) with an adjacent object; usually something that was part of the original picture. A shoe, underclothes, a garment of clothing, or another part of the anatomy. As long as the fetish is in place woman is adequate to pleasure. Hence no father figure will threaten him with castration and the female difference is "covered". Fetishism, thus, presents no threat to male potency. *But* a fetish also testifies to a male acknowledgement of lack.

The three concepts: castration, disavowal, fetishism – make their way from our psycho-sexuality onto film. The splits through which the subject is produced. The splittings preceding the Oedipal juncture and preceding sexual difference, as the loss of the object inducer by the cinematic signifier (a loss which catches up with and gives meaning to the divisions inducing the mirror stage, loss of object and entry into language).

Jacqueline Rose has criticised much film theory for not paying heed to the dynamics of sexual difference which determines film. The recognition of the phallic reference which structures woman as the image of loss and difference. The "putting on stage" of woman as a dark continent of otherness equated with all that is lost or escapes the system.

For it would seem that in cinema, the lack comes to relate to lack in Freudian terminology. Woman represents the losses that PRECEDE sexual difference, AS WELL AS THOSE THROUGH WHICH SEXUAL DIFFERENCE IS ESTABLISHED. The absence which cinema locates at the site of female has its origins elsewhere – in operations of signifier and foreclosure of the real. Woman becomes the embodiment of the lost real – but in a very derogatory manner.

However, we can look beyond the obligatory female acting out of loss or lack. By focusing on the losses inflicted by the signifier and seeing those ostensible losses as discursive impotence we can move forward into a feminist realm. We can remove woman from this impotent position (i.e. one of associating the woman with phallic and therefore discursive impotency) – putting in its place the symbolic castration of all, to then enable us to see that no one has Absolutism; but that feminism might well hold the "normative" subjectivity that both men and women can partake of.

In short – we move away from association with (female) genitals signifying in themselves – lack. And whilst theorists have said that the dissociation of the

phallus from the penis only ensures that the male can then associate his INTELLECT with phallocentricism, rather than his corporeal and fallible penis with Absolutism – we do have the starting point for symbolic castration of men carried out by female directors, producers and viewers. For then, there are actually no grounds to presuppose the male sex reads absolutism and wholeness in and to itself. In short – the body of either sex no longer relates to this absolutism. Maybe a new kind of transcendentalism can come about through, and only through, this negation of phallogocentrism. And this neo-transcendentalism is one which is constituted by a neo-metaphysics which realises sexuality has a new role (or no role!) to play. It would thus predicate absolutism as contradiction, schizophrenia and abjection. Paradoxically, then, one could not apply the rhetoric of metaphysics to such models; nor even absolutism; although I do personally believe that that is where any sort of god-brain-state lieth. But as we realise that to oppose a regime is to participate in it – to ensure its status quo – to then be able to define oneself – I am abjected in this belief.

Let us return to the seminal Freudian model of castration. It is thus quite poignant that there is a single-minded fascination with the female genitals (as lack) in relation to Freudian (and Kristevan) ideas regarding the symmetry between such terms as faeces, baby and penis.

The baby withdraws from the mother's breast. It is felt as a lack; a castration. We could include the act of birth itself, as a loss. However, Freud maintained that the castration complex was inextricably bound up in the loss of the penis! This is obviously a manoeuvre deployed to ensure maximum distance between man and the notion of loss. It would betray the fact that MAN (the male) was already structured by loss (castration) or absence prior to the registering of sexual difference; and that like woman he was already deprived of his being (already marked by language and the desires of Other). This is a very important point to consider and remember – especially in lieu of what we will further discover.
 Freudian belief that castration is formatively bound up in loss of the penis – excludes losses that have gone before – namely – the breast, the faeces, the maternal voice, etc. Moreover, we now have moved onto a politics of symbolic castration, i.e. separation from that which proclaims itself as wholly present to and of itself, in absolutism. We can see this Freudianism as (although very seminal to our theoretical development) a device deployed to put distance between man (masculinity) and the notion of lack. For man to admit to a lack (or losses) indicates some preceding loss; the deprivation of an "already" absolute male self. But the male *is* structured by lack through his entry into language and his constitution by it. Within language feminists have come to realise that man is as divorced from his corporeal being (his penis), his sexuality (aside from a phallogocentric role), his emotions (often very different from the "intellectual" [read disavowing, denying and even fascistic] realm he is supposed to continually inhabit), and his individual subjectivity, as woman is from her authorial self (albeit in a rather different perspective, as man still carries with him a privileging signifier). This leads me to believe that this regime is detrimental to men. Obviously not to the exacting misogynistic extent that it is to woman – but

debilitating nevertheless. Maybe because men have so few role models presented to them (how could they have in a phallogocentric society?) of men participating in symbolic castration. Society reads these men as masochistic and dysfunctional. A prime contemporaneous paradigm being the late Kurt Cobain. Any man who is castrated by women or castrates himself (still an endeavour which many feminists [quite rightly] do not automatically trust) suffers – no! not as greatly as woman – but suffers nonetheless. Queer, castrato, etc etc. There is hence no predication for the man who participates in this seminal endeavour. No matter how much others might stress the alternative masculination that results. I have written of the "abject" male artiste in the ostensible process of such a symbolic castration.

"Never before had he seemed so *male*" – as when he confronted himself as estranged from phallogocentricty – I said. Unfortunately, (or maybe fortunately) it would seem it takes a certain kind of crusader to venture forth in this way. And afterall, I, for one, do not wish for quasi-castratos. The kind who claim love of femaleness – only then to re-use phallic weapons against that which they claimed was part of themselves. But it is worth bearing in mind the men who do venture "out" and "in" – because, as I have just stated, they seem to become (in the light of divorce from phallocentricity) MY idea of man. An intercourse that is encompassing and vast; a penis-sex that is bigger and stronger for all its estrangement from the order. If they would only realise that they do not need that sanctimonious force. They might even glean the dynamics behind female love (which after all often appropriates and mocks the old powers – although I know that isn't what it is really about!).

It would thus seem that Freud delayed the nature of the castration crisis, to protect the male from the painful (personal and cultural) confrontation with his insufficiency. There is a retroactive status to the boy's recognition of supposed female lack. As if a prohibition is installed by the paternal admonition – lack is thus considered utterly alien to the male consciousness.

Freud grants the "little girl" no such reprieve. At the moment of anatomical unveiling, she makes her judgements and decision IN A FLASH. She sees the penis, knows she doesn't have it, and wants it!! There is no dalliance wherein she considers sexual difference does not exist and disavows it; or decides to continue her association with the maternal. This only comes under the rather scorned rubric of the NEGATIVE Oedipal complex. Freudian theory leads us to believe that the girl may latterly envy the power of the phallus (which is quite probable). However it does not account for earlier activities. The initial phases of the Oedipal complex that lead TO sexual differentiation. It is only THROUGH cultural intervention that the girl perceives herself (then mother) as lacking. Freud almost admits as much. He comments on a "female epistemological recalcitrance". That woman "accepts her deficiency with hesitation and reluctance ... (it is) unwelcome knowledge". Of course in the *initial* stages of the Oedipal complex – it will most certainly be unwelcome knowledge to a girl. Only latterly, will she (1) separate herself wholly from the mother and then maybe despise the mother for being a being of lack and (2) with an identification with the mother still in (partial) tact come to feel disturbance within herself.

Lacan comments on this sense of crisis and lack; bringing into the picture other sources. Afterall, castrations ARE only realised retrospectively with the entry into language. Such castrations produce the subject who is structured by lack LONG BEFORE the discovery of sexual difference: a subject whose coherence and certitude are predicated on division.

Freud's insistence on the little girl's experiences as a *direct* apprehension of what the boy is obliged to confront indirectly is very telling. Defense mechanisms (disavowal, fetishism) are masculine protectives against the primary losses. Freud maintained the boys "triumphant contempt" for his sexual other. This is a projection; the externalisation onto woman of what he cannot tolerate in himself.
 And once the subject has established the cause of anxiety as an external to himself he reacts against it. A phobic avoidance; even to the extent of a (Kristevan) homosexual sexuality; wherein women become simply inferiorised images of himself, the man.
 This projection is related to disavowal. A refusal to recognise. Perhaps it is too late – since his identity is founded by such a predication. Perhaps not!
 A refusal to recognise the unwanted quality of himself, as other. A refusal to be that which is unpleasurable, or threatening. Thus the subject protects himself against such an ontological predicament by separating off a part of himself; which he then projects onto the external world (of objects) and feels as hostile. This constitutes another of the mechanisms necessary to a sense of wholeness.

Paranoia, not surprisingly, plays a role in relocating the unwanted quality within the "inside" to the "outside". A strategy against unpleasure. Thus, the quality is placed at a "remove"; making it the object of scopic/invocatory drives. According to Freud this conforms to a defensive operation.

The male castration complex is founded on and by a dramatic division and differentiation of the sexes. Woman thus becomes the alien site/quality. The boy (in an Oedipal context), renounces his desires for the mother and identifies with the father.
 Vision provides the agency whereby the female become different and inferior (it is afterall AFTER the visual acknowledgement of the lack of penis). Vision is the mechanism for masculine belief in superiority; the assurance of non-castration. It is so interesting to see how this visual sexual differentiation comes to be the point at which the boy realises himself as male in a paternal/phallocentric realm.

As in paranoia, the threatening spectacle is easily disputed, or seen as unreal. The boy begins by having no interest; not even disavowing. But the authenticity of what he has seen gains ascendency as the exteriority becomes more defined.
 The exteriority of the unwanted quality is initially doubtful (as much in boy as in girl). So the ensuing revelation that woman lacks is *traumatic* and *uncanny*. (Uncanny = that which is frightening because it relates to what is known as familiar.) If the spectacle of female castration is uncanny then surely the male must have already KNOWN castration?! He has an intimate knowledge of loss – already; prior to the threat of loss of penis. Thus – and this is an important

point – the threat that now appears in the guise of woman – is a threat FROM
WITHIN HIMSELF (WITHIN HIS OWN HISTORY)!

At the heart of female otherness there remains some tie with something that is
a *déjà vu*/*déjà entendu* which affects male subjectivity. It would seem the male
is haunted by this similitude. A fear of becoming like the other; a fear of
doubling, dividing, interchanging the self out of which the sexual difference
arises. Therefore, what is known as "female" is what has been transferred to
her from the male. However, as I hope to show, this transfer is not irreversible!
Whilst many men respond to the threat of (re)contamination with phobias –
insisting on the absoluteness of their boundaries separating male from female
– we are aware that today those boundaries are dissolving.

And, according to Kristeva, the male subject will continue to be marked by the
uncertainty of his boundaries, and his affective valency. These will be all the
more undermining if the paternal function is weak or non-existent – opening a
door to psychosis, perversion or abjection. Thus is the case of the fetishist, who
cannot tolerate the image of loss he has projected onto woman, and is obliged
to cover it with a fetish. Whether he insists on sexual difference through a
phobic avoidance or attempts to conceal it with a fetish – he fortifies himself
more against *his* castration (than woman's castration)!
 Thus, we realise that the "normal" man IS constructed through the denial of
lack (whereas a fetishist denies female lack as a defense). He is driven by a wish
not to be that which he (denies he) lacks. He deploys PROJECTION. Freud
emphatically stated that fetishism is NOT derived from the supposed recollection
of any other trauma, other than that of viewing the "mutilated" female genitals.
In other words – there was, for Freud, no way that this could tie in with the
recollection of the trauma of birth. Which would seem, in this day and age, as
rather short-sighted. However, the use of the [Freudian] word "uncanny" opens
up the debate; as it relates to a previously known loss. See: Freud's case study
of the "woman with the shine on her nose"; in which he associated object and
subject in a seminal way, to illustrate the male defensive reaction, and the self-
referentiality of male fetishism to further attest to it as a defense. Please see the
full case study of this for the full input of its relevance.
 This leads us on to the case of Freud himself. It would seem (as pointed out
by Silverman, amongst others) that he has his own implication in fetishism. In
fact, one could come to wonder how much of his case studies were not
paradigms of fetishism in themselves. We could say his testimony IS fetishism
(after his own analysis!) in that it speaks of male discursive potency and female
impotency. But, importantly, Freud comes VERY close to admitting (in a
"subconscious" textual mode) what feminist theorists have been positing –
concerning the relation BETWEEN male lack and projected female lack. Freud
practically stresses this (albeit in the language of double-negatives!); i.e. when
a theorist stresses something so much to the contrary, yet still refers to "it" in
relation – one can posit that something integral is being said about that which
is stressed negatively. Incidentally, it was Freud himself that came up with the
concept of deducing statements from doubly-stressed negative statements!
 An example of male fetishism would be – a woman wearing a male sports
support. Whilst it conceals her anatomical lack it comforts the desiring male who

can then disavow his own lack (bearing in mind he is operating his subjectivity through a reflective psychological device). Whilst fetishism works to conceal from the male his lack – it inscribes BACK onto the woman "male" lack. Thus, it stands in for divisional apprehensions; and the losses suffered by the male in his history.

It can thus be said that cinema works to reenact these dynamics. The subject sends "out" into the world image that which exists in him in some (unconscious) way. His projection is a model of his refusal, and has its counterpart in others what he cannot take on board. Thus, the representation of woman as the "confessing" castrated (impotent) object. And he is thus not responsible for what he then sees, despite being desirously engaged in what he sees. He relies on the apparatus for the flow of images – the glow of the projection-beam-of-light. It is unclear quite when and how the cinema seems to participate in the projection onto others of what is unacceptable in the viewer's self, since the viewer doesn't determine what is projected. But it is safe to say that as there have been so many male directors, producers, crew and such – the correlation of cinematic projection and male subject's projection is likely to occur more often than not. And the viewer is caught in the flow of images and sounds which are produced THROUGH him. Thus, there is the viewer's identification with the camera and also the projector and screen: a sort of affirmation.

The viewer is therefore a searchlight – duplicating the camera, and he's also the sensitive surface duplicating the screen. To say "I see" the film can equal 2 contrary standpoints. I am the projector and on the receiving end I am also the screen. Combined together – I am the camera which points and records.

Thus, the viewer is inserted into the grip of the apparatus/technology. The viewer's perceptual relation to the text is a process of projection and introjection – sending out a stream/look whereby objects can also come back "upstream" in the opposite direction

Secondarily, there is introjection. The role in determining the viewer's relation to the diegesis, effected by the incorporation of one (or more) of the filmic characters. These representatives are taken into the self – providing a moment of subjectivity . This is something which we shall discuss later in the context of feminism. Sometimes these incorporations are contradictory to the viewer's structuralism – but usually it is enough to ensure an illusion of continuity.

We should not forget that cinematic projection always exceeds the viewer. It is activated by an external agency, and provides a metaphor for the nature of sexually differentiated projections. Again and again – the renewed Oedipal structure resituates the loss of object onto female; externalised displacement. "She" bears the scar of castration by which she enters language. However this is not the only "cut" she is forced to display. Because (as we have discovered) man is threatened by the distance that separates him from the phallus (it is afterall metaphysical); just as he is threatened by the separation from the real – his discursive integrity is established through the projection onto woman of that discursive lack. The symbolic lack.

As I have said – we come to see how these displacements work metaphysically. Loss becomes associated with woman as a SYMPTOM of the MALE condition. However, cinema exercises more than a metaphysical relation to sexual

difference. It depends on and initiates the transfer of male burden onto woman by projecting the projections upon which gender depend! This is what is all so very difficult to disseminate. This is what makes feminism itself so difficult a predication! For cinema does not construct this sexual difference by itself – what it does is to reproduce the roles of sexual difference. It coincides with the media's specularization of female. Always, seemingly, a shift away from critical blame. But it of course HAS contributed to a re-evaluation (as well a continuation of specularization) of women. Films like – *Alien, Aliens, Thelma And Louise* – examples of female protagonism are to be found in even mainstream Sci-fi, Horror, Thriller categories. There have been clothing changes (as puerile as that sounds, it actually signifies quite a lot historically) and lifestyle changes in cinematic representation. After all, a fixture to dress code signifies adherence to social code and this works for both sexes. Dress also plays an important part in a Lacanian attitude to sex and gender. Whilst we have accepted that the penis is not the phallus (even though men would still claim the phallus as significant of their disembodied intellect) – in film we have not paid, it would seem, significant attention to dress codes. Is it not true that in this respect the dress of man has detached itself quite radically through filmic history from symbolic rectitude? Even whilst it has worked to restraint woman more and more within a frame of accepted female appearance through apparel! Thus, woman's sexuality is defined less by body than negation of body (as her reality). And also I would say, that male sexuality has surely lost hold of its phallic grip. Because the phallus at one time fitted the penis – this can no longer be said to be consistent. It is not so much a hyperbolization of the sex organ that it represents – it is now a signifier for ultimate power! Whilst, the access to the phallus is predicated by possession of the penis, the relation between the two is based on something now arbitrary. Just what is it I ask? Something, apparently continuously guarded by male representatives!

Within our current histories man has increasingly disassociated himself from the visceral/corporeal body. As if attempting to slough off himself with the order wherein power has come to mean a dematerialisation. And so I ask – what of men's bodies? Surely this disassociation is not easy – since it was first built on VISIBILITY. First built on the specularization of female lack; contrasting with male visibility and sight. As female has been made the repository for specularity – she is identified with exhibitionism and narcissism. How strange, then, that we should have almost reached the very opposite. Whilst woman is obliged to "strip-tease" and display herself more and more – man has declined to show anything but his non-bodily intellect. Has he fallen into a phallic pit of his own making? Afraid to display this ultimate of all bodily parts – for fear that it should signify – not ultimate absolutism – but merely what it is – a part of the human body? In an instance of pure mischievousness – I wonder why our culture does not let us view the male sexual organ; whilst breasts, female buttocks and vulvas are all around? It is surely men who now will not let us see this organ which gave rise to the (now defunct) assimilation between signifier and signified; respectively phallus and penis. Phallocentricism aside – men, don't you mourn the lost of your corporealities; why have some of you invested so much, on behalf of so many; to fear such threat in exposure?

As this female (enforced) exhibitionism should, we assume, be the privilege of

the male organ display, we realise that the identification with exhibitionism enforced on women is as a direct result of the defensive activities of man from himself. He protects himself by converting it into scopophilia; the viewing of woman. This is insuperably an erotic contract. Woman is the mechanism by which man cloaks and establishes his phallic wholeness; and importantly, the means by which he derives pleasure from what he has renounced. Thus male self-display cannot fully effect itself – unless within the function of active scopophilia. The desire to be seen becomes the desire to see and know. Woman thus mirrors male castration, specularity, exhibitionism and narcissism.

It is thus impossible (as regards the cinema) for man to derive any satisfaction or comfort without the disavowal of the filmic lack (structured for him by woman); and any disappearance of the object reminds him of his discursive limitations. Knowing himself to be excluded from the site of authoritative speech, hearing, vision is distinctly unpleasurable, and threatens the relation to the phallus.

A filmic example could thus be – the "shot/reverse shot" manoeuvre wherein the female body is aligned with the male gaze; as this covers the absent site of production and places the male vision in similitude with the woman as a spectacle. Thus, he knows he is whole: the camera *is* the paternal anthropomorphisation. As we have discussed, the disavowal of difference (hence threatening realisation of possibility of castration) can be carried out through items of clothing and parts of the female body, as they become the locus of compensatory investment. Alternately, and this is very important regard the dynamics of film and cinema – there can be a disparagement.

This is a deflection away from the body part to the INSIDE, the interior. Castration is thus traced to the site of female interiority. Laura Mulvey located loss INSIDE the narrative (unlike the theorists of "suture") and paid attention to the castrations within the diegesis.

The "impression of reality" (with which cinema effaces its own status as discourse) relies on the restaging of the drama of loss (the return of the repressed) to account for the recourse to representations of lack, with which to dispel the spectre of phenomenal lack.

Thus the male protagonist experiences the anxiety of castration and the pleasure of neutralisation; and within the narrative repetition the viewer disavows the loss of something earlier perceived as part of self (as we have already discussed). Mulvey also testified to the source of unpleasure being externalised in the form of the female body. However, it is still disturbing to the male. It is still an assault, a haunting, of his subjectivity. It occupies a site that could pronounce itself retributive. Therefore, because of the believed violence of this retribution – the female image has to be "hidden", stripped further of discursive investiture; she is after all familiar, alienated only through repression.

Whilst this unwanted part of masculinity is shifted from outside of the male so it can be mastered by vision – the vision remains troubling to the male. He is also, don't forget, troubled by the weight of the signifier – the phallus – which he cannot visually live up to. Though the phallus is "naturalised" through an imaginary alignment with the penis it is never more than or less than a

distillate of the positive values at the heart of the symbolic order. And as we know, these values resist embodiment. Dominant discourses, which make up the symbolic order, help to define/localise the phallus by "imagining" a speaking subject (such an abject rub for men!) – forcing him into a position of the subject authorised to command those discourse of power/knowledge. In short, the phallus is the sum of all speaking subjects. (But we shall move on from this singularity later.) Therefore, like the phallus the speaking subject is the symbolic figuration which exceeds the individuals defined by it. It is the master of language and isn't spoke *by* language! The phallic one is therefore the unseen enunciator, with authoritative vision, speech and hearing. The problematics of the profilmic event are anathema to him. He can bear no reminder of that foreclosed site of production, much less the loss of the real. He relies on denying this in order to be an identity, a subjectivity. The castration crisis preceding from this source and therefore requires (demands) woman carry the symbol of his crisis. As Mulvey noted – this defense directly reflects male lack.

Thus, he will posit male representative within the diegesis to cover up his deficiency. These characters will carry attributes of the Absent One.

What does all this entail for woman; bearing in mind that she is structured through this secondary lack also? It entails her incapacity to speak with authority; her own authority. She becomes passive to scopic and auditory regimes. Her view is partial; she entraps herself. She sees things that aren't there (according to the authoritative vision); she hears noises in the night that don't really occur (according to the authoritative hearing), and so on. She loses control. *Her* gaze seldom hits the mark, although she herself is always on display. As Silverman cleverly points out – "... she manifests so little resistance to the gaze she often seems an extension of it ..."

Her words are even less her own than her image. She is scripted. Her words aren't so much spoken, as extracted. Her own voice mocks her; disparages her; incriminates her. Even without coercion – she always speaks as the other. She is contained. Her voice and body are synecdochic; obliged to absorb all lack. She at once becomes the representation of the lack of the real; the lack of the foreclosed site of production and the lack of the man. Her receptivity to the gaze reinforces its superiority; and her obedience to speak her lack on the command of the male voice proves the male vocal power. She simulates the crisis of man being subordinated to the diegetic and cinematic enunciation. Film becomes a delayed mirror reflection of man's past historical losses. And whilst her voice is a fetish filling in for what is unspeakable within male subjectivity, it represents the loss of plentitude (occurring on entry into the symbolic) displaying rather than concealing the lack in its protection of the male from castration. In this way the female voice is the recipient of a double burden of lack. Hers and the man's.

Man thus redefines the diegetic boundaries, situating himself in proximity to the apparatus (and production and creativity – in much the same way that by denying woman differentiation *he* gives birth and not she. See: Judith Butler's work on gender). And by the identification of the female voice with the body (a synchronisation we shall soon explore) his voice becomes transcendental; and

disembodied. Now we shall move on to examine how male subjectivity works to keep woman aligned with her body (now seen as a symbol of lack) to further ensure her impotence; and *where* she is positioned in order for this subjugation to continue.

21. Inside And Outside The Body

Synchronisation And Speech

Film theory has maintained, in the past, that there is no difference between recorded and prerecorded sounds; that the apparatus is capable of capturing and transmitting sound in all its auditory plentitude, without distortion. That there is no difference between dimensions of reality as regards the original sound and its reproduction (as there is in, for example, real objects and photographic images). Such theory would have us believe there is no loss, in relation to the sounds of the phenomenal world. This is based on the premise that one doesn't hear an image of sound but the sound itself; and that in this instance film is capable of restoring phenomenal loss.

However, it can be argued that every acoustic event is inseparable from the space in which it occurs, and that it is impossible for two sounds to ever be the same when some recording apparatus has mediated the access of one of the sounds. Thus, we can say that the film gives a "sample" of the profilmic auditory event. Furthermore, the recording apparatus performs the auditory perception for us – isolating, intensifying and analysing the sonic/phonic material. The physical perspective on the sound source is implied not through the context of everyday hearing but through the signs of a physical site. In this way, we do not hear – we are heard. We accept the apparatus as an ear with its attitudes becoming those of our own. Those sound signs thus place our hearing.

The voice in particular illustrates this dynamic. We have a proclivity to a faith in cinema's verity, its capacity of delivering "real" sound. Our philosophies identity the voice with a proximity – a here and now propinquity; the speech is defined as an essence of presence. A presence in the face of a system of absence (that is cinema). Whilst image may construe distance (the temporal space between production and viewing), the voice brings a charge of presence (a presence that the words require for transmission). Therefore our belief in a fictive event is promoted by the presence of the voice – so that it becomes a fetishistic device disavowing cinema's lack, helping to restore the lost object. With the voice being identified with presence, it gives power in order for the sounds and meanings to be placed in the present here and now, closing the gap between signifier and signified. This metaphysics births the illusion that speech expresses the speaker's inner essence, locating the subject of speech in the same ontological space as the speaking subject. In short – the subject determined by language becomes the speaker; promoting a belief in a self-presence too.

Lacan stated (as regards the relation of the subject, language and speech) that one can identify oneself in language, only by losing oneself like an object within it. Speech, thus, actually produces absence, not presence. The discoursing voice is the agent of symbolic castration; for on entering language there is a

phenomenal fading (aphanisis) as language preexists and coerces speech: as language is an Other!

The voice is a site of radical subjective divisions (the divisions between meaning and materiality). A partition between organic and organization; between the biological body and the body of language (the social body). Whilst the sounds of the voice may exceed signification both before the entry into language and after – the voice therefore can retain an individualism, in its texture or [Barthes] "grain". As babies we hear before we see, and the voice is identified with the infantile scene. Conversely, it is through the voice that the subject enters into language and is placed, thereby making a sacrifice which is associated with loss and can be seen/heard as the birth of desire and aspiration towards discursive mastery. I hope to examine the contradictions of the functions of the voice-as-being, and the voice-as-discursive-agent.

In cinema, the voice is identified with presence, with pre/extralinguistic properties; and exploits its status as "pure" sound. It is also promoting of a discursive capacity to amend cinematic absence.

The fetishistic operations of film theory therefore have to concern themselves with – not actual sounds – but "sonic *vraisemblable*" – the voice as carrier-of-meaning. Hollywood's sonic *vraisemblable* stresses unity and anthropomorphism, subordinating the auditory to the visual and making everything that is auditory related to the functions of human speech (i.e. even background noise functions to move focus to speech). The function of synchronisation, is thus, to anchor sound to a visible source, locating the voice to discursive capabilities. There is an emphasis on speech-acts within the diegesis, suturing the viewer/listener to a safe place in the story. It works as the analogy of the "shot/reverse shot".

However, of course, there is the sexual differentiation of the sonic *vraisemblable* which is mostly unnoticed. It works to embody the male voice with the attributes of the apparatus, and situate the female voice WITHIN a hyperbolically diegetic context. The system of displacements means the INTERIORITY carries a different status in cinema than it does in literature and philosophical texts (i.e. we are not discussing a Derridean "inside" at this point). This interiority isn't privileged with implications of soul or consciousness. Instead it implies restraint (linguistically and somatically). It therefore also differs from a Cixousian concept of bodily definition and inner narrative because in this instance it is a confinement. The female subject is organized around both castration and concentricity.

This alignment of the female voice with the female image makes for a synchronization – whereby the voice should come from the respective body. The "voice-off" strategy exceeds the limits of the frame but not the limits of the diegesis, which means that the owner of that voice is potentially recoverable and can be brought into the field of vision. The "voice-off" may evoke the threat of absence, so it has to be able to be remarried with its image, enabling unity.

The "voice-over" strategy, coded as occupying a different order from the diegesis is dislocated slightly, although it may occupy a position adjacent to the events – so that eventually the two will converge. Often the "voice-over" may invert the sound/image hierarchy, becoming a voice-on-high; on top of the

diegesis. It is almost exclusively male. There are in cinema's history very few female "voice-overs". The "voice-over" whilst placed apart is inaccessible to the gaze, thus breaking the rules of synchronization – and thus it is a male reserve. As it has no identifiable locus it is privileged to transcend the body, and whilst this means it has no corporeal power it also means it has no corporeal vulnerability. We can see, then, how to embody a voice is to feminize it. The female subject remains a spectacle, a castration and a synchronization. The male gaze is phallic and exceeds synchronization.

The camera holds the female subject to the unity of sound and image, thus she represents lack. The male subject is privileged with the ability to see without being seen, speaking from an inaccessible vantage point. This "voice-over" can thus become the enunciator, a metafictional, metalingual voice – the discursive origin itself, with the authority to effect displacement and condensation.

Interestingly, the superior knowledge of the "voice-over" isn't easily absorbed by classic cinema (as Silverman points out) because it pulls rank on the male characters within the diegesis, and the male viewer. Its non-corporeality pulls away from the narrative to its own narrative. The embodied, diegeticized male voice-over is usually not adopted as an alternative – instead it serves a different purpose. It is used to speak "in extremis", in drastic circumstances. We also have the voice-over as autobiography, as self-revealing; the body "inside out" as it were – displaying what exceeds the visual, or denoting a temporal flashback. It speaks from a need to master, or bind the past to now.

Involuntary or constrained speech is a general characterization of the embodied voice-over, as it often dramatizes an internal monologue, an inside-out monologue. It usually represents direct thoughts rather than speech. Here, the voice-over loses its status as enunciator, and is in no position to masquerade as the textual origin.

This all goes to show that the embodied voice-over designates not just a psychological interiority but a diegetic one too – and that it emanates from the centre of the story, rather from some other place and time; being as it is radically different from the disembodied voice-over. Therefore, what I am leading up to, is the concept that this embodies male voice-over seriously jeopardizes phallocentrism. It becomes an extremely dangerous site for the phallus. And the closer "in" that voice goes the further it travels from the "outside" (i.e. the disembodied voice-over). And as we know, this interiority equals discursive impotence, and lack of control. Of course, this is totally unacceptable to the male subject. But because film demands the visibility of both man and woman in film – the male subject is in a phallically insecure position.

Thus, he deploys strategies to displace attributes from the disembodied male onto the embodied, synchronized male; reinforcing the opposite of what is diegetic. He thus *redefines* the diegetic area. He places exteriority into the diegesis with the interiority, bringing the "transcendental" exterior male into the picture in that role as enunciator. Therefore, interiority no longer reads diegesis, and exteriority no longer reads enunciator, for he has brought exterior enunciation into what was the interior/the diegesis. "Inside" then becomes a *recessed* space within the story, and "outside" becomes the story which frames the recessed space. Woman is confined to the recessed space, man the latter framing space. (Silverman describes woman as being the diegetic locus, and man

the extradiegetic.) And as we can see, this means that the male subject retains an *impossible* identification with authoritative vision, speech, and hearing.

In instances where hearing takes privilege over speech, in film – there occurs control over the one who talks. The ear seems to be outside of the drama that contains the speech. Usually, however it is interiorized and thus inferiorized, except (as we shall see) in the cases of "confessional/talking cure" films, where the male subject's ear is exterior.

Usually, auditory incapacity equals verbal incapacity.The female subject's voice is often doubly diegeticized. A good example being a woman singing a song within a film. She sings to an audience within the film – thereby the male subject is aligned with the apparatus and is placed in a seemingly transcendental position. These sorts of devices ensure he remains in discursive control (like the voice-over) and the woman can only speak on command, or confess.

Interestingly, Silverman cites some examples of a distinctive quality precipitated by the depositing of a "male" body in the voice. Mae West, Marlene Dietrich and Lauren Bacall were all noted for their low and husky masculine voices. In these instances the voice exceeds the gender of the body it proceeds from, and that excess confers on it a status of language *and* sexuality.

However we shall concentrate on the female voice in the female body where we find an identification posited between the voice and an intractable materiality, and the consequential exclusion from meaning.

We find the incorporation of the female voice within the recessed diegesis, and the deployment of the voice to create a psychic order which confines it to the owner. And the corporealization (voice reflecting the body, and its lack) of the female voice magnifies the effects of synchronization. Thus the female subject can be seen (overseen) and overheard. The female voice within the female body is a return to the subject of castration.

With the sound regime as analogous to suture, woman is obliged to bear a burden of double lack. Castration is not only a trope through which cinema conflates the female voice with the female body, cinema also organizes female sexuality around the image of "the insatiable organ hole". This further gives interiority another semantic dimension; so we can see how interiority has a number of meanings.

Within cinema interiority marks the "inside" of the narrative. This designation actually obscures to a degree the other meanings of interiority that are made synonymous with femininity. There is the confining of the female voice to the interior; there is the issue of the voice being obliged to speak of a certain psychic "reality" on command; and there is the imparting to the voice of the texture of the female body. All these strategies place the female subject "on stage". Confining the voice and obliging it to speak on command – are strategies often used in "talking cure" films. A story within the story, as it were, is the structure of such films. The corporealized voice then emerges frequently within performance situations. However, I should point out that the psychic reality the female subject is forced to speak of isn't actually in opposition to her voice being seen as corporeal. In fact, the psychic reality that she talks has nothing to do with transcendence. Interiority establishes the body as the limit of

her subjectivity. The psyche is then an extension of her body – the "inside" of the body – confined by the body.

Freud insisted on the incommensurability of psyche and body, whilst also believing there was a dislocation of the psyche from idealist traditions which define it. However, while he attempts to define the psychical reality as separate from anatomy he strangely utilises a cinematic paradigmatic metaphor to speak of it. The metaphor he uses of the camera, the photographic apparatus is of course the very model of what Hollywood renders very gender-specific. His concept of this reality as normative of both sexes – is in filmic contexts normative of the male subject! The Hollywood exteriorization of authoritative speech etc (a psychical reality) is Freud's idea of the psychic interior. His psychic apparatus identifies with the cinematic apparatus too closely to be ignored. In fact, it adds to our argument.

Within "talking cure" films, which pivot upon disprivileging the interiority, and confining the female subject to a continual reference to her body – we can utilise two varieties of psychic reality identified with woman. Hysteria and paranoia. I wish my comments on these psychic realities to be considered alongside my earlier comments on mental illness. Whilst hysteria and paranoia have been used in cinema as psychical realities; they can also be taken by feminism, as paradigms of the way woman are spoken, and thus can be subverted so as to comment on subjects of speech – and how valuable it can be to comment directly on how women have to exist as spoken subjects of meaning (which all subjects do) WITHOUT the consideration of their subjective authorial voices in interaction with woman as a spoken subject. These are issues we shall investigate later on when we consider feminism and language (in the context of cinema).

However, let us consider, in this context – how hysteria and paranoia work in film to collapse the distinctions between mind and body. The curiously corporealized psyche is compatible with the blurred consciousness attributed to her by the materiality of her discourse. "Talking cure" films also deny woman the possibility of arriving at self-knowledge (she afterall, has no discursive potency). Self-knowledge must be brought to her by a mediating agency – a doctor, an analyst, a detective. Silverman makes an integral observation when she comments that the female subject speaks not so much the language of the unconscious, as the language of unconsciousness. There is also the location of interiority irremediably beyond its owner's consciousness. A figure of speech which describes this perfectly is – *she can't help herself*. She cannot help herself, in the sense that she doesn't have the discursive power or knowledge to solve her problem (if there even is one) and also in the sense that she simply *can't help it*! It's in her nature.

It is a "dark continent" of womanhood that is charted in cinema, and importantly also in psychoanalysis, where the female subject's voice also often assumes a similar corporealized form. A similar interiority is afforded the female subject. With three acknowledged points of entry – vagina, mouth and anus (with the vagina given pride of place, as it were) – it is however (in psychology) the mouth that is the starting point of female sexuality. Theorists have stressed the importance of the oral stage in psycho-sexual development (considering it

the prototype of later femininity – as some believe it equates the sucking function of the vagina). Thus, some believe(d) the notion of the female drives as being more concerned with the body's interior, rather than exterior. So, even psychologically, there is a belief that the female interiority is an extension of the female body. Therefore, the voice is a model of an "inferior organ" and also correlates to an "organ hole". Beyond the phenomenon of the striptease (a strategy utilised by cinema to demonstrate that there is *nothing to see/nothing left to see* [i.e. castration]) cinema also translates as a paradoxical imperative woman being given over to visibility. And also given over to the revelation of discursive impotence as regards the voice, which projects the yawning chasm of a corporeal interiority.

There is an implied equation between the female voice and the vagina, as a port of entry into her subjectivity BUT which is actually the site at which that subjectivity is introduced into her. The voice is the preferred point of the insertion (i.e. when she is confessing, crying, incoherent – then this subjectivity finds its insertion into her); however, if entry cannot be found this way (say, if, for example a film character [or patient] cannot or will not speak or utter) then the vagina is substituted (i.e. the discovery of her "nature" through an internal examination which should thus "speak" her nature for her).

The mouth is therefore really more to do with the generation of gender-differentiation (than the oral phase in psychological terminology) and erotically charged sounds which access the female drives (desires, memories, pleasures).

What is most gratifying to a masculine culture is the female voice providing the equivalent of an ejaculation. The outpouring, the involuntary gush – of what would otherwise be unknowable (i.e. sonically "unseen"). For example in pornographic films the female subjects are obliged to ejaculate yells and groans and other loud noises – to make sonically "visible" the affirmation of their "nature". Men always orgasm visually in porno films. This sonic manoeuvre ensures the proper working of the economy.

There is a very seminal example in the case of the film *Johnny Belinda*. A woman, who cannot speak and is hearing impaired, is pregnant. What psycho-analysis is quick to propose as a solution (to make good her lack), giving her an ideologically coherent content – is a baby. It gives her a surrogate voice because the baby emits the most exemplary of female sounds – the cry. Thus her interiority becomes represented as an extension of the maternal function. What is being said regarding femininity is that it develops from the promptings of an instinctual constitution, anchoring her interiority to her drives. She is spoken through her body, and what has been discovered has been introduced from outside via the penis.

The discursive divestiture, disallowing the female subject's textual production – has another angle to it within film. Talking cure films project into woman a psychic realm which doubles as a narrative within a narrative. In some films, where the female subject might be dead (this is true of many thrillers, and detective/crime genre films) the body is forced to speak in place of the impotent voice; the body yields its secrets up to the male hand/gaze. These "secrets" concern themselves with her sexuality and her reproductive faculty.

Silverman refers to a signifier used by Derrida to attempt to erase the opposition between "inner" and "out" and I wish to mention it here. What passes for essence always carries a trace of the previous inscription. The signifier (Derrida and Silverman refer to) is "invagination". It describes the inward refolding of *la gaine* (sheath), and the inverted reapplication of the outer edge to the inside of a form where the outside then opens a pocket. This we can apply to the female voice and the diegetic, psychic, corporeal interiority – as it creases the text to construct a recess/enclosure into which she is placed. She is thus placed inside the phallus as it is folded in on itself (so that the outer walls become inner walls). Thus such operations fold sexuality "into" the female subject – the dark continent. However, concentricity has no more natural claim on woman than castration. The instinctual condition/constitution that supposedly expresses femininity is merely a "textual pocket". Therefore, we can assume that the male is aligned with exteriority only to the extent that the female is aligned with the diegetic interior; and that the position of male as a transcendental figure (of utmost authority) is also a product of the same textual fold. We know that the male is still "inside", meaning really that he cannot be the punctual source of meaning.

Let us now move on to consider what happens when what has been disowned returns. It often returns as paranoid fantasies of entrapment, enclosure and suffocation. The female voice lures the male to a black hole of destruction wherein meaning drains from the system. And concept of this suffocation finds its representation in the fantasies concerning the Maternal Voice.

22. The Music Of/In Mother's Voice

Fantasies Of Comfort And Claustral Terror

A blanket of *sound* surrounding the infant on all sides. A sonorous envelope that sustains and cherishes. A mobile receptacle absorbing the infant's anaclitic facilitations. A bath of sounds. Quite simply – MUSIC.

All this has been said of the maternal voice. And let us remember that we are discussing the FANTASY of the maternal voice, in relation to the baby. However, there are opposite views too. The maternal voice whilst supporting the baby in a bath of music, *could* also entrap the child. I should also like to interject at this point that several of these descriptions could apply to the pre-natal child, and effect similar fantasies: in the context of the pre-natal child we should bear in mind the *figuration* of the woman as having the child inside her body, in contrast to the post-natal phenomenon where the figure is in a different position/perspective.

As Silverman suggests – the trope of the *sonorous envelope* grows out of a powerful cultural fantasy, which is shared by psychoanalysis/psychology, cinema and, also, the arts in general.

We have an image of the infantile containment; as the child is held in a sphere that is the maternal voice. As we shall discover further – these appearances can be charged with positive or negative affects/effects. The pleasurable milieu of the infant held by its mother's voice is the first model of auditory pleasure. Sound is the primary sense; all the more extraordinary because (as I have earlier stated) it exceeds physical parameters; it reaches further than the body itself can reach and it resonates in such a distinct and unique way.

The ambivalent nature of this fantasy says much about the predicament of the order which both receives and initiates the fantasy. Thus, as we speak of pleasure we also (within an order which predicates sexual difference as it does) speak of terror and threat. We could speak of an umbilical nightmare. And insomuch as this fantasy attests to the sexual differentiation of our societal realm, it also attests to the internalised, divided nature of [dialectic] subjectivity. Thus, the different meanings we attach to the fantasy depend on subjective "points".

One could posit that from the site of the unconscious, the image of the infant in a sphere of sound is an emblem of infantile plenitude and bliss. From the site of the pre-conscious/conscious system it could be an emblem of impotence and entrapment.

As I have stressed before – I will comment again, on the retroactivity of such an (imaginary) fantasy. It isn't fictive, rather it occurs after-the-fact. We only know of it now, as subjects within the symbolic order. This is the only way we can know of it and speak of it (the somewhat unspeakable). It is a translation or

reading of something irrecoverable; it is not an illusion or even fiction after a fact.

Importantly, the fantasy *bridges* two fundamentally disjunctive moments. Firstly, the infantile moment prior to the inception of subjectivity; a moment which is too early with respect to meaning and desire. The second moment is the subsequent moment which is rooted in desire and meaning and too late for fulfilment. It is important that we remember this *bridge*, as it will have prime importance as regards what I will further suggest. The first moment can only ever be imagined, and never truly experienced. It turns upon an imaginary (Lacanian) fusion of mother and child, hence unity and plentitude. The second moment marks the point at which the subject introjects a preexisting structure or system which gives shape, definition, order and significance to the original ineffable condition. The preexisting structure is what Laplanche calls "parental fantasy" and Deleuze and Guattari "group fantasy". It exceeds and anticipates the individual.

We can surmise that the dystopian version of the maternal voice fantasy is a symptom of male paranoia and castration. This contrasts with an operatic view of the voice: we shall later see how this is a bisexualised voice.

This is a fantasy of origins; an etymological and ontological concern. We consider the precultural sexuality, the entry into language and the inauguration of subjectivity. The infantile experience is associated with the moment prior to the creation of the world and Christian history. Within this vatic realm it is not always easy to locate the point of panic regarding the "cobweb" of the maternal voice. We need to look (and listen) to the recesses between prenatal and Word. And, as I have said, to the bridge(s). We can thus realise that the speaking subject is *somewhere else*. Not quite in and unto the Word, and lost unto prenatal experienceable fantasy. Silverman notes that there is a pointing towards deferred readings central to the organization of gender. Chion states that – familial drama finds its performance in another psychic scene, from that inhabited by the child. In other words, he acknowledges the construction superimposed onto infancy from a temporal/spatial vantage.

We can therefore make a subsequent recognition of the threat to the One who occupies this temporal vantage; the One who is a fully constituted subject.

However, this of course raises queries – of just who is this *fully* realised being? And how far does the making of a subject (and subjectivity) take us from the fantasy of infantile bliss, in order to occlude any threat to subjectivity? And furthermore why do we appropriate certain social devices to ensure the foreclosure of the fantasy?

Why is a representation of a mother/child relationship so critically stressful? I believe because, like many threats, it is dialectically internalised to such a degree that it requires stringent denial both socially and psychologically.

Society opposes maternal sound with paternal meaning and discursive thought. The maternal voice comes to represent the dark formlessness. At this point I would like to jump ahead of my premises to interject that I am fully aware of the psychological dangers of formlessness in relativity to the individual psyche. Whilst the formlessness is a seminal proposition to work with, especially to expose the forcible definitions of phallocentricism [this especially relates to

artistic endeavours and experiments]; nonetheless I speak from personal experience when I say that infinite disorder is not by itself and in itself a pretty contemplation for anyone who knows subjectivity – i.e. every human subject who is *aware* of ordered reality. On the contrary, it is an incredibly debilitating and painful experience; to lose subjectivity, even if it is done in the name of "breaking patriarchal phallogocentric bonds".

However, let us return to our argument; our erstwhile, but still applicable, dialectic. The anteriority of the maternal voice fantasy is seen as primitive; denying as it were form and illumination. It furthermore attests to the displacement of such qualities which characterise infancy onto the mother. We conceptualise the voice as the uterine night of non-meaning, therefore so too does the mother become that which has no meaning or ability to make itself meaningful. The child's underdevelopment is transferred onto the mother – seemingly with no predication for progress or discursive activity.

Let us consider three images of enclosure. The woven enclosure – the umbilical net – the cobweb. Through these analogies we grasp the identity of the subject who is threatened and in crisis. The motive of displacement onto the mother (which these 3 tropes demonstrate) of qualities of entrapment and threat design *interiority as undesirable*. The child is therefore a prisoner, and interiority reads discursive impotence. The child hears but cannot understand; furthermore s/he can make sound but it is not meaningful. Despite the fact that to the mother those sounds might well be loaded with meaning, and also despite the fact that the child may have an "understanding" (if we can call it that) of the sounds of the mother.

In other words, to be involved with the sonorous envelope is to be far away from signification. (It is also of course to be far away from the binaries and sexual difference that constitutes much language, but that is besides the point in many ways.) In order to gain access to the symbolic order the child transfers *in* to *out*.

Exteriority is defined through interiority. The shifting of the child resituates the mother within: the container becomes the contained. I believe that this phenomenon can be viewed as a process; a flux: but we shall return to this idea later.

A rhetorical slippage. Mother absorbs the semiotic immaturity: an inversion. The functions of the maternal voice as teacher, guide, translator, expositor, storyteller – are forgotten. Psychoanalysis tells us that by isolating the maternal voice the child produces its own articulations. I would at this point like to posit that this comes about partially or more fully because of the maternal voice. For hers is the first voice one hears; the first voice that importantly charts space, delineates objects, explains and defines the external world. The voice introduces the child to the Other; it is the foremost and most nurturing of mediators.

In Western culture – that voice narrates nursery rhymes, bedtime stories. Later on that voice tells us – don't touch that it's hot and it will hurt; you are so gorgeous I could eat you all up; you're so clever; what a good girl/boy you are; I love you ad lib.

But initially her voice remains unlocalized (although of course it precedes her image) during many formative moments of subjectivity. Her voice is all around.

This can be heard as the prototype for the disembodied voice-over in film. Because it is a voice PRIOR to image. It is therefore rather interesting that cinema usually utilises a male voice-over technique. In fact, I would go so far as to say that it is *astonishing* that this device which carries a supposed trace of Mother has become the prerogative of the male voice. It is as if there is a gradual societal fatherly seduction at work. [For an analysis of the seductive father, who apprehends female infants and takes them into the realm of the father (as his own property) – please see: Vicky Lebeau's book *Lost Angels: Psychoanalysis And Cinema*.]

The move to align such a phenomenon with the male voice-over also operates to effect a confinement to the inside of the female. She is in cinematic terminology forced into the diegetic "closets and crevices". This formation functions to reverse the primordial situation wherein we first encountered the entrapped male child, who is unable to produce meaningful language. Thus, as we have seen already many times – the male voice inherits "authentic" discursive power at the cost of stripping a woman (or mother) of verbal authority. All this goes to negate the mother's role as language teacher, commentator, narrator, etc. It strikes me as ludicrous that a woman's role could be negated in this way, and that woman should be reduced to the level of an linguistically and subjectively underdeveloped being. Has it been forgotten that women are part of the symbolic order in any event? Even if their position if demeaned and marginalised? Is it so threatening to assume that because a woman can partake of communication with her child it automatically means she no longer exists as a verbally coherent, discursively potent being? It would seem that this is sadly often the case. I have lost count of the number of women who have recounted tales of how their work colleagues, associates, even friends, assume that they have lost their brains on becoming mothers! The theoretical significance of this fantasy's reverberations most definitely does make its way into the workplace, the community and the home. I cannot help but include at this point my belief that many men criticise women with babies under the guise of such a phenomenon (she is now a baby-talker!) only because they cannot deal with a woman whose focus is not solely on them. When talking to a mother of a young child one has to realise that this woman has to operate and talk on many levels – which is not to suggest that she can't excel discursively, intellectually or theoretically (or in any way which is considered valuable and potent). Rather, it would seem that she can – and perhaps this is nearing the crux of the problematic I am trying to address. However, to return to the issue at hand. The imagined drama of the fantasy which finds its structure in a binary interiority/exteriority dialectic – is spoken from, and it actually speaks from, a position already structured by lack. Maybe the intolerance of mother/child symbiosis is a poignant reminder; a *déjà entendu* that in itself threatens. How else could it accumulate such vitriolic and reactionary polemics to its supposed effects? I once heard a young child (of a friend of mine) throw a typical two-year-old tantrum. She screamed at the very top of her lungs. She brought her mother to her. Her mother knelt down at a two-year-old-child height level and comforted the child; didn't pander to her but made sense of the child's distress *to* the child. End of scream! Whilst my girlfriends and I attempted to soothe our perforated eardrums [it was a LOUD scream!], we also all commented, almost

in unison, on how fascinating the sound was and what it signified. And how maybe we now carry that scream, our own scream, inside of us – not daring to let it out: but at the very same time we acknowledged that this female friend was a very intelligent woman, a psychotherapist, who was active in the community. In short, not a woman to be reduced to a space of impotence but a woman who was respected for her intellect and epistemological research. Maybe it is because the nature of a young child's scream is so terribly "outlandish" and often does unsettle the adult (of either sex) that we have problematics regarding how adults cope with infantile noise. I am not suggesting all women can carry on career and child-care in parallel; fluxes and changes within that duality (if it is a duality, which it often is) are often conflicting and never easy. Never un-noisy! But, however, a noisy child does not signify loss of discursive potency for the mother-child symbiosis and its discursive growth, which is ever-changing. It is obviously so easy to attribute unmanageable "nonsensical" noise to the mother of the child, as opposed to seeing it as the very healthy lung-airing visceral cry of an infant signalling to its carer: the carer then acknowledging the cry for what it is. Is it a secret disruptive language between women and babies? Or is it not an appropriate questioning on behalf of child to carer, which the mother will answer in *her* discursive, intellectual capacity as a fully substantiated subject? It can be either of these relationships accordingly.

However, the substitution of mother for child ensures that a demand can be made from mother. That demand is, markedly – the involuntary sound. I'd like to note that the involuntary sound is just that; it differs from the paradigm just discussed, in that it disregards female verbal, linguistic potency or skill; and female intervention or translation.

It is a sound that escapes her own understanding; testifying to the artistry of another superior force. The female voice must be sequestered – far away from enunciation; so that it is beyond articulation. And it must occupy an unthinkable point at the interior thought. This is surely a great feminist polemic?! I have always bolstered up the concept of the unthinkable. But, I realise that it is painful in reality at the same time it is artistically seminal and exciting. The female voice as the inexpressible point. However, in order for societal understanding and meaning it must be the interior of enunciation! An unrepresentable point; although myself and others have tried to engage ourselves with the abject inexpressibility of this quandary. However, only sounds are capable of conforming to the newborn baby cries. Only sounds can bring us the noise, babble, cry ... the crying. Consider for a moment – the horror film genre; the stalker movies; the slasher movies; the film noir(e)s; the thrillers; the mystery movies.

The reversals of the mother/baby expression are facilitated by a double organization of the vocal/auditory system. It permits a speaker to function as a listener (at the same time). His/her voice returning as sound in the process of utterance. It makes it difficult to locate the voice *in* or *out*. The boundary is blurred by aural undecidability. A replication within the former "outside" of something that begins "within". THE ACOUSTIC MIRROR. And this encompasses the potential for destabilizing consequences for subjectivity.

Since the voice is capable of being internal at the same time it is externalized, it can spill over from subject to object – from object to subject; violating the bodily limits upon which subjectivity hinges. It smooths the way, therefore, for projection and introjection!

PARANOIA – as the attribution of a material density to hallucinated sounds. This is one permutation of this slippage. Of such a spillage. Of such an abject dialectic. Within the Acoustic Mirror – the function of the female voice is called upon to perform for the male. Within a traditional familial paradigm the maternal voice introduces the child to its mirror reflection. It "lubricates" the "fit". It is important that we should remember these premises and concepts so we can apply them to following arguments.

A child learns to speak by mimicry; by imitating the sounds made by its mother: fashioning its voice after hers. Even *before* the Mirror Stage (and the entry into language) the maternal voice plays a crucial role in the infant's perceptual development. The first object is not only isolated BUT introjected.

We are at the point of considering a situation where the object has as yet no externality, since the object is no sooner identified as assimilated by the child. This kind of inchoate subjectivity has no boundaries and so has no subjectivity, paradoxically. The foundations for what will later function as identity are marked by primitive encounters with the outer world; accordingly these operate around the axis of the maternal voice. The child's economy is thus organized around this incorporation; the auditory field of the maternal voice. In fact, the child could be said to hear ITSELF through that voice, recognizing itself in the vocal mirror supplied by mother. The male subject later on hears the maternal voice through himself, for this reason – but by now it comes to him to speak of all he has transcended. Hence – enter the field of a disembodied transcendental metaphysics particular to phallogocentricism. (I am at this point not suggesting that this is the only kind of "metaphysics" we can concern ourselves with: there is afterall a personal subjective dialectic which I feel is closer to transcendentalism than its non-embodied phallogocentric version: if metaphysics can read itself as a state of *internalisation* of bodily, somatic, psychical, gendered difference.) I hope I have come relatively close to describing this oxymoral state of affairs: in short I have appropriated the word "metaphysics" for a neo-symbolically-castrated cadence.

This transcendence from that which threatens is however in my mind different. However, as Silverman points out there is a symmetrical gesture inherent in the model of the child who finds his/her voice through introjecting the mother's voice; and the child who acquires a refined discursive voice through projecting onto the mother his/her lack/loss (i.e. all that is unassimilable to the paternalized positioning). This would seem to be the main drive behind the duality of the fantasy.

The boundaries of male subjectivity are constantly redrawn through a process of externalized displacement onto the female of the abject. However, in my own work I have addressed such issues from the very points of abjection and feel able to recognize such a transference. At this point – suffice to say – the abject should read for my own part that which actually constitutes the system that first executed its displacement thereby affording it a certain power; albeit, as I recognise, a power that IS dependent on a certain temporality, or a spatiality –

a reading between the lines/gaps/tropes occupation. However, abjection is "free" which is why it is so alluring; however the price to pay [as Kristeva has describes] is the cost of subjectivity BUT only as we know it. This is the abject rub. We (abjects and myself) pay the price with our own bodies. We sacrifice flesh and psyche to become THE signifier and signified itself. Is this phallogocentric as we know it? No! I would rather assume it is closer to its supporting opposite [and I stress the word "supporting"/constituting] which hovers to let me know that as I am the signifier/signified in sacrifice, so my language is not of the opposite but is of the dilemma, the dialectic, in itself. As Lyotard stated that the dream-work does not think – because dream cannot represent itself or its desire – *it is desire* – so it would follow in this case. Abjection therefore actually "speaks" the very problematic that others are asking it to surpass. Maybe it itself asks itself to surpass it? The abjected female voice thus IS the very issue of abjection. It has no representation, and it cannot be represented ... following this line of thought. Its dynamic in itself – is the very dynamic of abjection. We/I can condense this no further!

Silverman very cleverly draws our/my attention to the "afterbirth" – which threatens the order of proper speech. Whilst, initially the maternal voice functions as a means to the child's identity – latterly the child hears within it the repudiated elements of his infantile babble.

However, it is the reversibility facilitating these introjections/projections which threatens to undermine the subject. In other words, whilst society may have literally cast them to a lower place – the self still has to confront this threat in personal proximity (i.e. in his/her own self). The return of what has been thrown away in order to be, as a subject. However, it is important to me to stress that this cast-off is only cast-off in relation to a patriarchal system. Let us consider how different it could be within the constraints of phallogocentricism. This is again a reversibility; as I see it the main threat comes from the "exterior" patriarchal order, for both sexes. Whilst I do not deny that this is OUR order necessary for the perpetuation of subjectivity, I nevertheless would like us to consider the losses we make within that order. As I have already stated (many times) this affects male and female. Whilst men do not have to perpetrate a phallic reality of absolutism and metaphysical transcendental in relation to themselves, neither do they have to physically castrate themselves (I consider the disreputation of new-men who seem forced to take castration literally); instead what I consider is necessary is the understanding that the male body also needs to be redefined. Men have soft sexes for a large percentage of the time. These "sexes" do not point in linear fashion up to an Almighty God in their own image: however men *do* have erections, which women both desire and need, and I might add admire. And these erections do stand up self-sustainingly; they do rise up by themselves needing no support [other than mental enticement] – so let us address this issue for it is surely very important that we realize the personal experience of men's bodies. Feminists in the past in their endeavours to redress an imbalance have seemed to overlook the individual male body. I think it is healthy that feminism has addressed masculinity in a radical way. However, issues cannot remain at this ostensible impasse. At the end of the day many women desire erect penises to penetrate them. But surely we can come to this concept and actuality no longer feeling raped, torn in two; as if we were

betraying our sisters or our feminist selves. We now know surely that an erect penis is just that. It can be beautiful, desired and it can also be on our own terms when we involve ourselves with men on an individual basis that allows our authority into the picture; even if our authority comes in the guise of a woman who appears in the guise of a labelled (by patriarchy) being. This is the time, surely, to encourage men to erection (for sexes) at the same time that it is necessary for women to grasp and subvert "derogatory" representations for our own pleasure. I would add to this that many women do derive sexual pleasure from enacting the role of "whore" "girl-child" "mama" ... but I believe at this point it is only justifiable to me when it is on our own terms (even if ostensibly, from the "outside" the power seems stripped from us). I have said before, but I will repeat it – in this respect psychological-feminism today (concerning itself as it does with language, representation and politics) needs to face men and convince them that feminism is their friend. Many men, and I do not wish to sound patronizing, are hard pressed to consider symbolic castration or redefinition without female help; in much the same way that many women cannot consider redefinition of themselves without feminist help. It is afterall not the penis (erect or flaccid) that harms woman but the male psyche attached to it. Incidentally, many women desire a penis that is not attached to a man. "I like dicks just not that man that goes with it." Surely this should give us some indication of the issues of sexuality and sexual difference. I am not suggesting that we all do not fragment others' bodies; men surely do this with women – but I believe a little consideration of the issues that got us to this "pornographic" situation would benefit us. This is also not to suggest that I am anti-pornography. I am not. I simply believe that a re-address is required in order that we realise why we DO separate the sex from the person, and why we do separate the person from the action or thought – pleasurable or denigrating as it may be. And I see no seminal possibilities in women separating themselves from the actuality of the penis.

Let us return to the issue of the crisis that the instability of the interior/exterior dialectic engenders in man, as regards film and psychoanalysis. It can be seen that the female voice is a dumping ground for disowned desires, and remnants of memories (and playbacks) of vocal incompetence. We can see/hear that one of the major threats is the migratory nature of the voice (we shall discuss this at the end of the book also). Thus film and psychoanalysis has so stridently attempted to establish boundaries, preventing circulation!

Within the fantasy of the mother and child in unison; the child's sounds harmonizing with the mother's – it is valuable to view this equation in the context of the unison occurring only *after* differentiation. The child's vocal emissions are equal to the mother's, following on from the differentiation. This is the basis for musical, psychic, corporeal separation and then restoration. The dream of recovering the maternal voice born from the experience of loss or division. This therefore testifies to a lack.

A polyphonic display; an orchestra – that is a succession of tensions and releases; union and divergence; opposed in their accords to then be resolved in unity. The drama of separated bodies and their reunion supports harmony. The reawakening of this voice always presupposes a break, an irreversible distance

from the lost object. As aforementioned, this fantasy is superimposed upon infancy by means of a backwards movement (*la démarche régrédiente*). With the maternal voice as the lost object, we can apply a Lacanian concept to the fantasy. The *objet(a)* which includes the faeces, breast and maternal gaze are the first little objects that one distinguishes from oneself and also the very ones that are kept as being partially connected to the self; they are not properly delineated external objects. The lowercase "a" in parenthesis denotes the word *autre*, or other. Their otherness is never strongly demarcated; they constitute a small part of the self which although detached from the self, remains part of the self. This "amputation" comes to represent what can make good the subject's lack. Therefore the voice can be included in this dynamic, being seen/heard as an object; an object bearing the locus of the powerful fantasy of phenomenal recovery. This maternal voice is also abject and *objet(a)* in turns, it would seem. It is thrown away (due to threat and fear) at the same time as it can be drawn back and sought for – to redeem the human condition.

The maternal voice is also what first ruptures plentitude and the continuum of bliss. It itself introduces difference. It charts and names the world for the infant. It is the first axis of Otherness; constantly reopening the opening which the imaginary object tends to fill. The imaginary is concerned with mother/child symbiosis and continuation. Thus, as we have already established the maternal voice IS the very first voice-over (in filmic terminology); existing as it does in a realm that precedes the ability to see, and as that which is also beyond vision. The sonorous envelope fantasy often forecloses on this aspect; usually producing a model that reverses the positions of child and mother, placing mother inside the *choric* enclosure; and inside the interiority.

Silverman points out that the underlying issue here would seem to be the subject's irreducible castration. This is, I believe, what ignites the fantasy of the mother as being in the child's position (i.e. inside an interiority: namely the sonorous envelope. I deliberately do not describe this "place" as *choric* in this instance as I still believe that Kristeva's definition of the *chora* somewhat exceeds other definitions). The issue of the subject's castration (loss of imaginary plentitude, and differentiation of object from subject: as in the drama of the *objet petit autre* [the earliest differentiation], would seem to be denied and counteracted by forcing the maternal into a position of exclusion from the symbolic order and discursive ability. Castration also occurs in the issue of that which exceeds and anticipates all subjects, with its ready-made meanings and desires. This in turn designates the cleavage which separates the speaking subject from the subject of speech: a cleavage as in the site of the voice itself as a vehicle for CRY and WORD. This concept is integral to what we shall later discuss.

Thus we can clearly see how the maternal voice swings between the polarities of, on the one hand, the cherished *objet(a)* [that makes good the lack], and on the other hand, that which is abjected or jettisoned as culturally intolerable – representing everything in the subject which is incompatible with phallic functions, threatening to expose discursive mastery as metaphysical.

A retreat from discursive mastery is like a recollection. Memory as fantasy! It is a retrospective view of infantile plentitude motivated by the crisis of symbolic castration.

Let us now refer to Freudian concepts of the ego and id. The ego wears a cap of hearing on one side. Later, the subject gives this position to the superego. The substitution of superego for the cap of hearing. The superego is determined primarily by the activity of listening. A word must be heard before it can be articulated; language is understood as coming to the subject from "outside", from the auditory sphere. The acquisition of language comes from internalizing others' voices, i.e. parents, whose voices also form the core of the superego. The superego thus comes about through an auditory aura. "I seem to hear everything that has ever been said to me all my life."

A dialectic between "inside" and "out". Interiority thus is the inevitable effect of subjectivity, not merely something that is synonymous with "woman" or mother. It is the result of being inserted into an already existing linguistic structure. The replication of inside/out is the replication of the structure or dynamic already present in the psyche itself; the auditory aura already within the psyche. Within the psyche the position of superior exteriority "above" the ego goes to the superego. The subject is also "inside" the symbolic and "under" the supervision of the superego. Cinema therefore disavows the auditory aura which surrounds/constructs the subject; which s/he also incorporates as an internal regulatory agency. Instead, of course, cinema works to enfold the female voice within the diegetic recesses. Talking cure films anchor interiority to the female – thus, moving the male subject from a position of linguistic/discursive subordination (associated with the superego) to a position that is ALL ego; a position of superior speech/hearing: a reflection of the symbolic order or auditory aura.

The sonorous envelope thus predicates a double interiority, endemic to subjectivity – which is incompatible with the phallic function. There is therefore an anxiety very much inherent in this fantasy. Fantasmatically, it can be resolved by reversing the positions of mother and child – placing the female in the interiorised envelope; but there is also the belief that the interior is the site of *jouissance*. This has (through various theories) come about through the substitution of the maternal singing voice with the paternal prohibitory tone, and internalising both. At the same time we acknowledge that the hierarchy of the ego and its "counterpart" the superego – the subject and the symbolic – can also go to make up a "veritable incantation of voices"; configured by the lateral vocal interaction of maternal and infantile.

I wish to again address a Kristevan notion of the *chora*, for I still believe this premise to be slightly out-of-line; and thus wish to bring it into the locality of what we are presently concerned with. My belief in the mis-interpretation of much of Kristeva's work – is something that is inevitably hard to re-assess and realign in present contexts. Kristeva's *choric* fantasy mocks me from the very offset. It belies that which I can speak about here. Unlike other theorists I wish to concern myself with that problematic at the very first. As Kristeva herself has stressed time and again – it is the very abjection of speaking about something that cannot be spoken [we should always bear this in mind], or regarding semiotics critiquing a "language" of deconstructivism which requires its own language to speak of it, i.e. the language which deconstructs is the same language that is in effect being deconstructed!

However, to return to a Kristevan *choric* – in this context, it is a desire to

retreat from the superego [exteriorised societal influences which are internalised] and symbolic, rather than to approximate the position of discursive mastery that they (superego and symbolic) represent.

It is a moment *prior* to the entry into language. (And the articulation of subject/object.) It is a fusion of mother and child but because it takes place in the *chora* Kristeva's fantasy revolves around interiority (it obviously also precludes the superego as we know it). But for me it does include some superego. In so much as it is starting to include *petit objets* and objectivity as VERY akin to the subjectivity. However, usually Kristeva's theory is read as a retreat from the auditory aura. I would suggest that as we realise that the maternal voice is VERY MUCH figuring in that aura, so I conclude that this is also what I gather from Kristeva's mis-read theories; for Kristeva always stresses the ostensible "pansexuality/bisexuality" of the maternal.

The mother is the first language teacher, she is the one who organises the world linguistically and presents it to the Other. This obviously occurs within the Mirror Stage − wherein the child reads him/herself in the reflection in the mother's eyes. Defining, interpreting the reflected image and fitting it to the child. This provides an Acoustic Mirror, in which the child first hears itself. Thus, it is the mother who first constitutes the auditory aura, although, I stress, the paternal (to say nothing of other close familial influences) comes to dominate infantile (self-)perception.

Therefore the fantasy of the maternal voice as "pure" sonorousness is a disavowal of her role as an agent of discourse and a model of linguistic identification. It is almost as if we forget that the mother is already a subject with a relative discursive potency which she presents to the child's reading. Thus, the maternal voice or female voice as an "agent" of babble is that which the male seeks to extricate himself from; an afterbirth that signifies semiotic insufficiency.

23. The Negative Oedipal Complex

A Fantasy That Leads The Way Through The Written Rules

It was in the mid 1970's that we encountered the *choric* fantasy as a product of the intersection of film theory, psychoanalytical theory and feminism. The Kristevan theory of the pre-Oedipal and the entry into language; the inauguration of the subject into language is also a fantasy about beginnings. The biologistic realm of uterine life and a homosexual-maternal facet. We shall now expand these premises.

Kristeva has always maintained that the *chora* – is [an] unnameable, improbable, hybrid (receptacle) prior to the One/Father. It is maternally connotated. I for my own part believe that theorists have jumped on the use of the word "receptacle"; whilst I do not intend to relieve Kristeva from others' critiques, I do believe that she was signifying something MORE when she stated "receptacle" as regards the *chora*. It is necessary to read her full definition in *Revolution In Poetic Language*; also see: *Sexual/Textual Politics* [ed. Toril Moi].

It is an expansive concept – a synonym for a semiotic disposition, or *significance*; a geno-text.
 If the semiotic precedes/exceeds the symbolic it is thus also bisexual/non-sexual/pansexual. The order is made OF it. It is also then by degrees – female. Female in this context partakes of both and everything. Sexuality then becomes the pleasurable (or not) assimilation of both, neither, or one – as a subject or pre-subject finds them, and is found by them.

At other times, it is the signifier to the moment prior to the mirror stage and the symbolic order. The remarkable conflation occurs when the *chora* is sighted; regularising what might be heterogeneous. The maternal becomes fused; confused with the infant, and comes to inhabit the *chora*.
 This puts the maximum distance between the maternal and the symbolic (which doesn't threaten sexual difference). However, the *choric* fantasy (predicated as Kristeva's desire to be) is shifted, traversed, and made negative. I would interject at this point that this is a semiotic negativity. It is brought to a *jouissance*. This runs a counteractive function aside from the protective, structuring fantasy; for it is something much more challenging: deconstructive.
 Also, within a Kristevan context, the maternal voice speaks to an erotic desire unassimilable to heterosexuality. (This is quite a radical reading in lieu of Kristeva's anti-homogeneous stance – which she has promoted in latter times. I wish to add to this concept the current Kristevan denial of all phenomena ostensibly homosexual; she seems to read homosexual as homogeneous; at present.)

The libidinal basis of feminism! Let us consider in many contexts this polemic; for it is a polemic, I believe. The *chora* maintains the mother and the prehistorical child: a creative collaboration. Synonymous with anaclisis; the child is involved with the mother, the mother being a source of warmth, nourishment, and care by means of vocal/muscular spasms, and the maternal answering of sounds/gestures which weave a provisional enclosure. But, we have realised that the maternal also exceeds that provision. Mother is much more than the sum of her parts as regards the infant. She partakes of all dimensions; realms. This was power previously granted to the masculine. Maybe we should consider the mother as masculine – but that would be straying too far from the truth – in our analysis. It is thus very problematic to consider woman in such a light. For an enclosure, somehow, still, reads – an inchoate impressionable/impressionist state/space; a primary glimmering of otherness – indicating/giving rise to the path towards the mirror stage and language.

Therefore, many read the Kristevan *chora* as something concerned with a unity rather than a differentiation. I feel that this is the crux of the problematic. It is a problematic of *reading*. The *chora* is prior to absence – it concerns itself with the unity of mother and child. The child within the *chora* – implies interiority and discursive incapacity. But have we forgotten (or been forgotten by) the fact that this *chora* is still somehow part of language? For me, this is the point of entry for Kristevan notions of Abjection.

The child solicits the anaclitic enclosure; a riant laughing spatial spaciousness. However, the non-differentiation of mother and child is undoubtably a CHAOS, which must be abjected – unless it abjects the very self. But, I would like to add at this point: have we not been here before? Do we not realise (make real in signification) the very crux of this absurdity? We know how "we" are read from within language, with all its chains of links of chains of signifiers ... and thus we know the abjection inherent in Kristevan theory. This is what concerns me so. That we have already presupposed our wretchedness – and have thus struggled with that which speaks us – to then make sense of it. "We" know. Who is this "we"? It can only be the *we* that I can imagine (as imaginary) whilst I speak THROUGH our language. For we know that the maternal STILL speaks as a subject through and by OUR order. She is not raped of her language to the extent that certain masochists would have us believe. She is not reduced to pitiful yet seminally poetic verses of young-girl-child-muse-Mona-Lisa-femininity. She is not merely that. She is the One who teaches all young peoples to talk and write and sing. She teaches history so that we can be made; and can make/re-make ourselves!

"One these mornings .../Still these mornings .../I'm gonna lay down my cross, and get me a crown .../Soon believing .../Late in the evening .../I'm going HOME ... ohhh, to live ON HIGH .../Soon as my feet strike Zion .../Gonna lay down MY HEAVY BURDEN .../Put on my robes in glory .../I'm going home one day to tell my story .../I've been coming ... over fields and mountains .../I'm gonna drink from the _ fountain .../You know all of our good sons and daughters ... that morning ... oh /We'll drink that ole healing water .../And we gonna live on for ever .../And we're gonna live on for ever .../We're gonna live ... on forever .../We

*gonna live on ... morning glory ... after a while/Yeah yeah ... soon as my feet
strike Zion/Gonna lay down my heavy burden/Gonna put on my robe in glory
I'm going home one day to tell my story .../I've been coming over fields and
mountains .../I'm gonna drink from the – fountain .../You know all of our sons
and daughters ... that morning/Oh ... we'll drink that ole healing water/Meet me
there ... early one morning/ Meet me there ... somewhere round the fountain/
Meet me there ... of ... when the angels shall .../Call ... the ... roll"*

The *chora* as the semiotic disposition of drives (as a result of societal pressure).
Energies move through the body (not yet constituted) and in the course of
development they are rearranged according to constraints on the body (already
involved in a semiotic process) by family and society. Therefore, the drives
(energy charges, psychical marks) articulate the *chora*: which is the non-
expressive totality formed by drives and their stases in a motility, as full of
movement as it is regulated. We thus see the symbiosis, albeit a problematical
one.
 Therefore the *chora* is inside the self; the libidinal economy. The maternal
body mediates the symbolic law – it is thus the ordering principle of the semiotic
chora. Therefore, the *chora* is the subject's internalisation of the maternal in the
guise of the mobile receptacle.

The *chora* extends into the life of the adult subject. The oral/anal drives within
the libidinal economy equate the assimilatory and destructive. However, let us
consider the death drive. The most powerful, and instinctual of drives which
predominates the semiotic disposition. It is governed by negativity. It is the place
wherein the subject is generated AND annihilated. A site of pulsional consistency
AND dissolvement of social coherence. I would like to add at this point that it
would seem to me that several theorists are confounded by the oxymora that
accompany such theoretics. I prefer to view such concepts poetically; and I
consider no seminal good can come from the ostensible floundering in the face
of such oxymoral "speak". Rather, that we are right now facing – the very
crucial dilemma of deconstructivism – and the only way forward for me (and I
believe that there is a way forward as a process/progress of the subject) is a
realisation of the internal dialectic which throws this problematic paradigm back
on itself. THIS is what I wish to address; and I believe this is the point where
many theorists falter. This is the point of personalisation. I believe that Kristeva
has a view of this, where other theorists fail. Kristeva does not present a wholly
coherent discourse – but it IS a coherent discourse if one incorporates the
dialectic and problematics within one's own premises. I feel we should bear this
in mind, for future references.

Lacan has been criticised for his definition of the Imaginary. Such a criticism
addresses a conservativism and conformity which tends towards a certain closure
(i.e. It is open to symbolic criticism) and is disrupted BY THAT symbolism.
Conversely, we have a Kristevan semiotic (in place of the imaginary) which is
revolutionary and breaks closure and disrupts the symbolic. We can see the
difference in the two dynamics.
 Both are correct to a point, it would seem. Both correlate to internal
demarcations. Labile dualities of the imaginary threaten the symbolic (for they

EXCEED the symbolic) – insomuch as the third party (the paternal figure) works to triangulate all imaginary dualities – i.e. mother and child – in the imaginary – known only through the signature of the paternal.

But, the semiotic is claustral as well as interruptive. But it would seem to me – only claustral insomuch as it denies the seminal role of the maternal. Because it is not merely maternal as we know it. The envelope is opened by castration and poses a threat to known representation and signification. Again, I would like to stress what I see as a paradox here; the envelope is STILL within the realm of signification. The maternal comes to the child as someone who is within the order of language. In short, mothers do not come to their children as inarticulate, discursively impotent non-subjects!

A double temporality. Whether one is an adult; or pre-Oedipal being. As a pre-Oedipal being the *chora* one inhabits is under siege from the symbolic (and its rupture signifies identity); and as an "adult" one knows the force which assails language; the NEGATIVITY threatening the collapse (there again one might not know such a threat!). It threatens to collapse *je* and *moi*.

Whatever, the *chora* accounts for the contradictions; the discursive marks of profound psychic ambivalence.

The *chora* in terms of place names. Subjectivity as a spatial series. Each term superimposed upon the preceding, as a palimpsestic occurrence. Series – *chora* – the apprehension of space; the experiments with utterances; an accession to subjective predication. As a child precedes so there is a clearer understanding of the relative dynamics and also unfortunately an increasing distance from the *chora*!

Silverman intensively critiques Kristeva in her book *The Acoustic Mirror*. She comments on the psychological process that describes the subject's entry into language. Importantly, she makes a decidingly crucial point when she comments on the difference of perception at that very point; and we should bear this in mind. Kristeva, in effect, describes the entry into language as a victory over the mother. She aids and abets this description with many "war-like" metaphors. But is this really the case? Is Kristeva being so apparently controversial, for its own sake?

Naming (the origination in a place) is a replacement for what the speaker perceives as the archaic mother. After all, language is concerned with the substitution of what is lost. I would like to add at this point that we all do learn the "throw-away" game as very small children. This game enables us to deal (ostensibly) with the loss of the real or/and imaginary. It teaches us to keep Mother in our mind's eye. It is a game about memory. As we toss the ball/toy/cotton-reel/blanket away – so we teach ourselves to remember what we are at this point about to lose. It is the nature of the human condition. The same dynamic applies to the "peek-a-boo" game. As we cover our eyes we learn to (re)store our beloved's face; knowing that a split second later, on removing our hand from our eyes SHE will still be there. Still, it is a gamble; for she might well have gone! But still, it is a valuable game of progression. For further information on child development, in this respect, please see: Melanie Klein's work.

However, the *chora* lives on. Quite how ... we do not know – until it comes back to haunt us; to predicate our psycho-sexuality; our reality; our everyday involvements. It mocks us. All the drastic phenomena that we experience, and all the times when we are caught up and ripped down, and speechless, and searching for reasons – then ... we might occlude its ejaculations or lay down with its pre-meditations. It is the human condition! The *chora* is thus the permanent scene of subjectivity. Covered over by other spatial developments.

For Kristeva, the subject will find itself AGAIN in the *chora*. A *déjà entendu*, a *déjà vu*! As close as nothing. As close as the very self to the dream!

Many theorists have found Kristeva problematic in that she aligns the maternal with the semiotic. I believe this reading to be an unfortunate appropriation. It is true enough that Kristeva does use language in such a manner as to suggest that the mother is the semiotic. However, I believe that we cannot restrict the semiotic or the maternal in such fashion. Kristeva's most seminal works concern themselves with abjection and to a degree symbolic castration – and I feel it is in our interests to involves these aspects at ALL TIMES. This is my idea of a FULL Kristevan reading. Silverman states that Kristeva's examples all come from male poets and theorists. And that furthermore, she is relying on the symbolic to negate the maternal. I believe that Kristeva has always gone beyond the symbolic and maternal to bring about an arena of symbolic castration and abjection which furthers such theoretical foundations. Silverman (rightly) notes Kristeva's proclivity to reinstate subjectivity in the carnivalesque, surrealist, psychotic and poetic. This is, Silverman claims, where Kristeva has placed the maternal substratum. This is where such phenomena surfaces. But surely by now we can see a little beyond patriarchal readings. This *bizarrerie*, which is still a feature of normative speech, is manifest in rhythms, intonations and gesture. But, and this is where Silverman balks over Kristevan theory (and in certain contexts it's entirely understandable) – it is also most apparent in infantile language (that which hasn't been rationalised in a discourse) therefore leading a strange path back to the interior space of the archaic (and somewhat mythologized and essentialised [and therefore disempowered]) mother. In short, the old "mother" that phallogocentricism established to pinpoint women; a woman with limited power and ability who although beautiful, sexually attractive and creative, was only so on male terms or in male fantasies; a figure that works against contemporaneous concepts of feminist authority.

However, in view of Kristevan theory and Silvermanian theory – I would like to raise the subject of contemporaneous feminine sexuality. I believe that subjective femininity could well be the key that is needed to understand where these two seminal theorists ostensibly differ. It is, I believe, a case of what women feel and what they feel they should feel. What they admit to feeling and what they secretly think about. I intend to apply this notion to my own fantastical works; as I feel this is the only fair way to explain myself. I cannot speak about other women's intentions but I can surely speak of my own! As I say we shall later return to my hypothesis regarding the conflation of Kristeva and Silverman.

Silverman believes that what Kristeva is listening for is invariably the voice of the mother. And Kristeva believes that one should listen to infant(ile) language with

maternal attentiveness, thereby shifting her focus to the role of mother as analyst.

She states that the arrival of the child breaks the auto-erotic circle of pregnancy. This I agree with. She goes on to describe the mother/child relationship as a different account of the relation with an other (that is – a loved-object). For the daughter to be a subject and to have access to the *symthetic* level requires a castration and an objectification; therefore the mother must tear herself away from the mother/daughter symbiosis. She must renounce the undifferentiated community of womanhood and recognise the father, at the same time as recognising the symbol. The child then becomes the means by which the mother accesses the Other. However, it would seem for Kristeva only relevant if there is a son. (Kristeva herself bore a son.) To bear a daughter initiates a reverse encounter with one's own mother. The mother of the daughter is in other words brought into contact with her relationship with her own mother. Thus, we assume that there can be either a differentiation of beings, or a oneness (as in "mother/daughter/grandmother" psychologically cyclical recountances) or a case of paranoid primary identification. Then, the child becomes the analyser. Kristeva, according to Silverman, is stating that the mother has to grasp (or cannot grasp) the notion of castration. In answer to this, I would posit that the mother is *already* a subject. She does not come to pregnancy, or go through pregnancy as an undifferentiated being. She may well be abjected at times. She may well be involved in a symbiosis which seemingly belies generations, but she is an identity. She is not giving birth as an unsubjectified being. HOWEVER, the child (in its "selfish" state of unsubjectivity) may very well consider its mother to have no discursive power and its father to have more discursive power, simply because it has been symbiotically engaged with its mother, and has considered her to be the very same as itself. It is thus not "us" who consider mothers powerless regarding language – but our babies who consider us "powerless" as regards discursive potency. Babies and infants demand that mother stays with them, only ever for them, dedicated to them – until they are grown enough to stand alone, and slough mother off (although there is of course always psychological residue). Babies are selfish in that they do not understand that mother exceeds what they perceive of her. Each child believes that mother is only what s/he makes of mother. This seems to me the nature of the infant because it IS an infant. If patriarchal society wishes to use that as an endorsement of female impotence then they mis-read child psychology and the roles of women. It would seem to me that therefore patriarchal society has the same view of women as an infant has! And where it is acceptable in an infant – it is not acceptable in an "adult" society. It is perhaps an effect of the residue aforementioned, leading one to believe that patriarchal society is comprised of nothing more than "grown-up" babies!

Silverman says that the Kristevan account predicates a move from the maternal to the analyst to the analysand. Whilst I do not wish to sound unnecessarily contentious – the gap between analyst and analysand has always been highly unstable, and is by its nature prone to reversal. Lacan researched such phenomena in his work (see: *Ecrits – A Selection*). However, we are not just involved here with the transferences between analyst and analysand, we are concerned with the mother/child exchange and relationship. And maybe

"exchange" is the operative word. Mother and child DO exchange. This is not to suggest that the mother is continuously entrapped in the role of inarticulate and under-formed subject who has to be spoken BY her child.

Mother can be seen as being locked in an embrace with her progeny and own mother that excludes issues of castration and difference. For myself, I believe that it is possible to suggest that a male child can lead a mother to a state of accepting sexual difference (as something almost internal); but then I would also posit that a female child can lead a mother to accept her own progeny as different and separate from herself.

The auto-eroticism predicated by a woman's pregnancy could give rise to the maternal figure as being both inhabitant and receptacle (re: the *chora*). But I believe this to be a rather phallogocentric proposal – in that it relies on a rather fixed binary. Auto-eroticism is taken to mean that which concerns itself with "sameness" but I would posit nothing is ever completely the same as something/ someone else, and consequently the psyche can only be fooled into thinking that for so long. Or one can fool oneself into thinking that for only so long. Even if the circle or cycle of pregnancy and birth is synonymous with non-differentiation – there will be a point when it is realised [made real] only partially. Individual experience will at some point intervene and belie total homogeneity.

Whilst Kristeva does posit motherhood as a force resisting difference – I would add to that that it is only possible hypothetically and in fantasy. I do not dismiss the temporal allure of such a notion (it can afterall be appropriated as a seminal device) but in the long run, when one incorporates other issues (especially personal inclinations and experiences) it is not profitable to regard motherhood solely in such a way. In this regard I agree with much of Silverman's criticisms.

We should therefore ask – who forms this auto-erotic circle (between a woman her child and her mother, as a repetitive community of womankind)? And what of Kristeva's desire to place the mother within it, and therefore estranged from discursive potency and the symbolic order? The answer it would seem could be derived from issues we have already discussed. The second point of hermeneutic entry into Kristeva's *choric* fantasy is the primacy of gender over generic infancy. Sexual difference plays a large part. The male child is very different and causes different subsequences to the female child. It, in effect, works to place the female child in a space of primordial oneness (with the mother and her mother before her ... ad infinitum). But it also places the female child on the "side" of paranoid identification phantasised as a primordial substance. The only exit is granted to the son who has exclusive access to the position of analyst (whilst his mother then becomes the analysand). Therefore, according to Silverman, in a Kristevan context the mother and daughter are engaged in a regression at the same time as Kristeva herself is engaged in progressing through the language of the symbolic order. However, I do not wish to turn this study into a condemnation of what female theorists apply to themselves. It is true to say that Kristeva as a person is closely related to the subject that speaks through her texts. I personally consider that Silverman has forgotten that a lot of Kristeva's "speaking" is speaking about the abjection of speaking. Whatever Kristeva posits is always either highlighted or shadowed by her underlying involvement in her very own abjection. It never fails to escape her

and she never fails to escape it – and therefore I intend to include abjection (as I have done throughout this book, I hope) in my own analyses of Kristeva and Silverman.

I would also like to interject at this point that the case for a *chora*, and existing in the *chora* – can only be "known" as such, through a predicament that is called – literally – non-subjectivity. The subject has to be non-subject. Whilst this would seem to be the direction that many female theorists and poets are going in – it remains to be seen (if it can ever be seen) just what total loss of subjectivity would mean. I constantly try to personally realise this myself. It's tempting as a feminist poetical device, but repugnant as a political device. I do not want to lose my subjectivity. However, in fantasy, and in the realms of psychological hypotheses I DO wish to LOSE this subjecthood that has been assigned to me, although only from the point of knowing this through the subjectivity I NOW have. Again, this brings us to the point of Abjection. Perhaps it would be valuable to retain this in our minds at this point.

Continuing with our premise also leads us to recognise that this means the exclusion of the male child from the privileged site of the *chora*. I state the word privileged insomuch as it is relative. Whilst this exclusion is obviously not as traumatic as an exclusion from the symbolic order – I do believe that it is traumatic, especially regarding men who involved with the arts in general. The arts are not always given the same respect as other fields of human activity. Men involved in the arts are often seen as pretentious at best and "cissy" at worst. Psychologically, I also believe there are detrimental effects for men who are automatically excluded from the *chora* (or *choric* predilection). Today in the 90's some men are questioning what it means to be masculine. They are utilising feminist research devices for their work. They are communicating with feminists and realising that feminism is not about (or rather shouldn't be about) robbing men of valuable assets and attributes. Men have to redefine their roles simply because women are. If they don't they will be erecting effigies to and of themselves that are actually mockeries. Feminists such as myself have never been afraid of masculinity. I am not interested in limp penises, or guilt-ridden men. Same as I am not interested in the guilt-ridden "white" community trying to make good its history. What I am interested in is a personal "truth". An erect penis is what I desire from a male sexual partner. I (may) desire something else or more or less from a female sexual partner. Either way, I am not out to actually castrate men. As we shall discover later on – my concept of castration is symbolic and has nothing to do with the male sex organ but a lot to do with prevailing attitudes and conventions. The crisis that men believed was upon them conjured up by feminism was nothing more than a justifiable loss of faith in the bullshit that they and myself had been fed for generations. Teach a man how to be a breadwinner and proud of it and then don't be surprised when he builds his sense of being and masculinity upon just that. It is a catch-22 situation. Today, with our changing sense of roles, men have to engage in the same work women are partaking of. Issues like pornography, erotica, role-playing, family, the work-place, economics, the family – have to be addressed by men. And feminism, or rather certain feminists, are there to help. And just as most politics should not be entirely judged by extremist factions – so too should several decades of feminist work not be judged by extremist factions –

even if some of those extremist or radical factions have some valuable points to say. But men have always had their jobs or roles to use to define ALL of themselves. Men don't say – I'm a husband, father and also a They say their profession first. Today men can't do that. I am not afraid of masculinity, as I've said. I welcome it. I welcome the erect penis. Unfortunately, for some women, the penis is attached to a man. Some of us love penetration but dream of a swollen penis attached to a female lover, as opposed to a man.

I do not welcome, however, the Phallus – *unless* it is under new seminal terms. I therefore expect men not to be afraid of their masculinity. But to look for its meaning somewhere well away from the Western metaphysical Absolutism we are all taught. And in my mind this does not make for a lesser man. On the very contrary – it makes for a more virile clever astute and masculine man. A man (or woman) who communicates with; dreams of and appropriates – an otherness; a sexual difference in a new light with the old light still being a beacon.

Silverman involves herself in some very complicated semiotic play with Kristevan theory. At the same time as she critiques Kristevan theory she also critiques Kristeva. Whilst this may be excusable – it is worth pointing out that what we are ostensibly involved in here is interpretation of someone else's language. Silverman claims that Kristeva's rhetorical language is in itself a negation of the desire to negate. It is a denial of the desire to spurn the symbolic. In short that by being "articulate" and immersed in the symbolic Kristeva mocks her very own *chora*. She acknowledges the poetry of the *chora* but is not willing to back it to the hilt, as it were. She disavows and disowns what is repressed in her own theoretics. Whilst I am tempted to agree in part – I am also drawn to pointing out that maybe it is possible to elucidate a dynamic that can involve itself in both articulacy and inarticulacy; and moreover discursive linear speech and poeticism. I am drawn by this notion because of my own abjection – also slightly (!) divided. However, it is my belief that it is a case of linguistics, rather than psychology at this point.

It would seem (certainly to Silverman) that Kristeva describes a corporeal union between mother and child, that installs the mother as a Master-Mother. The birth predicates a contract whereby the mother becomes her own mother. Kristeva implies that this homosexual facet is not homo*sexual* as such. However, it is problematic to clearly see the difference. Kristeva sees the situation as one which is closer to instinctual memory and also more open to psychosis; the more it is negating of the symbolic, social bond. Whilst this can be true to a poetic extent the implications reach rather far and wide. For what is inferred is that the daughter rejoins the mother only as a mother herself – and that this occurs only after the mediation of the father [phallus] and child [in this case a male child]. In so claiming this it would seem that Kristeva is denying the erotic nature of the mother/daughter relationship, by attributing to it the eternal return of the life/death biological cycle. In short – the daughter and mother can not share an erotic (re)union unless both have experienced motherhood (courtesy of the impregnating phallus). However, I do not wish to dismiss Kristeva's theories quite so perfunctorily. I have a notion that there can be certain metaphoric (in the Lacanian/Lyotardian sense) predilection in her beliefs, as well as, importantly, the

ever present Abjection which I personally feel "speaks" Kristeva throughout her works and theories. I thus wish to emphasise the importance of Kristeva's Abjection to extend the boundaries of what I am presenting. It is also important for me to dwell on the notion of Kristeva's own predilection. I have always found it highly informative and illuminating to consider an underlying forceful dynamic at work with and against her very words. Hearing her speak at the French Institute in London this year (1995), I was once again struck by the fact that Kristeva continuously addresses lingual (and personal) abjection in her every word. She very much does confuse (deliberately?) the notion of homosexual and homogeneous; and I wish to bring this to bear upon my present discussion.

Silverman says that Kristeva splits Mother into two. This it would seem comments highly (painfully abjectly) on binarization. Mother is the genetrix (procreator) and the speaking subject (who remains elsewhere). The former, according to Kristeva rejoins her own mother. But the eroticism is put onto the son. Desire is caused not just by distance (and sexual difference); being the key to her hypothesis. On the other hand – she disavows eroticism (mother and daughter) by calling it symbiotic clinging. Clearly this would seem homophobic. At best it would seem to call the reunion of two women something negative. Perhaps she is calling it by another name! Either way – it would appear that her language has mis-lead her to a point of not realising the differences (as well as the samenesses) between two women! These women thus do not Speak.

But is the Mother really placed back in her own (mother's) womb? Is she really completely *regressed*, as such, to this point? It would seem that Kristeva believes that she is fully re-encompassed. Thus Kristeva seems to relinquish speaking as this mother in her own work. Or does she? Is not the abjection of the speaking Kristeva saying something (very relevant) about this mother that she and we have ostensibly forgotten or relegated to no-man's land!?

Is Kristeva really this man's-woman? Is she really completely at home within the position of speaking subject as a woman subject who has simply appropriated male tools? And who can say when it comes to sexual/gender roles when we know that gender is really all about drag anyway? Kristeva infers that identification with motherhood is the threshold that leads to an estrangement from words, meanings and even sounds. Isn't this an abject statement about the very crux of our problematic? Or is she really resigned to cast part of herself to no-man's-land? I have to concede, that at this point, I have no right to assume a conclusion. I also believe that Kristeva herself never reached a conclusion. This, I believe, says a great deal about a certain kind of heterogeneity. I believe that regarding Kristeva (and this is only my rhapsodic interpretation) we have to involve our notions of heterosexuality and heterogeneity (as regards drives) and also homosexuality and homogeneity. If Kristeva has driven home but one point to me it is that all drives *must* be INTERNALISED, if knowledge production is to progress. For those who regard her theories as rather homophobic – I concede that I can understand why but that I prefer (as a bisexual woman of mixed race) to take those comments into a new revolutionary arena.

However, Silverman rightly asks – how can this mute mother, who is supposedly irrecoverable (except by her own daughter in childbirth) weave this anaclitic

enclosure which figures herself and her child? She can not. Or can she?

The mother cannot be the *chora* and inhabit it at the same time, simultaneously. I ask the poignant question of why? What decrees this phenomenon an impossibility?

Does someone else have to speak for the mother? Is it the artist? Conspicuously, is it the male artist – due to the erotic focus of the Kristevan son? According to Silverman, this strategy enables Kristeva to articulate a desire for the mother under the guise of heterosexuality (or with a pre-occupation with male homosexuality). We could wonder how little Kristeva's voice is a vehicle for the semiotic. This is of course impossible because THAT voice makes no sense to our rules. Or does it? Kristeva's voice speaks with lingual and epistemological authority, so is it then a defense against the union with mother? The reunion with mother would mean a collapse of her subjectivity; a loss of voice. Are we not trying to reach a point when a woman can engage in a symbiotic and erotic manner with another woman, and not have that union seen as just simply a narcissistic endeavour – but as a union that encompasses all the hard work that is ordinarily necessary? Is Kristeva's voice father-identified? If it is – then what does that mean – for she is a woman? Does Kristeva equate woman with mother? Silverman notes that the woman-as-a-speaking-subject is NOWHERE to be found within Kristeva's legendary work *Revolution In Poetic Language* – but then we know "woman" is a construction. We know that SHE does not exist – except in how "she" speaks us/me/you as women.

Therefore, we assume that Kristeva is approaching Mother through a protection of the son/father. We assume that she speaks from a position that is deeply within the symbolic, deeply estranged from the *choric*. However, I do not believe this to be the case. Women, although oppressed and largely silenced by the symbolic, do STILL have a participation in the symbolic. We have ALL built the symbolic. It is not a cut and dried case that states that to be male is to be in the symbolic and to be female is to be within the *choric*. The same applies to notions of masculinity and femininity. Women have participated (often, admittedly to their detriment) within the symbolic. We are still there within it. Even if IT speaks us, and we do not fully see ourselves within it. We are partially there. Many men do not feel "allegiance" with the symbolic but we do not credit them with *choric* promotion. This is not a case of blaming the mother for patriarchal "sins" but rather a case for the inclusion of women within a discursive reality. Women have always had the double-edged privilege of re-working their imposed roles. One could play the whore for one's own effect. But then it would turn itself back on the woman and make her a victim. I am not suggesting that women have always had an authorial liberty. But I have to acknowledge that women have played along with certain signifiers (and hopefully will continue to do so) so that where those signifiers have "spoken us" in the past – we can now become the signifier itself for our own effect. Maybe this is the Kristevan angle. Maybe it isn't. I leave it to the reader to decide.

At the end of the day Kristeva has to some extent situated mother on the "side" (if there has to be a side) of [symbolic] castration; replacing the thetic with the *chora* brought to us by artistic practices (albeit male artistic practices). But I believe this castration to be a symbolic castration – something we shall further research in this book.

For Kristeva (first-hand) the subject is posited by castration – so that drives against the thetic (the finality of the signifier; or the final stopping point of meaning – which is actually quite contradictory) don't give way to fantasy or psychosis but lead to a 2nd degree thetic – a resumption of the characteristics of the semiotic *chora* within the signifying chain of language – and artistic practices and poetic langauge can do that. In other words – Kristeva posits a new language and way of coming to signification which can overcome psychosis or schizophrenia by the inclusion of this 2nd degree thetic. For me, this is a Kristevan way of acknowledging the duality, the binary, the contradictory notion which Silverman first accused her of. It is as if she answers back by describing a neo-signification which encompasses/internalises a symbolic castration (i.e. estrangement from phallic patriarchal absolutism) whilst also acknowledging the characteristics of the semiotic – without mental disturbance – but rather a lingual signification that places the thetic beyond itself. To place the thetic beyond the thetic has always been the concern of the schizophrenic (who takes upon him/herself the responsibility of actually being the signifier [mark of meaning]) but this new concept in signification asks of all of us (or maybe just the individual) to place the meaning beyond the meaning. This would seem to me to be where I came in! The internalization and importantly the responsibility are again key issues!

But does Kristeva ever concede to her maternal longings? She does in *Stabat Mater* – where we encounter in her paper two columns of print. The left hand column is a whirl of words. It is a real semiotic cacophony of meanings and signifiers. It is ostensibly the voices of *chora*. However, it gradually moves towards a sort of grammatical propriety, and concludes itself with a subject-predication. It becomes more and more like the right-hand column (the linear patriarchal speak). One could automatically assume that this demonstrates the Kristevan affinity with the father-speaking-subject position. But could it also not be – a loud cry of the mother who was *already* a subject; already a discursive and articulate being? Is it not an ironic pun from Kristeva? Is she not saying to me that she was only here NOW so she could speak about it THEN and she knows I will only understand her now as I could possibly have understood her THEN. It is, as aforementioned, a case of temporality!

Silverman says that the Kristevan self-implicating *jouissance* is really a celebration of the mother and son relationship. But how does one know *jouissance* unless one can be self-conscious enough to do so? That self-consciousness is not, to my mind, reliant upon a sexual other – but it is reliant upon an Otherness/ otherness. Thus, I would preclude that what Kristeva is addressing is not merely the intervention of the actual man and his phallus (in the shape or figure of the father or son) but the internalization in the woman of some kind of thetic mark (be it primary or secondary) that signifies TO HER her own *jouissante* bisexuality/pansexuality (bearing in mind that sexuality is predicated on constructed roles and drag role-plays). Therefore, if one adds the mother/son equation to our prediction one sees that as this is based on loss (loss of the sexual/biologistic other) so too all equations are predicated on loss; some psychological, some genderized, some sexualized ... memory, smell, appearance, sound, physicality, inclination, history, identification, sociality ... and on and on.

The child becomes an other, regardless of gender. It becomes separate – it becomes other. Maybe it was always – other. Mothers and daughters may find affinity in the birthing process. I could add at this point that due to physicality daughters can quite succinctly IMAGINE their births and the births they will undergo – enabling a certain identification. Thus, maybe daughters and mothers recognise differences with difficulty. But only if they cannot see/feel beyond their biologistic identities. Silverman returns to the Kristevan description of a "community of women". Again I would posit that within this uptopian/dystopian community differences most definitely occur. Of course they do. I, myself, am a black woman born of a white woman. That in itself is a major Difference.

24. Better Listen To Mama!

It could be said that Kristeva's maternal fantasy is rooted in fear; that she is fascinated by a weakness ... the weakness of language. If it is warm, scented and soft; evoking a spatial memory – it also has no voice to it except, belatedly, the echo of quarrels and the sounds of mother's exasperation.

But I still believe that Kristeva is stating something indubitably poignant and poetic. As she has posited the abject nature of semiotics as the almost impossible critique of a language by language (to critique the natures of language one must utilise the language one is critiquing to do so) – so she is commenting on the desire for subjectless (voicelessness) which simultaneously requires the subject to be, to then know of it!

If Kristeva claims that to be without legitimation is an impossibility to imagine, a depressing "possibility" of transgression, with a void that causes an open wound in the heart and allows her as a subject to be only in purgatory – then she will, of course, yearn for the Law. But in her understanding of Abjection she will also be drawn to the abyss, the promised land, the heavenly apocalypse where cut-ups in time do not exist and the self is freed from a disreality by being wholly consumed by this new pelagic spaceless space – and she will remark on the perversity that this occurs at the expense of any self-hood who could use language and be used by language – so that she can tell herself (and us) about it. There is, in my opinion, an ineffable poetry to Kristevan theory. If women are driven to the abyss then they realise that they also have to exist in the symbolic at the very same time.

However, I believe one can return in hypothetic fantasy to the maternal realm, now as a speaking authorial subject and partake of both positions. Mother is only a voiceless un-subject in a uterine space to those who do not recognise her as an authorial subject aside from her maternity. In short, only over-grown babies see mother as a static one-faceted voiceless effigy to her own birth. Others may see a woman who can speak many languages. Perhaps this is what Kristeva is trying to illustrate. The myriad faceted prowess of a woman who can change into so many beings and non-beings.

I am in the process of becoming an other at the expense of my own death. "They" see this process The corpse (cadaver; *cadere* – to fall) falls completely away. It expels all bodily waste – it rejects all – until it becomes the non-subject consumed by the flames of the "promised land". The bodily fluids are what life withstands – parts of us are falling away and dying. Parts of myself (hair nails shit urine blood) fall away that I might be. I am at the border of my condition as a living being. My body extricates itself from itself so I can be. I expel words that make me be. I reject words that cause a little death in me. Until that is I reject so much that nothing remains and my entire body falls beyond the limits, beyond the boundaries of what is set up to define me. The corpse is the most sickening of all wastes. It encroaches upon everything. The "elsewhere" that I

imagine beyond time or in hallucination (so that I might be able to think beyond me and mine ego) is right here, in me. It is abjected into my world. Deprived of my world I fall in a faint. I lie on a razor edge with a glimpse of nirvana in the corner of my eye. This corpse without god and outside of science is the utmost abjection. The place where meaning collapses. The abject meets my superego – my master. What I want was not what I thought I wanted. What I do not want. Abjection is my safeguard. I have spit myself out, I have balked on the skin on the surface of mother's milk (a little object) that is mine and in me, so I am spitting out myself. I cannot assimilate. I have to give birth to myself (again). In a land of oblivion (remembered like *dêjà vu*) I cannot speak of the state I am in.

So for Kristeva, if woman has a role it is a negative role. But we should remember that the Kristevan definition of negative is highly complex. Rejecting everything finite and definite or loaded with structure and meaning. Woman thus becomes revolutionary. She also does not exist as she is spoken. But, it could be said that the Kristevan woman after having rejected phallic power – then moves onto the side of it and re-embraces it in a strangely ironic move. Silverman says that Kristeva always views the symbolic and semiotic as mutually antagonistic. At this point she makes no mention of Kristeva's enduring belief in the internalization of both. The two divisions could be read as two different desires – both when they are internalized – they take on a different tenure, do they not?

Silverman also believes that the desire for the paternal is gaining ascendency in Kristeva's work. Rather than the mother providing a first space for the child and being a tutor, she is becoming more a claustrophobic wrap that is suffocating. Rather than the mother being able to provide the necessary devices for the child to discover its subjectivity – she is damned as a presence that will forever rob the child of subjecthood. This is the point that Silverman brings in her interpretations of Abjections – stating that the Kristevan mother is described as something that must be excreted or sloughed off as an abject. It would seem to me that at this point the mother is capable both of being abject and discursively-empowered. Yes, she will be sloughed-off but she will also always remain both a memory of the semiotic and a tutor of discursive prowess. Silverman believes that this indicates the arrival of the third party (the father) who is necessary to the child's alterity. Kristeva would seem to be giving the father a pre-Oedipal persona! However, I believe that the mother herself can stop abjection – at the same time that she can not only abject but be abjected – and I believe the abjection to be a vital aspect of development.

According to Kristeva the father induces the child to abject the mother. This is as I've said – a pre-Oedipal father identification which proceeds through oral assimilation. It would seem that Kristeva is giving the work previously associated with the semiotic and the mother – over to the father.

Primary narcissism (first self-love/identification) is the point when the child realises that it isn't everything that the mother desires and therefore the child assimilates her/himself with the father. This fusion or unification with the father according to Kristeva maintains the father as someone who is like both parents (unlike secondary identification). Primary identification isn't gendered. But it

would seem that her account of primary narcissism IS sexually differentiated. Or is it? Does it really posit the mother as someone incomplete so that her desire travels beyond the child to the father? The child then follows the path of her desire and either incorporates the phallus (primary narcissism) or aspires to have the phallus (Oedipal). The child then come to exist within the signifier of the symbolic order. Therefore the mother assumes the role of representing castration and lack.

I would like to interject some extraneous thoughts at this point. Primary narcissism comes before the phallus, and if it is anterior to it, therefore to a degree, it exceeds it, positing the child as the one who lacks! The child simply knows that it is not everything that its mother (someone pansexual and simply greater that it) wants. Mother exceeds the child. The child knows not of desire (in the way an adult does) – so the child sets off to encounter her desire (not merely her lack – for she has no lack according to the child).

It is the father with whom the child must align itself, as a condition of subjectivity. However, bearing in mind what I have just posited this is simply an alignment with that which the child perceives the mother to want. Then secondary identification kicks in.

There are divergences between Kristeva's primary narcissism and the classic Oedipal complex. Does Kristeva's primary narcissism theory wonder whether one is or is not the phallus? Is the mother at this point (to us and not the child) phallic – i.e. everything and absolute? The classic Oedipal complex realises accordingly the difference between the having and not having of the phallus. According to Silverman, this depends on whether primary identification has occurred. According to Kristevan theory (unlike the Oedipal complex) this occurs OUTSIDE of desire or mediation. Silverman believes that the mother's desire is crucial to the activation of primary identification. She therefore mediates it. Primary narcissism occurs prior to a coherent objectification with the other (i.e. – before the child is a subject). It is extremely difficult to tell when one phase ends and another begins. However, I do have the feeling that whilst it may not seem overtly so, Kristeva is taking this into account; although I will concede that it reads as if she is stating that sexual differentiation has already occurred in the child. To the child – we must insist – it has not. I am certain that Kristeva is aware that the mother's body, to the child, is NOT the codified body as we know it!

To further illustrate my point I would like to forward the paradigm of the third party (involved in primary narcissism) as being a lesbian partner/lover of the mother. If the mother desires a woman, than surely her child (on realising that his/her mother is looking beyond him/her to the third party) will assimilate him/herself with the third party who would be in this case a woman. Secondary identification could then occur through subjectificatory identification with woman or man; or indeed with the mother (if the child still perceives its mother as wanting nothing more than her child). The child could well turn to a male presence for identification with the symbolic or a female presence; and as I've stated the mother herself could handle primary identification by herself – in that the child could choose to turn back to the mother (sensing something in her that could still be the third party – i.e. her role, and ability, as tutor).

However let us return to Silverman's argument with Kristeva. Primary narcissism leads to subjectivity (the child gradually separating itself from the semiotic union with the mother), and entry into the Oedipal stage (where sexual differentiation *does* occur). According to Kristeva this deprives the mother of primacy, but as we realise this is not necessarily the case. Primary narcissism makes the father the first love object (I believe this only occurs if the child gleans an idea that this is what the mother desires [not merely lacks]). However, following this train of thought – we take the father as the "privileged being". The one who has discursive powers within the imaginary as well as the symbolic. I could add at this point that from an adult-subjective position – the child could become him/herself the Phallus which it believes its mother desires – but there is no evidence that the child could know of sexuality, or biologistic sexual difference, in this way. The child could try to emulate ANY fantasy of its mother. However, according to this Kristevan theory the mother is jettisoned before the mirror stage. Her abjection becomes a precondition for language (i.e. the gap separating the sign from the referent; the signifier from signifier).

Silverman reckons that Kristeva therefore dispenses with the maternal voice. But primary narcissism gives priority to the voice over the image. Kristeva believes the "ideal" identification with the symbolic upheld by the other activates speech (more than image). But we could say that the signifying voice shapes the visible and therefore reality.

So, Kristeva's paternal voice becomes the acoustic mirror shaping subjectivity and reality for the child. But the gap between any love object or identification, and the child, could become the gap of signification. In short, what I am saying is that any sense of separation from the "symbiotic/semiotic" mother induces the sense of self, or subjectivity. Even a child coming to realise that the breast or voice of the mother is not part of him/herself – could be enough (more than enough to trigger a sense of self-ness); let alone the interference of small objects (Lacan's "small objects"). It would therefore seem that Kristeva is simply using genderized terms for something which is not and does not have to be gendered; even if we are reading her [hypothesis] as predicating gendered subjects within the symbolic order. I believe this is the point at which confusion arises between Silverman and Kristeva. Kristeva, ever vigilant of lingual and temporal delusions, is speaking abjectly as an adult would speak a child and not as a child would speak a child. We would do well to remember this point in our analysis of psychoanalysis, rhetoric and sexual politics.

However, according to a more traditional polemic (!) we take primary narcissism to signify the first lead into the Oedipal complex. This is the next step.

This supposedly is the Freudian point of depriving mother of a primacy. But it would seem only likely if we take primary narcissism (the anterior step) as signifying maternal lack as very different from desire. Whilst I recognise that desire is often based on lack (i.e. – what the subject psychologically lacks s/he will reach out for desirously) – we have to consider the temporal attribution of the child's perception. Traditionally, the father (as third party) thus becomes both imaginary and symbolic. The child her/himself *can* become the Phallus. Culturally, it would not seem unusual to consider the child as the largest object to make connection with the vaginal passage, or to be the most demanding of all

phenomena to connect with the cervix, uterus or vagina. The baby's head becomes a phallic head (culturally and also medically seen as much larger than the shaft of the baby's body) – and this gives out cultural signals that basically all women secretly desire a baby simply because a baby is the largest object that their vaginas will know. It would seem that the acknowledgment of the difference between a child and a lover (whether that lover is fucking with his penis, his fingers, her fist or her tongue) isn't recognised. And it should be. Social acknowledgement is vital at this degree of sexual politics. A female (lesbian or bisexual) lover's fist (followed by wrist and arm) is maybe more affecting and physical than a man's penis. Then again, a man can also use his fist (to poignantly penetrate a sexually aroused woman; not to abuse her) and his fingers on the intimate parts of a woman's body. Let us not get caught up in the battle of whether a man or woman can give better pleasure to a woman. Let us not become wholly diverted be issues of SIZE despite the cultural pleasures involved (for sex is usually in the head before it is in the pussy). It is a case of it being on the woman's terms.

But then, the child could be ANY fantasy-figure or substitute (physically or psychologically). However, according to Silverman's interpretation of Kristeva – the mother is jettisoned BEFORE the mirror stage. Because of what I have already written and inferred, I believe this to be a case of mixing up pre-symbolic signification through the translation of symbolic signification; bearing in mind that only symbolic signification actually means anything to us as subjective adults.

However, accordingly (as regards Silverman's understandings) the mother's abjection becomes a precondition for language (i.e. it becomes the gap that is needed for the separation of sign from referent, signifier from signified). Kristeva thus gives precedence to the ideal identification with the symbolic as it is upheld by the other, and as it activates speech (more than it does image). The signifying voice shapes the visible reality. Therefore the father dictates the reality. As I have already tried to explain this is not the (gendered) case.

Is Kristeva's paternal voice the acoustic mirror? Or is the bridge between child and mother the gap that is necessary for subjectification, identification (also) and the introduction of the symbolic? I believe that Kristeva uses a great deal of irony in her descriptions of psychological developments regarding language and subjectivity. I confess that I will leave the conclusions to the reader. How are Silverman and Kristeva reading the abilities of their readers? Do they entrust a homosexual or heterosexual readership, or interpretation? How does that align (or not) with the concept of homogeneity or heterogeneity?

However, Silverman goes on to accuse Kristeva of severe defenses against the pull of mother.

"Make me do this – make me do that …/And like the cat that take the bird …/To her the hunted, not the hunter/Mother – stands for comfort/Mother – will hide the madman/It breaks the cage and fear escapes and takes possession/Just like a crowd rioting inside/Mother – stands for comfort/Mother – WILL STAY

MUM/Mother – she stands for comfort/Mother – WILL STAY MUM ..."
("Mother" – Kate Bush – from the album *Hounds Of Love*)

We can follow two interpretations, psychologically. Two versions of the Oedipal. There is the heterosexual (which is aligned with the symbolic), and the homosexual (which disavows the symbolic). Overall, the Oedipal complex is two-fold. There is the positive Oedipal complex and the negative complex. A boy can have mixed feelings towards his father and an affectionate "object-choice" inclination towards his mother but at the same time he behaves like a girl (being affectionate to his father and jealous and hostile towards his mother). *Extraordinarily, Freud never gave a female version of this (two-fold) theory.*

Silverman suggests that the pre-Oedipal has been replaced by the negative Oedipal (i.e. homosexual desire). Freud suggests that the pre-Oedipal desire travels to the Oedipal phase, and hence, heterosexuality (i.e. no hostility to the father). It would seem that above and beyond everything, what Freud could not understand, was a prolonged attachment to the mother by the girl-child or daughter. However, it is important that we always remember, that it is ONLY through the FANTASY of paternal seduction according to Freudian theory, that we arrive at the positive Oedipal complex (i.e. the girl-child's desire for the father). Nothing according to Freud accounted for the prolonged attachment of the girl to her mother other than actual physical stimulation (i.e. the washing of the child, or the adult comforting the child). Of course, we can now see that a child can arrive at the point of Oedipal complex without the intervention of paternal seduction. In fact, at the level we have just discussed (wherein the child does not acknowledge sexual difference) this would seem even more unlikely. It is ONLY at the level/point of the Oedipal complex that sexual difference is acknowledged, disavowed and then fully acknowledged.

At a standard level – castration is the point at which the boy-child realises that he cannot desire his own mother or his father will castrate him (even if he is up until that point desirous of the mother-figure, the father-figure will loom large and threaten him with the loss of his newly discovered penis/subjectivity). Thus the boy exits the Oedipal phase. The girl-child will enter the Oedipal with the impetus of the castration being the necessary factor for her entering a positive Oedipal complex; i.e. – having no phallus to lose – she will therefore desire the paternal phallus.

According to this hypothesis, the *girl's* desire for her mother is only initiated through symbolic castration, and thus the entry into language. The ostensible "lack" equals the desire and need for the signifier. Therefore, symbolic castration leads to the desire for mother. It is not so much a "fading of being" (Lacan) but a separation from ma. We now know that this is not the case. Any separation from mother is described by a gradual and perpetual relationship – as I have above described. After all, what possible other "object" (for girl-child or boy-child) could possibly be such an ALL? And it is such an ALL which has been sacrificed to patriarchal meaning. Lacan also recognises that this ALL-IN-ALL (different, I should stress, from a metaphysical patriarchal absolutism) could possibly drive the non-subjective, or coming-to-subjectivity, *child* to step beyond

that which it believes is its everything, and which it is everything to.

The entry into language could be an eclipse of the Real. Following that train of thought, the woman assumes her burden of lack (of mother) and the patriarchal lack of motherhood (semiotic lack) too. But, as we know, the female body isn't just an ostensible site of insufficiency, but also the girl-child will be propelled into the positive Oedipal complex. Love for mother. Love for father. The desire for the mother (within THIS acknowledged patriarchal system) becomes ONLY a contradiction of the normalised desire for the father. It is an investment in the Phallic realm of reality and by investing in that one assumes that this means a disvalued opinion of that which the order doesn't consider real. Therefore, we realise that the pre-Oedipal is foreclosed upon. We surrender any inclination to the realms that, in effect, exceed the Oedipal. Or we describe those realms only THROUGH the Oedipal. This manoeuvre, thus, brings the mother/daughter relationship into the realm of symbolic castration and Lack, rendering satisfaction incapable of becoming real.

To impute the daughter's erotic involvement/investment with the mother to a pre-Oedipal reading (from a post-Oedipal reading) suggests that female sexuality precedes language in such a way as to make it a sort of "nature". To place it so firmly in the Imaginary (in a Lacanian sense) – makes of it an essence, which is highly problematic. As the mother/daughter relationship is outside of signification it is also outside desire. Again, very problematic.

However, we can posit it within the Oedipal complex. This makes it an effect of language and loss, and posits it within the symbolic; and within desire. To speak about a desire which challenges dominance from within representation and meaning, rather than as an essence/biology.

It would seem that one's unconscious desires are very far from monolithic. They are divided between two scenes (negative and positive Oedipal?). I also think of all the discursive and relational strategies which activate psychological fantasies; some corresponding to maternal desire.

Thus, I believe, as I have previously stated, the tension in Kristeva's work is very much evident in the bifurcate hypothesis that I have arrived at.

We could view her work as the *choric*, semiotic, genotextual eruption upon/of the unconscious desire which anchors her to the Oedipal/symbolic, by way of her subjective desire, and also anchors her to the semiotic with her sense of not being what they told her she was.

Or we could imagine (imagine being the operative word) – that the *choric* is that which exceeds/precedes the symbolic, always pressuring the linearity of identity. For I believe, much as I am subjectivity confident – there is some-thing pressuring my sense of "I". Most of the time it is "I" who pressures this eye. This is what I feel Silverman does not take into account.

Let us then consider the Kristevan sense of "negativity" as the negativity of the negative Oedipal complex. Negativity, in this instance can be read as the rejection of how I am read or how I read myself ordinarily. It has little to do (in this reality) with a desire which is at automatic odds with the phallus; rather it

takes on board the rules of the father to further address them. Maybe at this point we are thinking of a neo-complex. A sexuality/genderization that considers more than its binarised predecessors.

For, as we have already deduced, the pre-Oedipal (and Oedipal for that matter) come only AFTER the fact. We do not know how we were *before* we "were" as we know ourselves now. We can only use our present language and its drives, pulsions and pressures to read clues into our previous pre-selves. If mother was pansexual, all-sexual in her "non-sexuality" than I believe that it makes sense. "That" is what we search for. We do not search for what we have lost. But for what we can never have. An indescribable wholeness that belies our definitions of subjectivity. Who could possibly desire or want THE very thing which mocks our sense of autonomy. BUT, it is only by the rules of our very OWN autonomy that we desire it!

One could say that Kristeva literalizes the *choric*, and subsequently cannot imagine mother as also occupying a symbolic position, much less any discursive potency. Silverman concedes that there is a value to *negativity* (the forces working against patriarchal symbolism and language) but is keen (as I myself am) to stress women's investment (unconscious or not) in this order. Yes, we need the *chora* and *enceinte*: but as we fantasize unity we also need separatism. And, most definitely, feminism needs the negative Oedipal complex. But I realise that I have to recognise the unconscious (or the *déjà vu*) mother for who she is. She is not Luce Irigaray's "woman" (if Luce Irigaray's woman is any kind of reality). She is not this figurated being with her "two lips … constantly embracing" like some higher being of a cosmic nature, who never looks/speculates upon another [for we ALL speculate; it is the *results* (represented within a biased culture) of speculation that can lead to projected essentialisation], and who is only interested in the tactile. Patently nonsensical, when one can equally posit that a man's two testicles constantly touch each other (within his scrotum), as well as touching his penis and being cradled by his groin. That is also surely a kind of self-referential and protective "hugging" of oneself to/by oneself.

Therefore we should recognise the unconscious mother as Oedipal rather than a pre-Oedipal. The unconscious mother is only pre-Oedipal *if* we truly imagine her as either sexless or pansexual (although we know not of sexuality anyway) or as a being with no difference about her, and this is impossible to imagine.

Silverman accuses Kristeva of being auto-critical of the pre-Oedipal in such works as "Women's Time" (mentioned much earlier in this book) and *Stabat Mater*. As a mother she seems to be critiquing motherhood's inability to speak by using a paternal voice.

It is however my belief that the disruption of the *choric* upon the symbolic language is not in itself meaningless. The *chora* has to point women forwards rather than being a regressive device. I therefore like to consider motherhood (and the *choric*) as necessary to the radical splitting which must occur for a being to be. And as I have stated mother is capable (if not for the most part, better equipped) to guide her child through that Split; this obviously involves Lacan's Mirror Stage, which I tend to regard as a maternal area of guidance. It is crucial that feminism come to terms with symbolic castration. I mean this in two ways. Namely the acceptance of the lack of penis, and the subversion of the

premise that the penis is always the phallus (i.e. the absolute signifier). As well as coming to terms with my separation from mother and futural daughter – I can then cope with the gap that separates me from language (as that gap affects us all). And the gap that separates me from the pre-Oedipal and Others/others. I can also then appreciate unity. As I have stressed before I give predominant stress to the interiorisation of separation. In this way I can see that the *choric* fantasy is really the fantasy that deals with the entry into language and the negative Oedipal complex.

25. Body Maps Sound Tracks

Feminist writing and performance has centred itself around the female body. Irigaray, as aforementioned, has promoted a language that in itself reproduces the qualities of the body and sexuality. Contrary to Barthesian theory there has been the belief that the sexual identity of the author's body makes a marked difference. I ask myself just what that difference is? A difference in experiences described or expressed; this is undeniably true. But is there really a difference in the actual linguistic drives? Whilst one may automatically initially believe that women best involve themselves in the drives and pressures of coming to writing (or expression), in that they may challenge the way language works; we know that many male writers write "female" or spatial prose, and involve themselves in experimental performance and voice-work.

Also as we have realised, the alignment of female voice to female body can work to effect an essentialising entrapment. Experimental voice-work today often tries to extricate itself from the concept of a fixed singular voice being tied to a (fixed) body. The voice can be multiplied, looped, magnified, distorted to effect a subversion of synchronisation, and redefine the spectator/spectacle relationship, and blur interior/exterior distinction.

Whilst Irigaray is critical (quite rightly) of the phallic economy, her alternative has proved itself also problematic, in its predication of a morphology. It would seem to many feminists, including myself, that the answer lies in deconstructing the phallic problem without falling into the trap of a reductive supposition of a female morphology. We already know that sexual difference derives from the problematics of Sameness (the woman is simply a little man who becomes a castrated man after the Oedipal complex). The female genitals are also thus defined through this symmetry with the penis (the clitoris being an inferior penis, or the vagina being a complement to the penis). If a woman doesn't represent either of these two options she becomes a stand-in mother; the only heterosexual object a man is capable of loving. Thus we shouldn't forget the seminal power of Irigaray's critique of phallomorphism. She quite rightly expounds the theory that male desire has nothing to do with woman; rather it is solipsistic and self-referential. Strangely, as I have mentioned in the former chapter that self-referentiality is also a quality she confers upon woman when she privileges the two lips of the vulva (ostensibly placing importance on this part of the body over the vagina, clitoris, breasts, in her poetico-theory). She claims the female body as a continuous, auto-erotic entirety which may be news to many women whose concept of auto-eroticism and sexual activity is very genital specific. I am not suggesting that the whole body is not an erotic zone. But it seems to me rather misguided to ignore that many women gain pleasure from very specific clitoral/vaginal/anal stimulation. She also appears to disregard the simple fact that sex also begins with the mind and that female fantasy can play a major role. But what is truly remarkable is her claim that because the two

lips of the vulva are continuously embracing, a penetration by the penis interrupts natural female pleasure. This somewhat conjures up a mind's-eye picture of a vulva that should stay permanently sealed. She makes no mention of whose penis could be causing this interruption. Why it could be the woman's own dildo or vibrator, to say nothing of other "interruptions" such as fingers, tongues, toes, fists or other inanimate objects. Irigaray's "auto-eroticism" appears disturbingly a passive affair. Link feminine language with this idea of sexuality (i.e. the plurality of a female language equates with a plurality of the vulva and body) and the whole idea becomes ridiculous. However, I am not dismissing the idea of a body-language completely. Corporeal experience can be interestingly spoken and the body of the language can also be corporeal. Maybe an alignment of poetic language with libido is more appropriate; but that can also be problematic if it's too essentialised (i.e. reduced to a passive/active binary, and not a sense of psychic and libidinal [the issues surrounding psychological concepts of desire] experience). Lacan on the other hand concerned himself with the loss of the body when woman comes to language and the resulting problematic of that for *any* being. The incommensurability of signifier and body. Irigaray has thus neglected to address the relation of language to referent.

For Irigaray believes in a new language. I will only call this language "female" for want of a definition. To believe it is actually female is to warrant the *same* iconic, indexical relation of body to language that she opposes regarding phallomorphic language. This highlights a failure to distinguish between the real body and the discursive body. As many feminists realise – Irigaray's mimicry can be a valuable strategy but unfortunately that is as far as it goes.

Female corporeality thus reads "optatively". How the body might look or feel. Irigaray's description of woman has an extradiscursive reality to it, which somehow comes into existence without cultural interference or a mediating representation. And also because she often uses the present tense in such descriptions one assumes the words have a referential value. This is of course the dilemma I am trying to address. To describe a femaleness, in terms of a corporeality which is supposedly akin to "real" female experience, has to pass through the mechanism of the discursive. Somehow Irigaray assumes "her" female being to exist in another dimension (a wonderful tactile loving dimension) that neither requires nor subsumes the discursive body. Many women write their bodies this way (myself included) – but it is fantastical in its way – even whilst it assumes to be "real"; or true-real. However, I still believe that this account of female corporeality has its place if only to address the *abjection*. One can confuse the real body and the discursive body (the meaning occupies one order and the biological another order); the real mediates/determines the discursive. And vice versa! Importantly, the subject's relation to her body is lived out through the mediation of language, but the body is moulded and coerced by its representation and signification. Discursive bodies mould real bodies in myriad ways. Gender is one consequence; hence why I can posit that gender is actually drag (a construction) [see: my paper "Propinquity, Mobility And The Semiotic: Considering Constructions And Prohibitions"]. Even if one stripped the discursive which separates the subject from her actual body the influence of culture would still remain.

I can therefore say that the actual body is un-coverable in or out of language.

But, as feminism has shown us, we can re-write the body. Let us consider the discursive body (and the actual body too) if feminism hadn't already re-written so much!

The aim is to change the discursive conditions (and boundaries; to say nothing of signifying chains) under which women live with their bodies, rather than trying to escape the discursive by the impossible wish for a pre-discursive sex. So, as I have already said – whilst many women may write a fantasy of themselves (cosmic-natured, nurturing "creatures") the only progress I believe can come of this is to write THROUGH the diegesis apparent, and be aware that what is written IS fantasy – so that we can ask WHY it is written (and in such a way) to then move on to using language to concern ourselves with a full discursive phenomenon. We cannot simply slough off our present bodies (and their descriptions) as these have been inscribed within language to such an extent because, in layman's terms, "we need something to go on". This is why I personally utilise the descriptions of the madwoman or hysteric to expand on. That is the description of myself therefore I will take it. No-one would know what the hell I was on about if I suddenly arrived with a new set of references. All signifiers are chained together. It is my job to join together new sets of chains not disband all sense of signification. If I were to disengage from the present body it would have a profound effect on subjectivity (which is founded on the discursive body). It would also disrupt other women's subjectivity, and I am afraid I cannot do that.

It can also be said that Irigaray fails to differentiate between sexuality and the body. I have already dwelt on this to an extent. Sexuality cannot be read directly off the body. Even if the psyche *is* a projection inward from the surface of a constructed body, the psyche is a category without which there can be no sexuality. The sexual requires internalisation and fantasmatization of the subject and object. Despite some philosophical or religious beliefs. One requires the installation of both as *corporeal images* within the psyche.

Sexuality requires that the subject must occupy a particular position within a psychic *mise-en-scène* (scene setting). Some may like to think that true liberty comes when the human no longer has to involve her/himself with the mind regarding sexuality. One should be able to enjoy sex and sexuality without the engagement of the mind because this is merely the influence of a damaged/damaging patriarchy. Maybe this is the case!? But we will never know this. One cannot posit that we should all have sex like animals without thought because this is simply unfathomable. We experience our sexuality (without even knowing it) through the psychic and discursive subjectivity. It would not make sense to our sexual selves if we did not. Camille Paglia more or less describes this in *Sexual Personae*. Sex is about power-play. It is about ROLE. It can be about love; but it is always about the psychic influence on our bodies.

The psycho-sexual scene-setting is itself a product in part of reminiscence and deferred action. Pleasure experienced by the body is possible through happenings elsewhere (even if it seems like it is a direct physical re-action to physical stimuli). And I am not just concerning my argument with the results of sexual fantasy. It is not that black and white. Even when we are involved in what we perceive to be the most integral, honest and loving of sexual

encounters – we are still involved in an intercourse which relies upon the psychic and discursive histories of ourselves. Memory, fantasy, history. The unconscious.

We have nothing to gain in the Myth of some sort of sexual immediacy; despite what certain theorists tell us. I am thinking at this point of certain "religious" philosophies (namely some versions of old-cult pagan religions or Satanism – which has always advocated "true" sexual freedom for women – but which in actual fact seeks to shackle women in roles that deny their discursive or intellectual powers, by telling women it is wrong to intellectualise their sexuality. Rather they should simply *feel* it instinctively). This angers me because what it seems to me they are playing on is the old adage about women "relaxing during sex"! Of course women should relax and enjoy sex. Duh! What fool believes that we shouldn't?! But it is ignorant to assume that the mind is still not in play. It is the mind that somewhere in some distant corner of the consciousness makes the senses sing with imagery with the KNOWING. If I do not know the significance of a finger touching me, how can I respond? If I do not know what it is to really desire someone, how can I desire? Simple as that!!

I can not gain from believing that my body simply reacts to stimuli regardless of my mind or subjectivity. It is a nonsense; despite what certain factions tell me about denying my "true instinctual" self. All messages to my body come from my psyche and return to my psyche, in a cyclic continuum – and no one can possibly tell me that my psyche (my subjectivity or sense of self) has suddenly become absent or non-existent just because I am being sexual. Rather it is my psyche that makes me sexual not my sex organs. It is language and the representations which arouse me. It is sensual imagery which arouses me (again I stress that this does not mean just sexual fantasy. But rather that I wish to know what it means when I'm crouching or lying on my back or touching a part of someone or doing wild things with someone or myself). I have to know what that means to myself as a person or else nothing has meaning! It is *not* a clinical (phallogocentric) debate which is going on whilst I am sexual. I don't have to take time out to contemplate political relevance; rather it is part and parcel of my sexuality.

Incidentally, I would also like to add at this point a male re-active to some of the points I have already raised. I would like to address the issue of male feminism. Many male colleagues and acquaintances revel in informing me that they are definitely not male feminists. It is as if they predicated this from a reactionary view-point which only highlights their misunderstanding. It actually highlights everyone's misunderstanding. Whilst the cultural jokes that feminists make (like most "groups") are amusingly light relief they should not be misconstrued. Somehow it has come to be believed that a male-feminist is at worst a wimp and at best a hypocrite (or vice versa). A male-feminist only reads women's books and partakes of women's studies as a diversionary tactic. "Holding his Virago [women's publishing house] book in one hand whilst he tries to put the other up your skirt." Charming you with his "sympathetic" mien; he can be heard to cry out about how much he loves his sisters. He's "right behind you". Or so he says. Unfortunately, one wouldn't necessarily want him on your side if it came to a "fight". Let us not pretend the battle of the sexes is over!

But does it not seem strange that somehow our society has defined men in only

two ways regarding women's rights and issues of sexuality/gender and sexual difference? The wimp or the hypocrite. How sad!

I can only ask – where is the man who is secure enough in his masculinity that he does not have to align his gender with Absolutism, or fascism? Where is the man who does not align his discursive being with phallogocentrism to such an extent that his body and/or subjectivity suffer because of it? Where is the sexual, erect, intelligent, non-threatened man? I do not ask for his apologies. Why apologise for something which you have not done? But why not ask for some assistance from your sisters? The representation of manhood predominantly dominating our present culture is not that which many women desire. Many virtues have become weaknesses. Why does this still prevail? Does it really all boil down to the bedroom? Or is it the boardroom?

At present, as I write this (and I admit that my main concern is of course for women) I can only say that it would seem to me that only certain factions of our society are dealing with this dilemma. The dilemma of manhood today. Within the black community, it would appear that things differ, although only slightly (and maybe only within popular "yoof" culture i.e. music, where sexual politics still takes somewhat of a back-seat to racial politics. So it is probable that so long as young black men and women are united in the fight against racism, they are less likely to fight each other regarding sexual politics). The Black reality is such that women can be strong women and men can be strong men. I admit this is a slight fallacy, or cultural concoction. but what I have never made sense of is the assumption that strong women make for weak men, or vice versa. Strength comes from the realisation that others (the other) is different but no less. Because women are so "far behind" in these stakes, perhaps it should mean they should be more. Let us sort the men from the boys! This will be my only comment on the subject – but I personally can not abide "boys" "wimps" "hypocrites" or "braggers" *within* the context of our patriarchal society.

However, let us return to Irigarayan theory. There is no doubt that Irigaray relies upon binary opposition (a form of symmetry). The male discourse and sex being aligned with identity and vision (i.e. teleological); and the female with simultaneity (non-identity, tactility, proximity). It strikes me at this moment how sad it is that proximity and plurality somehow implies lack of discursive power. It is as if closeness and multiplicity forecloses on the subject's ability to still be a subject. I do not believe this is the case. There can be closeness and there can be multiplicity – but the subjective can still be intact.

To consider ideas concerning the multiple/contradictory subject, I will refer back to biological identity. Whilst the subject's history isn't altogether defined by biologistics, there aren't many moments when its history is uninflected by it. It has a cultural bearing. Our access to social positions is determined by that cultural recognition; even if one's identification runs *counter* to that recognition. The pattern of identity acquires meaning and politic value when it is related to a socially assumed gender. Let us consider how this is still measured in terms of the Oedipal. It is not the same for a woman to align her identity with her father, as it is for a son to align his identity with his father – even though our society knows that this occurs. We still apply the same meanings. We still say – "she's a tom-boy" and "he's a mummy's boy". Our terms of gender; our preconditions

of gender, still run along the lines of masculinity and femininity, to signify a specific biologistic. It is not accepted that a woman who likes ostensibly "masculine" pursuits could simply be acting femininely; i.e. that it could actually be viable that women can do and be things that descriptions of what it is to be feminine decree they are not.

We can see that there is a cultural specificity and commonality behind these definitions. If one wants to change them – one battles the entirety of the culture.

French feminism grounds commonality in the body (specifically the sexual body) and views this positively.

Political feminism in Europe and the U.S.A. equates it (commonality) with exclusion and oppression and views it negatively.

Therefore, we deduce from these two paradigms: a femininity that is an inherent condition and a femininity that is concerned with learned responses and attitudes.

I am compelled to state at this point that it is my personal belief that regarding myself I am a mixture of both. I share a biologistic condition of having a female body with 50% of the population. However I have little in common with the majority of biologistic women; and furthermore refuse to homogenise the female sex to such a state that that is all that I am about. I, as a person, am about more than that. However, I also realise that my nurturing by my culture has oppressed me. I might have been oppressed because of my biology (which I certainly am) but that oppression came "after the cause" as it were. My oppression came a long time after people actually placed meaning. It was not my female body (specifically) which decreed that there were umpteen things I could not be or do. So it is positive and negative; but ultimately it is up to me to utilise or disband meanings and constructions. It is positive to me in that I enjoy the biology of my sex; it is negative to me in that it pins me down. It is positive to me that I can discursively describe the constituents of my political oppression; but it is negative to me that society sees no reason for my desire to bring my bodily experience and personal psychical experience to everyone's discourses. (Incidentally, I nowadays take great delight in telling men how illogical and unreasonable they are being in the exact tone of voice that they and their fathers used on me and my mothers: counteractive as it may seem – it is quite a buzz to see phallogocentric people quaver as they are forced to view their own insecurities in the mirror. It is surprising what a patronising voice can do! Anyway, I digress.)

Silverman is reluctant to dismiss concepts of femininity in favour of the notion of a subject who is capable of multiple even contradictory positions, without the considerations of biological identity. I agree that it is important not to lose sight of this biological identity as we critique how it affects our discursive selves and our actual bodies.

Importantly, Silverman notes three things which are fundamental to all subjectivities (although our disavowal or projection of these things may say more about the masculine subjectivity than ostensibly the feminine subjectivity). These three things are – castration, subordination to the gaze of the cultural Other and "discursive interiority" (namely, the insertion of the self into a preexisting

symbolic order. Cinema insists on female lack, specularity and diegetic containment, as it promotes masculine potency, vision and diegetic exteriority. However, ALL subjective identity is formed by the separation from the mother. As we have already discovered (separation may occur through gradual objectification; and some elements may remain small objects [*objet a*] which we know to be the first inkling of a gap or loss, although these small gaps do not constitute the full formation of the ego).

Subjectivity is thus formed by the loss of the real (Lacan) which we take to be that which cannot be symbolically represented (i.e. death or sex), or rather the losing of the access to the real. We have spoken a great deal in this book about the retrogressive nature of the pre-symbolic description, as an example of a sort of abjection as we can only know of the pre-symbolic through the symbolic. Also importantly, especially concerning some feminist beliefs – is the notion that identity must be formed through the presence of a speculating Other; or the gaze of the Other. Without this Other no identity can prevail. Therefore, it would follow that what is taken to be "femininity" (with all the psychological states previously mentioned herein – of being specularized, castrated, etc) is actually what all subjects (regardless of sex) must endure to become discursive beings. Therefore, it would seem vital that women to not deny these manoeuvres or determinations, and that men come to realise that they too are "feminine" in terms of the formation and sustaining of their subjective identities. It is therefore of no real use for feminists to demand the eradication (in hypotheses and representation) of the gaze or specularization *per se*. But what we can do (rather than demand from others) is work towards the knowledge that specularization doesn't have to be sexist as such or gender specific in the manner in which it has previously been misconstrued. Both sexes and genders speculate. The gaze of one upon another is integral – be it the gaze of the child on the mother, or vice versa; the man on the woman or the woman on the man. If we extract the phallocentric from this specular equation – we can be some way towards omitting the factor of women being seen as lacking the predominant factor (i.e. phallus). Rather we should reverse the equation so that it is the man who needs to realise his femininity. All subjects are castrated from the pre-symbolic. I refuse to call this *pre-symbolic* (or Real) anything like that which is *phallic* (but it is safe to say we are all castrated from the ubiquitous continuum of space that we dream or fantasise the pre-symbolic or pre-castratory realm to be). We are separated from the REAL. Thus we need to examine the unconscious and the repressed parts of the psyche; for in there we will also find elements of femininity. We can now see how *femininity* is not only about those of the female sex. Femininity is a discursive signifier; a representation of a history, or the determination of a subject.

26. A Cathexis: Identification And Desire

We can also find other meanings of femininity (rather than meanings of the body or contiguity, although we know these to be valuable) if we look at the negative Oedipal complex. The desire for mother rather than the desire for father, at the point of full realisation of identity. The negative Oedipal complex differs from Freud's hypothesis which states that the phase when the girl-child erotically connects with her mother is a phallic phase. In short, the girl becomes the phallus her mother desires. Freud described this as a "clitoral" phase [the clitoris, he believed, being a inferior penis]. It is only with the castration complex that the child becomes a "proper" woman; a little woman, who desires her father and wishes to "get a child from him" (i.e. become pregnant by him and prove she is a real woman). Prior to that she is a "little" [read: inferior] man. Freud of course believed that sexual play or activity that concerned the clitoris was simply an atrophied or stunted version of the "proper" vaginal activity that "real" woman partook of.

Post-Freudian feminist theories have therefore rightly taken issue with the notion that the desire for one parent presupposes an identification with the other parent. It does not have to be so that the child can and will only identity with the mother after its desire for the father occurs. Freud based his theories on this sort of bifurcated model or binary. Identity on the one hand and object-choice (object of desire) on the other hand.

Therefore, for Freud, female homosexuality is a sexual indifference, and an identification with the father. Irigaray noted that Freud missed the singularity of the child with the maternal realms; misses the original desire between two women, and reduces everything to what the boy-child feels for the woman-mother or phallus (as represented by the phallic-mother).

It is thus *not* that this phallic model fails to account for the morphological difference of women but that it forgets the crucial role of the mother, whose face is the first visual mirror in which the child sees itself, and whose voice is the first acoustic mirror within which the child hears itself; to say nothing of the gradual process of separation that teaches the child that "parts" of itself are actually parts of its mother. Therefore this identification far precedes Freud's notion of identification AFTER desire for the father. In short, the relationship between mother and child is enough in itself for the child to know both of identity and of desire (desire we know occurs after an identification of something wanted is acknowledged. Desire is formulated upon a "wanting back" what the psyche believes is part of itself in some way; be it physical, or psychical). The child who gradually separates from the mother (due to the mother's tutelage) can thus acknowledge that he desires the mother. Whilst this can be called primary narcissism – it is important to notice the differences between a Freudian notion of primary narcissism and what I and others are

positing as part of the negative Oedipal complex. The child's identity is formed by incorporating its mother's face and expressions, sounds and movements not just prior to the mythical moment when it first sees its reflection (see: Lacan's Mirror Stage) BUT importantly also after that moment, as it assimilates with the system of language.

So from this we can see that it is far more accurate to suggest that the little boy is feminine than it is to suggest that the little girl is masculine until castration (i.e. the Oedipal complex, as we know it).

We can then say that both concepts come into play after sexual differentiation. Hence a little boy can (after the beginning of the Oedipal complex) BOTH identify with and desire the mother (i.e. this has been called the negative Oedipal complex for boys, rather than the negative version for girls which I am concerned with here).

What is vital to our theory here above and beyond anything is the belief that there can be BOTH A CONJUNCTIVE IDENTIFICATION *AND* DESIRE (OR EROTICISM). This of course pulls apart Freudian theory regarding his slant on the negative Oedipal complex, and the *timing* of when identification and desire occur. It shows us that the third party phallic intervention is not a given common denominator for subjective formation or the formation of desire. As I have already stated – the child who realises that it is not everything its mother desires does not have to look beyond her (as if it were she that were lacking something) but is rather going to look towards its own growth towards subjectivity. Therefore, we must also bear in mind that the desire of the mother is a desire that every sexual person feels – which is for something (psychical or physical, although the psychical predetermines the physical) lost, not something lacking. There is a great difference between something lost and something lacking, and it's important to note this semantic difference.

So our notion of the simultaneity of identification and desire tells us something very poignant about the Freudian psychological history that we have inherited. Namely, that the simultaneity of eroticism and identification completely covers up, represses and censors The Feminine. How very telling! This hypothesis is of course vital to feminism, and the further one considers the "original" Freudian theory the more one wonders the extent of the threat to patriarchy, that we should have been given a theory from a paternalised reference point that took all power away from women and predicated our identities on the intervention of the Father in the shape of an Absolute, moulding, quasi-maternal or life-giving, phallogocentric figure. As I mentioned earlier in this book – this sort of Freudian theory dictates that women remain undifferentiated bodies of no identity therefore allowing the men who impregnate the women to actually be the "life-givers" or mothers.

Freud did state that desire and identification do converge around femininity OR masculinity; and calls it the pre-Oedipal; he then of course follows the pre-Oedipal with the Oedipal proper. However, because there is no sexual differentiation prior to the Oedipal – the convergence of desire and identification is really the Negative Oedipal instead of the Oedipal. I would like to return to a rather Kristevan hypothesis at this juncture. Whilst it can be argued that Kristeva

doesn't do the Maternal any favours, I would once again like to stress that I do not believe that she is actually predicating a notion of the maternal as sexually differentiated. What she (and I) am trying to describe is a notion of the mother (pre-Oedipal) as simply "looming large" which is not the same as the mother being Phallic. The child may become aware of the mother's breasts, lap, arms, warmth, smell and voice; may even be aware of the smell of her sex – but does not know it as something sexually differentiated. I feel it is important to consider this when coming to the idea of the later (Negative Oedipal Complex). The mother is simply everything to the child – only latterly will the child realise it is separating/separate from its mother, and seek her in various forms that [are] becom[e]/ing sexually differentiated.

Regarding the positive Oedipal complex (according to Freud); the girl doesn't identify with the mother, rather she seeks to replace her (in the father's affections). In the pre-Oedipal, the mother is the love-object and point of identity. Freud believes girls play with dolls to mimic the maternal role (which actually contradicts his theory of a young girl's "phallic phase"), so it is hard to know quite the consistencies of Freudian theory regarding when a child seeks to turns active from being passive. He obviously believed it was active behaviour for a child to replace her mother in the father's affections although this would simultaneously signify the end of the "clitoral" phase and the start of the "passive" vaginal phase!

Let us recapitulate. Freudian theory tells us that the child doesn't distinguish between its self and its mother at the period known as pre-Oedipal. Later, Freud says that the child knows of subject/object relations (even at the level of language), as this is evident from observing child's play. Thus, we presume that the entry into language requires the girl-child displacing desire from the penis to the baby (doll) and then to the father. Therefore, after the pre-Oedipal (but *before* the post-Oedipal) there is a period wherein the girl's identity is formed by incorporating the mother's imago, and this would seem to coincide with the Freudian phallic phase, notably the girl wanting to be active. This active side of the girl's femininity (i.e. doll-play, etc) signifies an attachment to her mother. Therefore, if we follow this train of thought, rightful passivity comes when the attachment is broken and the girl-child "wins-out" against the mother! And nowhere in this train of thought do we have any sense of the mother's tutelage and the separation from the symbiosis of mother and child being something that can still have meaning to the child's sense of desire or identification.

The identification with the mother during the negative complex is in part an identification with activity (rather than passivity). For we can clearly see that however confused Freudian theory might seem, it equates femininity with passivity as a consequence only of the positive Oedipal complex, and its cultural discourse (and let us not lose sight of the cultural discourses and ideologies that come with these complexes).

The symptoms that Freud uses to illustrate his belief in the girl's love for the mother become part of the symptoms of an imaginary investment in the maternal figure – as in the girl wishing to impregnate her mother or bear her a child (possess or be possessed by). We can see that these ideas come from a

phallogocentric realm. And one could also posit that even if the girl-child does want to occupy her mother's place this does not have to be at the exclusion of the mother from the erotic economy, nor of the reversibility of their positions. The third term to the equation (the father) doesn't even figure except as a rival. And the third term can also be the child that the little girl wishes to give her mother or receive from her mother. (This is similar in a way to Kristevan notions of the three-generational relationship).

The convergence of object-choice and the identification with it – is, in a manner, narcissistic. It is clear that there is a close kinship between a narcissistic love and an object-choice because object-choices ALL relate back to the protagonist; the one who is choosing (consciously or otherwise) the object. In my opinion desire is always about narcissism (or thwarted narcissism, or narcissism-disavowed); because all desires have some relevance to what the psyche requires for itself, to fulfil itself, on its own terms. Object-choice and desire are thus preceded by the psyche's acknowledgement of itself (one could say it is self-referential); even if, as I have stated, one is unaware of the causality of one's desires.

We can separate this narcissism into categories, for an easier examination. Incidentally, self-consciousness also has its roots in such desire. One becomes conscious of the self through the realisation (usually sub/unconsciously) of a something "out there" that one wants or lacks. The self then becomes embarrassed that it does not possess that quality within and withdraws to question its very self. Abjection occurs when one desires something "external" that one realises is part of the self (that is missing or denied) and so the self turns against the self for wanting something that it cannot in actuality "have" fully.

We will define different elements of desire/narcissism, for easy analysis. There are as follows:
a) desire for what is actually herself (the subject herself).
b) desire for what once was.
c) desire for what one would like to be.
d) desire for someone once part of herself.
All these elements of desire can manifest differently. One can identify with or desire a human quality or characteristic, or a memory, or feeling.

Categories b), c) and d) can exemplify the girl-child's relation with the mother, whom the girl once confused with herself (prior to differentiation) and whom she aspires to be (after the subjective/objective division is made).

Category a) is made possible by the incorporation of the imago of the mother, who is loved according to b), c) and d) (identification with the object of desire).

Self-love presupposes love of the object in whose image one finds oneself. There could be no object choice if one was not aware (consciously or not) of oneself. One therefore desires because of one's own love of self (and the elements that are captured in oneself; i.e. parts of mother that were once parts of the self). Feminine love occurs through the narcissistic rather than the anaclitic. Therefore it is not a feminine inability to cathect to an external object *rather* than a refusal to cathect with an object that is not one of the first in her history; or distinguish her desire from her object-choice in the way the positive Oedipal complex would

have her do. Feminine narcissism therefore represents a form of resistance to the positive Oedipal complex (a complex that shows itself to evoke feminine self-loathing and self-contempt; to say nothing of extolling antipathy between women).

The negative Oedipal complex, and all that it entails, is therefore seminal for current feminist thinking and action. It expands on the Irigarayan biologistic theory and places the post-modernist theories of anti-biology in a better perspective without completely dismissing either, at least in my mind; as it is still my wont to refer to both those theories. This theory also brings into sharp focus the feminine struggle against the phallic economy, whilst not relying on a biological essentialised identity. Whilst I personally still explore the notions of a poeticised post-modernism (multi-context and contradictory) in much of my work – I realise that this (non) subject that I involve myself in describing, is not always a feminist being, a feminine or female being. That poetic being I often write about is a non-being (discursively) and whilst "she" may highlight and investigate many seminal and informative issues, I have to – and I hope I have – always paid paramount regard to the positioning of "her", as positioning (regarding language) is something I see as very much an integral key.

Despite the importance of this negative Oedipal complex (and what I have posited above as elements of desire, narcissism and object-choice) I am keen not to lose sight of the fact that it IS still different for a young boy. The femininisation of the boy soon takes on a different slant, because the stakes differ.

And what happens to narcissism upon the entry into the Oedipal complex? I wish to move on to issues which have always fascinated me. The issues of Mourning and Melancholia, as they connect to the female subjectivity.

27. Mourning And Melancholia

A Human Condition

Irigaray locates the site of melancholia at the point of the castration complex. She believes that with the girl's love for and identification with her mother – there comes the point of realisation of her own and her mother's castration (not unlike the boy's Oedipal complex experience).

Irigaray notes the symptoms which surface in female subjectivity – painful dejection, loss of interest in the outside world, loss of the capacity for/to love, inhibition of activity, and introjection. On the surface it does seem a classic case of how many women feel. A type of hysteria, or hysteria itself. Unfortunately, [and this is an important indicator to my theory] Irigaray's "woman" doesn't have the capacity for self-love great enough to fall back on her melancholia. We should remember here that melancholia comes from self-love. Hysteria is an abject state of the internalisation of the signifiers of both masculinity and femininity. I prefer to see hysteria as the internalisation of my own masculinity (not my father's). However, melancholia is about the failure to realise or make real self-love. The failure to take issues back to the Lacanian Real whilst still being interned in the realisation of the subjectivity. Melancholia is failed desire. It is a desire for a temporality that does not exist. It is a desire for a reality that does not exist. It is a desire for time itself to run differently to how it does, or for the world to be dis-real maybe.

Irigaray in her theories is almost on the verge of admitting that the girl doesn't enter the Oedipal complex through the desire for the father but for the mother; and that this is a desire that can coexist with identification. Irigaray does fail to acknowledge between the symbolic castration and the castration complex. It is of paramount importance that these two not be confused. It is impossible for the girl to enter the negative Oedipal complex through the sexually differentiating castration that Freud writes about, because that would devalue the mother and put the child's desire onto the father. In order for the child to desire the mother the child has to know nothing of the world of patriarchal sexual differentiation, otherwise she would follow the path decreed by that patriarchal sexual differentiation. The child simply wouldn't have enough narcissistic reserves (as it were) to continue to desire her mother or be melancholic; simply because if the child could sexually differentiate she would see mother the way patriarchy sees mother and her identification with her would be based on self-contempt and insufficiency.

However, if the child enters the Oedipal complex through a symbolic castration (i.e. an aphanisis of being/separation from mother) rather than the Freudian devaluation of the mother it is possible that one can conceive of the complex beginning with a period during which the girl-child could desire and identify with the mother and her narcissistic reserves could be built up. We can thus see the difference between the symbolic castration (a natural separation

from the mother) and the castration complex (a crippling devaluation of the woman-mother). Hence, with the advent of castration the girl would be encouraged to reject the mother BUT feel pleasure in still identifying with her, which would lead to melancholia. Therefore, I wish to posit that symbolic castration (the natural separation of a young child from its mother as it grows and progresses into the symbolic) is a healthy progression for both sexes of child.

Melancholia is a type of mourning. One could say it is the "human condition". We lose our sense of the real to become part of the world of representation. The pressures on us from the semiotic are nothing more or less than the human can or should endure.

Melancholia is the loss of a loved object. Mother can become lost to us because she has been de-idealised – but I would add to this that in some ways she is lost to us anyhow. The extent of our loss is unclear to us. After all, all babies grow up and move away from the semiotic, which becomes unclear to us and is only measured at an unconscious (maybe subconscious) level. This affects the entirety of our social order. Our social order thus protects itself from that "knowledge" or rather, I should say, from that pressure.

But that loss is relocated within the subject's sense of self (within the self's own desires). It relocates in the same place as the imago of the mother. At this point I would like to interject with some Jungian theories. The notion of the animus or anima (masculine or feminine parts of the self) could own a lot to this hypothesis. The animus could be a woman's sublimated wish for a "man" who is symbolically castrated; the anima a sublimated wish for the lost woman-mother. The animus thus is no real man, "he" is simply an imaginary "masculinity" that is symbolically castrated. This castration, for myself personally, could involve one of two directions. The castration from the realm of the father (i.e. the animus becomes the man inside of a woman's psyche who has [although of course "he" is not actual so does not think] rejected the phallogocentrism of his "Father" in favour of "his woman", i.e. the psyche of the woman within whom he has his "abode"). Or the symbolic castration could entail a masculine presence within the woman who, because he has been separated from the mother, mourns her lost to both himself and the woman whose psyche he inhabits. Both these ideas of mine accentuate castration (separation) as an occurrence of both men and women. Either castration from the mother, or latterly rejection of the realm of signification (i.e. the realm of the Symbolic Order and Law of the Phallic Father) – comments greatly on the feminine. We shall further examine the issues of men castrating themselves from the symbolic order, in favour of the feminine (incidentally this does not signify male feminism, or a physical state of *castrati*).

And as I have tried to explain, rather than a lost object being dismissed it is relocated within the subject's own self (the same place, in fact, as the mother's imago which enables the girl to identify with her). Therefore it is rather irrelevant that Freud claims the girl will then reproach the lost object-choice since that object-choice is already internalised and incorporated with the self. Rather Freud claims that the object-choice-cathexis becomes shattered. The girl does not behave "normally" by withdrawing the libido from the object and displacing it

onto another. Rather she absorbs it into the ego. Freud therefore does not comment on the fact the libido-ed object-choice was *internalised* already. However, Freud goes on to claim that the withdrawn object-choice goes on to establish the subject's ego. And that furthermore the shadow of the object falls upon the ego which will henceforth be judged by the superego (as though it [the ego] were an object). Therefore object-loss becomes ego-loss and the conflicts between ego and loved-lost-object becomes a cleavage between the critical activity of the ego and the ego as altered by identification.

This is all very interesting and I do not outrightly dispute Freud's claims. Kristeva too has picked up on this and based Abjection on this paradigm. "To each ego its superego" is a basic tenet of abjection. The self desires but the superego (formulated by societal and familial pressures) absconds the ego's desire. Therefore, I spit out part of myself. I balk at the possibility of possibly desiring whatever it is I desire. *I am beside myself* – in my human condition and my desires.

However, what Freud has not taken into account is the fact that the self already desired that which it had lost, and that which it had to draw back into itself. So I dispute the notion of a freed libido (i.e. the libido that once thwarted and has no new object to attach itself to) and I am also in doubt concerning the nature of the libido withdrawal back into the self. It surely goes back into the self (the subject) in the same way it was present in the subject to formulate the subject in the first place.

From this we can assume, as Silverman rightly points out, that the above propositions describe a pathology, and also a psychic condition specific to the female version of the Oedipal complex, and we can see the rigorous internal surveillance which the woman puts herself through, and is put through by. There would seem to be the tendency to treat herself as an object to be examined (overheard, overseen, and confessing). Importantly, a woman does not have a more developed superego than a man. According to Freud, in order for the object to be (re)incorporated back in this way it must have been loved narcissistically (loved according to a libidinal model, as in the negative Oedipal complex). It is obviously premature, if not abortive, to suggest that lost-objects somehow constitute the entirety of the ego; or that lost-objects might not be subsumed by the superego. However, I believe I differ from Silverman in believing that lost-objects do and can journey back to the self (rather than being displaced onto another object) and that this is not endemic to women; and that displacement onto another love-object is not specific to men.

Freud claims that one on hand that can be a strong fixation to the loved object which will remain in present tact and on the other hand there is little power of resistance in the breaking of the bond between subject and love-object. This would seem to imply that narcissism affects the strength of the fixation. Some object-choices/love-objects can thus refer back to narcissism, and once withdrawn back to their relation to the self(love) become the substitute for the erotic connection. I have personally dwelt on this theory in some of my poetical works, where I describe an "internalised love affair". This "love affair" can occur despite the fact the loved-object may be absent or in conflict with the self – the "love relationship" need not be relinquished. Please see: *Bridal Gown Shroud*,

for my writings on the *animus* (my own signifier for a lost love-object that is internalised.)

It could be said that the internalised anger against the internalised love-object is more an anger to do with the devaluation of the mother than the fact that the object is lost but the self still desires it. The mother is at this point sexually differentiated and seen as insufficient. I am in two minds about this. I believe that some lost love-objects aren't acknowledged to the self as being objects of the mother's. Some may be acknowledged to the child as being transferred onto other beings and things. It would seem to me likely that the subject (male or female) feels anger at the self at still desiring that which in actuality eludes the self. But the possibility of hostility at the external devaluation of the mother is highly probable. Many women consciously feel cheated on behalf of their mother's status, as well as their own, and that is only consciously. I hasten to add this anger or hostility (at self or external determinations) occurs after the negative Oedipal complex I've been discussing.

Freud tells us that the internalised object is more a network of unconscious memories, than a coherent entity. All these memories carry mnemic charges. The "cure" for melancholia, then, according to Freud, lies in the de-investment of the libidinal charges attached to each memory trace! This can occur if the death drive dictates to the superego (the superego will then dictate to the ego that these "things" have no meaning for it).

What becomes clear (or muddy, dependingly!) is the ambivalence of the attachment of the object to the self. In melancholia the struggle is between love and hate. A case of if I can't have it – I don't want it; I didn't want it anyway.

One seeks to detach the libido or desire from the object so that one can use that desire or libido *against* the assault or invasion. Memory traces struggle to survive, or obliterate themselves. Freud (ever eager to rid the ego of these investments) describes a process of discarding each object-attachment once it has been rendered of no worth or value. However, it would seem that this Freudian "cure" is what initially *causes* female melancholia, which commences when the libido begins to withdraw from mnemic traces within which the girl finds the object and herself. Only the object is capable of inducing melancholia in the subject because the object is the one whose signification or significance is "reinforced by a 1,000 links" or memories.

It is highly probable that the process of devaluation never reaches a conclusion; unconscious memories will still retain their cathexis and will promote the desire for the maternal elements, despite counteracting cultural influence or the superego. However, a detraction will certainly reduce the mnemic reserves (a "shrinking", in effect); the beloved object may become less pleasurable to the subject; a less pleasurable Mirror in which identity is found. Silverman, therefore, proposes (and I agree with her proposition) the reconstruction of the negative Oedipal complex.

In conclusion – we can see the larger psychological picture which addresses the profundity of the "impossibility" of a female subjective constitution. Initially, the male version of the Oedipal complex seems symmetrical to the female version (identification sequestered from desire; the girl incorporates the maternal and

chooses the father as the love-object, and vice versa). Despite the fact that desire plays a necessary role in the son's relationship to the father it isn't his desire but his mother's and the symbolic order's. And it isn't just that the phallus finds its way to the son's unconscious through the mediation of the mother's desire BUT that her erotic investment in the paternal; is a *precondition* for the son's paternal identification. For example – Hamlet cannot align himself narcissistically with his (deceased) father because of his mother's failed libido.

No similar desire facilitates the identification of the properly Oedipalised daughter with the mother. Contrarily, identification must be sustained through the greatest of odds; in the face of cultural disparagement, and self-castigation. Silverman notes that it is little surprise that Freud suggested that women love themselves only to the same degree the man can love them. I believe we should keep this statement in mind (as well as the psychology that has lead up to this statement). Some of the women working with authorial voices today are paradigmatic of the reverse of that statement. It is my wish to encourage other women to be narcissistic beyond their perceptions of love; to be self-involved, self-referential and examining and most of all self-loving – more than any man can love. Self-love is more important than any love, and there is, furthermore, no true love for another without it. We cannot allow our narcissistic reserves to dwindle (they have been tapped and drawn-upon, emptied out and pillaged in numerous psycho-sexual, sexually political ways for centuries). We can no longer allow the vampiric enervation of our self-love.

And to recap on Irigarayan theory; we can see that she may deny the hold of the mother over female desire but she does admit to the importance of maternal attachment. Even if it is hypothetical or poetical. Let us be aware of the reality of our experiences with our mothers and the hypotheses that we can investigate for our own good. What is crucial to this theory is knowing that issues have been discussed and theoreticised as if some huge leaping break occurs between earlier investments (in the maternal), early narcissism *and then* the realm of the normal adult woman. Narcissism and desire cannot be assumed to occur within the period preceding the Oedipal complex BUT RATHER simultaneously with the initial phase of the complex. Desire occurs before sexual differentiation! I do believe both Irigaray and Kristeva are trying to deal with this notion in their works, although it would seem that they rely on the paternal element for a conceptualisation of desire.

Irigaray sees the woman as an exile, who desires proximity. She sees libidinal discontents as a result of the distance from the mother, with closeness being the cure. But it is surely self-closeness that is the cure. It is surely the realisation that "she is in me" that is my cure? And furthermore, proximity (with another) without some sort of separation leaves me without subjectivity. It also leaves me without desire!!

Therefore I wish to not get caught up in the abolition of desire, although as I have confessed the poetical hypothesis of subjectless is enticing; but how would I know it was enticing if I were not a subject to know of its allure? Only as a subject can I desire nirvana or the abyss – wherein I become subjectless (without cut-up, time cut-up, mediation, representation, or loss of the spatial continuum).

It would seem that Irigaray has had to substitute another woman in the place of the maternal woman. The lesbian lover thus assures the important gap

necessary between the subject and object; and the lack is pinpointed to the severance of the umbilical cord.

Irigaray seems to want to do away with subjectivity because it impedes closeness. It is surely the ego she wishes to do away with. The "ego" has become confused with our current populist cultural "male ego". It is that ego she wishes to abolish, not her own sense of self and her own (importantly) sense of her own senses. Therefore I will presume (and please excuse my presumption) that it is the "male" phallogocentric ego which she claims hinders propinquity. This is understandable. Phallogocentric denial does hinder closeness. And furthermore that phallogocentric ego is in us ALL. Whilst the misogynistic gaze represses women; the gaze itself forms us all. Women do need the Mirror Stage. To see themselves in their carer's eyes. All babies requires the Mirror Stage. What we need now are expanded definitions of the selves that we find in the mirror. Women rely upon their Images for identity (even if it is to rebel against). Women also rely upon their discursive or spoken selves – without which nothing or nobody would ever make any sense! We need external images and the imaginary "camera". It is up to us to expand on its semantic propositions (of us).

For we are all appropriated as an image. We are appropriated as an image in language. Perhaps this is what is problematic for Irigaray, as she bases much of her sense of self on tactility. And our sexuality is inseparable from fantasy, scene-setting, drag and role; the subject as it is POSITIONED. What seems intimate and private (wholly self-propagatory) is in fact structured by a cultural "camera" and its capabilities.

We ourselves have a mind's eye view of ourselves; we cannot "forget" ourselves, although often, sexually, we wish to "lose ourselves". Nancy Friday has commented on this to an extent in her book *Women On Top* (about female sexual fantasy). She calls it the swept-away phenomenon. "I want to be swept away" – i.e. I want to forget my responsibility as an active, autonomous being. This may be fine within the realms of sexual fantasy (and all sex concerns fantasy to an extent) but it becomes disabling when we deny how we are constructed beings – which doesn't mean that we cannot do anything about it. Female subjectivity is therefore no escape from specularity; our subjectivity amplifies its effects. The Mirror Stage is the point when we incorporate an image. The Photo Session (in our subjective journey) is when we ourselves are appropriated. Both stages are emblematic of femininity. The Mirror Stage attests to narcissism. The Photo Session/Stage to exhibitionism. Both are integral to a sense of self. Hence it is important for women to have a necessary narcissism and exhibitionism.

To follow on from this we can see how a collapse of the scopic regime on which sexual difference currently constructs itself would have far-reaching, indeed, huge significance for feminism. Feminism should deal (full-frontally) with the position of the scopic in the formation of the subject (bearing in mind that our current patriarchal version of visual female lack [i.e. no penis] is but a utilisation of a bias).

Narcissism, melancholia, subjectivity, and the gaze – are all issues which complicate a woman's relationship to her body; and the connection between the body and language. We encounter a voice that cannot speak without assuming an identity, entering into desire or invoking the Other. We have complex

relations to fantasy and reality concerning the embodied and the disembodied female voices. When we listen to music (without actually seeing the performer or singer) there is no body. But that doesn't mean that there is nobody there. There is a discursive body, a body whose identity is encoded in language but by the very nature of singing there is a voice that tries to free the already-written restraints. There is a voice that tries to sing a new description of the actual body by expanding the limits of the discursive body. There can be a voice that by its expression tried to address the issues of the body/voice polemic. But we must bear in mind that the voice is most idealised when the subject is least visible. Therefore, we must deconstruct phallogocentric dictates for our own use. In cinema the voice is usually matched with the body (even if retrospectively), and even the female "voice-over" becomes the same as the *embodied* male voice-over (i.e. autobiographical, a bodily presence).

Therefore feminist filmmakers have pursued the vocal itinerary of the voice-over, voice-off and the synchronised and symmetrical. Instead they experiment with DISSONANCE AND DISLOCATION. Likewise feminist performers and singers work with distorted, multiple voices and images which present contradictory readings. Love ballads sung by women in Doc. Martens with tattoos; subversive personal images which distort the written agenda of the body; whispering soft voices that mock the notion of a passive femininity; ironic lyrics that convey a neo-feminist and androgynous imagery; sexy guitar playing and illustrious enjoyment; not being seen as being special or noteworthy because you're a girl in a band, but being special and expressive in your own way, anyway; writing and singing all the things you've ever wanted to say and doing it well; feeling proud of the sound of your own voice.

Regarding film, there are ways for filmmakers to fracture the diegesis that we have discussed in previous chapters. Experimenting and changing things, so that it becomes impossible to say whether a voice comes from "inside" or "outside"; so that a voice is mismatched or unlikely – all these devices can problematise the alignment of corporeality and voice. For the female voice has enormous discursive, authorial and conceptual possibilities once the limits of corporeality are changed, lifted or altered. And the female voice can include most importantly the authorial position, and as Silverman states, it can abstract from the literal and contribute instead to a metaphoric speech. The use of the word "metaphoric" is very important to me. For metaphor is poetry; it is the selective process, that travels laterally, spatially rather than in a linear fashion.

According to Lacan and Jakobson metaphor concerns itself with symbolism, condensation (as in the Freudian dream-work); it illuminates the notion of "symptom" (the replacing of one signifier by an associated one: rather than metonym which by connecting signifier with signifier "sequentially" forms a vertical movement [much like the syntagmatic prose found in most Western "realist" writing] which sheds light on the origin of desire). Metaphor also concerns itself with a "stack" of possible selections of meaning. A metaphor always means more than it says. Behind what a discourse means there will be other meanings; the process is inexhaustible. Metaphor implies choice. Behind choice there abides our value judgement. And we should not forget that language can only operate (does only operate) through the designation of an object in its absence. Only by absence can symbolism (language) come to be;

which is what we have said about desire. We hallucinate the desired object; we speak the language of "the absent". But all signification refers to other and more signification; in an endless chain. By re-positioning signifiers we can alter the play of signifier against signifier; we can draw new filigree threads of meanings to other meanings. Certain signifying "nodal points" (fixed points of reference which in effect pinpoint many other referents) have to keep their position, least we all lose sight of many many meanings – but new threads of meaning can converge upon other meanings. I picture a massive inexhaustible cobweb of threads and "upholstery buttons" (picture how the fabric converges at that point), but I also, importantly picture what many scientists picture regarding their studies of space, time and the Big Bang. Even though it is nigh-impossible to imagine or even almost conceive, space itself is curved – all bodies speeding outward from the point of the Big Bang; all planetary bodies expanding themselves as they speed away. Like a dot on an expanding balloon (where everything on its surface expands) so that dot will move away from other dots; but the space will still be curved and relating to other bodies. However, curved space is, of course, spatial – 3-dimensional unlike the surface of a room. So if it were a room one could exit through one door on the left-hand side of the room and find that one has actually entered the room through the door on the right-hand side. Like this language is expansive (but not Absolute) but relating.

28. In Her Own Voices

Authors, Auteurs And Film

In 1968 Barthes announced the death of the author as the originating force behind the literary text. In filmic history it would seem that male directors exerted their own presence as the producer of the look. Similarly, writers of "realism" led us to believe we should not add our own signification to their stridently enunciatory "all-present" "I"s, or their visions. With the advent of post-modernism, of course, things became up for question. We could then question the "truth" or "vision" of the male protagonists (to say nothing of the female characters) in fiction or film. Feminism especially has given us the opportunity to make work that has a resisting force to it, in that it resists the metonymy already presupposed.

We could say that the author has lived on as a discursive agency since the late 60's. We now automatically read far more subtexts into film; and we now challenge the notions of the director's transcendental and ultimate "eye". There is a theoretical space (a space of reading) where we hear the female voice from the interior of the film but we hear that she speaks with a authorial power, rather than her being a site of male denial.

There is an ambiguity about the terms under which the author meets his unmaker. How does it happen? When? Where? What does it mean? Roland Barthes asked questions like these of our (artistic) culture. Writing can mean three things. It can come under the rubric of *écriture*. It can mean modernist (that which purports to "realism"). It can concern itself with the activity of productive meaning (post-modernism, after a fashion).

"Writing can be a system of graphic traces where identity is wholly lost, beginning with the identity of the body that writes." This writing continually plays out the death of the author. It doesn't need its author to be, it can be reactivated in his/her absence. Since the notion of the author behind the text is really an illusion; one only needs to be reminded that language is "absence" anyway. There is no need to fill the empty "speech-act" with a body. "I" in the text is the one who says "I" not necessarily the author. The only "person" language requires is the subject (who means nothing in actuality) but who suffices to initiate the text. However, like Barthes, we do not want to eradicate the author entirely; rather we wish to reinstate her in new positions and meanings. She can be an agency or agent of *écriture*. This *écriture* also signifies a group of texts by writers such as Mallarmé, Valery, Proust, and Baudelaire, amongst others. Barthes' theories do become rather unstuck, however, because we are aware that the modernist text isn't as adverse to authorship, as he might have us believe. In reply to this Barthes suggests that the modernist text places the author at the margin rather than the centre of the text; the text doesn't kill the author so much as displace him. However, many of these texts paradoxically

rely on proper-name usage.

But what is most fascinating for me, is the notion of the rebirth of the author (after this textual-death). If we can consider the author dying at the margins (or boundaries) of his work and then being born again anew as, maybe, an impersonal writer rather than one who is psychologically, coherently existent with the text. Barthes refers to this writer as a scriptor.

However, like the writer-as-individual the writer-as-scriptor seems capable of corporeality, for can we not see his dis-membered hand at work? Barthes believes that this scriptor is not furnished with a being/form which exceeds or precedes his writing. His "subject" is not the subject on which the book is predicated; for there is only the speech-act, and "every text is written eternally here and now". This is the modernist scriptor.

I hasten to draw attention to the notion of the modernist as we have come to understand it (i.e. a teller of "realism"), as we know this to be questionable, and the modernist scriptor – who ostensibly says something about his own textual absence, death and rebirth.

Perhaps what is the most seminal and illuminating thing to remember is a quote from Barthes, regarding the modernist scriptor – " ... having buried the Author ... can no longer believe his hand is slower than his passion ... on the contrary, his hand, detached from any voice, borne by a gesture of inscription (not expression) traces a field without origin ... or at least with no origin but language itself ... the thing that ceaselessly calls any origin into question ..."

So "writing" can also designate a way of reading which discloses the cluster of quotations that make up the text. We can therefore say that the author is doubly removed or displaced. Firstly, cultural "voices" replace him as the speaking agency behind the text, consequently unitary meaning succumbs to discursive heterogeneity (he "is spoken" many times). Secondly, this plurality is activated through and within the reader, who supplants the "author" as the site where text comes together!

An image of re-generation has come from an image of authorial dissolution! The birth of the reader must be requited by the death of the Author, and the reader comes to resemble the author-as-scriptor. The reader has no psychology, history or biology but is the one who binds all the traces that form the writing into a one-ness. Silverman asks – "why must the writer be killed three times over?" First with his proper name, then by becoming only a writing "hand" and then by being reborn as a "reader". Her answer lies in not the dissolution of the writer but his/her recovery in a new guise. Years after Barthes wrote *The Death Of The Author* he brought him back with a "reprieve" in *The Pleasure Of The Text*, wherein the author becomes a FIGURE (somewhat lost) in the text. This figure signals the return of an authorial body, not a corporeal figure or biographical figure but a figure as the materiality of writing. The body of the author becomes the eroticised body of the text; the body of the text undergoing an anthropomorphisation. Seemingly going back on what he said before – this figure brings back the organ of the voice (whereas previously Barthes had described a vocal severance). Now Barthes seems to extol "writing-aloud"; the writing-as-the-voice and word made flesh.

Is this a perverse playing with the notion of the discursive body? Making it

voice its abjections?

"Writing-aloud ... phonetic ... a theatre of emotions ... searches for pulsional incidents ... language lined with flesh ... text ... hear the grain of the voice ... the patina of consonants ... voluptuous vowels ... carnal stereophones ... articulation of body, tongue, NOT that of meaning ... language ..." [Barthes]

Previously, Barthes had claimed to desire and need the author; now he would seem to glorify in the corporeality. Is this a narcissism? And as I have previously asked myself – is this not an address to the discursive (already spoken) body; abject yet paradoxically majestic within language?

Barthes went onto compare "real writing" with the microphonic sounds of cinema, which permit us to hear "breath, gutturals, flesh of lips, presence of human muzzle". An acoustic magnification. Barthes' commendation evokes a magnification of the face.

Finally, the author has emerged with the corporeality and vocal palpability of the author "behind" the text. This is a vital assessment, for us to remember. The author at a "level" with the author "behind" the text (albeit without the latter's biographical history). The facial magnification that Barthes presents (fragmented bit by bit) as he attempts to hold it outside of the references of classic representation, and gender. However, no discourse of the body can hold off sexual difference for very long. Sexual difference will always function as a structuring absence; it is in fact the very ground of Barthes' "battle" against the traditional author, and his struggle to install the modern scriptor in the other's place. This brings us around again to those issues of the female body brought to language, and how sooner or later the female body will be spoken. So, although Barthes doesn't specify, we can assume that what he wishes to annihilate is the male position (the social status and biographical civil status of the male); with its phallic rectitude, linearity and dominant meaning. By dispossessing the author, and furthermore killing him off (several times) [!], Barthes was trying to strip away the patriarchal, paternal legacy. Barthes was aware of the divide drawn between discourse and the author because language itself writes itself that way! Barthes also was aware of metaphor, he characterised the body by using the metaphor of "neuter" and "composite"; realising, too, that woman is often "castrato" when she is spoken (i.e. the little castrated man).

Let us examine how the metaphor "castrato" could (in a certain scenario) have derived its representational force from the figure of a castrated (neuter) man dressed as a woman. Barthes in effect although gendered as a man and qualifying for a certain author-ity or author-itative position instead erases his cultural/sexual identity and becomes a woman. For we know that gender is a drag! So Barthes (in The Pleasure Of The Text) severs his link with the phallus and assumes a feminine persona. However, for the woman it is different. She can assist the sexual and discursive divestiture of the male only in a mediated or displaced fashion. She can assist in the removal from the male of his privilege. BUT, SHE HERSELF HAS NOTHING TO "TAKE OFF". Much the same as, racially, the black person has no privilege to divest him/herself of but can assist in the removal of white privilege. The de-privileged are therefore in no position to

experience these "removals" themselves, especially (paradoxically) unless they "stage" them. This is one reason why I am sceptical of white liberalism when it purports to speak for Blacks. It is a "robe" that can be removed or not removed to suit. Blackness cannot be removed. Black gay men cannot play at being "skinheads". Skinhead iconography, whilst not rife in gay sexual-role play is apparent. Black men can play at other roles, but not that one. Whilst gay men know that it *is* all role-play – others may not.

This cultural "strip-tease" (the taking off of a role to assume another "more truthful" one) is in itself a privilege; which only highlights female "lack", or Black "lack", once that lack is textually exposed. Incidentally, I wish to stress at this point that I fervently believe that no-one should be a singular "truthful" representation of themselves; I do believe in artifice to enable one to dis-identify with oneself. I believe in artifice, masks, make-up; and am against absolute self-presentation. Deception highlights multiplicity. However, certain mimes and roles can hurt others and reduce them to textually exposed lesser beings. A gay skinhead may wonderfully mock the fascism that he seeks to undo or subvert, but if he reduces his gay black brother into an essentialised being of fear (the quavering subjugated black male all too horribly familiar, fortunately becoming more and more a thing of the past): what price then? I realise that what goes on in the bedroom is different from a city street at night (or day); and that within the comforting and liberating environs of gay/queer clubs, societies and events – things do differ.

The issue is therefore to find a place where the female voice can be heard, not stripped of its discursive rights. Sexual difference can be suspended only by modelling both genders on the accepted logic of one of those genders. And "woman" is the preferred standard. Is this an outrageously sexist conclusion, I am arriving at? Not if one considers the lacks both genders face, or are told they embody. Are many men not tired of denial? Are many women not tired of their lack of voice and the angry, yet often strangely flaccid, men? Are some queers not heading in the right direction with their sexual politics which understand sexual construction, and subversion? I hasten to add that I do not wish to describe these groups in generalised terms. I am well aware that misogyny, racism, prejudice against difference or disadvantage exists in the straight and queer world, and that politics do not always involve all straights and queers who believe hedonism covers up many an issue and indifference even more. But we are all of us hedonistic and indifferent at times. I'm appalled (personally) at the thought of having to address issues 100% of my time!

But let us return to our current concern regarding the author. Silverman is struck less by the author's demise than by the crisis in traditional authorship. There are of course great problematics in modernist texts or *écriture*. We may find male voices that no-one purports to claim, which still bear the marks of masculine enunciation. Is it a fragment of a discourse with the female as Other? I, myself, have for the past few years been writing a novella about a woman's animus. It is a poetic description of the relationship between a woman and her (internalised) "male". The pronoun "he" appears whenever I wish to signify the animus; the discursive male; and the male of female sexual fantasy (who is still the male belonging to the female). Is this not what happens in many modernist

texts? An acknowledgement of the discursive, fantastical and actual pronouns (and genderisations) that come to us, as we come to them, and in effect – are them? I have also tried (within my novella) to reconcile the subject-matter, subject and reader with a narcissistic state.

Singing can be a privileged trope through which Barthes describes "vocal writing" (the author within the body of the text). The face, mouth, tongue are already present, afterall! The male opera singer is thus femininised; the female opera singer already "female" finds access to a state of "equality" wherein she can find her own expression, authorial voice, abjection, drama, role etc. Lyrics are poetic; they in themselves de-privilege assumed masculine absolutism, although overly-mimed masculinity usually counteracts this (for e.g. male rock singers whose "posturing" either ironically undermines the "singing" or self-indulgently fortifies the patriarchal absolutism). Strangely, I believe that "pop" in Britain, in the last few years , is a good example of the ironic "strip-tease" as performed by the male artist; but it is a delicate line between divestiture and assumed divestiture (just because it's "trendy"). The male "torch-song singer" might be an answer to the dilemma. Men can divorce themselves from the phallus to then come to language in unlikely places, aside from the normative dominant perspective. Unfortunately, male torch-singers are few and far between (except within opera [which is a form of Torch or, is it that Torch is a form of opera?]). I would take a chance and say that the finest male torch-song singer in Britain is definitely Marc Almond (please see: *The Last Star: A Study Of Marc Almond* by Jeremy Reed). The late Ian Curtis also contributed his own unique work.

Over the channel in Europe, torch-song singers seem more accepted; more "at home" even; less "eccentric". In the states we can find a selection of male singers bordering on "torch-song" territory (Scott Walker through to Michael Gira, and the late Kurt Cobain) although many have trodden a delicate line between divestiture and mockery, *and* the "touching-back" upon (re-investment in) fear of femininity, in some of their more phallogocentric works (for e.g. Henry Rollins' expressions are often meant to be ironic, self-mocking and subversive [aimed at men who cannot confront a fascistic father-figure] but often more than anything else seem reliant upon an exposé of discursive "female" lack and his contempt of it). I stress again that phallogocentrism isn't a celebration of male sexuality. Men celebrating their sex differs from phallogocentrism which only concerns itself with narrow definitions and metaphysical absolute meanings, which have nothing to do with male bodies or psyches – except to essentialise, constrain or terrorise them. As much as some men seem to want, and need, to disprove the paternal (their own father's) "Absolute power", they continue to resort to using it (in their expressions), when the going gets tough! After divorcing themselves from a defunct phallus they can then reassure themselves they still have a superior (metaphysical) intellect.

The female authorial voice exerts itself at the expense of the system of projection and disavowal. Therefore, we find an enactment, in a displaced or mediated way, of male (symbolic) castration and female authorship to be connected. A neutrality (as aforementioned) comes through the accepted female

model, not the male; for the male does not deal with any sort of lack or metaphor (as in poetry); discursive or actual body. The reconstituted authorship should be theoretically located at the level of the text's materiality, rather than at the level of narrative or characterisation. We should conceptualise the relationship between the author "inside" and "outside" ("outside" meaning the biographical author).

An author (as regards film and cinema) can place personality imprints on his/her film, guaranteeing a unity; a coherence. S/he is both origin and meaning, but his/her feelings are separate, and s/he cannot be seen. S/he is "outside"; with her/his intelligence gleaned by traces or signatures left behind (i.e. the author "inside"). Visual STYLE thus becomes very important to directors/auteurs. This privileges the body-as/of-text over and above the author-as-transcendental-meaning.

Authorship can also be a series of oppositions that recur from film to film by the same auteur. The author "outside" haunts the margins, eventually (in Barthesian fashion) to return to centre stage. S/he doesn't have complete control, rather a mental agency responsible for primary level of cinematic meaning (i.e. author as origin, but not all meaning).

The author "outside" and the author "inside" marks a distinction. The "outside" author projects "in", rather than the other way around. The "outside" is a catalyst only within a much larger, heterogeneous process of production. The auteur can also be unconscious to his contribution to the film (film can in this way be unconscious).

Through seeing this we realise that film can be a site of contestation between multiple codes. Some theorists believe the authorial signature to be latent; hence it is the final ultimate level of cinematic organisation (though not necessarily of meaning); the auteur being beneath or behind the text, but not the body of the text.

The emphasis on structure gives way to an emphasis on process; "evoked both through the multiple references to the dream-work" [latent contents in the film's "unconscious"] and through the identification of authorship with a "pattern of energy cathexis" (Silverman). As we can see from this description the auteur makes an unconscious contribution to the film, BUT the film, as well, has an "unconscious". And we can also see how this view differs from Barthes in that the auteur does not reside in the body of the text, but beyond it.

This theory replaces the previous structuralist model; desire replaces the binary opposition; *desire* becomes the thing that persists from work to work within a filmic canon. The notion of authorship as a "pattern of energy cathexis" makes us reconceptualise the author "inside" and the author "outside" relationship (although the author "outside" is a projection of the author "inside", he is also the point from which desire issues, and is an absent origin, so to speak).

Now let us move on to the theory of Stephen Heath. Heath doubts the possibility of an author ever being the source of the discourse, and shifts the focus away from the auteur/author as creative agent or "personality", because of the social basis of language. Instead he believes that "ideology" and

"subjectivity" are adverse to ideas of authorship. Heath is concerned (regarding "subjectivity") for the position constructed *for* the spectator, i.e. the "subject-effects". Heath (like Barthes) has followed the line of enquiry that leads to the one who reads or views the text. And importantly, what Heath adds to the issues we are investigating is the concept that the subject is actually produced (him/herself) through textual meaning; rather than being a Barthesian viewer who can create meaning. Therefore issues concerning the construction of subjectivity can't merely be added into *auteur* theory, rather they must supplant it. According to Heath, ideology is the origin and impetus. Cinema is an ideological formation (not the expression of an individual). The ideological formation then accounts for textual meaning by appealing to the individual to place meaning, therefore promoting the belief that the individual gives rise to meaning, rather than being spoken by it (which, of course, s/he actually is). Therefore the ideology itself "lets" us believe we place the meanings when we have (in effect) already been constructed by it; thus so have the meanings we will place.

Silverman asks what happens to the author "inside" the text, as a result of this? It would seem both author "inside" and "outside" are effaced. It would seem that the author returns once again if we look at the remarks about the "history" (social mensuration of the "times") of the subject. And that examining films within that history reveals not the author so much as the insistence of the unconscious (i.e. similar to the "pattern of energy cathexis"); and so the author is seen as a textual figuration.

However, there are problems to Heath's theory. Silverman rightly says that the categories of author and subject aren't as exclusive as Heath suggests. And she suggests that the aim should be to grasp the author precisely *as* the subject.

Since 1972 the issue of authorship has ceased to become of major concern, and issues of the film text as a discourse have become instead the problematic.

Who (or what) is speaking? Cinema seeks to efface the sites of production, presenting itself as a story without a teller; therefore it would seem vital to start viewing its text as an *utterance*. Before there was a marked distinction between discourse and story; now we can add two vitally important categories. That of the SPEAKING SUBJECT and the SUBJECT OF SPEECH. Quite simply the speaking subject is the existential person engaged in a discourse; and the subject of speech is the *discursive marker* through which s/he assumes linguistic identity. There is an interdependent relationship between the two. Only through concrete utterance can a speaker enter into subjectivity and through the connection to the speaking subject the subject of speech has signifying value. Through language one constitutes oneself as a subject – it establishes the ego. Subjectivity is the capacity of the speaker to posit him/herself as a subject. Ego is s/he who *says* ego. Subjectivity is the linguistic status of the person. The first-person pronoun is thus the signifier through which subjectivity is activated in language.

Applied to film, this is problematic. Film is disallowed entry to the site of production (by virtue of the double absence on which it's based). Suture works to obstruct the process of enunciation by folding the story (*histoire*) over the discourse (*discours*). It's hard therefore to know who or what speaks. Cinema

isn't generally construed as a linguistic medium (relegating language to the interior, as it does). The concept of speech is usually metaphoric. Hence, the film's discourse must be accounted for other than as linguistic utterance. The integral question is therefore – what is the filmic equivalent of the first-person pronoun? Because film is visual – the question of "who is speaking?" becomes "who is looking?" Well, the camera looks, therefore it must surely enunciate the film; being as it is the privileged apparatus. The camera frames and organises space. A fictional gaze (where the gaze stands in for the camera) is assumed to be ideological – since it represents the discourse as a "story from nowhere, told by nobody". At least, it is nobody *outside* of the fiction, but it is received by somebody. Films can therefore be ideologically (as well as cinematically) spoken.

The author is barred from this film-as-discourse, and the site of enunciation; although s/he may make occasional quiet returns to it. The spectator's primary identification is with the camera (as "pure" perception); therefore erecting a barrier between the speaking subject of the filmic text and any authorial person; and therefore also excluding ideology.

This notion is opposed by some theorists. Alternatively, the connection is not between the camera's point-of-view and the authorial point-of-view, but rather between the camera p.o.v and the fictional characters (secondary identifications), which tends to break down the pure specularity of the screen/spectator relationship and displace it onto relationships more intra-textual (i.e. relationships to the spectator posited *within* the image and the movements from shot to shot). So, the exclusion of the author from enunciation and the focusing on the construction of the viewer could be the conceptualisation of the subject of speech; which is a concept that Silverman herself once formulated and has since found to be rather curious. She described the character (or group of characters) most central to the fiction; who occupy a position equivalent to that of the first-person pronoun. She also saw the cinematic subject of speech as a discursive marker or stand-in for the viewing subject, *rather* than as a representative of the authorial subject. Silverman has since, of course, re-thought this theory. Certainly, some fictional characters *do* represent the viewer (and thus also structure him/her). But more than that Silverman has no intention of putting the newly reconceptualised author in place of the cinematic apparatus; but she believes that the auteur may constitute one of the speakers in her film . She, herself, says " ... there may at times be pressing political reasons for maximizing rather than minimizing what might be said to derive from this authorial voice."

For the author must be understood to speak her authorial subjectivity, and also the subject of speech must be understood to be integral to Silverman's theory. Following this, it will figure not as the character who constitutes the viewer and marks *his* position, but as any representation through which the *author* is constituted as a *speaking subject*. Silverman adds that she is not advocating the Barthesian "author" (who has been laid to rest), but rather an author who is subordinate to all discursive restraints – who would be nothing outside of the cinema; "an author 'outside' the text who exists as a dreaming, desiring, self-affirming subject only through the inscription of an author 'inside' the text, and not one who could ever lay claim to a radical and self-present exteriority, even though he or she might masquerade in such a guise."

One could say that – this is how I speak because I speak I exist through this text, as a subject of speech, and therefore this is how I come to speak (and to

be). The subject of speech is the representation through which the speaking subject is established, and hence why Silverman claims that the exterior author exists only as a desirous being *through* the author as a speaking subject.

Feminism can benefit from rethinking issues of authorship (especially regarding Hollywood texts). The enunciation we have been discussing is not the same as a paternalistic enunciation. Paternal enunciation doesn't have to be a metalanguage; something that resists disruption, and keeps female discourse inside the diegesis. Enunciation doesn't have to be that (a monolithic dominant phallic phenomenon). An author "outside" of the text can speak her subjectivity not just through her apparatus but through various forms of identification and textual organization (usually considered secondary but not necessarily so).

Contemporaneously, female filmmakers can ask themselves – who is speaking? Who is being spoken? We no longer assume that the camera is the only speaker, as this forecloses on so many possibilities. I would like to add that only someone like Hitchcock could *so* align himself with his camera (and be so phallically dominant) to the extent that he perceived his own identity so fully (with the camera) that the textual system of the film became his own vision. Hitchcock was a notorious voyeur and this explains a great deal; that he actually became the (phallic) apparatus, and we can see how he was actually being spoken (negatively) through his own films.

Admittedly, it is difficult for those voices which speak against the operations of dominant meanings to be heard; especially as the most likely avenue for them is to manifest themselves in irregularities, rather than systematicies.

Jane Campion (writer and director of the award-winning film *The Piano*) is in my mind an auteur who deals with many of the issues raises in this chapter and previous chapters. Especially so because in *The Piano*, Ada, the female protagonist, doesn't formally speak (except through her music, sign-language and the voice we hear [not synchronised with her body] which is a voice-over/voice-off, and we are told, the voice of Ada's mind's eye). We hear a voice speaking from "somewhere" and it seems so incongruous because like all mind's eye voices it is more than a little eerie and disreal. It is not the voice of ordinary projection or enunciation, even. It is one of the most bizarre and beautiful of all cinematic "voices" I have ever heard. Simply because it is so unlikely. It is not a secret that is being given away (i.e. we are not violating Ada's psyche) rather it is a voice that the filmic event has sent out in its mediation to let us know. It is the first voice we hear, and also it is the last voice we hear in the film.

Ada (V.O.):
"The voice you hear is not my speaking voice,
 but my mind's voice."

I shall not fully examine all aspects of *The Piano*, for that has been done already. However, I would like to suggest that contrary to some feminist opinion the film shouldn't be read as a depiction of a creative woman gradually being ravaged, or being taken from one "patriarchally" restraining family role-position, to

another. Many feminists have criticised the ending of the film, claiming that Ada simply ends up in a patriarchal household under the ownership of lover Baines (rather than her husband Stewart). It seems to me that not only does this ignore Ada's phenomenal spirit and WILL (and right from the offset we are informed of Ada's will; in fact, I would say the film revolves around Ada's mighty will); but these claims of ravagement and the reverting to familial restraint also ignore the dynamics of Campion's auteurism.

Ada is a character that encourages women to identify with her. Film critics claimed that she wasn't like-able (male critics, I should add) but this seems to me rather laughable. Ada is spirited, talented, sensual, and has no care for the finickety, pious morals of the time. Her and her daughter share a symbiotic almost magical relationship (although, again, some men have suggested to me that Ada was in fact not a good mother). I find this unbelievable, and have not yet met one woman who found the mother-daughter relationship anything other than touchingly beautiful. Campion herself says: " ... the complicity between Ada and Flora [the daughter] is frightening... " And so it is. Flora is not a child who is suffocated by her mother; she is a child who has her own freedom of expression; she tells lies (for her own amusement), is duplicitous, complex and creative; she is also a child who has been taught by her mother (for we know that there was no paternal influence until Stewart). Flora is her mother's daughter through and through. Who could not be touched by the scenes (depicting just the two of them) in which they interact, almost dream-like and above anything so pleasurable. Ada plays the piano whilst Flora dances and cart-wheels. The two brush each other's hair and giggle together. Flora sleeps inside of her mother's huge, cage-like constriction of a skirt-bustle. But whilst the skirt may confine Ada's sexuality, it does not confine her child – it protects her in her (Flora's) own world of seashells, dusky lighting, soft salty smells, and sounds of piano and ocean. Flora is too aware of her mother's strange and strong WILL. Although she too has her own child-like sense of mischief. It is only for her own reasons of child-like pique that she betrays her mother – and that they both come to grief.

But to return to issues of authorship and Campion herself. Just because Ada becomes part of a "normal" family in the end and starts to try to speak "normally" does not mean to say that this is Campion's expression. What I am trying to say – is that (although I personally feel it is Ada's will which brings her to the point of accepting life with her lover George) this end could be an ending that is already spoken. Campion and any feminist viewer could see in this, a poignant reminder of how we are spoken. This again makes me happy that I don't read the ending as a conforming action on the part of Ada. Even if I did, Campion could be spoken at that point. Campion may not be aligned with either her camera, Stewart (although at times one feels she does identify with him), George, Flora, Ada or the Maoris and Stewart's aunt and community. From what we have discussed in these last few chapters it is apparently clear that Campion simply cannot be aligned with her camera (as if she were a dominant source of meaning as well as the camera itself). Campion may have found herself in the voice-over of Ada; in the actual music played by Ada; in the native Maori woman Hira, etc, etc.

She may have been in Flora's dancing, or in the silence:

Ada (V.O.):
"There is a silence where hath been no sound
There is a silence where no sound may be
In the cold grave, under the deep deep sea."

Campion may identify with the (symbolically castrated) George (and many women do identify with him!), as he is the dispossessed wanderer; the in between; the man that women dream of. She may identify with Ada's first voice-over; just a voice inside the head, that can only be known through the strangest of mediations. Campion may have found herself the subject of speech in many many ways; as well as the enunciator in various ways. A speaking subject and a subject of speech. We may not always hear *her*, but often I'm sure we hear her very clearly in myriad tongues.

Certain feminist theories concerning the author have tended to overlook the issues we've mentioned (often to quite a formidable extent). The author has in some theories emerged within the context as an untheorized "outside" text and punctual source of sounds and images; as if some theorists wish for a nostalgic unproblematic agency; completely ignoring the sense of the author as one constructed in and through discourse; someone separate from the desires that circulate within her texts (with desire investing itself not just in formal articulation but also in recurring diegetic elements).

For example; there can be 2 discourses. One feminist; the other a repressed femininity. An example I'd like to return to is a scene in *The Piano*. Ada is teaching herself to speak, and she wears a veil over her face; so she can remain in darkness. She doesn't want anyone to hear her practice her speech.
 This could say a great deal about the director as a subject of speech.

There is the spoken discourse of the director through the camera; secondly there is the association with the character. There is a blurring of what is "inside" and what is "outside".
 To analyse what is going on we should shift our focus from systematicity to disruption and contradiction. We need to be theoretically "sharp" and attentive. If we shift our focus very sharply from systematicity to disruption we will engender a re-authorship; A HETEROGENEITY.

Let us consider the guises assumed by the author "inside" the text. Authorial subjectivity can be inscribed in a couple of ways.
 An authorial inscription as it is described through a distinction between the speaking subject and the subject of speech; BUT which hinges on a psychic mechanism (about which linguistics says little, i.e. identification). Emile Benveniste came up with this specific theory; and it requires, as we have seen, considerable psychoanalytic back-up.
 And an authorial inscription which assumes a more dynamic, less localised form; the libidinal coherence that films by a particular director are said to have (a desire).

A filmmaker can be said to function as ONE of the enunciators in his/her films;

as works will inevitably include certain sounds, images, characterisations, motifs, patterns, configurations, etc. These provide the equivalent of linguistic markers, through which subjectivity is activated. However, this doesn't completely account for the "inside"/"outside" authorial relationship.

A director may turn the camera on her own face (or voice); incorporating results in the guise of visual representation. It would initially seem a first-person pronoun; but it differs, The relation between "I" and the speaker who deploys that signifier is based on convention (the relation between IMAGE of filmmaker and actual filmmaker is based on similitude; an iconic representation; easily muddled with what it designates). In other words, at a certain point the filmmaker becomes the subject of speech. It doesn't mean that this image is an ontological extension of material reality of what it mimics. Rather than reflecting the author "outside" it constitutes her in the way a mirror reflection (retroactively) installs identity in the child.

Movies construct viewing subjects through identification. Authorial subjects are similarly constructed (although by wider textual supports). Identity is impossible (as we know) outside of symbolism (and the imaginary). An image which might seem evidently part of the individual it depicts can be claimed by individual only by identification. And as Lacan realised identification inevitably turns into MISRECOGNITION.

The combination of author "outside" and "inside" (to make an appearance of the director within the film) also works to make a 2nd misrecognition. The site of narcissistic idealisation. Appearing in her own film, the filmmaker speaks as the point of absolute textual origin, (for e.g. Hitchcock often made cameos in his own films; as if he were in control of both the "outside" and the "inside"). Or a director can speak from within a history/ideology (for e.g. Godard); or he can show himself to be a textually bound subject (for e.g. Fassbinder).

Secondary identification can be with an anthropomorphic representation (not the director's own), rather with an other (fictional character). Godard did this by having a "stand-in" for himself in his films; he in effect locked himself to his stand-in narcissistically. Many directors look to sustain themselves in their characters; and this is based on the level of fiction, of course. This secondary identification is another device for transcendent mastery; especially if the character is a dominant male who can be equated with a dominant cinema.

I am once again drawn to discussing *The Piano*. Many have assumes that Ada is Campion's identification. But Ada doesn't speak (at least not until the end, where we hear her making inchoate [and importantly, UNDERCOVER] guttural sounds); so this surely says a great deal about Campion the director, if she does identify with Ada. Most importantly, that she is aware of how she is spoken. There is a lot to be said in secondary identification when it features characters who are subversive, or outcast, or exiled.

Ada (V.O.):
" ... I am quite the town freak, which satisfies ... "

It satisfies Ada that she is the "exile". Does it not say something about Campion

too? I should add at this point that all Ada's speeches are voice-overs.

The "author" outside may also find a mirror in the body of the text. I am certain that this is undoubtably the case with Jane Campion. The choreography, the movements, the compositions of objects within the frame, the craft, the disruptions, the multiplies narrative, the experiments with sound, the creation of atmosphere, the articulation of light and shadow – all these things and more say a great deal about Campion's *Piano*. They inhibit or encourage identification, abjection; using actors, scenery, sound, and colour. So, an identification can be a narcissistic "recognition". Campion is recognisable (to us and to herself). But her film is still imbricated with the ideology of its time, hence we have the subject in speech. Another good example (one which Silverman notes) is the director Peter Greenaway, as I'm sure anyone familiar with his canon would agree. Some directorial signatures may be left randomly, and we should not forget that just because there's no obvious signature doesn't mean there's no director "inside".

Aside from this sort of identification there is another – namely *desire* (not so terribly different from other identifications).

The authorial scenario for passion; the scene of desire – it is the scene called FANTASMATIC. It is the unconscious fantasy (or cluster of fantasies) which structure dreams and other psychic formations – but also, importantly, object-choice, identity, and the subjective life as a whole. It generates erotic tableaux in which the subject is positioned; its function to display the subject in a given place. There would seem to be a repetition at work here. Scenes/films will replay the erotic tableau with all the original characters (drawn from a familial reserve) but in subsequent productions all actors but one are frequently recast; and that one who remains may assume different roles and guises. It's not hard to spot the psychoanalytical relevance of this; nor apply it to some directors' canons.

Freud gives us some ideas of the fantasies which organise psychic life this way (many derived from the Oedipal complex, which we have already discussed). There's the fantasy of the primal scene; the fantasy of seduction; the fantasy of castration; the fantasy of being beaten, etc. (there are obviously more than I have mentioned here). We can further see the seminal value of these once we delve into them and start linking them. Once all instinctual variations have been considered (i.e. the negative and positive Oedipal complex) and the likelihood of the fantasising self being in more than one subject position at a given moment of fantasy – things become fascinating. I should like to dwell on the "beating fantasy" which Freud analysed. This fantasy is capable of assuming both the male and female (although the female side to the fantasy in feminist terms has yet to work its way into our cultural understandings as well as it could).

Authorial desire can therefore be structured around a "scene". Bertolucci, for e.g., uses the fantasy of maternal seduction.

However, these generalisations really don't giveaway anything about the actual workings of desire in a body of work, as fantasies can work in myriad ways. I could posit that Campion (at least as as regards *The Piano*) concerns herself with the fantasy of female autonomy, expression and male symbolic

castration: although obviously seduction plays a large part too. Therefore, each fantasy has its own consequences for the object-cathexis and identification (which may also vary and be mobile). We can begin to see how authorial identification and authorial desire start to become one and the same phenomenon. The identification with a character (by an auteur) is determined by the subject-position the character occupies and also the fantasmatic "scene" (which the narrative traces in some indirect way). Authorial desire and authorial identification are thus mutually referential; on examining one an opening to the other invariably occurs.

It is also important to remember that the position the author occupies within the (scene-) setting of desire may transgress the author's "outside" biological gender. It is exciting therefore to move on to investigate when and how this "transgression" occurs. And we should also *not* ever forget the biological libido (masculine or feminine) as we come to these investigations. For it is not the same socio-politically for a woman to speak with a feminine voice, as it is for a man to do so. We have already explored this to an extent previously within this book. All manner of cultural imperatives dictate an easy match between gender and subject-position; thus insuring that a transgression from the "easy-match" becomes a site of resistance to sexual difference. In this way we can see that to follow certain definitions of what is masculine and what is feminine lead us to the perpetuation of a "sexual difference" theory that benefits few and represses many. This is why I believe I can claim to want to disband "sexual difference" as we know it now; but to want to respect sexual difference in biological terms (of course other differences, should also be respected: racial, physical, mental, etc.).

The fantasmatic constantly draws in fresh material; it is far from "full" or complete; it is always absorbing the outside world. This is a very revolutionary concept. We are, in effect, contributing to our own temporal histories. The fantasmatic might include radical white-on-black, black-on-white fantasies (a neo-slave/master dynamic); male fantasies of an autonomous woman [who is *neither* mother or child]; fantasies about women that women understand (the re-enactment of male on female abuse, but between two women so that it can be exorcised); "abject" fantasies; apocalyptical fantasies, abduction fantasies, etc.

The fantasmatic is drawn towards new socio-political parallels, and can lead to relevant "scenic" changes. I firmly believe this. It is always vital to ask of any authorial desire: how has it assimilated history? And how might it be seen to act upon history?

I'd like to return to *The Piano* at this point. What do we make of Campion's desire? We could speculate that it is a seduction fantasy; but it is a seduction fantasy that is markedly underscored by a castration fantasy. Stewart staves off his own castration when he chops off Ada's finger. He is a sad character who knows he will never be able to bear/bare himself; his other self. Why, he cannot even bear to have her gently stroke his buttocks; it undoes him. Baines on the other hand is the Campion desire for the symbolically castrated man. Strangely he is also a "white nigger" (a term devised by Norman Mailer). He is the man who has rejected his own culture for another culture (signified by Baines'

adoption of the Maori culture) but he is abjected because of it. Although, obviously *The Piano* is set in another century, so that, in Campion's own words they do not have "20th-century sensibility about sex". But that isn't what is important to our discussion here. What we are concerned with is the history of the production, which is very much of the 1990's; and therefore comments poignantly on authorial identification, desire and fantasy.

How can the authorial desire assimilate history? How has it acted upon this history?

Campion's authorial desire has surely told us a great deal about her own repetitive passions and concerns. And it has told us a great deal about how she sees her fantasmic-self as a creative being. This desirous and desired being plays the piano with a passion (never before depicted by cinema) and loses herself in her expression (as never before depicted by cinema) whilst her own progeny also to lose themselves in the beauty of their mother's artistry: doing balletic movements, self-absorbed, narcissistic and self-assured; whilst the man of her own making severs himself from fascist absolutism, instead living deep in the jungle in a hot-house with just his dog and food and pipe – waiting only for her (he does not exist aside from her – his narrative begins and ends for Ada); and therein is the mood that passes through you. This film tells us so very much about the fantasies of women today. It has taken up the enforced-role of the castrated woman (Ada having her finger chopped off) and has asked that we allow Ada's WILL to act upon history-making. There is an *uncanny* (something familiar but lost) passion and emotion to *The Piano*, which has affected women more than most contemporary films.

I have already briefly mentioned nodal points. Let us return to this; by way of the point of entry into the libidinal economy. That entry can be executed via the nodal point. This might take the form of a sound, image, scene, place, action – to which the film repeatedly returns. Whilst *The Piano* is poetic and multi-contextual, there are nodal points. The music, for one, is exceptional; certain repeated piano melodies haunt and haunt, time and time again. The music simply regurgitates itself to such an extent that it becomes a powerful emblem of the content of the film. It is a major nodal point. Ada's stare (a slow deliberated action) also provides us with the necessary knowledge to understand her narrative. The sound of Flora interpretating her mother's sign-language, and Ada's emphatic, impatient signing coupled with the silver note-pad and pen around her neck. The piano itself, its keys; they are present even when the piano is absent – as when Ada draws the keys on the kitchen table. Of course more than anything we are forced to contemplate the language of these people (their spoken and written words) and the language of Ada. Hence, we return to the nodal point of Ada's piano (for we are well aware that this piano is not simply anyone's piano; although it may become the viewer's piano, if identification allows). Ada is reduced to written language when she sends a secret message to Baines (inscribed upon a key of her precious *piano*), and of course Stewart finally relinquishes his Victorian Patriarchal hold on Ada when he believes he has heard her "speak". He believes he hears her "voice" right inside his head in the middle of his forehead. It is as if he knows that "inside" voice; that internal voice is the signification of himself, as he is destroyed by his own patriarchy. And as he is destroyed by his own ghosts. Rather like Heathcliff when he heard the

deceased Cathy calling to him; only hearing her after he had lost her and after he had sacrificed his soul to the paternal world and its investiture. Emphatically, this voice that Stewart hears in the middle of his head – is the voice that is like "a mood that passes through you" (please see/hear: Michael Nyman's soundtrack recording). It was his aunt who says in the film that Ada's music is like – "a mood that passes through you"; and so is the voice of Ada that Stewart claims he hears, and which finally forces him to let Ada go (to a place where her will must have its way).

Silverman states that the nodal point may come as an "excess", and this is surely the case with *The Piano*. It is a fixation; and we are surely fixated by Ada, her piano(-playing) and her passions. It is also vertiginous, like an intoxication. For that is also what Baines feels (and what Ada and Stewart also feel). The intoxication finds its expression in the swirling of fingers over keys; the swirling of the camera as it disappears into Ada's highly-artistically created hair-do and then beyond into the dense lush forest; in the draw and lure of the cliff-tops and ocean; in Ada's fingers and her daughter's dancing. All are charged with a driven-impetus, and a magic.

The authorial fantasmatic can also be tracked to the level of the actual story. Desire can be found in the narrative, in this way. This is certainly true of *The Piano*. In this way we can find traces back to the author "outside"; Campion by her own admission is fascinated by the *pakeha* (the white New Zealand settler), as that is her heritage; as I am also sure she is biographically concerned with the notion of a creative and artistic woman, alone in a "man's world".

Sometimes the fantasmatic "scene" can be sketched by the larger narrative trajectory, repeatedly mapped by films with the same authorial signature. At other times the fantasmatic "scene" may give rise to an insistently scenic narrative structure.

I should like to finish by drawing our attention to the work of the director Liliana Cavani. Although, at first glance, Cavani may not appear overtly feminist, there is a strong covert occupation to her filmic canon which is fascinating. Desire and authorial subjectivity (and identification) are inextricably bound up with one another in her works. There are no objects as such (to yearn for or possess) rather models to imitate, incorporate, and intersubjective spaces opened to us for sharing. As Silverman says – " ... a cinema of being, not having ..."

Cavani's subjective desire finds expression through the repetitive figuration of phallic divestiture. Her fantasmatic "scene" is of male (symbolic) castration; it is strangely narcissistic. It is involved in masculine masochism; masculine criticism of the symbolic order. But Cavani privileges each of "her" men: " ... each of my male actors looks a bit like me ..." she says.

What female desire could find an expression in a preoccupation with male characters? How does the masculine come to be at the very boundaries of sexual difference? And as Silverman expertly puts it, how can this be – " ... beyond the phallic pale ...?"

Cavani's male characters are serialised (in her works) as experiencing a

divestiture; a cultural estrangement; or a self-mutilation. Thus her authorial desire maps itself out. The Cavani male deliberates self-loss and loss of the phallic legacy; he assumes a different paternal lineage (one predicated on negation and suffering [I'm almost reluctant to suggest "he" is almost Jesus-like, but it's certainly true, after a fashion]). *Jouissance* accompanies his sacrifices, for he knows something the other men do not! He laughs at the collapse of the paternal hierarchy. His is a dispersed subjectivity; a consciousness for all the people. However, the important point is stressed, that in the wake of the collapse of one hierarchy, another has sprung up in its wake (rather like Jesus' disciples' new religion, or a misandrist feminist matriarchy; in fact any system that is destroyed only to be replaced by its Other). To challenge this, the Cavani male, *again*, situates himself on the side of the dispossessed (thereby divesting himself of himself!!). His continuous attempts to refuse power and privilege are an attempt to show that there IS NO DIFFERENCE! This is the most poignant film-making; I urge you to investigate Cavani's work. Thus we begin to comprehend that divestiture leads to the abolition of difference; and discursive divestiture too leads to the abolition of sexual difference (i.e. gender constructions, as we know them).

Cavani seems drawn by the notion of androgyny; but what is more important (for OUR history) is the enactment (again and again and again) of the demise of the traditional, phallic, male author (which is really what Barthes desired). And in its place a non-phallic, SINGING, FEMALE VOICE ARISES.

Male (symbolic) castration becomes the agency whereby the masculine subject is forced to confront his *own* lack; and is re-made as a woman. But most importantly, fantasised male (symbolic) castration is how women construct *themselves* as the speaking subjects, and emerge within the text.

We can therefore see how the resistance to feminism is actually a resistance to the LOSS OF DIFFERENCE. Film has based itself on the emphasis of the male who is unable to confront femininity directly. But, many intelligent and feminist women are attracted by anti-heroes, in film. The kind of anti-heroes who oppose the "rules", divest themselves of that metaphysical power that their fathers tortured both their mothers and themselves with, and who continually refuse to build another Absolutism. And these men are much more virile than their conformingly patriarchal predecessors. Moreover, female authors and auteurs fantasise these men. Female fantasy is the last bastion of liberation, for us all. The men in female fantasies are virile and aroused; but they are more than anything empathetic with the feminist need to move away from the fascist legacy of patriarchy. Strong women demand strong, individual men (not men who ride on the backs of their mis-guided fathers); and it is my belief that strong men desire strong women (who won't turn away from their bodies; their desires; their bodily problems, or emissions) as patriarchy has told them (and us) women might. Nor expect them to carry an impossible burden; the burden of always having to take the active responsibility of both partners; women now want to take responsibility for their own actions and desires. Women no longer want to *be* touched; *be* kissed; *be* seduced; *be* fucked. Rather they want to touch; to look; to guide; to instruct; to fantasise; to fuck.

This reversibility is centrally inscribed in Cavani's films. She denies the difference between mother and son; the male character and the author "outside"; the authorial and the spectatorial subjectivity. Instead we have a symbiotic mirror-ing between each of the two pairings; causing a collapse of the binary.

Cavani's marginal male subject also constructs her authorial subjectivity at the site of that divestiture. Through using reflecting narrative elements, she foregrounds the imaginary/Imaginary. This collapse of the binaries also predicates a position that is not always "I" as we know it.

At the same time the film points beyond sexual difference, hearing a voice that neither originates nor defers – but articulates a characterological system through which it constructs itself as both author and (in another sense) female.

What is the fantasmatic "scene" (psychologically) towards which we have been progressing (and which is at the root of the authorial inscription)? And how is this truly "feminist"?

I mentioned a while ago the fantasy of the child being beaten. I wish to dwell on this to further illuminate my theory. The child being beaten concerns itself ostensibly with a punishment and humiliation (but issues of another kind may have be substituted). In short, the beating has latent content. This scene is in accordance with Freudian theory: i.e. it is part of his case-work which noted a patient's dream. Let us remember, latent content is of paramount importance, and dream-work (latency) does not think for itself, it is merely desire itself.

The dream can be read in stages:
1) The father is beating a child (whom I hate).
2) I am being beaten by my father.
3) Some boys are being beaten (by a fatherly representative). I am probably looking on.

Freud supposed that the first stage (1) could only be a vague memory. The fantasy proper begins with stage (2). At this point the female child can relate this to the Oedipal. The child is therefore being punished for a desire, or is even being satisfied masochistically by being beaten (this also can tie into the focus of desire moving from genitals to anus: thus it becomes a pleasurable "anally" orientated experience). Masochism is common in female fantasy obviously because it allowed a sublimated or repressed sexual freedom of expression. However, because this fantasy is so repressed it's recoverable only as a "construction of analysis". Stage (3) which features the group of boys actually fills in for the young girl as targets of pleasurable parental punishment.

I'd like to interject at this point in case any readers have a problem with my seemingly "casual" statement regarding female masochism. Following the train of psychoanalytical thought that tells us that ideologically, and socio-sexually, women (as they are spoken as young girls, mothers and loyal wives) are not supposed to enjoy their own autonomous or self-created sexual pleasure – it thus (unfortunately, but perfectly logically) also follows that female masochistic fantasy (and I STRESS fantasy) is not uncommon. Within the realms of fantasy, masochism allows women to experience the relinquishment of a projected role. If women are told that they are "bad" girls to be sexual their fantasies will of course reflect that, and pleasure will be gained from subsequent fantasy. Sex as

something "naughty" and "dirty" is still a very predominant part of our social-sexual ideology (it is so much a part that it is in fact necessary for many people to still consider it "naughty"; and to consider the "best" sex as something subversive rather than ordinary). However, to return to the above paragraph, the hypothesis of a parent punishing a child and it being (latently) sexual is not uncommon if you research our sexual history and its latent meanings.

Freud maintained that the gender change between stages (2) and (3) of the dream is motivated by demands of authorship. For Silverman, stage (3) satisfies 3 transgressive desires. The desire that boys (rather than girls) should be loved/disciplined in this way; the desire of the girl to be a boy whilst being so treated; and the desire to occupy the male subject position BUT under the sign of femininity, rather than masculinity.

Since the fantasmatic scene is always assimilating new material it is perfectly feasible for these desires to be historically incorporated and activated! One could therefore says that Cavani's fantasmatic scenes involve a girl who turns herself into a group of boys (namely the male characters that she creates in her films). BUT, then importantly, she positions them as female subjects (i.e. castrates them).

And again I feel it is vital to stress that these boys, or men – belong exclusively to the female author. They are not any men "out there" although of course they are men – but they are more importantly, Cavani herself. They are Cavani's fantasy men. This is terribly important to many of my theories; and I feel this applies to the work of many women writers, performers, poets and singers. The men many women sing or write about are male muses, but are actually themselves. The finest lover is the lover inside of oneself. The most erotic male fantasy figure is the one who inhabits a truly daring female-subject position. I have written before (in my essay: "Michael R. Gira: Speaking In Space" in the book *Bridal Gown Shroud*) a man is all the more "masculine" (in a newly liberated way) the more he inhabits a "female" position.

Cavani's films (concerning themselves with a "beating fantasy") display a libidinal attack on sexual difference. The fantasy dethrones the phallus and femininity becomes the norm of subjectivity. It is odd that many may believe this Freudian example to aide the continuation of patriarchal phallogocentricism, and gender categories. It is through feminism that history can be seen to have worked on this *mise-en-scène* of masochistic desire.

Foucault told us that a group of signs can be called a statement because the position of the subject can be assigned. Silverman has stressed what Foucault seems to dismiss – that of the relation between author "outside" and author "inside"; and the key role of the libidinal economy of the marginal male subject who functions as a nodal point for the author's dream; and who also casts upon the female author that which she would like to be (i.e. a woman occupying a male subject position but ONLY as a castrated male).

The structuring force of this dream goes beyond Cavani-as-speaking-subject; therefore, in a way, Foucault is correct to say that there's something more critical than the determination of the relationship between author and what s/he says; and that is to establish the position which the reader/viewer will come to

occupy through identifying with the subject of a given statement. That position is critical. It is assignable and importantly – re-assignable.

Silverman admits to sharing a Cavanian desire for the divestiture of the phallic male; and further goes on to say that her own authorial subjectivity in some ways reflects the one those texts project. She says that she has concerned herself with the lacking or castrated male in her work; has found herself in others' works; others' acoustic mirrors. In so doing, she has turned the focus of the Oedipal from the male onto the female, to the benefit of many women. The Freudian anatomical castration complex has become the symbolic castration (which benefits us all; as it is the principle that effects separation from the mother and entry into language [which exceeds and anticipates the subject]). The positive Oedipal complex has become concerned with giving priority to the feminine; the negative Oedipal becomes a place of desire for and identification with the mother, and generator of narcissism; not forgetting feminism! Lastly, symbolic castration (as well as heralding our entry into subjecthood) can also save us from the confines of phallogocentric domination, as we seek to remove ourselves from its dominant tenure; reinstating the feminine for both genders, paving the way beyond sexual difference.

It is my belief that we can pass these acoustic mirrors onto others. I shall continue to look into others' mirrors, and I shall continue to listen to others' acoustic mirrors; most of all I shall not cease examining my own.

Nina Simone
Mythologised as a crazy temperamental black woman, whose public had to be protected from her. As a young girl she was turned down by the Curtis Institute Of Philadelphia because she was black. She had been practising her music for seven hours every day. The rejection was so intense that she never got over it; instead changing her name to Nina Simone to play the devil's music.
 "Some say that Hell is right below us
 I say that Hell is by my side."
Other black activists (from the entertainment world) persisted in their involvement in civil rights, but Simone was to stand alone. She carried the burden by herself (one of the few to address radical issues in song), when many became tired of the struggle. She was so pro-black that white audiences feared her. Later, she was to become paranoid, believing the FBI were "out to get her". Martin Luther King had been assassinated and her political involvement placed her in a vulnerable position. As she got older the strain began to tell. She suffered hallucinations and became just "too tired".
 Her immense strength of character and (sometimes frightening) temperament made her one of the most unique black female singers of modern times. Her voice lilts and rasps simultaneously; singing chords rather than single notes.
 "I would NOT have been a peaceful person."

Jarboe
Lyrical poetry; literal, ambiguous and metaphoric. Each song is individually undertaken and addressed; fully allowing the articulation and liberation of *the persona who lives within each song*. Thus, each song contains its own ambience; each voice its own recognition; be that voice guttural, softly spoken, or

accented. There is therefore a poignant attentiveness to voice inflection and intonation.

Multiple personas and various voices are presented as a collection on Jarboe's solo project *Thirteen Masks*. As Jarboe herself says, regarding multiplicity – "...what it implies is of such second nature that it's hard to be analytical."

There is a razor sharp humour to her canon. There is also often a sense of possession; the line between her ostensible possession and mine, as a listener, blurs. But above all, there is unutterable pleasure to be found here; a *jouissance*.

Subject matter is often simply and complexly involved with perceptions and expressions of love. Imagery is lush, haunting, meditative, often hallucinatory. Sacrifice. Emotional vampirism. Promises. Lost souls. Pledges. Ancient stories. *"...come into me, listen..."* (from "Listen" on *Thirteen Masks*). Ancient instincts. Odes. Emotional pain is always dealt with by an unforced address. There is also a "touching to and fro" upon the resources of operatic fervour and the theatrical (in the sense that she is very aware of and experienced in the dynamics of live performance). "All I can say is that in my mind when I record or when performing in front of an audience, I am nude and sacrificial. *No matter who I am.*"

Jarboe is a member of the bands Swans and Beautiful People Ltd. She is also a solo artiste.

Kate Bush

Once called the Princess Of Suburbia. Subject matter ranges: Rural Olde England; poetry written on the walls of her parents' barn, fictional dead spouses, Heathcliff and Cathy, fictional incest, lions, swallows, The Ninth Wave, Symbolism, Red Shoes, Bulgarian folk vocals. The banshees for backing vocals. There's a circular nostalgic quality to her work. Cycles and links between children, parents and fore-bearers are continually re-traced. Bush's nostalgia isn't maudlin or sentimental; it is magical, silver and gold; pleasurable and eternal.

For years it would seem that many overlooked her talents of composition, to say nothing of her instrumental and songwriting skills. Few have written as much varied, inspired and individualistic work.

Her two brothers are muses: Heathcliffs to her Cathy (a childhood pet-name). Their deeper voices sometimes backing up her vocalisations, to produce an intoxicatingly sexual effect. Theirs is a cerebral fantastical musical "incest".

"Waking The Witch" has Kate begging for mercy at the hands of patriarchal oppressors; with one brother gruffly "damning" her innocence, her sexuality, at the end of each line she utters. They end up putting her in the "dunking-chair" for being guilty of witchcraft (or so we are led to believe from the sound effects). But many of the men in her songs are fantasy creations that say a great deal about the sexual imagination, for these men are a woman's men not belonging to their fathers; they are symbolically estranged from actual phallogocentric power.

In "Get Out Of My House" a Midsummer's Night-like mule man attempts entry into her "house". He woos her with poetry; they arouse each other with the power of sex. "The Man With The Child In His Eyes" is further testimony to her fantasies. *"Nobody knows about my love, they say he's lost on some horizon."* But, as she says this is the man that's there when she goes to bed, turns the light off, stays up late and who knows all her situations; yet isn't

actually there for others to see.

"...*Just being alive, it can really hurt. These moments given are a gift from time...*" (from "Moments Of Pleasure")

Kate Bush runs her own production company; she writes, produces and arranges all her music.

Liz Fraser

Chattersome nymph Echo may have sounded just like Liz Fraser once upon a time. There is something indubitably avian about her singing; as she mutters away to herself, murmurs secrets and then lets her voice project outwards. Fraser has a referential language all of her own; it is unique. During the 80's she stood alone, and apart from other vocalists; if not for her extraordinary vocalisation, then definitely for her perfectionism. Her sounds are unworldly yet they relate emphatically to the body. They quite simply proclaim themselves as the individual sounds of a woman's throat, lungs, spleen, solar plexus, larynx and imagination. The listener is required to place her own fantastical and seductive meanings to Fraser's utterances before Fraser whips the sounds away into another realm by alternating between what must be thousands of significant, but mutable, messages. The very fact that one cannot *fully* detect recognised symbolic words within her repertoire only heightens the possibilities of pleasure.

Liz Fraser has perfected her techniques; she utilises "circular breathing" so that her instrumental voice sings out on indrawn breaths and outward breaths simultaneously or in a looping effect. Always at great pains to be exactly perfect in performance, audiences sometimes have to wait and wait whilst she attempts a song again and again; but that is without doubt the prerogative of the true diva. Concurrently, whilst she can "caw" she can also produce a curious dove-like noise; singing with heightened almost vertigo-inducing breathlessness. There is a dis-real quality to all her work, as if one were hearing the sounds of the world that might ordinarily escape the human ear; like a refraction or magnification of sound as we know it.

She covered Tim Buckley's "Song To The Siren"; the title is crushingly ironic in the face of her delivery. "Aikea-Guinea" finds her chanting to herself before her voice trips up and down the scales with bewildering intensity. "Quisquose" is built upon the usual Cocteau Twins guitar work and a great clanking piano, whilst she executes child-like sing-songs before abruptly breaking into an almost Arabesque and Arabian throaty warble, that seems to threaten the most disturbing of things, as it builds its own patterns.

Cora Martin

Cora Brewer was born in the 1920's in Chicago. In her teens she was adopted by the legendary gospel singer Sallie Martin. She became lead singer in Sallie's ensemble (replacing Dinah Washington); which was the first female touring group. Has voice has both deep soulful cello tones to it as well as a biting improvisational nature. The song "Didn't It Rain" (in my mind one of the greatest gospel songs ever) was an early hit for her. She is accompanied by her church choir and urges the singers on to greater and greater heights of fervour. It is quite simply utterly arresting, and her voice roars above her backing singers with an unbelievable power.

Her phrasing is often downright insidious, and she demonstrates a melismatic virtuosity. Today, she still continues to conduct her church choir.

"They say I brought the curlicues to the West Coast."

She is a stylistic wonder.

Dorothy Love Coates

Born in Alabama in the 1920's (where she still lives) Love Coates first became famous as lead singer and composer for the Original Gospel Harmonettes. Her irresistible swing and politically-focused lyrics were combined with a terrifying stage presence. So physically athletic and strong she would swirl down church aisles or collapse to her knees trembling with the force of her song. She was one of the most powerful leads of the golden era of gospel. (Rather like the great Willie Mae Ford Smith before her, who is recognised by all as the most influential female gospel soloist [despite only ever recording six songs in her prime], and whose voice was so great and had so much volume that engineers had to mike her as if she were a chamber group. Characteristically, in folkloric fashion, she comes into a song when she feels like and follows her own timing).

Love Coates also has her own inimitable sense of timing. An attitude and an intensity. As well as the most powerful of lungs. The song "Troubled" is her own composition. It demonstrates perfectly the fine line between gospel and the blues. She moans and chuckles to herself whilst giving her message to the world.

"... and you got the power Lord ... POWER ... to fix it so ... I won't be ... I won't be troubled ... troubled no more ..."

Kathy Acker

Kathy Acker is well-known as an avant-garde novelist. She has worked, studied and taught at various universities across North America. She was present during punk in New York, and has forwarded her own unique blend of writing; which includes sexually explicit language, plagiarism, cut-up, mixed narrative, poetic-prose, multiple personas, and, basically, lingual gymnastics.

More than anything it would seem she has worked hard at "reclamation"; the reclamation of pornography, or sexual explicit-ness, pleasure and pain; and the reclamation of definitions and meanings. Her books display their own desire to subvert the notions of gender.

It is self-representation as self-beauty; getting in touch with all the suppositions about gender that women have been forced to accept and conform to. That they/we have been forced to swallow. Invert. It's about examining what women have internalised and making it positive.

" ...art doesn't come from ... one man going to hit another man; art comes from a gesture of power turned against itself ... when you take that emotion and turn it in on itself ... what women do ... women are almost 'natural' artists ... [they] walk around the world finding patterns of sensuality."

To hear Kathy Acker read her work aloud is to hear your most painful and pleasurable thoughts vocalised. I heard her read in London a year or so ago. I have tried to never let the memory of her reading go (although memory is unfortunately a wily devil). It was the most wonderful experience.

Women stepped into each other's eyes; dizzy and intoxicated; because there was nothing like losing yourself in another woman's eyes when you can go so

far without your ego stopping you – like looking deep into your own dreams. Female pirates maraud on journeys; for they have no sense of what or whom they should be (being out in the middle of the ocean as they are). They all have the most beautiful, intricate tattoos; they make bets who can endure the biggest tattoo or spanking. They laugh; they work. They talk. They proclaim, exclaim, reclaim.

Epilogue

For now has surely come the time; for I am leading (as I have also been led) −
to the point of the supposition of sexual-difference-less. To grasp before its dies.
That is not to say I am not this being called "woman" rather that I refuse to be
part of the oppression: reliant upon the forces which led to my oppression; as
a voice. I will move on up a little higher. I will not be just that which I am in the
status quo; time then for me to fantasise a man and make him woman. Away
[from all] this Absolutism.

The End

Bibliography

Abraham, N., and Torok, M., *The Shell And The Kernel: Volume 1*, (ed.) N.T. Rand (The University Of Chicago Press, Chicago and London, 1994).

Barthes, R., *The Death Of The Author* (Hill And Wang, New York, 1986).

Barthes, R., *The Pleasure Of The Text* (Hill And Wang, New York, 1975).

Breuer, J., and Freud, S., *Studies On Hysteria* (Hogarth Press, London, 1957).

Butler, J., *Bodies That Matter: On The Discursive Limits Of "Sex"* (Routledge, New York and london, 1993).

Campbell, J., *Myths To Live By* (Paladin).

Campion, J., *The Piano* (Bloomsbury Publishing, 1993).

Carter, A., *The Sadeian Woman – An Exercise In Cultural History* (Virago Press, London, 1987).

Chesler, P., *Women And Madness* (Doubleday, New York, 1972).

Chodorow, N., *The Reproduction Of Mothering: Psychoanalysis And The Sociology Of Gender* (University Of California Press, Berkeley, 1978).

Cixous, H., *The Book Of Promethea* (University of Nebraska Press, Lincoln and London, 1991).

Cixous, H., *Coming To Writing – And Other Essays*, (ed.) D. Jenson (Harvard University Press, 1991).

Cixous, H., and Clément, C., *The Newly Born Woman* (Manchester University Press, 1986).

Derrida, J., *Writing And Difference* (Routledge and Kegan Paul, 1978).

Derrida, J., *Of Grammatology* (John Hopkins Press, 1976).

Devereaux, G., *Why Oedipus Killed Laius* (paper in "International Journal Of Psychology". Vol.34, 1953).

Devereaux, G., *The Psychology Of Feminine Genital Bleeding. An Analysis Of Mohave Indian Puberty And Menstrual Rites* (paper in "International Journal Of Psychology", Vol.31, 1950).

Fisher, J., *Reflections On Echo – Sound By Women Artists In Britain* (paper for the MOMA "Signs Of The Times" exhibition).

Freud, S., *The Pelican Freud Library*, ed. J. Strachey, general ed. A. Richards (Penguin Books, 1973-86).

Friday, N., *Women On Top – How Real Life Has Changed Women's Sexual Fantasies* (Hutchinson, 1991).

Fuss, D. (ed.) *Inside/Out – Lesbian Theories, Gay Theories* (Routledge, New and London, 1991).

Gaar, G.G., *She's A Rebel – The History Of Women In Rock And Roll* (A Blandford Book).

Gilbert, S., and Gubar, S., *The Madwoman In The Attic: The Woman Writer And The Nineteenth-Century Literary Imagination* (Yale University Press, New Haven, 1978).

Gilman, C. Perkins, *The Yellow Wallpaper* (Virago Press, London, 1988).

Gladwell, A.O., *Bridal Gown Shroud – Essays And Fiction* (Creation Press,

London, 1992).

Griffin, S., *Woman And Nature – The Roaring Inside Her* (The Women's Press, 1978).

Hazel, V., *Strains Of Silence: Jane Campion's "The Piano"* (essay in "Photofile Forty", Australia, November 1993).

Hay, M.J., and Stichter, S. (eds.) *African Women – South Of The Sahara* (Longman, London and New York).

hooks, b., *Ain't I A Woman: Black Women And Feminism* (Routledge, London) *Outlaw Culture – Resisting Representations* (Routledge, London and New York, 1994).

Irigaray, L., *An Ethics Of Sexual Difference* (The Athlone Press, London, 1993). *L'Oubli De L'Air Chez Martin Heidegger* (Minuit, Paris, 1983).

Juno, A., and Vale, V. (eds.) *Angry Women* (Re/Search Publications, 1991).

Koestenbaum, W., *The Queen's Throat: Opera, Homosexuality And The Mystery Of Desire.*

Kristeva, J., *A Kristeva Reader*, (ed.) T. Moi (Blackwell, Oxford, 1986).

Kristeva, J., *Powers Of Horror – An Essay On Abjection* (Columbia University Press, New York, 1982).

Kristeva, J., *Revolution In Poetic Language* (Columbia University Press, New York, 1994).

Lacan, J., *Ecrits – A Selection* (Routledge, London, 1992).

Laing, R.D., *The Divided Self – An Existential Study In Sanity And Madness* (Penguin Books, 1970).

Laing, R.D., *The Politics Of Experience* (Pantheon Books, New York, 1967).

Lebeau, V., *Lost Angels: Psychoanalysis And Cinema* (Routledge, New York and London, 1995).

Marks, E., and de Courtivron, I. (eds.) *New French Feminisms* (Harvester Wheatsheaf, 1980).

McEvilley, T., *Art In The Dark*, in A. Parfrey (ed.) *Apocalypse Culture* (Feral House, 1990).

McNeil, H., *Emily Dickinson* (Virago Pioneers, Virago Press, London, 1986).

Milner, M., *The Hands Of The Living God – An Account Of A Psycho-Analytic Treatment* (Virago Press, 1988).

Minh-ha, T.T., *Difference: A Special Third World Woman Issue* (in "Discourse 8", Fall/Winter 1986-87).

Mitchell, J., *Psychoanalysis And Feminism* (Allen Lane, London, 1982).

Mitchell, J., and Rose, J., *Feminine Sexuality: Jacques Lacan And The Ecole Freudienne* (Macmillan, London, 1982).

Moi, T., *Sexual/Textual Politics: Feminist Literary Theory* (Routledge, London and New York, 1985).

Paglia, C., *Sexual Personae: Art And Decadence From Nefertiti To Emily Dickinson* (Penguin Books, 1992).

Reed, J., *Marc Almond: The Last Star* (Creation Books, London, 1995).

Reinelt, J.G., and Roach, J.R. (eds.) *Critical Theory And Performance* (University Of Michigan Press, 1992).

Ronell, A., *The Telephone Book – Technology, Schizophrenia, Electric Speech* (University of Nebraska, Lincoln and London, 1989).

Sarup, M., *Jacques Lacan* (Harvester Wheatsheaf, 1992).

Saunders, L. (ed.) *Glancing Fires – An Investigation Into Women's Creativity* (The

Women's Press, London).

Shuttle, P., and Redgrove, P., *The Wise Wound – Menstruation And Everywoman* (Paladin, 1986).

Silverman, J., *Shamans And Acute Schizophrenia* (paper in "American Anthropologist" Vol.69, no.1, 1967).

Silverman, K., *The Acoustic Mirror – The Female Voice In Psychoanalysis And Cinema* (Indiana University Press, Bloomington and Indianapolis, 1988)

Sontag, S., *The Aesthetics Of Silence* (essay in "The Susan Sontag Reader", Penguin Books, 1982).

Sontag, S., *Writing Itself: On Roland Barthes* (essay in "The Susan Sontag Reader", Penguin Books, 1982).

Ussher, J., *Women's Madness – Misogyny Or Mental Illness?* (Harvester Wheatsheaf, 1991).

Walker, A., *The Temple Of My Familiar* (Penguin Books, 1990).

Walkerdine, V., *School Girl Fictions* (Virago Press, London, 1990).

Wallace, M., *Black Macho And The Myth Of The Superwoman* (Verso, London and New York, 1990).

Wallace, M., *Invisibility Blues – From Pop To Theory* (Verso, London and New York).

CREATION BOOKS should be available from all good bookstores worldwide. Ask your bookseller to order from the following suppliers:

Distributors to the UK book trade:
BOOKPOINT, 39 Milton Park, Abingdon, Oxon OX14 4TD.
Tel: 01235-400400 Fax: 01235-832068
UK non-book trade and mail order requests:
AK DISTRIBUTION, 22 Lutton Place, Edinburgh EH8 9PE.
Tel: 0131-667-763197 Fax: 0131-662-9594
Distributors to the US book trade:
SUBTERRANEAN COMPANY, PO Box 160, 265 S. 5th Street, Monroe, Oregon 97456. Tel: 503-847-5274 Fax: 503-847-6018
US non-book trade and mail order requests:
AK PRESS, PO Box 40682, San Francisco, CA 94140-0682.
Tel: 415-923-1429 Fax: 415-923-0607
Canadian distributors:
MARGINAL, Unit 102, 277 George Street, N. Peterborough, Ontario K9J 3G9. Tel/Fax: 705-745-2326
Australia and New Zealand:
PERIBO PTY LTD, 58 Beaumont Road, Mount Kuring-gai, NSW 2080.
Tel: 02-457-0011 Fax: 02-457-0022
Europe:
TURNAROUND, 27 Horsell Road, London N5 1XL
Tel: 0171-609-7836 Fax: 0171-700-1205

Further information is available from:
Creation Books, 83 Clerkenwell Road, London EC1R 5AR, UK.
Tel: 0171-430-9878 Fax: 0171-242-5527
A full catalogue is available on request.